The Focal Handbook of
COMMERCIAL
PHOTOGRAPHY

Gerry Kopelow

FOCAL PRESS

Boston Oxford Johannesburg Melbourne New Delhi Singapore

Focal Press is an imprint of Butterworth–Heinemann.
Copyright © 1998 by Butterworth–Heinemann
Ⓡ A member of the Reed Elsevier group
All rights reserved.

∞ Recognizing the importance of preserving what has been written,
Butterworth–Heinemann prints its books on acid-free paper whenever possible.

 Butterworth–Heinemann supports the efforts of American
Forests and the Global ReLeaf program in its campaign
for the betterment of trees, forests, and our environment.

Cover and book designed by Leo Kopelow.

Library of Congress Cataloging-in-Publication Data

Kopelow, Gerry, 1949–
The Focal handbook of commercial photography / Gerry Kopelow.
p. cm.
ISBN 0–240–80214–4 (alk. paper)
1. Photography— Business methods. 2. Commercial photography.
3. Photography —Vocational guidance.
4. Photography — Equipment and supplies. I. Title.
TR581.K663 1998
770'.68 — dc21 97–33002
CIP

British Library Cataloguing-in-Publication Data

A catalog record for this book is available from the British Library.

The publisher offers special discounts on bulk orders
of this book. For information, please contact:
Manager of Special Sales
Butterworth–Heinemann
225 Wildwood Avenue
Woburn, MA 01801-2041
Tel: 781-904-2500
Fax: 781-904-2620

For information on all Focal Press publications available,
visit our World Wide Web home page at: http://www.bh.com/focalpress

10 9 8 7 6 5 4 3 2 1

Printed in the United States of America

THE FOCAL HANDBOOK OF
COMMERCIAL PHOTOGRAPHY

For Lloyd and Desta Bartlett,
with affection and respect.

Contents

Contents

Introduction

Stewart Brand, editor of *The Whole Earth Catalog*, has said, "When a technological revolution overtakes a craft, one has but two choices: either you get up on the steamroller, or you become part of the road."

Commercial photography began as a craft but has now evolved into a potent mixture of art, science, and business — and it is, most certainly, being overtaken by a technological revolution. To extend Brand's metaphor, there is not just one steamroller to consider, but several: Some are related to computers and digital imaging, some are related to advances in silver-based technology, and some are related to significant changes in the way that photographers acquire training and manage their careers.

The Focal Handbook of Commercial Photography is a contemporary and pragmatic guide to career planning and professional practice that will help both aspiring and established photographers make appropriate choices in the face of the ongoing metamorphosis of our industry. The scope of this book is wide because photography has become a multidisciplinary activity. Successful photographers must possess, or at least appreciate, the skills of the artist, entrepreneur, accountant, designer, carpenter, chemist, creative director, keyboard wizard, and futurist: They cherish enduring elements of a two hundred-year-old technology while straining to acquire, or at least understand, countless subtle aspects of embryonic technologies that are only minutes old.

Many photographers are irritated or confused by the emergence of so many new technologies. They lament the passing of a time when

even commercial photography could be a contemplative pursuit. But things have changed. Today, the mastery of a few basic tools and techniques is not enough — efficiency and proficiency are now the characteristics most prized at the cutting edge. Here is an exchange between Bruce Birmelin, a concerned reader of *Photo District News*, and Nancy Madlin, the editor of the magazine's *Electronic Studio* section:

Dear Editor:
As I lifted the December issue of PDN *out of my mailbox, I looked to see what this month's topic would be. Surprise! Another issue devoted to the electronic studio. It's obvious that* PDN *thinks that digital imaging is the future of all photography, but can't the editors find other worthy topics of interest? Maybe a new magazine is overdue? You could call it* Photo Digital News. *Respectfully,*
Bruce Birmelin, Toluca Lake, California

Dear Mr. Birmelin:
I too wish that technology wasn't changing as rapidly as it is. In fact, I sometimes wish that computers weren't invented at all. If computers aren't yet part of your life, I am glad for you. But at some point, computers will enter your work in some way, big or small — and at that time we hope that you'll appreciate the fact that PDN *has made a commitment to stay on top of things as they develop.*
Cordially,
Nancy Madlin, Section Editor

Commercial photographers are professionals. A profession is defined in the *Merriam-Webster Dictionary* as "a calling requiring specialized knowledge and often long academic preparation." To resist or ignore the necessity for constant learning is to invite Stewart Brand's steamrollers onto your back. This handbook provides an overview of orthodox business and technical strategies together with a template for interpreting new developments.

Commercial photographers know, or have guessed, that the money they make is not necessarily related to the cost of production of their work. That there can be a significant gap between the cost of production and the selling price of commercially made photos is demonstrated by the lifestyles of high-profile shooters who support huge studios and an

entourage of assistants, studio managers, accountants, stylists, and even groupies. Though their numbers are shrinking and the glitter is a little attenuated, you can still name several of these celebrities, perhaps you've seen them in *People* or *American Photo*. It is likely that you have read their coffee-table books or even seen their videos. We lust after their accounts and their executive jets.

I do not promise to make you into one of the photographic elite. My purpose in mentioning them is to demonstrate that there can be a great deal of profit in commercial work, enough in some cases to allow an opulent style of life. Yet for every celebrity photographer there are hundreds of less conspicuous workers doing comparable jobs in a much less ostentatious manner. Usually they work by themselves or with a part-time assistant. They very likely maintain a black and white dark-room, or even process color prints. They do not necessarily live in New York or Los Angeles. They do not want or expect to become famous. Still, they love — or at least enjoy — photography. One might be billing twenty thousand dollars per year, another might be billing two hundred thousand dollars. If you are one of these people, or want to be, you can make more money in less time with less effort. This book will tell you how.

Perhaps the distribution of this book should be limited to commercial photographers and their intimate friends and family only. If our clients find out how cheaply and how easily much of our work can be done, there will be chaos in the marketplace. Still, preparation is required. The commercial photographer who expects to make a decent living must efficiently manage three principal areas. First, all things photographic must be totally controlled. This includes buying equipment, shooting, processing, studio design, and more. Second is everything related to the business of photography, such as selling, bookkeeping, and banking. Third, to be more than just a survivor in this business involves a particular set of intellectual and emotional skills: These have to do with creative problem solving and with stress management because most commercial photography is produced under pressure of short deadlines exacerbated by nervous clients.

I have learned about all this, largely by trial and error, over thirty years. I have learned that conventional practice is not always the best way. Some ideas look good on paper — if you have one foot in ice water and the other in boiling water, statistically you are comfortable — but

do not work out in real life: In order to do well one must be both clever and balanced, hardworking and harmonious, focused yet relaxed.

As this is being written, electronic imaging is not yet as widespread as conventional silver-based film technology, so a large portion of this book catalogs the techniques needed to make high-quality photographs using nonelectronic materials, processes, and support services. A chapter about finding and financing the tools-of-the-trade explains how and when to buy, rent, borrow, lease, share, or build your workspace and equipment. Another chapter details technical strategies for efficient studio and location lighting and shooting.

The segments devoted to the electronic studio and the electronic darkroom cannot substitute for a college or technical school program, but they do offer some basic insights into how and why non-silver-imaging technology is being so rapidly integrated with commercial photography, graphic design, and non-photographic printing and publishing.

Along with listings of career, education, and professional development options are included interviews with seasoned industry leaders and innovative newcomers. Alternative ways of doing business, like partnerships and cooperatives with designers, printers, and other photographers are evaluated, together with marketing, negotiating, and time-management skills. A separate chapter deals with accounting, tax planning, rates and fees, contracts, credit, collections, and insurance.

Two chapters devoted to showing how commercial photographs and print advertising are actually made track the technical and creative procedures involved from conception, through production, to successful application. These chapters also explain the special vocabularies of traditional and electronic production, and they describe some of the personalities and politics unique to the advertising industry. Another chapter is devoted exclusively to client–photographer relations.

Three additional chapters are devoted to legal and ethical issues: The first concentrates on copyright, contracts, releases, and what to do if your client goes bankrupt. The second addresses ethical standards, obscenity, libel, and privacy, as well as the relationship between photographers and their communities. The third chapter addresses environmental concerns and practices that are specific to our industry.

The Focal Handbook of Commercial Photography has been created to help you succeed in our increasingly complicated world. A quick read-through will provide an overall perspective, something that is difficult to acquire from specialized magazines, manufacturers' technical bulletins, or casual conversations with professional colleagues. Detailed study of individual chapters will provide immediate guidance in dealing with specific problems. Most of all, however, I hope this book will demonstrate the possibility, the potential, and the necessity of continuous learning.

Until recently, professional photographers were motivated by everyday traditional values like ambition, entrepreneurial creativity, and individual achievement. The romantic persona of the lone-wolf shooter as stylish high-priced problem solver is still attractive to many, but the expanding electronic marketplace has added new wrinkles. By allowing those who can afford the appropriate hardware and software to produce and manipulate photographic-quality images, the new technologies devalue the efforts of individuals working alone, and increase the value of cooperative efforts among photographers, designers, production houses, printers, and clients linked together over telephone lines, fiber-optic networks, or by magnetic or optical media.

Wholesome and profitable participation in cooperative enterprises — electronic, or otherwise — requires an appreciation of the professional practices of each of the other participants, but to properly complete this introduction I need to reveal a personal attitude that will be revisited periodically throughout this book. Like magazine editor Madline and distraught reader Birmelin who were quoted earlier, I am not thrilled by the encroachment of digital imaging. This is not the stubbornness characteristic of some of our more reactionary colleagues: It comes first from an abiding love of silver-based photography and second from a distrust of the motives of some of the most vocal proponents of high technology.

To my mind, the rapid proliferation of electronic alternatives is driven by three main factors: greed, politics, and the desire for more powerful creative tools. The creative impulse will be enthusiastically explored later in the book, but I want to introduce one or two radical notions early on, if only to stimulate a little analytical thinking about the relationship between commercial image-making — by whatever means — and society as a whole.

Consider this: A computer is a nearly perfect product according to present-day economic thinking. Universally desirable, at once sophisticated, entertaining, and a status symbol, any computer is guaranteed to be passé, if not obsolete, within six months to a year, necessitating expensive upgrades or replacement. Software is an even more perfect consumer product in that it is absolutely necessary to animate all those highly desirable machines, the infrastructure necessary for its creation is minuscule relative to the profits associated with its sale, and its functional life is typically measured in months or even weeks. A gargantuan, well-heeled market addicted to self-destructing products has made Bill Gates, CEO of Microsoft Corporation, one of the wealthiest people on the planet. As professionals we need to know the potential of the new tools. As business people we need to know the true costs. As responsible citizens we need to know the repercussions.

The initial hoopla surrounding digital imaging coincided with the onset of a major and prolonged recession, and for a year or two the implications of the latter were mistaken for the implications of the former. I, for one, was certain that financial ruin was just around the corner — business was shrinking and those who were not computer literate were doomed. Happily this gloomy scenario has not materialized for me and many others. My commercial photography business is now successfully interfaced with, but not dominated by, the electronic revolution. Simultaneously, associates and colleagues have jumped into the digital realm with both feet and their lives have changed dramatically — some for better, some for worse. I believe all these stories will assist you along your path to professional accomplishment.

CHAPTER ONE

Starting Point

WHO IS A COMMERCIAL PHOTOGRAPHER?

A commercial photographer is anyone who earns a living producing photographs that serve the purposes of a broad range of businesses and institutions. This definition excludes portrait and wedding photographers while it just barely includes photojournalists and corporate or government staff photographers. The spectrum of commercial work is wide, and the commercial shooter is found wherever there is healthy economic activity. Commercial photography is a major lubricant of the capitalist machine, and the competent commercial photographer is a problem solver, facilitator, and interpreter.

Photography links the objective material world and the subjective world of impressions and ideas. A photograph is a relatively permanent two-dimensional record: It has the power to induce thoughts and emotions and, to some degree, behavior. In this way the commercial photographer, like the advertising copywriter or the television or movie scriptwriter, is a surprisingly influential player in the formation of popular culture. As the servants of industry, photographers are required to present people and products in a way that conforms to the wishes of their clients. Money changes hands and persuasive images are created. It is a demanding business. Who are these image makers? How do they learn their skills? Many are the products of technical schools and colleges. Some are self-taught. It is likely that they have worked as an assistant or an apprentice to some established professional. Perhaps they have crossed over from a career in the design or advertising industries.

Regardless of their exact path into the business, successful commercial photographers exhibit three qualities: a keen aesthetic sense, an appreciation of technology, and an affinity for intense interpersonal relationships. The balance and particular manifestations of these three characteristics will determine an individual's style and special strengths. No amount of training or self-motivation can make up for their absence, but learning can certainly make them shine. The marketplace has a way of preselecting its long-term participants. Simply reading this book is an indication of your desire to expand your skills.

A willingness to learn is crucial to those photographers who must do a wide variety of work to survive. A few photographers have developed a lucrative specialty together with a devoted clientele — they enjoy the rare pleasure of refining to perfection that with which they are already familiar. However, most professionals are less exalted working stiffs who cannot shoot just food, fashion, or world leaders; but rather they must be adaptable and accommodating in order to do well in the shadow of the celebrity shooters.

To achieve a respectable level of skill in many areas requires stamina and an active intelligence. It is impossible to learn all that is necessary in an academic setting, and it is not sufficient to simply watch someone else work. The most effective learning is accomplished by actually doing, by trial and error. The successful commercial photographer will be willing to take some risks, to experiment, and to occasionally fail.

Happily, there are several motivating factors that make the work of self-improvement less arduous. Some would argue that the thrill of creating fabulous images with cutting edge photographic technology is sufficient reason to patiently endure the rough spots. True enough, but remember also that a busy commercial photographer can be one of the most highly paid professionals in his or her community. Six figure incomes that compare very well with those of doctors, lawyers, even orthodontists, are not uncommon in healthy markets.

The busy professional photographer will be working in close contact with other high achievers. His or her client list will include entrepreneurs, upwardly mobile corporate types, politicians and civil servants, active cultural organizations and performing artists, together with designers and art directors working in the advertising industry. Commercial photographers associate with some of the most stimulat-

ing and intelligent individuals that urban society has to offer.

Why then are there so few photographers who achieve their full potential? Perhaps it is simply a lack of imagination coupled with a willingness to settle for the ordinary and the easily accessible. Oddly, an addiction to ordinariness may be a reaction to the complex technology at the heart of photography today. Because there are so many variables in photographic processes, some photographers become overly conservative in their approach: After developing a process or technique that works they become attached to it, fearful of change.

There is no substitute for a solid grasp of the fundamentals of photography. Basic technique is a foundation for growth. However, it is also important to have a finely honed ability to distinguish what will help and what will hinder as high-tech materials and tools flood the photographic world. By the application of common sense, by experimentation, and by the occasional bending of the established rules of practice, it is possible to keep ahead of the competition, make money, and still have some fun.

AN OVERVIEW OF COMMERCIAL WORK

It is unusual for a photographer to be able to specialize and do well. Although everyone will find favorite disciplines within the trade, reality dictates that one has to be ready and able to do most of the work that comes through the door in order to survive. This is particularly true in the early stages of establishing a business. Such a proposition may appear intimidating to the beginner, but for a number of reasons the situation is actually a blessing in disguise to both novice and established professional.

First, a variety of work prevents boredom and stagnation, conditions that can end your business. Second, a wide range of work compels the photographer to acquire, maintain, and sharpen skills that cannot be learned any other way. Third, there is an interdisciplinary feedback effect that automatically enriches each new project. The commercial photographer works at the apex of a pyramid of creative people: By supplementing and enhancing the creative energies of his or her clients, the professional photographer participates in the life of the community. Finally, a willingness and ability to do a variety of work guarantees that there will always be some work to do. Variety is an

insulator, a buffer that protects against downturns in particular sectors of the economy. The big corporations call it diversification. Commercial photography embraces so many disciplines that a complete mastery of all of them is just as unlikely as the possibility of succeeding by focusing on just one. Nevertheless, it is necessary to have at least a cursory understanding of most of them if only to eliminate those that do not appeal and to clear the way for deeper study of those that do.

Advertising illustration is what most people think of as commercial photography's most visible and prolific incarnation. People working in this field are responsible for the images we see on billboards, bus cards, packaging, and newspaper and magazine ads. These pictures are the still-life equivalents of TV commercials, and they are so important a part of the business of selling that their production attracts the biggest budgets and some of the most ambitious photographers. The challenge is to present the product or service that is being touted in an imaginative way, while at the same time maintaining both aesthetic and ethical standards. In this field one acts not only on behalf of a very visible client, usually an advertising agency, but also on behalf of an invisible client — the public. The most attractive personalities practicing the art of advertising illustration are able to tell the truth with flair. It is sobering to keep in mind that the demanding client who pays your fees actually gets his or her money by selling something, with your assistance, to thousands or even millions of people.

Although advertising illustration encompasses many subcategories, the most significant is probably product photography, which is glamorized and elevated by the razzle-dazzle and big spending of national or international advertising production. Taking pictures of objects in the studio, however, can also be the most mundane of activities. Consider, for example, the black and white shot of a can of peas that appears in the newspaper ad for the local supermarket. In the middle of the spectrum is catalog photography of various levels of sophistication.

It is in this diversity that we see the really outrageous potential of commercial work: Some of the most ordinary product photos are shot by highly trained people using large-format digital cameras in well-equipped studios, while some of the most spectacular ad campaigns are shot with 35mm equipment and little more than available light. Who does the work is often determined only by the attitude of the photographer. This is particularly true of fashion photography, which is really

4

a clandestine form of product photography in which people are used as props. Specialized photographic skills and equipment as well as the help of outside professionals are required to properly undertake that most ephemeral form of product work—food photography. Here the photographer relies on a stylist or chef to find and prepare whatever consumables are to be photographed. Some sort of preparation area is required in the studio.

A step away from the often overheated advertising industry is the slightly more prosaic shooting that is produced directly for corporate clients. Again, there is a kind of hierarchy to this category: Annual reports and portraits of Chief Executive Officers rank at the top of both the remuneration and glamour scales, followed by on-site industrial reportage of various levels of intensity, followed by public relations and newsletter photography.

Advertising and corporate markets provide the basic fare for most professional photographers, but there are other areas that can generate plenty of income for the enterprising and the adaptable. Editorial photography for magazines does not pay as well as strictly commercial work, but then neither does the shotgun shooting of audiovisual production. Both fields need the same talent—an ability to quickly illustrate an idea or a point of view with entertaining and cogent sequences of related images. The rapid evolution of multimedia production technology means that there is a lot of this work available to those who are energetic and clear-minded enough to work at the fast pace required.

Architectural photography is engaging but fussy and specialized. Although it usually lacks the more reliable financial guarantees of regular industrial work it can be a rather elevated occupation when the architect is talented and the building is photogenic in style and situation. Working with realtors, developers, and construction companies is a little less fun, but when buildings are being built or bought and sold, large sums of money will be changing hands and reasonable fees can be expected.

A little less obvious but no less demanding is photography of the performing arts. All urban centers support professional theater, dance, music, and oftentimes video or film production as well. Two nonphotographic skills are necessary to get along in the rarefied world of entertainment: patience and tact. The main requirement in terms of

technique is the ability to work unobtrusively. A hungry commercial photographer will do the occasional wedding or private portrait, but constant contact with other professionals in the worlds of culture and business tends to erode the desire to please ordinary folks. I believe that it is better to give away this type of work as a gift to a friend or colleague rather than to rely on it for income.

The restoration of old photos is less trying, and it overlaps with other quite lucrative copy work such as the duplication of architectural renderings and the production of slides of graphs and charts for audio-visual presentations. This is usually easy money for the pro who maintains his or her own processing facility or electronic imaging system. Taking in photofinishing for other professionals or the general public can be rewarding, but a lot depends on the circumstances and the temperament of the photographer.

AN OVERVIEW OF EQUIPMENT
FOR COMMERCIAL WORK

This book is a distillation of my three decades of experience as a professional photographer working in a midwestern city of six hundred thousand. I have become an accomplished generalist and regularly shoot assignments from all the categories of work listed above. Through the years I have simplified my collection of tools into a reliable, flexible package.

Reliability of equipment is extremely important. You need to have complete confidence in your picture-making machines just as your clients need to have complete confidence in your picture-making abilities. Flexibility is also critical. Your tools must be able to keep up with what you are doing. For 35mm work I use 15mm, 28mm PC, 35mm PC, and 400mm fixed focal length lenses, 1.4X and 2X multielement telextenders, and 21–35mm, 28–105mm, 80–200mm, 75–300mm zoom lenses. With my medium-format cameras I use 35mm, 45mm, 55mm, 65mm, 80mm, 150mm, and 250mm lenses plus a 2X telextender. When shooting 4" x 5" format I use 47mm, 58mm, 75mm, 90mm, 121mm, 150mm, 250mm, and 480mm lenses. There are many trustworthy equipment manufacturers but no machine is totally fail-safe. For this reason I carry at least two 35mm or medium-format bodies on every assignment away from the studio.

6

For lighting equipment I have two medium-power (1200 wattseconds [ws]) and two high-power (3200ws) line operated electronic flash packs, plus a variety of heads, reflectors, barn doors, snoots, softboxes, and grids. I use Lowel DP lights supplemented by Photogenic mini-spots for tungsten work. Lately I have added three compact high-tech battery-powered 650ws flash units to my collection of Metz 60-series portables.

Why and how this particular equipment was selected will be discussed a little later, but I will say now that I believe this collection of tools to be the irreducible heart of a commercial photographer's arsenal. It is possible to own less and rent what is required for each job but eventually the extra hassle of locating and testing rental equipment is not worth the effort.

THE STATE OF SILVER IMAGING & THE IMPLICATIONS OF ELECTRONIC IMAGING

Most of the comments above relate strictly to commercial photography using silver-based light sensitive films and papers. As discussed in the introduction, things are changing in our industry. One generalization applies to the current and near-future situation: Silver imaging is a very, very highly evolved science, whereas digital imaging, regardless of how quickly it might be evolving, is in its infancy.

As this is being written, modestly priced ($1000 or less!) digital cameras are toys that don't come close to the image quality that any point-and-shoot 35mm camera can produce. Even high-end digital cameras and accessory backs costing many tens of thousands of dollars only approximate the quality of medium-format conventional systems while sacrificing convenience, portability, and speed of operation. It is true that the computers needed to store, manipulate, and distribute digitized images are becoming cheaper, faster, and easier to use. The fact remains, however, that a computer is not a camera and image storage, image manipulation, and image distribution are not the main concerns of most practitioners of commercial photography, global ambitions notwithstanding.

There is a roadblock in digital camera development — the *charge coupled device* (CCD). It is a solid-state sensor that turns photons of light into electronic signals that can be captured and organized by comput-

ers. The CCD problem is one of mechanical size. Film records light with tiny sensitized crystals of silver bromide. The degree of detail that film can record is limited by the size of the crystals. The resolving power of many commonly used films exceeds the resolving power of even the finest lenses because the sensitized silver-bromide crystals can be made to be only a few molecules wide. Charge coupled devices are crude by comparison. They require multilayered silicon crystal structures composed of many millions of molecules, thousands of internal electrical conductors, precise temperature control, sophisticated software, and a pile of expensive hardware in order to reliably produce a usable image. Just like the clunky internal combustion engine, digital imaging depends on a lot of fancy engineering to keep it going at an acceptable level of performance.

The most practical interface between conventional photography and digital imaging is called scanning. The scanner is a digital camera specially designed to make accurate electronic copies — called *files* or *scans*— of conventionally made negatives, prints, or transparencies. Because they do not have to be portable and because they can do their work in minutes rather than fractions of a second, many scanners are reliable and precise, but, at least for high-end equipment, not inexpensive. Cheap flatbed scanners look like desktop photocopiers or fax machines, and, at five hundred to fifteen hundred dollars, provide photomanipulators with enough digital detail to almost mimic 35mm quality. More sophisticated drum scanners range in price from five thousand to one hundred thousand dollars and beyond. Happily they are commonly owned by digital service bureaus — the reincarnations of what used to be called typesetters—so super high-quality scans can be purchased for a few dollars. Since the design, graphic arts, and printing industries are rapidly going digital for everything from layout to plate-setting, this is an extremely important consideration.

Unless some revolutionary breakthrough in CCD technology occurs soon, today's basic approach to both conventional and digital imaging will exist for some time. Fine artists will never completely surrender the subtle power of silver imaging, and most commercial photographers will depend on scanned images of silver-film originals to interface with the electronic universe. High volume catalog shooters and those photojournalists who use existing digital cameras can expect reductions in equipment weight and increases in the speed of opera-

tion. The rest of us can definitely depend on conventional cameras and films as our main tools, but we must nevertheless become fluent in digital techniques so that we can stay productively connected to the world of electronic design, electronic prepress, electronic printing, and multimedia. Maintain a reasonable perspective by remembering that digital image manipulation is not photography. Although the value of commercial photography is being assailed by technological change, the need for commercial photography is indisputable, regardless of whatever technology ultimately dominates the market.

The Nature of the Beast

TECHNICAL TRENDS IN THE ADVERTISING INDUSTRY

Everything in advertising is changing. Digitization has the potential to put virtually the entire process — concept development, design, production, printing, and, via the Internet, even distribution — on a desktop. As our clients embrace more and more of this technology their attitudes toward and their requirements of commercial photography are evolving.

All change is a two-edged sword. On the one hand, CD-ROMs full of license-free photography are giving art directors and designers lots of low-cost raw material to insert into their layouts. The ubiquitousness of image manipulation hardware and software allows these same advertising professionals to use cheap pictures to construct photographer-free original imagery. On the other hand, the cheap imagery is cheap because it is ubiquitous, so every computer literate art director and designer in the world is doing more or less the same thing, *Adobe PhotoShop* notwithstanding. And some of their clients are beginning to notice.

What this means is that the market is becoming markedly divided. The purveyors and users of $5.00 images are on one side, whereas the providers and buyers of original, purpose-built photographs are on the other. In the former group, respect for quality photography and quality photographers is dropping, whereas in the latter it is rising. Photographic hardware — be it digital or conventional — has little to do with this divergence, because a quick scan can make any conventional image into a digital image.

The technical specifications for commercial photographs are also rising and falling. The Internet is expanding exponentially, but so are books and special-interest magazines: An image for a multimedia production can be low resolution, whereas an image for a glossy two-page magazine spread must be high resolution. Newspapers and newsmagazines are using images transmitted via modem and satellite direct from digital cameras, while large-format fine-art photography based on one hundred-year-old technology is also thriving. There are lots of similar examples. A fundamental truth persists: A low-resolution digital image can be made from a high-resolution conventional original, but a high-resolution conventional image cannot be made from a low-resolution digital original. Film lives. Those who really know film and its uses still do well.

BUSINESS TRENDS

Individuals within the advertising industry are being pulled in two directions. They are being pressured to produce their work faster and cheaper using new technology, but as computers speed up, their work is being more widely and more quickly distributed: This same technology is educating the consumers of advertising to higher and higher standards. The response of the industry has been, on the one hand, the consolidation of successful agencies into global conglomerates, and on the other hand, a proliferation of small and quirky "boutique" studios dedicated to highly original design.

Across the industry corporate downsizing means that individuals are working longer, harder, and often for less money than even a few years ago. People are becoming impatient, parsimonious, and less inclined to trust unknown suppliers.

Commercial photography operations are by nature small and efficient. The lean, mean corporate climate impinges on us in two ways: shrinking budgets and obdurate demands for flawless performance. See Chapter 19 for information on coping with difficult clients and Chapter 26 for information on coping with stress.

ETHICAL TRENDS

The advertising industry, like the fashion industry, is based almost entirely on trends. Style is ephemeral by nature, and even that which is considered to be in good taste varies practically from moment to moment these days. Our cultural values are partly created by the styles that advertising sells (Santa Claus as visualized by Coca-Cola), and the styles that animate advertising are artifacts of our culture (Chevrolet is tried, tested, and true).

Advertisers and advertising professionals like computers, cultural globalization, and all forms of electronic communication because they make the dissemination of commercial imagery easier and faster. The advertising industry is becoming more serious and more cynical as the tools of selling become concentrated in the hands of fewer people. In his chilling autobiography, Albert Speer, who managed the production of war materials for Nazi Germany, stated that it was radio technology — top down, one-way, and instantaneous — that permitted a small group of criminal lunatics to control an entire country.

The interaction between the creators of advertising and the owners and users of advertising is not as much fun as it used to be. We know more about how the various commercial media work, how efficiently advertising moves products and cultural icons around the world. Although I am not equating the mavens of Madison Avenue with Hitler's henchmen, it is sobering to think that geometrically increasing sales, driven by intense advertising have permitted the tobacco industry to back away from its traditional hard sell at home while working relentlessly to addict women and children in Asia.

The implications of our personal involvements in the advertising-driven hedonistic and materialistic pandemic are more obvious now than they once were, yet the legions of competent unemployed who stand ready to replace us if we falter are eerily present as we consider the demands of the industry we serve.

If a major electronically driven trend in advertising at the end of the twentieth century is farther, faster, cheaper, then we who provide the industry with technical and aesthetic services should somehow position ourselves to have a say in determining content. The technology of advertising is not unlike other technologies. In the world of physics we have nuclear weapons and we have nuclear medicine. In the

world of advertising we have avaricious propaganda and we have campaigns against child poverty. We choose the level at which we wish to participate.

AESTHETIC TRENDS

Funny thing about trends...they tend to create countertrends. One unfortunate aspect of digitization has been a proliferation of low-resolution imagery. Which version of an original oil painting by a master artist would you rather contemplate: a superb photograph, a coffee-table book reproduction, or a thumbnail scan on a computer monitor? We know how Bill Gates would vote, but Internet or no Internet, a beautiful photograph still has a lot of power. Ironically, the rush to scan and manipulate is propelled by advertising that typically features exquisite photography. Go figure—if you do, it becomes clear that computer salespeople are not completely straightforward. Low or medium resolution is fine for the consumer and for small business, but high-power marketers demand ultra-high-resolution imagery to sell their wares.

Remember the paperless office? It wasn't so long ago that the computer industry was flogging their hardware as a bulwark against deforestation of the planet. Well, we are still awash with paper, and significantly more of it, not less. Much of this paper is computer-generated waste of course, but some of it—newspapers, magazines, books, brochures, and art—is, and likely always will be, a permanent feature of our culture. This is because, like a healthy child who can automatically distinguish between fantasy play and the real world, we are genetically and culturally attuned to paper-based media. Aren't you reading a book this very minute? We deeply appreciate real images. And photographs can be the realest of the real. Photography lives. Those who really know photography and its uses still do well.

TRENDS IN THE STOCK PHOTO INDUSTRY

Stock photo discs are only one component of current stock photography practice. Once again we see a diverging evolution: quantity and economy on the one hand; quality and character on the other.

The shadow of Bill Gates looms over the marketplace as his stock photo colossus, Corbis Corporation, rapidly acquires electronic distribution rights to private and public photo archives. Gates' intentions for Corbis are not yet completely clear, but other electronic distributors, notably PhotoDisc, Corel, and Digital Stock are happily providing ever-expanding libraries of license-free pictures for literally a few dollars per image. Contributing photographers are paid modest rates, sometimes as low as two to five dollars per photo. There is no shortage of CD shooters, although each signing of a well-known photographer still rates a mention in the photographic press.

Some professionals express anger at what they perceive as high-tech prostitution among their colleagues. Others see the proliferation of stock photo discs and on-line providers as writing on the technological wall: digitize or die. Others view the phenomenon with benign indifference. For these individuals, the rapid expansion of electronic stock is just another symptom of a cultural madness that manifests itself in a million different ways throughout the world.

Ironically, the electronic stock industry's own marketing practices provide an insight into the true state of affairs. Consider the following: There has been a rush to digitize commercial stock portfolios, the theory being that low-resolution thumbnails could and would be exported to potential buyers of stock photography for a nominal fee, with high-resolution files or transparencies available by wire or overnight courier once a selection is made.

To the quiet amusement of those like myself who see digital technology as a tool rather than a way of life, this approach has proved to be only modestly successful. The Image Bank and Tony Stone Images have been forced to drop research fees to stay competitive and other stock agencies have found that they cannot abandon printed four-color process catalogs in favor of on-line or CD-ROM libraries. Many art directors and designers find electronic browsing and buying either too clumsy, too complicated, or too time consuming...they want images on paper, for detail, for color, and for fast, direct access. These people — referred to as "creatives" by the "suits" who manage the business side of advertising — are the human interface between the originators of original commercial photography and local, national, and international machinery of advertising production. To a large degree, their preferences define our market.

High-end stock agencies are themselves establishing legal precedents that protect original imagery through aggressive policing of copyrights. Successful prosecutions in case after case of image theft have resulted in large settlements — often $100,000 or more — that protect individual creative works, even as the quantity of such works explodes exponentially.

One significant consequence of all this is the growth of *assignment stock*. In this instance the agencies use fax or e-mail to transmit wantlists to their photography suppliers, who in turn create self-assignments that fulfill specific requests. The level of detail addressed in this process can be the same as that for a traditional assignment awarded by a local client to a local photographer. Assignment stock simply uses modern communications to make the process independent of geography and to build an easily addressable archive for future repeat sales, such as high-end electronic stock CD-ROM discs. In most cases, respect for creativity and originality is maintained within a globally integrated framework. In addition to my conventional commercial work, I shoot for two assignment stock agencies, a practice that links me to national and international markets that I don't have the time or expertise to exploit on my own.

TRENDS IN PORTRAIT & WEDDING PHOTOGRAPHY

A diverging low-end and high-end pattern also persists in the consumer-oriented world of portrait and wedding photography. Those willing to make a substantial investment in electronic tools can expect to generate reasonable money shooting kids on Santa's knee or fast glamour makeovers down at the mall. In these and similar circumstances, small-format digital cameras tethered to desktop computers and inkjet color printers are replacing Polaroid or long-roll cameras. In slightly upscale applications, this same technology provides instant proofs and economy-level reprints for department store portrait studios.

The widespread use of powerful still photography in high-budget print advertising coupled with the remarkable growth of fine-art photography collecting has created a second economically significant cultural stratum composed of ostensibly visually literate, well-heeled consumers. Smart, experienced shooters are finding that a lucrative market exists for editorial-style environmental portraiture and quasi-

documentary slice-of-life wedding photography, as well as skillfully executed traditional work. Simultaneously, we see an increasing demand for fine black and white prints for albums and home display.

Some high-end portrait and wedding studios are finding electronic previews boost sales and increase customer confidence. Most consumers, regardless of how sophisticated they might be, have been conditioned to find technological instant gratification very attractive. Expert electronic retouching is a pricey, but highly salable service in these markets, as well.

Conventional shooting techniques and materials still predominate for both high-end and low-end portrait and wedding photography, especially on location. Taste and sensitivity distinguish the two realms from one another. Appropriate use of lighting, posing, and styling techniques, in combination with an ability to capture attractive and natural expressions separate master photographers from the more pedestrian — just as in the world of advertising or stock photography.

Professional Training & Career Possibilities

EDUCATIONAL OPTIONS

Consider what might be a typical path toward a career in commercial photography: Probably the first stirrings occur early on, perhaps with the encouragement and guidance of a teacher or parent. Once in possession of a 35mm camera, a simple black and white darkroom, and a subscription to a photography magazine for inspiration and instruction, any young person with some initiative will become familiar with the fundamentals. Some photography courses in high school or at a technical college complement a continuing commitment to personal development through membership in a camera club, work on school yearbooks or newspapers, and participation in photographic workshops and seminars. Part-time positions in areas related to photography, such as retail sales, photofinishing, or assisting established photographers, point the way to more specific training.

Faculties of Fine Arts at many universities offer photographic courses that emphasize style and personal expression. More practical-minded students might consider vocational schools or private institutions that focus on the technical skills and equipment required for the actual practice of commercial photography. (A comprehensive listing of more than one thousand college-level photography programs is available from Kodak. Write and ask for publication T-17, *A Survey of College Instruction in Photography*, Eastman Kodak Company, 343 State Street, Rochester, New York, 14650.)

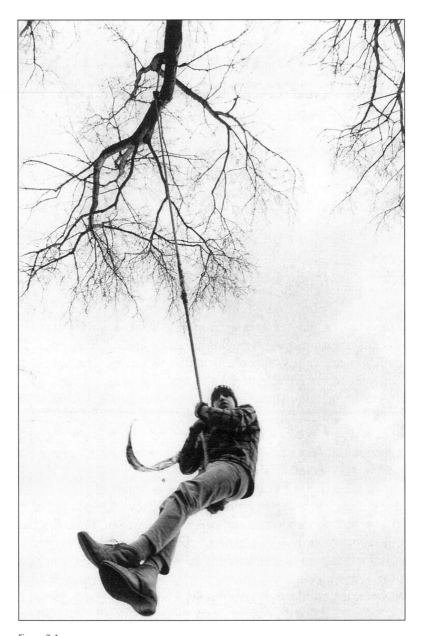

Figure 3.1

I was fourteen in 1963 when I made this image. The kid swinging on a rope was shot with a wide-angle lens from ground level. I used to carry my camera with me everywhere in those days. My advice for aspiring professionals: Start early! (*Minolta SR-2 Camera/28mm and lens/Kodak Tri-X film/Available light.*)

While preparing for employment it is worth remembering that the mastery of photographic skills alone might not be enough—accounting, management, and marketing savvy will widen your horizons. A university education that encompasses a broad range of studies in both arts and science will stimulate the intellectual development necessary for satisfying and productive interactions with professionals in both photographic and nonphotographic fields later on.

Before committing to an intensive (and possibly expensive) educational program, seek out the advice of at least a couple of practicing professional photographers to see what education they obtained for themselves and what they require their employees to know. Most professionals are willing to give a few minutes of their time to students: Write a straightforward letter requesting an interview— include a reference from a trusted teacher or someone you know who is already well established in some aspect of the photography business.

After school, a one-, two-, or three-year period of apprenticeship will result in a more thorough understanding of real-world photographic and business practices. Established commercial photographers can be located through the yellow pages and perhaps persuaded to offer employment to beginners willing to take on basic jobs like sweeping the studio, running errands, painting sets, etc. Keep up your own personal work and show it to your employer from time to time. You will be given more and more responsibilities as you progress. A few years of experience in a busy studio should make one employable in virtually any city in the western world.

CAREER OPTIONS

Here is a listing of some of the career opportunities in commercial photography:

Aerial photography*	Corporate Staff photography*
Annual Report photography*	Editorial photography*
Architectural photography*	Glamour photography
Automobile photography	Fashion photography*
Boudoir photography	Fine Art photography*
Catalog photography*	Forensic photography
Commercial photography*	Industrial Staff photography*

Livestock photography
Military photography
Movie & TV Still photography*
Pet photography
Photography of Art Work
Photojournalism*
Photo Finishing
Photo Restoration
Photo Retailer
Photography Teaching
Portraiture*

Public Relations photography*
Publishing
Retouching and copywork
Scientific photography
School photography
Sports photography
Stock photography*
Studio Product photography*
Team photography*
Wedding photography
Wildlife photography

*See Chapter 15 for more detail.

SOME REALITIES OF THE WORKPLACE

For a long time I resisted hiring people to help me. Even though I was overworked I was reluctant to become an employer. After a while I recognized this resistance to be a little irrational. Finally I realized that what I disliked about the employer–employee relationship was having to tell someone else what to do.

I have never had a job working for someone else. My natural inclination is to structure my own time and do what I think best at any given moment. As a child of the egalitarian 1960s, I believed that this sort of life was best for everyone. The idea of ordering people around was offensive. Nevertheless, the sometimes harsh realities of business and my own physical and emotional limitations put an end to this idealistic state of affairs. For several years now I have employed a variety of part-time and full-time assistants and lab technicians.

I now understand that there are people who flourish in an environment that is organized by others. I think this characteristic is valuable in an employee insofar that it is an indicator of potential harmony. The ability to function within a preexisting structure does not overshadow other significant character traits like intelligence, honesty, or imagination, but rather it simply encourages a healthy interpersonal bottom line.

Competent assistants must be well versed in all technical and aesthetic matters; studio managers must have a grasp of modern business

practices and how they fit with professional photography; darkroom staff are expected to be reliable perfectionists. In some operations these roles are juggled by one trusted employee who may eventually become a full partner in the business. For any prospective employee, training, experience, and motivation are key factors in breaking in to the market and succeeding.

I am hired by my clients to perform a service. Anyone who works for me is automatically enrolled in that same enterprise. Consequently, they must perform a surprisingly wide variety of tasks in ways that suit me. These tasks are often technically complicated and aesthetically sophisticated—dull people don't cut it. I hire people after a personal meeting and a quick review of their formal qualifications and references.

Although I trust my intuition when hiring, I do rely on performance to weed out unsatisfactory people after a two- to three-week trial period. Curiously, because my work is complex, I can use a simple criterion for evaluating those who work with me. I assign a job, describe how I have done the job myself in the past, and I very carefully list the results I want to see. I do not insist that my methods be followed. I simply insist that the results I want are achieved by civilized, sensible means. I am willing to go through the process three times, in depth, for every task, no matter how small. I look for someone else to hire if three times is not enough. As is typical throughout the world of commercial photography, several of my assistants have moved on to professional careers of their own.

It is important to note that entrée into commercial photography is not limited to people with formal training only. Those who have independently worked a significant distance toward a mastery of the medium and are willing and physically able to work long hours for very little pay can usually find some sort of starting position. Build up a portfolio of insightful, technically excellent images, and show your work around (see Chapter 17 for marketing information). Persistence, cheerfulness, and self-motivation are sought-after characteristics and certainly, the ability to learn on the job is crucial. Be adaptable and accommodating. Remember that those who intend to prosper as an assistant, studio manager, or business partner to a commercial photographer must have an affinity for the intense personal relationships which inevitably accompany photographic work at a professional level.

SUCCESS IN BUSINESS

People who work for themselves are differently motivated than those who work for others. Call it the entrepreneurial spirit, boot-strap capitalism, self-preservation, or just plain greed—there is no doubt that an individual's inner drive toward personal gain is the engine that drives economic growth.

This entire book is devoted to strategies for success in photography and related occupations. Every chapter details the conditions that an enterprising individual must reasonably expect to satisfy before a business can become profitable; in general, however, the prerequisites for success can be summarized in three words: prepare, promote, and persist.

What is preparation? When the time comes to set up a full-time business, preparation means the creation of a business plan, and finding the right tools, technical support services, and financing: in other words gathering together all the resources that are necessary for the business to function.

What is promotion? Promotion is the active dissemination of information. Any new enterprise must be integrated into a network of established businesses, some of which buy and sell goods and services between themselves and some of which sell goods and services to individual consumers. How can all this buying and selling take place without a constant exchange of information regarding the products and services that all these businesses produce? No longer can someone invent a better mousetrap and then sit back and wait for the world to beat a path to their door—there are just too many better mousetraps. Be as clever, as subtle, or as heavy-handed as circumstances require, but let people know what you do!

What is persistence? Although pig-headedness and self-confidence are both manifestations of persistence, I prefer to think of persistence in terms of a commercially "uncool" concept: faith. I am not talking here about religious notions of faith, but rather about a respectful acceptance of the idea that wholesome effort is usually rewarded.

Working in the Industry

THE ADVERTISING CULTURE

Advertising culture is tense. The only other industry that provides as direct an interface between creativity and avarice is located in Hollywood, and just like show business, the advertising business is one big deal in progress. Just like the dealmakers in Hollywood, our dealmakers are under constant pressure to find or dream up concepts that can be sold for money. Whichever cool equivalent to Norman Vincent Peale that they might happen to venerate, a player in the ad game has to struggle mightily to stay positive, to stay attractive, and to stay sharp.

The exchange between commercial photographers and our primary customer—the advertising industry—is an almost exact parallel to the deal the advertising industry makes with the rest of the business world: We exchange visual concepts for money. The nature of our day-to-day relations with the advertising industry is determined by our attitude toward this exchange.

Although I have always made a good living from commercial photography, twenty-five years ago I entered the profession reluctantly and was suspicious of the advertising culture and the people inside it. I started in photography as a fine artist, and I was committed to a world-view that denigrated greed and applauded self-expression. For many years I experienced a good deal of internal conflict because I felt that I had been forced into commercial work in order to provide for my young family. I now see that advertising, like all business activity, has positive as well as negative manifestations and implications, and that the peo-

ple involved in advertising are no more and no less worthy than the rest of us. The industry rewards aggressive self-interest while at the same time rewarding imagination, ingenuity, and whimsy, thus creating a strangely charming culture of commercial creativity along the way.

LIFE AS A FREELANCER

The dictionary defines a freelancer as "someone who pursues a profession without long-term contractual commitments to any one employer." Intense, short-term contractual commitments are normal. Oftentimes the connection between supplier and client is informal and only lightly binding. Working conditions are determined more or less at the whim of the client, and there is sufficient competition to make pricing a near-mystical exercise. Victims of aggressive corporate restructuring are rightly shocked to find themselves unceremoniously thrust into a working environment where benefits and long-term security have fallen away, where permanent jobs are extinguished in favor of contracting out; yet I know many busy, happy photographers. What is it that permits freelancers to survive and prosper under pressures that threaten to bring so many others to their knees?

Rapid technical and economic changes are affecting the way businesses are organized. Corporations are divesting themselves of full-time and full-benefit employees in favor of temporary, part-time help who have no expectation of health benefits or pensions. This shift is not limited to blue-collar workers: Executives and professionals are finding that a white collar is no insurance against the fulminations of the market. The changes are not just limited to people, either. Big companies are turning what used to be wholly owned subsidiary operations into independent suppliers, and highly competitive independent suppliers are racing to deliver whatever their clients require "just-in-time" and at pared-to-the-bone prices. This is all happening for three reasons: (1) to lower costs and maintain profit levels, (2) to shorten the time required to respond to change, and (3) to permit the efficient servicing of a myriad of niche markets, rather than just one big market.

In our own industry, the big print production and catalog houses of the past are largely gone and the ranks of salaried shooters, graphic designers, and mechanical prepress specialists have thinned considerably. Tasks that were labor-intensive career options just ten years ago,

such as typesetting, layout, paste-up, stripping, screen making, and color separating, have all been shrunk to desktop proportions. The buyers of advertising and design services are turning away from big, "full-service" agencies in favor of small, specialized agencies that are cleverly exploiting the new technologies.

All this is old news to freelance photographers. We have always had to run what today are called "lean" operations: We are small, usually only one or two full-time employees. We are diversified, in that we serve a variety of clients from every sector of the economy. We are independent, since we provide our own pension and health benefits and work almost exclusively on short-term contracts. We are flexible, since we know how to find suppliers like stylists, prop makers, and assistants as the need arises. We are integrated into the local economy, since we draw supplies and support from the businesses and institutions that function in the communities around us. We stay current with technical change, since our survival is dependent on servicing clients who themselves are embracing technical change.

My father dropped by my studio on a particularly busy day, and after watching me hustle around for a while he remarked, "When you were young you swore that you would never work nine to five, now you work five to nine." I have to agree, since sixteen-hour days are fairly frequent. To succeed as a freelancer requires a strong sense of self, a good product, and a clever business plan: Read all about it in the following chapters.

PARTNERSHIPS, ASSOCIATIONS, & COOPERATIVES

So here we are, nearing the turn of the century, presumably wide awake and ready to adapt to whatever new challenges the economy has in store for us. How will the traditional model of commercial photography look in the near future? Some sour advocates of global competitiveness predict that the future will belong to a super race of warrior technocrats, but our industry seems to be moving toward increased integration and cooperation. I believe this tendency is a response to the electronic integration of the advertising world— information technologies need content, and we are content providers.

Partnerships, associations, and other cooperative arrangements among photographers, designers, writers, marketing specialists, and

multimedia producers are the practical manifestations of a burgeoning spirit of mutuality. All of these professionals can make use of the same computer hardware, the same software, and the same telecommunications services. They need each other's talents, they know each other's clients, and they thrive on each other's referrals and recommendations. Still, it is unwise to make a legal commitment to any partnership, however informal, without some type of trial period. A Chinese proverb says that one never really knows the character of another until you have shared an inheritance: The same sentiment applies to the sharing of a business. I have experimented with several different professional partnerships of varying degrees of formality. Each was an intense educational experience.

My first association began spontaneously, during a chance meeting with a major competitor at a color lab. After we got to talking, we realized that if we could meld our operations the two of us would have a monopoly on the supply of high-end commercial photographs in our city. Right then and there I invited my new friend to move into my studio. The arrangement proved very fruitful: Our clients tolerated higher prices because they recognized the creative power of our team approach. We could afford to keep all processing in-house, and so realized greater profits and control. Marketing was easy, since we were the only game in town. The thing broke down because we didn't know each other well enough...my new partner's recent divorce and subsequent tax and legal problems diverted his energy and threatened my confidence in his commitments to me. We split after less than a year of interesting, profitable, but tumultuous interaction.

My second attempt occurred at a different point in the economic cycle. Two years of recession had tired me out, and I was looking for a way to reduce the stress associated with managing a business alone. The owner of a local lab had built up a commercial photography practice on the side, and he proposed that I move into his building so that we could share shooting, bookkeeping, housekeeping, processing, and marketing according to our interests and abilities. I had known this individual professionally for more than a decade, and I liked him. His offer appealed to me so I took him up on it. I rented out my own studio and worked out of my friend's facility for the next eighteen months.

Never having worked in an environment with more than two employees, it was a revelation to watch my associate direct the ten or

so people that worked for him. Unfortunately, we began to disagree over various management issues. We parted on civil terms, but I had come to dislike what I perceived to be my partner's old-fashioned top-down approach to management, while he had begun to dislike what he perceived to be my excessive trust in the laissez-faire approach. I returned to my own studio with renewed energy and a reawakened appreciation of the joys of independence.

The most satisfactory partnership of all was with my own son, Leo, who is a graphic artist and designer with a degree in Fine Arts. After he graduated from the University of Manitoba, Leo worked for one of my clients for three years, and then he moved his growing freelance business into my studio where we shared space, a computer, and a number of clients and projects. It was a pleasure working together, and I was really sad when he decided to follow his fiancée who had accepted an irresistible job outside the country.

Even in the absence of a formal partnership it is possible to experience some of the advantages of cooperative effort by maintaining cooperative relationships with other businesses and business people. This means networking with clients and suppliers you trust and respect.

The Making of the Product

CONVENTIONAL PREPRESS & PRINTING

Except for those images intended for slide shows, multimedia applications, and exhibition display, all commercial photographs end up as reproductions printed on paper. It is essential to know something about the processes that convert layouts, photographs, illustrations, and type into a form that is reproducible on a printing press for two reasons: First, the creation of commercially useful photographs is more efficient once the technical requirements of photomechanical reproduction are fully understood. And secondly, understanding how and why conventional printing is being computerized provides many practical insights into the future of digital photography.

The most widely used printing process is called *offset lithography*, also known as *offset* printing or *litho* printing. In this process the printing surface is a flat, flexible plate which has been photochemically prepared so that image-forming areas accept ink and reject water, while the non-image-forming portions reject ink and accept water. In the very early days of offset, the plates were made of stone, but now they are made of thin sheets of aluminum alloy.

Modern litho presses are big multistage machines that operate at high speed. They are set up as a series of interlocking *stations*, each of which is composed of three rotating cylinders. One of the three cylinders is wrapped with the printing plate. The second cylinder is covered with a *blanket* of rubber that is kept dampened with a mixture of ink and water. The third, or *impression* cylinder provides just the right amount of pressure for optimum transfer of ink to paper. There is one

station for each process color — yellow, cyan, magenta — and one for black. Additional stations are required for the application of additional spot color, varnish, embossing, metallic foil, or other effects.

The advantages of litho printing include the ability to reproduce fine detail, good results with inexpensive papers, short preparation or *make-ready* times, acceptance of a wide range of paper surfaces, the capability to print at very high speed, and good compatibility with photomechanical methods of reproduction. The disadvantages of offset include the necessity for close monitoring of the ink and water mixture, problems associated with precise alignment due to paper stretching, and difficulty with particularly dense inks. I discuss how these characteristics relate to photography a little later.

Letterpress is a much older system of printing using photosensitized copper- or zinc-coated plates which are chemically etched so that image-forming areas are raised and non-image-forming areas are depressed. This process is still in fairly common use today for business and computer forms, labels, and stationary. Letterpress handles dense inks very well and provides excellent reproduction of type and fine detail. Although letterpress is less wasteful of paper than litho printing, it does require a higher grade of paper for good results. Letterpress systems are relatively slow because they use rigid, flat printing surfaces and so must be sheet fed. The printing surfaces are also more expensive and more difficult to prepare than those used for offset.

Prepress

Printing is only part of the process of nonphotographic reproduction. Sometimes the preparation of materials for printing, or *prepress*, is attended to by the printer, but most often this is the responsibility of an outside supplier, called a *color house* or *service bureau*. These people take instructions and materials provided by a designer and, using a variety of techniques, create the high-contrast films that the printer will need to make, or *burn*, the printing plates which are fitted to the press.

In the case of photographs, prepress begins with the creation of a *halftone*. A press cannot reproduce various densities as continuous tones like film and photographic papers can. Instead, differing densities are printed with discrete dots of ink: Small dots spaced far apart appear to the naked eye as a light tone, whereas larger dots, spaced

closer together, appear to be a dark tone. These dots, or halftones, are clearly visible in any printed material with the aid of a magnifying glass.

The degree of resolution in printed material is dependent on the size of the dots, which, in turn, is dependent on the quality of the paper. Coarse, absorbent papers like newsprint cause the dots of ink to spread and merge with one another unless they are spaced well apart. That is why photographs in newspapers appear soft and lacking in detail. Fine-grained coated papers allow the use of very tiny, closely spaced dots that render detail very clearly.

The traditional method of making halftones requires a contact printer or a precision *process camera*: In either case, a sheet of high-contrast copy film is sandwiched together with a glass or plastic screen ruled with very fine lines. The spacing of the lines determines the size of the dots. A coarse screen suitable for newsprint has 45 to 80 lines per inch, whereas a fine screen for very precise printing has up to 300 lines per inch. Most images in ordinary books and magazines are printed using a 150-line screen.

Today most halftones are made with a computer and an electronic drum or flatbed scanner, in which case the screens exist only as software. With the right equipment and the right operator, this process can be markedly superior to the old optomechanical methods because this new technology eliminates mechanical defects like dust marks, scratches, or fingerprints, as well as optical defects like poor focus or misalignment of the process camera. Electronic systems are capable of creating halftones that yield many more gradations of gray than conventional methods. (As this is being written, direct digital printing employing entirely electronic photography, layout, prepress, and platemaking is just beginning to establish a foothold in North America. Nevertheless, a real halftone is still required to make a printing plate for a conventional press.)

Duotone and *tritone* are special printing methods that enhance the depth and realism of black and white photographs. For duotone reproduction, one halftone is created that captures only the highlight areas of the original, and a second halftone is created for the shadow areas. Two printing plates are made, and each is used with a different color — black and brown, for example. Tritone printing uses a third halftone, printing plate, and color for the middle tones. These processes can produce images that rival original photographic prints for tonal range and detail.

Color *separations* are special halftones made from full-color originals. One halftone is made for each primary color by sequentially exposing or scanning a full-color image through red, blue, and green filters. In *four-color process printing*, plates made from the separation halftones are used to sequentially lay down yellow, cyan, magenta, and black ink. (Yellow, cyan, and magenta are, respectively, the complementary colors of blue, red, and green. Black ink adds overall density.) Extremely precise alignment, or *registration*, of all plates is required for sharp, accurate printing.

Printing Controls

Now we move into an area that relates more directly to commercial photography. As we have seen, printing and prepress involve a lot of equipment and many steps. Just as photographers can choose different filters, vary development time and temperature, or burn and dodge in the darkroom to alter the appearance of the final product, color houses and printers can alter some of the parameters of the processes they employ.

No method of reproduction is perfectly accurate, and both photography and printing have their share of technical shortcomings. Here are a few nightmarish problems that can wreak havoc in nonphotographic printing together with some possible remedies:

1. Moiré patterns are caused when objects with regular, repetitive textures or designs are reproduced. The half-tone dots visually interact with the subject's texture to create highly visible wavy lines or stripes in the printed piece. These distracting effects can sometimes be diminished by changing screen gauge or by changing the angle of the screen.

2. Black detail on a black background or white detail on a white background are very difficult to reproduce. Photographers can help by choosing film stock carefully and by lighting carefully — properly lit and exposed transparencies usually perform better in these circumstances than color negative films, for example.

3. Damaged originals can cause all sorts of problems. Slides in glass mounts are at risk for scratches or punctures. A slight deformation in a photograph caused by a rough handling, improper storage, a paper clip, or even by writing on the back, will likely show up in a scan.

31

4. Gold or silver lamé as well metallic or fluorescent colors are notoriously difficult to reproduce. More subtle, but familiar colors, like skin tones and foliage can also reproduce less than faithfully. The only remedy is to photograph test patches and to reproduce the tests by the same method of printing as that proposed for the finished piece. The results should be reviewed together by photographer, designer, color house, printer, and client, in order to predetermine what choices of film, lighting, ink, etc., are most appropriate.

5. Reproducing certain subjects against a pure white background (*close cutting*) can be tough, whether the close cutting is to be done photographically, mechanically, or electronically. Curly hair and bicycle wheels, for example, require very careful lighting, or lots of time in prepress with an airbrush, razor knife, or *Photoshop*.

Color houses and printers provide a series of proofs at various stages in their work. Designers and clients will look at these proofs and decide what needs changing or fine-tuning before the job is printed. Proofs from the color house are annotated, or *marked-up*, to indicate necessary alterations in color balance, color saturation, contrast, detail or modeling, uneven color, or improper registration. Poor photographs can be repaired, to a degree, by conventional retouching, careful scanning, and by electronic manipulations of the scans. A basic rule says that the better the original image, the better the final product. Although brightness, color cast, contrast, highlight and shadow detail, and color saturation should all be properly attended to by the photographer, all of these variables can be, and often are, altered in prepress. If proofs show up problems, the color house may have to retouch the halftones by hand, or even rescreen, rescan, reseparate, and reproof to satisfy a client. Depending on the cause, the client, the color house, or the photographer may be blamed and held financially liable for the additional costs and lost time.

At the printing stage the available controls are fewer and less subtle. Printers make monochrome proofs, called *bluelines*, from the same film they will ultimately use to make their plates. This is the next to last opportunity to catch layout and type errors. The very last chance is a *press check*, which happens at the printing plant while a job is being run. The printer provides the designer or the client with samples from the first sheets passing through the press, and decisions are made whether

the job should be run as set up, run with alterations, delayed, or canceled altogether. It is very expensive and time consuming for all concerned to actually cancel or delay a job that is set up on the press. However, this certainly can happen when the paper stock is wrong, when blocks of pages (*forms*) are set up out of sequence, when registration is wildly off, when serious typographical errors (*typos*) are detected, or when photographs or illustrations are found to be missing, upside down, or reversed left to right. Every printer will be happy to tell you his or her own horror stories.

Some fine-tuning on the press is normal and expected. Slight registration errors are usually easy to fix, as are spots or streaks of uneven color. However, one must realize that modern presses are big and many pages are printed together. Color saturation, color balance, and overall density can be altered by manipulating the flow, color, and viscosity of the inks, but these changes will unavoidably affect many images on many pages. Compromises are inevitable.

I have been responsible for press checks for a couple of my own books, and I have found the experience to be intense, but exhilarating. Printing plants are noisy, smelly places. The presses and binding machines operate at a furious pace. In larger operations there are usually several presses running at once, all serviced by a constant parade of forklifts ferrying barrels of ink, huge rolls of paper, and pallets stacked high with finished work. Press operators vary in skill, integrity, and patience. When everything comes together there is nothing quite like it, but when things go wrong, it feels like a special department of hell.

How Photography and Printing Fit Together

A technically excellent commercial photograph is an image that can be accurately reproduced with a printing press. Traditionally, color houses and service bureaus have preferred to work with large, properly exposed transparencies because they record a wide range of densities; all of the tones that can be printed with a press are available for the separator to work with during prepress. A printed image is viewed by reflected light, and so is much more like a photographic print than a slide. The full range of density and color present in a high-quality transparency will exceed the capabilities of the press, so it must be compressed or limited when the separations are made.

A poor photographic print, i.e. one that lacks detail in the highlights or shadow areas, is impossible to fix during the prepress process and as a result will print poorly. This is not to say that high-quality prints or lower contrast transparencies cannot be well reproduced. It simply means that prints or slides intended for nonphotographic reproduction must have, at a minimum, the same range of tones and detail that the press is capable of achieving. A similar logic applies to resolution: A finely detailed photograph will reproduce well with a coarse screen or with a fine screen whereas a less-detailed photograph will reproduce satisfactorily with a coarse screen, but poorly with a fine screen.

In the old days, printers concerned with quality demanded large-format transparencies so that they had more than enough image "information" to work with. These days such an approach is considered serious overkill. The change is due to increases in process control — beginning with the photographic process and ending with the printing process. For printers and service bureaus, electronic scanning and prepress make what used to be an art into a science…quantitative controls have replaced qualitative analysis. For photographers, process control means that a much wider range of image-forming media — 35mm, medium format, large format, and a variety of digital-imaging technologies — are suitable for reproduction purposes, as long as they are selected and applied so that the results exactly fit the intended method of nonphotographic reproduction. These days, photographers have to know exactly how their clients will be using their photographs.

A GLOSSARY OF PRINT PRODUCTION

Aspect ratio
Refers to the ratio of width
to height.

Back to back or **backing up**
Printing on both sides
of the sheet.

Baseline
Imaginary line that type rests on.

Binding
Method of attaching and
securing paper.

Bleed
Extra amount of printed image
which extends beyond the trim
edge of the sheet or page.

Blend
Smooth transition from
one shade to another.

Body copy or **body text**
Main text of a story or article.

Broadside
Advertising sheet, usually
a self-mailer.

Bullet
Typographic symbol used
to set off lists or call attention
to sections of text.

Camera-ready art
Typeset copy together with
line drawings and continuous-
tone copy that is ready in all
respects for photomechanical
reproduction.

Caption or **cutline**
Short text to explain picture
or illustration.

Center spread
Two center pages of a publica-
tion, used as a double spread.

Close-cut
Photographic method that high-
lights an image in a photograph
by removing the background.

Character
Any letter, number, punctuation
mark, or space in printing mat-
ter.

CMYK
Cyan, magenta, yellow, and
black — the ink colors used to
print four-color process work.

Collate
Gathering of printed sheets
or signatures in proper order for
bindery.

Color key
Color proof made from
separations.

Comprehensive (comp) or **mock**
Layout of art and type, either in
black or in color, used as a pre-
sentation.

Copyfitting
The process of calculating how
much copy will fit in a given
space using a particular font.

Cropmark
Marks used to define how a
printed piece will be trimmed.

Die-cutting
Cutting board, paper, card stock,
or other material with regular
or irregular designs.

Dingbat
A typographic ornament
or symbol.

Display type
Type used primarily
for headings.

Dot gain
Dots from halftones in four-
color process printing larger
than they are on film. Can be
adjusted by printer.

Download
To receive a file on a computer
sent by another computer.

DPI
Acronym for dots per inch,
method of describing resolution
used when referring to the
resolution of computer moni-
tors, printers, and scanners.

Dropout, knockout, or **reverse**
Type or graphic appears in white
against a dark background.

Dummy
A mockup; it shows how a piece
will fold.

Embossing
Producing a raised image
on paper or other material.

Engrave
To incise designs or images on
the surface of a material from
which printing impressions can
be made.

EPS
Acronym for encapsulated post-
script; a computer file format.

Feather
A soft edge around an image.

Figure
Line illustration or photograph
of any kind used in a publication.

File conversion
Act of changing digital file from
one platform or file format to
another, i.e. DOS to Macintosh or
Word Perfect to Microsoft Word.

Flat
A group of pages loaded in the copyholder for photographic plate making. Also denotes the combined masked negatives.

Formatting
Applying a specific typeface, size, alignment, and other elements of style to copy.

Four-color process
The printing of the four primary printing inks — yellow, magenta, cyan, and black — together to produce full-color images.

Gradient fill
A smooth blend.

Grayscale, continuous-tone, or **halftone**
Artwork with range of tones between black and white.

Greeking
Dummy copy in a layout that will be replaced eventually with real copy.

Grid
Basic page parameters margins and columns on which design is done.

Gutter
Inner margins of two facing pages in a publication.

Hairline
Finest of an assortment of printing rules (lines).

Identifier or **logo**
Combination of symbols, illustration, and type used to represent a company, a business, etc.

Imposition
Arrangement of the pages that are to be printed on one side of a sheet so that when cut, folded, and trimmed, they will be right-reading and fall in numerical sequence.

Impression
Degree of impression or force required between the printing plate or form and the printing stock. A kiss impression is the ideal contact between plate and stock.

Ink
Combination of pigment, pigment carrier or vehicle, and additives. Most are petroleum based and transparent.

Input
Put into a computer, usually text.

Italic
Type that slants to the right.

Jaggies
Undesirable stair-stepping edges on text or graphics.

Justification
Spacing of lines of type to a predetermined measure so that both margins are aligned.

Kern
Any part of the face of a type letter that extends beyond the body. "Kerning" is adjustment of space between character pairs.

Key
Legend or index identifying components, parts or other fixtures of an illustration.

Lamination
A plastic film bonded by heat and pressure to a printed sheet for protection.

Layout
Arrangements of a book, magazine, or publication so that text and illustrations follow a desired format.

Line art, bitmap, monochrome, or bilevel
Composition of solid black lines and images without graduation of tone.

Line conversion
Photographic process whereby continuous-tone copy is converted to line work.

LPI
Lines per inch; used to measure half-tone screens.

Make ready
Process of preparing a press for a print run.

Masking
Blocking out of a portion of an illustration to prevent it from being reproduced.

Masthead
Heading that identifies a newspaper or publication.

Measure
Length of a line of type measured in picas.

Mechanical
Page or layout prepared as an original for photomechanical reproduction.

Output or **runout**
Materials produced from a digital file; can be in the form of film or paper, negative or positive.

Overrun
Copies printed in excess of the specified run.

Page proof
Page taken from each page and proofread as a final check.

Pantone
Pantone Matching System used for specifying and blending colors.

Paper or **sheet**
Medium to print on.

Newsprint
Light pulpy stock used for newspapers.

Bond or *writing*
24-lb grade used for photo-copying, laser printers, and letterhead.

Text
Premium printing paper heavier than writing, used for booklets, newsletters, etc.

Cover
Heavier than text, used for booklet covers, kit folders, cards, etc.

Coated
Paper with an outer layer of coating applied to one or both sides. Available gloss, dull, and matte.

Paper negative
Inexpensive negative used for producing printing plates when quality is not of prime importance.

Paste-up
Process of pasting an image or type on a reproduction page or sheet.

Pica
Unit of measurement used in printing; 1 pica = 12 points. For practical purposes, 6 picas = 1 inch.

Point system
Method of measuring type sizes.

Postscript
Computer language used for electronic layout.

Printing
Transferring an image to paper in order to make multiple copies.

Quickprint
Generally photocopying or simple one- or two-color printing.

Digital
Printing done straight from digital files, usually four-color process.

Offset lithography
Ink transferred to paper by a rubber blanket or roller which has received image from a paper, plastic, or metal plate; common method for letterhead, brochures, magazines, etc.

Thermography
Gives the effect of enamel-finished raised lettering.

Relief
Raised image area that transfers ink to printing surface.

Flexography
An industrial printing method used to print on cartons, containers, etc., and on surfaces such as plastic, acetate, corrugated cardboard, cellophane, and foil.

Woodblock and *letterpress*
Forms of relief printing.

Intaglio
Recessed image area that transfers ink to printing surface. Engraving and gravure are common methods. Engraving is used for high-quality small runs such as wedding invitations, etc. Gravure is used for postage stamps, stock certificates, etc.

Screen printing
Porous fabric allows ink to flow through areas not covered by stencil to printing surface. Used for T-shirts, bags, banners, etc.

Waterless
High-quality lithography printing that does not use water.

Web
Printing on a continuous role of paper, used for large runs as for newspapers and magazines.

Press proof or **press pull**
Proof removed from the press to inspect line and color values, registration, quality, etc. It is the last proof before the complete run.

Press run
Total number of copies of a publication printed during one printing.

Proof
Used to check work.

Laser
Paper proof from laser printer; made from digital files.

Splash, Fiery, Iris, or *Canon*
Color paper proof made from digital files.

Blueline
Proof made from output negatives. Used to show position.

Colorkey
Color proof, made from output negatives.

Proofreading marks
Set of standard symbols that indicate corrections on a document.

Register
In printing, to align a type page so that it exactly backs the type page on the reverse side of the sheet. Also, precise matching of successive color impressions.

Register marks
Small symbols used by printers to position different layers of a project being printed, embossed, etc.

Resolution
Refers to the degree of clarity of a photograph, computer monitor, or printer.

Resolution or DPI
Refers to the degree of clarity or sharpness of output and is measured in dots per inch (dpi).

Runaround
Type that flows around a graphic, following its contour or form.

Run-in (on)
Notation to set copy in the same paragraph although a break is currently shown.

Run ragged
To be uneven or unjustified.

Scaling
Determining proper dimensions of an image to be reduced or enlarged when printed or output.

Scan or scanning
Process of digitizing photos and graphics for computer use.

Service bureau
Supplier that provides various computer-related services, such as color proofs, scanning, retouching, file conversion, runout, prepress, etc.

Signature
Sheet of paper printed on both sides and folded to make up part of a publication.

Shade
Intensity of color; measured in percentage of dots.

Spread
Two facing pages in a publication.

Style sheets
A process of automated formatting in a computer program that allows you to set up formatting commands for text.

Stripping
Cutting out and placing in position.

Swatch
In printing, a color sample.

Tear sheet
Sheet extracted from a publication that contains an advertisement or other matter.

Thumbnail sketch
Very small, concise sketch used as a preliminary presentation or as reference for final rendering.

TIFF
Tag Image File Format; used to store scanned computer images.

Tiling
Process by which a document larger than the paper it is to be printed on is broken into sections the size of the paper and then assembled manually.

Tracking
Space between letters and words in text.

Trapping
Slight overlap of colors that appear next to each other in a printed piece.

Trim size
Size of a publication after it has been trimmed to its final dimensions.

Turnaround
Time from acceptance or beginning of a job until the completed job is delivered.

Typeface
Set of characters distinguished by specific style and design characteristics.

Velox
A positive photographic paper print made from a negative.

Virgin fiber
New fiber used to create high-grade paper.

Watermark
Design or text impressed on paper during the paper manufacturing process.

Web offset
Lithographic printing from rolled, continuous stock.

White space
Parts of a designed page where no type or graphics appear.

Window die-cut
Opening in the front cover of a publication.

WYSIWYG
Acronym for *What you see is what you get*, means the composite page viewed on the screen represents what the printer will output.

HOW COMMERCIAL PHOTOGRAPHY IS PRODUCED

Concept, Creativity, and Style

Prepress and printing are reproduction processes. Although they employ an array of subtle techniques, their fundamental raison d'être is accuracy— to render on paper as faithful a reproduction of the original as possible. Photographic copywork is a similar sort of technical exercise, but all other photographic enterprises depend on a more creative approach.

Excellent photographers are really artists, people who, according to *Webster's* Dictionary, "use imagination and technical skill for the creation of aesthetic objects." Commercial photographers are commercial artists, since the aesthetic objects they make are commissioned by or sold to commercial users. Although most of this book is devoted to the acquisition of technical skills, it is important to realize that imagination does not diminish in significance simply because art is created for a commercial purpose.

A commercial image begins with a problem. The problem usually belongs to an art director or graphic designer, but many other people find themselves in the same predicament— they have a need to illustrate a mental concept with a visual image. These people become our clients the moment we convince them that the visual image they need is a photograph we can provide at a cost they can afford.

According to *Webster*, a concept or idea is "a transcendent entity that is a real pattern of which existing things are an imperfect representation." Herein is the fundamental dilemma: Our clients are in charge of the transcendent entities, and we are in charge of the imperfect representations. Because advertising is a business in which concepts are bought and sold, commercial photographers are valued in proportion to their ability to reformulate mental constructs as real artifacts. Commercial photographs are purpose-built visual analogues of specific ideas and feelings. So, before even considering a technical solution, one begins the work by trying to penetrate the mind of another. In the client's head lurks a notion, sometimes ephemeral and sometimes peculiar, that requires our sympathetic assessment and interpretation.

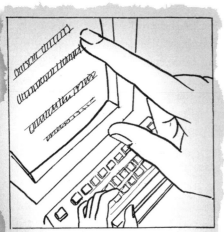

Figure 5.1

Here is a layout, with the art director's written notes, and the finished color image. The designer rendered a more or less realistic perspective that could be reasonably reproduced with a camera — unfortunately this is not always the case. Check the layout carefully before you accept responsibility for the final results. (*Mamiya 645 Super/55mm lens/Kodak EPP film/Electronic Flash plus 1 second exposure for screen*)

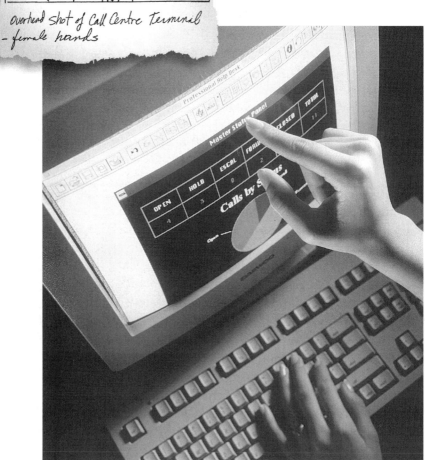

In the world of commercial photography, creativity is the process of acquiring an understanding of the client's desires and intentions and then rendering a photograph that, with originality and flair, makes those desires and intentions real. The particular manner in which originality and flair animate the work is referred to as *style*.

Specifications

We begin the divination by paying attention. A phone call, an e-mail, or a personal meeting will initiate an exchange of information; the richness of which is determined by the client's ability to communicate and by our ability to concentrate. It is important to determine quickly how clearly the client is thinking. If the client has a real understanding of the concept that he or she wants illustrated, then the process can proceed quite efficiently. If he or she has only a fuzzy idea of what is required, then the process will be slower, and riskier. The risk in the latter case can be financial, professional, and profoundly personal in nature. Should you bet your resources on a concept that turns out to be different than what the client thought he or she had described, you lose money. If word of such an occurrence spreads around the advertising community, you lose professional esteem. If you take a mistake in judgment too much to heart, you lose self-confidence.

Chapters 18 and 19 offer advice about negotiating with clients who have differing temperaments and intellectual capabilities, but for now, here are twenty questions that will help determine the exact specifications for a proposed assignment:

1. What is the aesthetic purpose of the photography?

2. What is the commercial purpose of the photography?

3. When is the work required?

4. What film and format is required?

5. When working with an agency, who is the ultimate client?

6. What is the budget, and who is to be billed?

7. Will the client find and pay for models, props, and stylist?

8. Who will be responsible for retouching or image manipulation?

9. Will the client arrange access, security, and cleanup on location?

10. By what method will the photographs be reproduced?

11. How many different shots or setups are required?

12. Will the client attend the shoot?

13. How will time lost to bad weather be dealt with?

14. Who will evaluate the work?

15. How will any costs for reshooting be handled?

16. Who will oversee proofs and printing?

17. Who is liable in any litigation arising from the use of the photographs?

18. Who will own or store the negatives or slides after the job is done?

19. Who will own conventional and electronic reproduction rights?

20. How soon after approval will payment be made?

The remainder of this book will help you understand why these questions are important.

Deadlines and Timelines

Many tested professionals believe that deadlines are arbitrarily established by perverse clients. They support this attitude with the sardonic observation that "there is never time enough to do the job right, but there is always time to reshoot when things screw up." I feel it is a big mistake to think this way.

A deadline exists only as an element of an agreement between a client and a photographer. By agreeing to deliver a finished image at a specific point in time, you become responsible for creating your own deadline; if it later proves unreasonable, you will have mostly yourself to blame. Avoid backing into an unprofessional corner by learning the value of timelines.

A timeline is a schedule that lists in logical, chronological order all the tasks that must be completed in order to bring to fruition a particular process of production. In the advertising world, a timeline for the production of a brochure or mailer might look like this:

1. Concept development

2. Concept presentation and approval

3. Design development and approval

4. Copy or type development and approval

5. Creation of a layout and mockup

6. Presentation of mockup

7. Presentation, revisions, reapproval of mockup

8. Selection of suppliers

9. Negotiations with suppliers (color house, photographer, printer, etc.)

10. Art direct photography

11. Presentation and approval of photography

12. Supervise retouching and manipulation of photos

13. Final copy and typesetting

14. Separations, assembly, and prepress

15. Color house proofs presented, revised, and approved

16. Final film and bluelines from printer

17. Printing begins with press check

18. Printing

19. Inspection and approval

20. Dye-cut, fold, bind, and package as required

21. Deliver and distribute

22. Invoice

23. Collect payment

24. Pay suppliers

For a complicated job undertaken at a leisurely pace—a coffee-table book, for example—this timeline might extend for several months, but most advertising projects must be completed in eight weeks or less.

Rush jobs are sometimes produced in just a few days. Note also that almost every item on the print-production timeline is actually a discrete process with a timeline of its own. Photography is no exception. Here is a typical timeline for the production of a commercially valuable photo:

1. First contact with client

2. Aesthetic and technical evaluation

3. Contact potential suppliers (stylists, assistants, etc.)

4. Estimate time requirements and costs

5. Present aesthetic and technical approach and quotation

6. Negotiate formal agreement

7. Engage and supervise suppliers

8. Obtain props, build sets, and acquire required equipment

9. Test, evaluation, and approval

10. Shoot

11. Deliver film to lab or process in house

12. Edit

13. Mount or package

14. Present and ship to client for approval

15. Reshoot, process, and edit as required

16. Invoice

17. Collect payment

18. Pay suppliers

It is always possible to establish realistic deadlines as long as the timeline requirements of the photographic process are carefully considered in relation to the timeline requirements of all the other processes involved in a print-based commercial project.

New Ways of Working

My introduction to digital imaging occurred at a large photography trade show and conference several years ago in Vancouver. The first afternoon was to be taken up by Kodak: Some exciting new products were to be introduced to the crowd of about 250 photographers from across the continent. We appeared at the appointed hour to find a slick seminar room set up with a big screen. A well-turned-out marketing individual from Rochester explained that we were going to be shown a film.

Kodak was a major sponsor of the Winter Olympics that year, and North American TV had been blitzed with a series of Kodak-produced commercials for the games. Perhaps you remember them—they depicted a huge stadium filled with thousands of people who, by way of synchronized flip-cards, sequentially displayed gigantic Olympic and Kodak logos and colossal pictograms showing the various Olympic sports. A fabulous panorama of fantastic fireworks glowed above the crowd. I remember being impressed with the precise choreography and the sheer physical scale of the undertaking when I first saw the spots on the tube. The film we were about to see, we were told, would reveal how the commercials were made.

Once the lights had dimmed the show began with a reprise of the commercials — spectacular in 16mm color — followed by a twenty-minute minidocumentary. The inside scoop was quite a revelation. It turned that there was no stadium and no cheering crowd...just eighteen or twenty people on some risers in an ordinary-looking studio: In their hands they held blank pieces of cardboard. The other 18,980

people, the stadium, the choreographed cardboard, and the fireworks, were all computer generated. A couple of digital workstations and a handful of technicians were responsible for the whole thing.

When the film ended you could have heard a pin drop. The lights went up to reveal a room full of pale faces...we had all been completely taken in by the original spots. Each and every one of us was an image-making professional, yet not one of us had realized the fake. Everyone was shocked at the flawlessness of the deception. Some were angry. After several minutes of stunned silence, the questions started to fly: Wasn't this unethical? Wasn't image manipulation a visual fraud? Was this the future of still photography? Was film dead?

The executives from Kodak were flabbergasted with the response. They had expected praise and admiration for their dexterous display of digital dominance. They wanted to talk about Kodak's soon-to-be-available electronic imaging technology, but instead they had to defend themselves against accusations of having played fast and loose with the public trust, not to mention the livelihoods of all those present. Yet the suited minions gave no quarter: "This is the future," they declared. "Get used to it!"

Flash forward a few years from that day in Vancouver....What my colleagues feared for the future has proved to be something less than threatening. The people who predicted filmless studios were just as wrong as the people who predicted the paperless office: As this is being written there still exists a thriving commercial photography industry based mostly on conventional film technology. What is happening — and what will continue to happen — is the integration of digital-based and film-based technologies. Film is too useful and too powerful a medium to abandon, but digital imaging is too useful and too powerful a medium to ignore.

The following discussion is an introductory primer on how digital imaging works and how it complements traditional imaging practice.

THE DIGITAL IMAGE

A conventional black and white negative or print is composed of tiny particles of metallic silver suspended in an emulsion spread on a paper or plastic base. A conventional color image is composed of tiny particles of organic dye suspended in several emulsion layers, spread one

on top of another, also on a paper or plastic base. In both cases, the image-forming components are so small as to be nearly invisible to the naked eye, yet together they permit every conventional image to exist as a physical object — a collectivity of real particles — that can be seen and touched.

A digital image does not exist in the same way as a conventional image because a digital image cannot be seen or touched without some sort of physical interface. Webster defines *interface* as "a surface defining a common boundary of two bodies, spaces, or phases...a place at which independent systems meet." We can see and touch an interface surface, be it a piece of film or photographic paper, an inkjet, thermal wax, or dye-sublimation print, a cathode-ray tube, or a solid-state display screen, but we cannot see or touch the digital image that it represents. A digital image exists only as a mathematically coded series of electrical or magnetic potentials within an electronic device.

A computer encompasses and manipulates digital images in somewhat the same way that the brain encompasses and manipulates thoughts. Inside our biological computers consciousness is supported by massively interconnected networks of neurons; no brain...no thoughts. In a computer, digital images are supported by somewhat less massively interconnected networks of electronic switches and magnetic or optical storage devices; no hardware...no image.

Thoughts are plastic, and subject to all sorts of influences. We can test drive a variety of possibilities on a mental plane, taking action after having arrived at an appropriate conclusion. Digital images are also plastic: Ensconced within their electronic environment, they can be juggled and teased and mutated at will.

HOW COMPUTERS WORK

A computer consists of a power supply, a central processing unit (also known as a CPU or microprocessor), some combination of electronic, magnetic, and optical memory, together with an array of input and output devices.

A computer's job is to manage electrically, magnetically, or optically encoded signals. These signals are simple, in that they are either there or not there: Their presence or absence is the physical analog of zero or one in binary counting, a system that uses combinations of zeros and

ones to represent all other numbers. A computer is a device in which millions of little switches—located inside electronic circuits, on magnetic tapes and discs, and on optical media—are lined up in order, and switched either off or on in a particular sequence. This switching is governed by an internal clock, and the rate at which it operates (clock speed) is expressed in cycles per second, or Hertz (Hz). These days we talk about millions of cycles per second (MHz). A computer of moderate speed runs at 50 to 100MHz, while a 250MHz machine is considered very fast.

Some switches are set to the equivalent of one or zero only once, and cannot be changed. An array of such switches—whether magnetic, electrical, or optical in nature—is called read-only memory (ROM). Some switches are set, and remain set, until they are instructed to change. An array of such switches is called random-access memory (RAM).

Some switches are slaves that function together in precise accordance with predetermined algorithms — step-by-step instructions for the solving of mathematical problems. A CPU consists of millions of incredibly tiny, interconnected slave switches that have been etched onto a chip of silicone called a large-scale integrated circuit (LSI). The instructions that govern the operation of the CPU are permanently encoded in ROM as well as delivered from the outside by way of input devices like a keyboard, a modem, a scanner, a magnetic disc, or CD-ROM reader. A special grammar called machine language is used to distribute instructions within the computer.

In order to make a computer perform functions that are meaningful to human beings we need a device that translates human desires into machine language. For most applications software is that device.

Having instructed a computer to execute a specific task, we need to know how the work is progressing and what the final result will be. Monitors, printers, and plotters usually perform these functions, but a host of other mechanisms will work as well: When a microwave oven is controlled by a microprocessor, popcorn is a legitimate output device.

HOW AN IMAGE IS DIGITIZED

A digital image comes into being through an electronic system of image recording or digital capture. Fundamental to this endeavor is a solid-state optical sensor, called a charge-coupled device (CCD), that converts light to electrical energy. Charge-coupled devices are the basic

elements in most electronic imaging hardware from video camcorders to high-end large-format studio still cameras.

An electronic camera uses many CCD sensors grouped together to transform an image into a grid of picture elements, or pixels. Each pixel is assigned a value that corresponds to the average of all the brightness and color levels within the pixel's area. This value is encoded as a sequence of zeros and ones. In computer terminology, each zero and each one is a *bit* and eight bits is one *byte*. The black and white data for one pixel occupies one byte of memory. For a color image, one byte per primary color component is required for each color pixel, hence the term *24-bit color*. All the bytes from all the pixels of a complete image are stored as a data block, or file. The file size for color image storage is usually three times that of a comparable black and white image.

We know from conventional photographic practice that the finer the grain and the larger the piece of film, the higher the resolution. The same is true for digital imaging, except the key variable is the number of pixels rather than the number of grain particles. The mechanical size and physical arrangement of sensors determine the capture capabilities of digital cameras. Two basic configurations exist at present: scanning backs and digital arrays.

Scanning back cameras capture images one row of pixels at a time. These cameras use a mechanical worm-drive arrangement to move a very thin line of tiny CCD elements across the image area, so they are capable of very high resolution. Scanning backs record full color information in one pass, but they are so slow that moving subjects cannot be rendered reliably. A setup similar to scanning back technology is used in flatbed scanners that digitize existing photographs and transparencies.

A digital array is a square or rectangular arrangement of a large group of CCD sensors. As this book is being written, an array that is both practical and affordable in size will capture an entire image at once, but cannot approach the resolution of scanning back cameras. In addition, digital arrays are monochromatic devices, so color images require sequential exposures through red, green, and blue filters. An approach that allows instantaneous color capture requires an array with built-in filters, an arrangement that significantly reduces resolution. A third variation uses beam splitters to simultaneously record the three primary colors on three separate arrays, but high cost has limited development of this option.

DIGITAL RESOLUTION

Few processes of reproduction other than photographic printing can use anywhere near the amount of information recorded on film, and because most commercial photographs are intended for mechanical reproduction, a digital image of appropriate resolution will certainly work just as well. But we need some way of quantifying resolution in order to make a correct match between a particular electronic imaging process and an intended application.

As described in the previous chapter, we know that decent four-color process offset printing requires at least a 150-lpi half-tone screen. How does this translate to pixels or megabytes? Happily, there is a simple mathematical relationship between the number of pixels in a digital image and the minimum file size required for high-quality photomechanical reproduction.

A prepress rule of thumb says that for good reproduction an image destined for half-tone reproduction should have a resolution of double the dots per inch (dpi) or pixels per inch, as that of the intended half-tone screen line frequency (lpi). Therefore a 150-lpi screen requires an original image that provides 300 pixels per inch, minimum. Here is the math for a printed 8" x 10" image of reasonable quality:

8 inches x 300 pixels per inch = 2400 pixels

10 inches x 300 pixels per inch = 3000 pixels

2400 pixels x 3000 pixels = 7,200,000 pixels

7.2M pixels x 3 bytes per pixel = 21.6 MB of image data

Absolute photographic quality requires larger files — up to 240MB for an 8"x 10" film output that will appear, even under a powerful loupe, as indistinguishable from an original 8"x 10" transparency.

THE ELECTRONIC STUDIO

Do we give up our conventional film cameras in favor of the closest electronic equivalent? Some photojournalists and low-end portrait operations, more than content to trade resolution for speed, have already made the switch to the $7500–$15,000* 35mm-style electronic still cameras (ESC) available from Kodak, Nikon, Minolta, and Canon.

Some high-end studio shooters are using $40,000 to $100,000*
Dicomed, Phase One, or Rollie backs on their 4"x 5" cameras to shoot
near-perfect, filmless still-life arrangements for substantial dollars.
Middle-range catalog and general commercial operations are shooting
direct to digital with $20,000–$40,000* Leaf or Sinar backs on their
Hasselblads. What about the rest of us?

These numbers are necessarily approximations.
Prices are changing so fast that mail order suppliers do not list specific figures.

SCANNING

I and many others have no inclination or need to spend tens of thou-
sands of dollars on a digital camera or camera back. The advertising
industry in general will be dependent on film input for at least the next
couple of decades. Nevertheless, electronic image handling for retouch-
ing and aesthetic manipulation as well as for design, layout, and
prepress, is now the industry standard. A scanner of some sort is the
only interface between film and computers, so complete image control
requires complete scanning control.

Laser or drum scanners, often costing $1 million or more, have been
the standard in the graphic arts industry for many years. Because they
use ultrasensitive photomultiplier tube (PMT) sensors, high-end drum
scanners are capable of recording an extremely wide range of density
and color at up to 15,000-dpi resolution. More economical drum scan-
ners with diminished but still very impressive specifications are
available in the one hundred thousand to two hundred thousand dollar
range. All these scanners rotate an original image — attached to or fit-
ted inside a cylinder — through the path of a slowly moving, finely
focused beam of light. The original art must therefore be unmounted
and quite flexible.

Most photographers and digital imagemakers will find that flatbed
scanning technology has improved to the point that drum scans are no
longer necessary for quality reproduction. As this is being written,
flatbed scanners in the one thousand to five thousand dollar range are
offering resolution exceeding 5000 dpi for originals up to 2"x 2", and
600 to 700 dpi for originals up to 8 ½"x 11". (The dependence of resolu-
tion on original size flows from the fact that a fixed-size CCD is used in
conjunction with variable internal optics to cover larger or smaller

areas. Since small originals are most likely to require magnification, this is not a problem. A 35mm slide carefully scanned at 2000 dpi, for example, will reproduce very well at 8"x 10".)

It is important to realize that all scans are not equal. Just like chemical processing, scanning is a subtle intersection of art, craft, and science. Just like fine-art photographic printing, scanning should not be a one-way-fits-all operation.

In Chapter 5 we read that process controls are tools that match the characteristics of both conventional film and digital images to the needs of the printing press. Scanning and postscan adjustments are critical to reliable outputs. Because many variables must be attended to, scanners are usually sold with bundled software that is advertised to automatically optimize contrast, sharpness, color, brightness, and more; but just as in the darkroom, the best results demand do-it-yourself involvement. Powerful software programs like *PhotoShop* provide graphical tools called histograms that facilitate the optimization process for each visual parameter. It takes time, patience, and dedication to acquire all the necessary skills but those who have done it are glad they did. (See the interviews in Chapter 8.)

Kodak's ubiquitous Photo CD system is promoted as an economical compromise between in-house flatbed scanning and service bureau drum scanning, and sometimes it is. Professional Photo CD provides five file sizes corresponding to five levels of resolution for as many as one hundred originals up to 4"x 5". The scans are delivered on a CD-ROM, together with a thumbnail printout for each scanned photo. The file sizes range from a 25K to 25MB, which means that theoretically at least, some very good results are possible. Unfortunately not all providers are sufficiently expert to operate the Kodak Photo CD workstation at maximum efficiency.

Here are some guidelines to help you extract decent scans from both Photo CD and service bureau suppliers:

1. Solicit word-of-mouth advice and shop around for quality work.

2. Tell the provider in advance that the scans should match your originals.

3. Tell the provider that the scans are intended for photomechanical reproduction.

4. In the case of Photo CD, don't accept a disc that is delivered with bad thumbnail proofs: The thumbnails are indicative of the quality of the scans.

THE ELECTRONIC DARKROOM

A lot of useful digital imaging can be done without pricey digital cameras or exotic output devices. Two or three thousand dollars will buy a computer and monitor capable of running sophisticated image manipulating software at only slightly less than acceptable speeds. High-resolution scans of conventionally produced images are readily available from service bureaus at moderate prices. Another two or three hundred dollars will buy an 88 MB disk drive with removable media so that large image files can be readily imported, exported, and transported. When digital-related business proves profitable, a flatbed scanner and a color inkjet proofing printer will bring a significant number of day-to-day tasks in-house.

As digital skills improve, a system with only modest capabilities will prove frustrating. There is no limit to the amount of money that can be spent on sophisticated digital equipment, but let's take a look at some practical options for conveniently manipulating a high-resolution file of perhaps 40 MB, which will yield 5"x 7" reproductions of near-photographic quality.

You will need a computer with a CPU that operates at 150MHz or better. (If your starter machine is fairly modern, it can likely be upgraded.) A digital imaging rule of thumb states that for quick operation, you need at least three times as much RAM as the largest image file you will regularly handle. Since RAM comes in multiples of 8MB, a fast machine needs at least 128 MB of RAM in order to conveniently handle 40 MB files, although 256 MB is better. Since both digital-imaging software and digital images themselves are memory intensive, a 1- or 2-gigabyte internal hard drive (a gigabyte is 1000 MB) and a CD-ROM reader are also required, in addition to a Syquest, Zip, or Jaz drive with removable cartridges ranging in capacity from 100MB to 1GB. A 17" or 20" high-resolution monitor driven by a good video accelerator card is recommended, but not absolutely necessary. Such a system can be assembled for between five and ten thousand dollars.

Figure 6.1 A–C
Digital imaging: What is it good for? The marketing department of Manitoba Hydro decided that my charming midsummer portrait of three cows contemplating a solar-powered automatic watering device would work better as a winter scene. Digital techniques were skillfully employed by retouch artist Ray Phillips to eliminate the original foreground and background—trees and snowbank were provided by image B, which was flopped left-to-right to match the angle of the sunlight. The electronic composite was output to a 4"x 5" color negative. (Original in color.) (*Mamiya 645 Super/80mm lens/Kodak PRN film.*)

A.

B.

C.

AN OBSERVATION

This book is devoted to fostering the skills required to produce high-quality commercial photographs. Many of the skills associated with digital imaging are not photographic in nature, rather they are more closely connected to design, graphic arts, prepress, and publishing. Photographers who acquire computer skills inevitably become, in some degree, active players in those industries, and consequently enter into competition with their own clients and suppliers, and their clients' clients and suppliers. This may be the beginning of something unpleasant, not unlike the downward competitive spiral that damages those neighboring communities that compete too fiercely with one another for investment capital and industrial development.

Computer Applications & Telecommunications

Computers are becoming indispensable business tools. Photographers who work on their own are some of the most stubborn holdouts, but the rising tide of automation will prove irresistible in the end.

Bookkeeping chores are often the first to be automated. Because photography businesses are relatively uncomplicated, the use of a computer to number crunch might seem to be technological overkill, but there are a number of advantages. First, if you establish a regular routine for data entry, everything you need to know about your business will be at your fingertips. The computer is an electronic cardboard box with the lovable ability to automatically organize the information put into it. There is tremendous peace of mind knowing that every financial detail is safely stored away and instantly accessible. Second, computer-generated invoices and financial reports engender respect in the other business people you will be dealing with. Bankers in particular respond wonderfully to the tidy and accurate printed lists of aged receivables so easily created by machine. Third, computers have multiple applications that are more than useful in the photography business.

Word processing is very handy for all facets of business-related communications. Desktop publishing applications and a good inkjet or laser printer allow the production of sophisticated brochures, press releases, and illustrated proposals. Computer-generated labels make direct mail advertising a snap. There are programs available to organize stock photo files. There are specialized on-line data banks and user networks stocked with up-to-date technical and marketing information

of special interest to photographers. Finally, electronic imaging and image enhancement are rapidly encroaching on areas that have been traditionally dominated by conventional processes.

A defining characteristic of the commercial photography business is the high speed at which things happen. Computers reduce response time and increase accuracy in decision making. Many of your clients are computerized, and it is to your advantage to understand their language. If you are not already computer literate, consult with a friend who is. Most people involved with computers are very patient with beginners because it is very likely that they were initiated by a knowledgeable friend themselves.

A BASIC SYSTEM

Computers come in two basic types: Apple and IBM. There are a few Apple imitators and an incredible number of IBM "clones." The way things have evolved, Apple systems are preferred by graphic artists, art directors, and other professionals concerned with the design of print media, whereas IBM machines have been mainly dedicated to business and accounting applications. As the industry evolves, however, the two systems are beginning to intertwine: The distinctions between them are sure to diminish or disappear in the near future. Both IBM and Macintosh machines can be used today for accounting or design, but there are advantages and disadvantages associated with each technology that only an experienced user can explain. Making an informed purchase will involve some research.

Because of the proliferation of clones, IBM machines are available at lower prices both new and used. Useful used machines can easily be purchased for less than one thousand dollars. Ultrasophisticated systems can cost many tens of thousands of dollars. The main determinant of price is computational speed and memory capability. Happily there are many perfectly adequate bookkeeping programs that work well on simple machines.

When matched with an inexpensive (one hundred to two hundred dollars) dot-matrix printer, a cheap IBM clone can automate any photography business. Dot-matrix printers are noisy and relatively slow devices that use discrete dots of ink to build up the image of letters and numbers on paper. Although very readable, this output is not very elegant, particularly if used for important business letters or promotional

61

materials. A low-end system can be upgraded when more cash is available by simply substituting a more expensive inkjet (three hundred to five hundred dollars) or laser (seven hundred to twenty-five hundred dollars) printer. These devices can print a variety of perfectly reproduced type and graphics faster and more quietly than a dot-matrix printer.

If the money is available, a better choice for someone interested in desktop publishing might be an Apple, or an Apple clone. The graphics software for these machines is generally quicker and easier to use than that designed for IBM systems, although this is changing rapidly as the two platforms begin to merge. Accounting chores may be handled on the Macintosh as well. Startup costs will be higher than for IBM type equipment. Elaborate Macintosh systems with a lot of memory are preferred for digital electronic image enhancement.

Almost all computer systems are expandable, which means that memory and speed of operation can be enhanced by purchasing plug-in electronic modules. In other words, it is possible to start with relatively cheap and simple equipment and then upgrade as money and performance requirements increase.

ACCOUNTING & RECORDKEEPING

Keeping track of numbers was the first computer application, dating all the way back to the days of room-sized vacuum-tube monsters. Today, every small business can afford an "accountant-in-a-box" to make number crunching easier and more useful. Because bookkeeping chores are universal throughout the business world there are literally hundreds of software packages available to chose from — too many to attempt to review here. Specialized software packages designed especially for the photography business are also readily available. They all handle the basic tasks: invoicing, checkwriting, inventory control, and automatic management of payables and receivables.

Any business can be computerized relatively painlessly as long as one has the self-discipline to devote a few minutes each day or a couple of hours each month to enter the appropriate data via the keyboard. This work is amply rewarded by the satisfaction and peace of mind that come with knowing exactly where you are financially at any given moment. In addition, figuring taxes and making decisions on major purchases are much easier.

WORD PROCESSING & DESKTOP PUBLISHING

Computers have many applications beyond the domain of numbers. Even habitually nonverbal types like photographers must communicate occasionally in nonvisual ways, so it makes sense to exploit microprocessor technology with word-processing techniques. This book was written and edited entirely on a portable IBM clone and then submitted to the publisher on disk.

Simply put, all software devoted to helping writers — such as WordPerfect or Microsoft Word — makes a computer into an intelligent typewriter. By invoking simple commands with one or two keystrokes the electronically literate scribe can correct spelling and grammar, access a dictionary and a thesaurus, reposition words, phrases, or large blocks of text, as well as specify format controls like italics, bold print, and underlining. Many word processors will allow page layout to be previewed and manipulated. These days even moderately sophisticated software environments permit graphics like line drawings and photographs to be imported via an optical scanner or modem.

It's easy to see how creative computing can become an addictive occupation, but for our purposes the computer as marketing tool is more than an intellectual plaything. Combined with a good printer, a computer becomes a miniature publishing plant — an efficient generator of highly presentable print advertising.

It is important to remember, however, that access to powerful design tools does not automatically make one a powerful designer. Don't embarrass yourself: Consult with a professional or take a course in graphic design before launching any significant desktop-publishing enterprises.

MANAGING YOUR IMAGE LIBRARY

Anyone who produces a lot of images quickly finds that storage and retrieval can get out of hand without a good filing system. This situation is particularly annoying and wasteful for those who wish to resell commercially produced photographs to more than one client. In-house stock photography files are much more useful if all the images can be cataloged and properly cross-referenced so that photos with multiple uses are rapidly accessible.

A moderate state of organization can be achieved with traditional methods by very, very meticulous people; practically speaking, however, nothing comes close to a dedicated computer-based image management system. Even basic machines running inexpensive software will make personal stock photo management a breeze. A comprehensive image management package will permit the user to reference thousands of images by dozens of categories such as subject type, original client and application, season and location, technical criterion, previous sales, and much, much more. When actual photos or slides are pulled from storage to be sent out to buyers the programs can generate stick-on labels carrying pertinent data for shipping and captions. High-end hardware and software will accommodate photo libraries in digital form so that images may be previewed on the screen and then transmitted electronically via the Internet to potential buyers or by creating Photo CDs that can be shipped by mail or overnight courier. Creative applications are limited only by the cost of the equipment and the imagination of the user.

ON-LINE SERVICES

The previous discussion hints at the possibilities of computers as marketing and accounting tools — but there is more. Although they began as number crunchers and subsequently evolved into powerful manipulators of both words and images, computers are truly awe-inspiring instruments for the storage and management of information.

A data bank is an electronic repository of intellectual knowledge — an electronic library accessible via the keyboard. Your computer can be linked to massive, special purpose data banks through a modem (an electronic device that permits high-speed data transfer over the telephone lines). Some machines can be equipped with a built-in modem, whereas others operate happily with a standalone unit. Modems are not expensive but they come in a number of configurations: The ones that operate the fastest cost the most money but save time on-line.

Photography-oriented data banks index all manner of technical, management, travel, and marketing information. Users can electronically browse through vast electronic libraries and then download those files that are of interest. The breadth and depth of the information out

there cannot be described adequately in a few words. Users subscribe by paying a monthly rate to an Internet provider, a usage fee based on the amount of time on-line, plus long-distance telephone charges. (See Chapter 17 for details.)

Every Internet user can access chat lines and real-time forums that link hobbyists, students, and professionals to experts and teachers from specific fields. Commercial on-line services specific to the photography business allow clients to communicate with photographers, photographers to consult with equipment manufacturers and retailers, or purchasers of stock images ... the list goes on and on. With a few keystrokes electronic portfolios are broadcast and viewed, assignments assigned, and travel arrangements coordinated. Completed jobs can be delivered electronically anywhere in the world.

Here are some on-line services of interest to the computerized photographer:

America OnLine	(800) 827-6364
BIXnet	(800) 227-2983
Compuserve (Photoforum)	(800) 848-8199
Delphi	(800) 695-4005
Galacticomm	(954) 583-5990
Genie (Photobase)	(800) 638-9636
Imagenet	(401) 822-3060
Photonet	(800) 368-6638
PhotoSource	(715) 248-3800

ELECTRONIC IMAGING & ELECTRONIC IMAGE MANIPULATION

The biggest newspaper in my city recently constructed a new multimillion dollar building for their editorial offices and printing plant. The building was built without a photographic darkroom, yet this was not a design error, just a sign of the times.

Photographers for the *Winnipeg Free Press*, using conventional 35mm SLR camera systems, shoot exclusively on color negative films.

Exposed film is processed on a small C-41 processor. Developing and drying take just a few minutes in the machine. Negatives are then digitized with an electronic scanner and transmitted through a local area computer network (LAN) directly to a monitor on the desk of the photo editor. The editor uses electronic controls to manage contrast, density, color balance, and cropping — image content can also be modified but presumably things are not altered to the point where they distort the reality the photographer intended to capture. The images are then electronically transferred to the production room where plates for mechanical printing are prepared. In conversations with the newspaper's photographers, I learned that although they appreciate the speed and control electronic imaging permits, they miss the control they themselves used to exercise during conventional processing.

Digital cameras store images on magnetic media — a relatively slow process, involving relatively bulky hardware. The *Free Press* photographers still use conventional film and cameras because they are faster and more compact than their electronic counterparts. Others in the world of photojournalism have entirely abandoned conventional cameras and film: For them, the ease with which direct-to-digital images can be manipulated and transmitted to and from remote locations transcends the inconveniences associated with the technology.

The scenario described above is only one of the many circumstances where computer technology is encroaching on familiar chemical and optical photographic processes. All the new technologies are said to increase production speed and reduce waste, but usually at the cost of image quality: Conventional films and papers record information at a molecular level — because molecules of silver bromide are very tiny, even a small piece of film can store a tremendous amount of data, and image resolution can be extremely high. Because the electronic equivalent of photographic film uses electronic sensors that are several orders of magnitude larger than silver bromide crystals as recording elements, photographs produced electronically must be significantly lower in resolution.

Once a conventional image is digitized in a high-quality scanner the game changes. The limitations on photographic quality for photographs that exist solely as computer data files is a function of the memory capacity and the operating speed of the host computer. Small machines can cope with only very crude levels of resolution,

whereas sophisticated systems costing upwards of two hundred and fifty thousand dollars are essentially unlimited. As technology advances, the gap between these extremes is narrowing. The Catch-22 is output — machines that can download high-resolution image files to electronic storage media are limited by the quality of digital printers when image files are printed out on paper. Super quality digital printers that output to specially coated papers or to photographic film are extremely expensive.

I think that ultra-high-end electronic photography and real-time in-house electronic image manipulation will be prohibitively expensive for most of us, at least for another few years. What will happen, though, is the option to have conventional images scanned and restructured at small production houses or custom labs, in much the same way that we get color laser copies at the quick-print shop.

Technical, business, and ethical issues arise because the production of printed material is no longer an exercise in reproduction of existing photographs, but rather is more and more an exercise in the reproduction of manipulated photographs.

Photography and information now share a common digital language. This paves the way for a brave new world of imaging with interactive books, instant news, and many previously undreamed of applications. The Gulf War was the first war to be pictured electronically — some of the most compelling images were produced by automatic video cameras attached to high-tech weapons. Is photojournalism no longer trustworthy? Is photography destined to be a source of information or an entertainment vehicle? Who owns a manipulated image? Will individual photographers benefit from image manipulation, or just a few industry giants? Who is morally responsible for the impressions and feelings evoked by an altered image? Who is legally responsible? We have yet to find out.

TELECOMMUNICATIONS

As we have seen, computers talk data and images over the telephone lines and over intraoffice networks. The technology that was invented to facilitate this process has given us two invaluable communication tools: the facsimile (fax) machine and e-mail. Fax machines incorporate low-resolution scanners for digitizing printed material. Incoming

information is turned into hard copy via a thermal printer using special paper. (Thermally activated paper fades in about six months but upscale fax machines use plain paper for permanent results.) Many units also provide a copy function. Fax machines with built-in answer-machine capabilities are becoming more and more common.

Computers can perform fax, e-mail, and voice-mail functions with the installation of a communications card. Documents can be received, stored in memory and then printed out, while word-processed document files can be transmitted to another fax machine or computer without the use of paper. Computer-fax technology requires a scanner for digitizing printed material: The only other approach is to type into your machine directly, but of course, this won't work with graphics or photographs.

In just a few years fax has become an indispensable link between photographer and client: Layouts are transmitted in seconds — bypassing expensive and time-consuming couriers — and Polaroid tests are faxed back. I communicate with my publishers almost exclusively by fax, which is just as fast but much cheaper than long-distance telephone calls.

E-mail is computer-to-computer keyboard-based communication. The link between computers can be a local office network or could be the Internet and the World Wide Web. I have an e-mail address that I hardly ever use. I prefer fax and the telephone. Others are addicted to e-mail and the instantaneous no-cost global connectivity that it provides.

Those of you who work in highly competitive markets may wish to reduce response time with other electronic communication devices. Cellular phones and pagers are highly portable and relatively inexpensive — away from the studio they replace the functions of a secretary or an answering service at a fraction of the cost. Personally, I have avoided these machines because I find them distracting and depersonalizing — but I freely admit that I have lost work and discouraged some potential clients because of this attitude. I rely on a remotely accessed answer machine and regular telephones when I'm away from the studio.

The Nuts & Bolts of Doing Business

GETTING STARTED

Before you hang out a shingle, I recommend you visit a lawyer and an accountant. These professionals will guide you through licensing regulations, sales tax rules, and the basics of recordkeeping. If you are about to expand an existing business, they will help you decide whether or not incorporation is necessary and recommend banks to approach if new financing is required. It is prudent to obtain their input on the details of any loan proposals as well.

Having consulted with legal, accounting, and banking experts you will be ready to start normal business operations. Money will be flowing in from your clients and out through the bank to suppliers — you will have to keep meticulous track of it. I suggest that early on you establish a regular and reliable record-keeping procedure. There are two choices: Pay someone to take care of the books on a monthly basis, or do it yourself. Either way, attend to it properly or your much needed concentration will be endlessly diverted by escalating paperwork.

If you elect to do the books on your own, the cheapest method is a "one-write" system. This is a clever arrangement of specially printed forms which use built-in carbon paper strips to make journal entries automatically as you write out checks and statements. You can find a supplier in the yellow pages of the phone book under "business forms." The sales rep will show you how to use the format that best suits your business. A more expensive but much more flexible alternative is a personal computer with accounting software. (Read more about this method in Chapter 7.)

COMMERCIAL CREDIT

Once established in business you will become both a user and a dispenser of commercial credit. After business gets busy, it will be difficult to personally run around buying all the things you need. Accounts at camera shops or photographic wholesalers will allow you to order by telephone materials which can then be delivered by the supplier or by courier if deadlines are tight. Such accounts may be opened easily provided you have decent references from a bank and a couple of other suppliers.

If you have not been in business long enough to have established a good credit rating, approach the credit manager of the store you want to deal with and explain the nature of your business and the amount of material you expect to use each month. You might show him or her the business plan you prepared for the bank, deleting some of the detailed financial information that only your banker should see. In most cases, you will be expected to buy what you need with cash for ninety days or so, and then an account will be opened on a trial basis. If you pay your bills on time (typically thirty days), credit will be extended on a permanent basis. Everything depends on your reliability.

Work to establish a mutually beneficial relationship with your suppliers. As long as you pay your bills you have a right to good service: Commercial photographers must often work to short deadlines so the appropriate photographic materials must be close at hand. Insist that suppliers keep your favorite films, papers, replacement lamps, and chemicals in stock and that they fill your orders promptly. They should be prepared to fly in special items occasionally. If you are having problems with one of your supplier's employees, let management know. Complain if the situation does not improve. It is considerate and sensible to keep your suppliers informed of what you are doing almost in the same way that you keep the bank informed. From time to time, send samples of your best work so that they can see what you make with the materials you buy from them.

Once you are using credit on a regular basis you will find that suppliers are much more flexible than banks when special circumstances arise. If you have a particularly large job coming up, they will often increase credit limits temporarily so that you can stock up with extra supplies or equipment. In tight circumstances they will allow debts to be paid off over several months, provided your previous track record has been very good.

CREDIT FOR YOUR CUSTOMERS

The main difference between commercial photography and portrait photography is that the clients of commercial photographers are always other businesses or professionals, whereas portrait photographers are almost always dealing with the general public. On average, the business community requires at least thirty days for the processing of invoices. If you expect to be paid in cash or with an instant check you just won't fit into the existing cycle. There is some pressure, therefore, to extend credit to anyone who asks for it, but it is unwise to do so. Even large, seemingly well-established firms can be in financial difficulty while still maintaining an appearance of solvency.

The way in which your suppliers manage credit can serve as a model when you extend credit to your clients. Ask for references when credit is requested or expected by new clients. If you feel it might be tacky to question a new client directly, don't be shy about doing a little research and calling up their suppliers. Commercial credit-rating agencies will provide detailed information for a reasonable price. If you can find out what bank they deal with, your own bank manager can determine what the general state of their affairs might be. This approach is especially helpful with new clients calling you from out of town. A credit check is not underhanded or dishonest: It is to everybody's best interest to weed out the bad apples as quickly as possible.

COLLECTING YOUR MONEY

When you are uncertain about a client and they are requesting services on a very large scale, to request a deposit as partial payment in advance — 20% of the estimated total billing is not unreasonable. Even a large corporation can understand that an independent small businessperson will need some guarantees when extraordinary expenses are expected to be incurred on their behalf. If they can't pay an advance they likely cannot pay at all.

In almost every case, once a healthy relationship with a reliable client has been established, you will find that the extension of credit is not a problem. Nevertheless, it is only prudent to keep track of your receivables with an eye open for early detection of trouble. You will find that each firm has a particular way of paying bills. Some pay on receipt

of invoice and expect a small discount, perhaps 2%, in exchange. This is not unreasonable. Others pay in fifteen to thirty days, and this is not unreasonable either. Sixty days is tolerable, but ninety days is, in my opinion, too long to wait for payment.

Many advertising agencies are notoriously slow. Because they handle huge amounts of money intended to pay for expensive magazine space, television time, or billboards, they get into the habit of holding on to their clients' money as long as possible in order to earn the interest that can be a substantial part of their income. The smart ones will pay their suppliers quickly, if only to guarantee good service. However, be warned that some agencies treat their suppliers in a very arrogant fashion and don't pay for sixty, ninety, or even one hundred and twenty days. You will have to decide for yourself if this is acceptable.

It is important to watch for changes in the way a client pays. If checks are beginning to take too long you are entitled to an explanation. Your flexibility when a client is tight for cash can earn long-term loyalty and a lot of repeat business, but trust your instincts: If a situation seems unstable or unsavory, protect yourself and insist on payment in advance or cash on delivery. Don't be intimidated by a possible loss of work — if they need you they will find the money. If they can't pay, the nicest job in the world is a waste of time.

Generally, impending insolvency is not the problem. There are firms who just habitually pay late or only after a phone inquiry. Invoices can go astray or sit forgotten on someone's desk waiting for an authorizing signature. Once in a while there will be a problem with the work you've done and the client will avoid calling: Your only clue will be the delay in payment. Also, checks do actually get lost in the mail occasionally.

The remedy for these problems is to maintain the attitude that after a job is done and the invoice sent out, that it is your money out there. Learn the name and the telephone extension number for the person in charge of accounts payable at each of the various firms you deal with. If there is an unusual delay in payment get on the phone. Politely but firmly press for payment or a good explanation and some acceptable alternative, such as two or three postdated checks.

Money Management

BORROWING MONEY

If you are good at photography and even moderately successful at making a business out of it, you will soon want to own your own working tools, some of which will be big-ticket items. It is likely that you will turn to a bank for financing. Unfortunately, looking for money from lending institutions is not a straightforward proposition in the case of commercial photography because the size of the required loans and the nature of the risks involved make involvement relatively unattractive for banks.

An institutional lender who is not approached properly may balk at taking on a photographer as a customer for several very understandable reasons. First, a banker sees commercial photographers primarily as professionals trading on their talents. But in such a technical field, talent is difficult to evaluate, especially in the case of a relative novice. Next, the cost of equipment will likely be somewhat more than the cost of a car and somewhat less than the cost of a house but, unlike the car or house, in the event of insolvency camera equipment is impossible to sell at anywhere near its original value. Another problem is the fact that the practice of commercial photography offers no income guarantees—billings can vary from zero to thousands of dollars per month in the most capricious fashion. Finally, a modest commercial photography business often requires several different types of bank involvement: long-term equipment loans, short-term money to cover one-time-only expenses for big jobs, as well as some kind of revolving line-of-credit supported by receivables.

All these loans might total under one hundred thousand dollars. This is smaller than the usual house mortgage and certainly much smaller than a typical startup loan for other types of businesses — both of which require significantly less paperwork to keep track of. Smallish loans that may require unprofitable amounts of time to administer squeeze photographers into a kind of credit gap: What the bank must provide is too complex to be a personal loan but too small and fussy to be a normal business loan. Fortunately, it is possible to overcome these negative factors using methods that are not in any way dishonest or even mysterious. It is simply necessary to learn how bankers think.

Three conditions must exist before a bank will enter into a credit agreement. These are the three "C's": character, capacity, and collateral. *Collateral* is equipment or property belonging to the borrower — the bank gets title and sells the collateral should the borrower default on repayment of the loan. *Capacity* is the borrower's financial ability to service the loan in an orderly way. *Character* refers to those aspects of personality that the bank considers necessary in its customers: honesty, reliability, and perseverance.

The loan-approval process is simply the bank's way of determining the existence and balance of character, capacity, and collateral in each potential borrower. When approaching a lender, it is important to have all the information they will require assembled ahead of time and close at hand. I recommend that a written proposal that takes all the bank's concerns into account be prepared as the first step in the search for financing. Even if you do not intend to borrow, making an appraisal of your financial circumstances just as a banker would do is a sensible beginning to any commercial enterprise.

Borrowing Criteria

The borrower's capacity to repay what has been borrowed is determined mathematically. A business incurs monthly expenses that are subtracted from the income generated by sales. What is left after loan payments is profit. Too much debt drains a business and makes life hard. If a bank loan is to provide money to buy equipment, it is necessary to prove that the equipment will generate more than enough money to repay the loan that bought it.

It is a paradox built into the capitalist system that to borrow money

when it is not required is easy. Demonstrating capacity takes some ingenuity when the need for a loan is real. The saving grace for commercial photographers in search of bank money is the impressive potential for profit. What distinguishes commercial photography from other businesses is the fact that the selling price of a photograph is not determined by the cost of production, as is the case with most manufactured items; instead, its value is linked to end use. A photograph that costs two hundred dollars to produce might be worth three hundred and fifty dollars if it is to appear in a local newspaper and could be worth five or even ten times that amount if it is to be used in a national magazine ad. In addition, because a commercial photographer is a highly skilled professional, as well as the manufacturer of a salable product, photographic services are often billed by the day or the hour rather than by the job. Even early on in a commercial photographer's career it is not unusual for fees to exceed those of legal or medical professionals. A few tear sheets or display prints of profitable assignments, along with a detailed accounting of expenses incurred and time spent, will go a long way toward reassuring a lender. Simple, but true.

It is to your advantage to supply documentation on other long-term commitments you have fulfilled. You may be seeking your very first business loan but don't be shy about listing any student loans, car loans, or mortgages that you have properly discharged.

Once convinced that the capacity to service a loan exists, the lender will require security in the form of collateral. This gives the bank some recourse in case of default; but viewed in more positive light, the bank is saying that by lending money it has become a partner in your business — it wants to see that you have made a commitment as well.

If you intend to start a commercial photography business you are an accomplished student, a very advanced amateur, or a professional photographer ready to expand. You will have already acquired some cameras, lenses, and possibly a lighting system. Now you need more. A bank will generally finance up to 50% of the cost of new professional equipment if the equipment itself is the only collateral. That leaves the other 50% for you to find on your own. The bank will go farther if you can put up more security. Equipment you already own may be acceptable, as will real estate or a vehicle that is free and clear of any other encumbrances. It is the responsibility of the borrower to protect everything given as collateral by insurance.

Tying up assets might appear a bit grim, but remember that the rewards of the entrepreneurial system are offered only to creative people who extend themselves; you must take some risks in order to grow. In this regard the conservatism of banks is sometimes perceived as an impediment to growth, but forcing every credit decision through a bureaucratic review is a prudent counterbalance against the possibility of overextension.

BORROWING TECHNIQUES

Proving capacity and arranging for collateral should be a pragmatic, nononsense procedure. While you make your pitch, however, another sort of evaluation will be going on at a more subtle level. Any long-term business relationship involves trust, so you must demonstrate that you are reliable and hard working as well as highly skilled. If you get into difficult circumstances your banker will make decisions that could have profound effects on your family and your future: his or her impressions of your character could be the critical factor if the financial conditions are marginal or unpredictable.

In almost every case the banker will make a judgment on these matters independently, that is to say without requiring letters of reference or approval by his or her superiors. As an aspiring commercial photographer you are already preselected to be intelligent, creative, and sensitive. Hopefully you are honest as well. Your only concern, therefore, is to be clear about what you want, straightforward in presenting your circumstances, and candid in response to any questions.

The physical format of the loan proposal need not be elaborate to be effective. Obtain an attractive three-ring binder (the kind with smaller rings is best), as well as some stiff divider pages with index tabs. Make typewritten labels for each of the following topics: education, work experience, credit history, business rationale, financial statements and tax records, net worth, awards and public recognition, community service activities, marketing plan, loan requirements, and examples of commercial work.

After gathering all the appropriate data, write in very plain language a short, concise, dissertation on each of the topics listed above. Be honest but not modest. If you can afford it, now is the time to obtain a few hundred sheets of quality stationery with a contemporary letterhead

imprinted on it. It is a conceit of many commercial photographers that they are natural designers, but my advice is to approach a real graphic artist or designer and have a suitable letterhead created. If money is a problem offer an exchange of services. Type what you have written on the stationery and perforate the left-hand margin with a three-hole punch for insertion into the binder.

Under education list your academic training, mentioning specifically any diplomas, degrees, awards, or honors that you earned. A letter of recommendation from a favorite teacher or professor is also helpful. If you are self-taught or didn't excel academically then use this section to list your work experience and include copies of letters of reference from former employers. If you assisted an established photographer, include samples or at least a listing of any of his or her work that you participated in producing. A few remarks relating your previous work experience to the plans for your own business could serve as a conclusion.

Your credit history is a record of what you have borrowed in the past and how you disposed of the debt. Be as detailed as possible. If you are switching banks because of a change of location and had a good relationship with your former banker, a letter of reference should be appended. If you are switching banks for some other reason, for example the loan officer with whom you had a good relationship was transferred or retired, a brief explanation of the circumstances is necessary.

A business rationale is simply a statement of the goals, intentions, and methods involved in creating and running your particular business. Describe the market you will be catering to and why your expertise is salable. A short-term projection of earnings and expenses together with medium-range projections of capital spending is appropriate here. Don't be effusive. Remember that banks want imaginative, but very pragmatic customers.

If you are already established as a commercial photographer or have been involved in a related business such as portrait or wedding photography, insert copies of your financial statements and tax returns going back at least two years.

Your net worth is the value of your assets less the amount of your debt. On a sheet of paper make a list of everything you own such as cars, cameras, house, and furniture. Indicate the fair market value of each item. Total those figures. List and add together all your debts including car loans, mortgages, and credit cards. Be completely frank:

Bankers take a very dim view of undisclosed debt. Subtracting the debt total from the total value of your assets yields your net worth. It doesn't have to be a large number, just a positive one.

If you are good at photography, you have likely won some awards or contests. If you are in business you can list awards your clients have won for projects in which your work was included. For example, if you photographed a building for an architect, and that building later won a design award, you could add that award to your list with a footnote explaining that the architect's winning entry was illustrated with your photographs.

It is a wholesome gesture to offer some of your time and services to community institutions and service groups. On a professional level, such work is often a central component of highly visible campaigns so your volunteer efforts benefit yourself at the same time that they benefit others.

A marketing plan is the map of your method of entry into the commercial marketplace. A strategy for selling your services could include direct mail of specially prepared samples, cold calls to art directors and corporate marketing people, or even a contra arrangement with local magazines for advertising space. Whatever your approach, it should be logical and specific to your skills.

Describe in exact detail what loans you are seeking and to what purpose they will be applied. A projection of the positive impact that the money will have on your income is obligatory and so is a proposal for a manageable repayment schedule and sufficient security. A description of your existing life insurance program and an indication of your willingness to buy more should it be necessary to further secure the loan is also appropriate.

Finally, get some first-rate examples of your best work made up in 8½" x 11" format and have them laminated and punched for insertion into your book. Reproductions of actual magazine ads, billboards, or editorial layouts that feature your photographs are very effective. Be sure to include some enlargements made directly from your original negatives or transparencies; most people have never seen commercial photography close up and are very strongly impressed by carefully made first-generation prints.

After taking the trouble to put together a professional presentation, shop around. Just like you, banks provide a service at a price and their market is as competitive as yours. Look for flexibility, decent rates, and

a loan officer who displays appreciation for your patronage and respect for your work; the day of the stern, paternalistic banker is long past. People who are overly eager to obtain much needed cash often leap at the first deal offered, forgetting that they are entering a long-term relationship with implications that extend far into the future. You have an obligation to yourself to ensure that any banker you deal with is empathetic, conscientious, and fair.

MAINTAINING GOOD RELATIONS WITH YOUR BANKER

Once you have entered into a satisfactory long-term arrangement with a financial institution, every effort should be made to take care of your obligations exactly as described in your agreement. If you have established a revolving line of credit based on receivables, you will be required to provide a monthly statement of both receivables and payables; from this information the banker can gauge the health of your business. However, if business has been flowing smoothly for some time, the monthly statements will get filed without a careful look, and the relationship that you worked so hard to establish might become a little distant. This is not a problem as long as no changes are required and times are good; however if conditions do fluctuate and you have to renegotiate, a lot of energy and time will be wasted re-establishing contact.

I recommend that from the start you consider your banker as a silent partner and keep him or her informed of what is happening in your business. If you elect to use direct mail or magazine ads as promotional tools, make sure that samples get to the bank, along with a brief note listing new clients or interesting projects that the sales efforts attracted. Similarly, from time to time inform the bank of awards you win or community service work that you have undertaken. It is not inappropriate to invite your banker over to your studio when you're shooting so that he or she can develop a mental image of what you do and how you do it. Remember that commercial photography is a glamorous and mysterious business to outsiders.

The bank should be apprised of bad news as well as good news. For example, if a client of yours goes bankrupt and leaves behind a bad debt or if a market sector you serve declines, let the bank know how your

business has been affected and what countermeasures you are taking. By maintaining an ongoing relationship with your bank, it will be much easier to negotiate new loans for expansion. If sudden misfortune should strike, you will receive a much more sympathetic hearing and a more generous accommodation.

If your first loan proposal does not satisfy any banks, you will have to look for money privately. This is not at all unusual for an entrepreneur just starting out. If you decide to approach a relative or friend, they deserve the same business-like attitude that you would bring to negotiations with an institutional lender.

TAXES

If you are in business to make money, the government has an interest in your success. That is to say, a portion of your profits are not yours, but are actually funds collected and held in trust on behalf of your fellow citizens, and they must be submitted at prescribed intervals to the city, state, and federal agencies that are empowered to collect them.

Of all the creditors you may have, governments are the most powerful and the most intractable. All matters relating to taxes require your constant, scrupulous attention.

Recordkeeping

You need to maintain clear, current, and accurate records of all your financial transactions relating to business. You should have a separate business checking account. Mark the date, the recipient, and the purpose of each payment on the check stubs. Keep a daily list of expenses and retain receipts for every item. If you obtain a Taxpayer Identification Number from your city or state sales tax bureaus, some of your materials and equipment can be purchased sales-tax free, but you must also collect sales taxes from your customers. You are liable for these taxes even if you neglect to collect them from your clients.

Deductions

The IRS considers a business legitimate if it makes a profit three out of five years or if the photographer can prove that the business is run

according to the profit motive, as defined in the tax guidelines.

Current expenses such as rent, utilities, postage, and office materials can be deducted from income for purposes of tax calculation. Materials consumed to manufacture photographs, such as film and chemicals, are legitimate deductions. Travel necessary for business is fully deductible, whereas expenses for meals incurred while traveling for business are 80% deductible. Entertainment expenses relating to business are also deductible at 80%. Commissions paid to agents or representatives, professional fees paid to lawyers and accountants, and salaries paid to full- or part-time employees are deductible, with some restrictions. Grants, fellowships, and scholarships are tax-free provided they are related to furthering your professional education. Charitable donations are treated differently in different states. A capital expense such as a vehicle or a piece of photographic equipment that has a useful life of longer than one year is deductible, but the cost must be amortized (depreciated) over several years.

If part of your home is "used exclusively on a regular basis as a principal place of business" then a portion of your mortgage interest and other expenses can be legitimately deducted.

Income taxes can be reduced in a couple of ways. You can arrange for payments for large projects to be paid in installments, over two or more tax years. You can also spread your income among family members as long as certain conditions are met. For example, salaries paid to children must be related to work that is appropriate and reasonable to the child's age and that is actually done by the child for your business.

All tax matters are, of course, carefully scrutinized by the IRS, so obtain professional advice in order to optimize your position.

INSURANCE

There are potential financial liabilities associated with running a business that can extend far beyond the resources of most ordinary people. Capitalism responded to this risk by inventing insurance, a system that pools relatively modest monthly or yearly cash contributions (premiums) from large numbers of individuals into big pools of cash, which in turn are distributed back to a few individuals in relatively large lump payments according to certain conditions. All of us are in some degree of denial about the possibility of illness, crime, financial difficulties, or

even death, so we tend to procrastinate about our personal need for insurance of various kinds. This is a big mistake.

Insurance can protect against unforeseen expenses related to loss or damage to equipment, buildings, or vehicles that we own, as well as loss or damage to property that we do not own. Real property can be protected by fire, theft, and auto insurance, and possibly *bailee* insurance, which covers the property of others — such as props and rental equipment — that might be in our possession temporarily. Negatives and prints can be protected by valuable papers insurance. Liability insurance protects us against loss or damage sustained by other persons or their property on our premises or during the course of our business activities elsewhere. Nonperformance or malpractice insurance protects against claims from deeply unsatisfied customers. Life and disability insurance compensate our families or ourselves in the case of death, serious injury, or a long-term illness.

Insurance packages purchased through professional groups, such as the Association of Magazine Photographers, are much less expensive than policies purchased by individuals through insurance brokers. Individual programs, however, can be more carefully tailored to specific needs. Because insurance policies vary widely in terms and conditions, it is wise to seek advice from insurance experts who are familiar with the needs of commercial photographers. If such a person cannot be found, try to locate someone who serves the film or entertainment industry. (Good housekeeping and the installation of sprinklers, alarms, steel doors, window bars, safes, and security cupboards all help reduce insurance costs.)

When buying insurance it is the responsibility of the insured to completely disclose any pertinent facts that could affect coverage, such as business practices, preexisting disease, and the type, condition, and value of equipment or buildings.

If a claim is made, the insured must prove that a loss has occurred, that the loss is covered by the policy, that the insured has a legal interest in the loss, and that the policy was in force at the time of the loss. It is also the responsibility of the insured to demonstrate the value of the insured item or injury at the time of the loss and to promptly inform the insurer that the loss or injury has occurred.

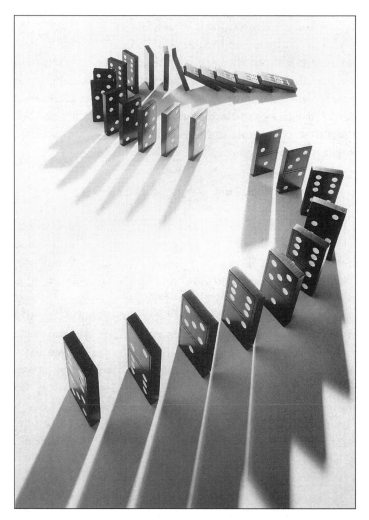

Figure 9.1

Something Missing in Your Financial Planning? That was the cutline in the ad for which this image was created. These oversized dominoes were custom-made of aluminum for use in a TV commercial and were passed on to me for still photography. Careful placement and hard lighting created shadows that lead the eye to the metaphorically important gap in the chain. (*ToyoView 45G/150mm lens/Kodak VPS film.*)

If all the above conditions have been met, it is the responsibility of the insurer to pay the claim according to the conditions of the policy. One significant consideration: It is sad, but true, that aside from the loss of goodwill, it is to the insurers' financial advantage to delay payment of what might otherwise be a perfectly legitimate claim as long as possible. For this reason it is absolutely necessary to obtain personal recommendations and references from satisfied clients before placing your business with a particular insurance company or insurance broker. If you feel that you are being stonewalled in the event of a claim, talk to a lawyer immediately.

PLANNING FOR RETIREMENT

The artistic temperament often shuns money talk and financial planning. However, by following the suggestions outlined in this book, you will likely be able to make a decent living as a commercial photographer. Making a decent living, however, is not the same as providing for a comfortable old age.

To live well in retirement requires sufficient savings (capital) to generate an interest income that will sustain the lifestyle you want. Here are two simple rules that will point you toward a secure financial future: First, pay yourself. Start saving a portion of your earnings, perhaps 10% of your gross income—although no amount is too small —every month, month in and month out. Second, start early. Don't waste time. Compound interest is a powerful mechanism, and the earlier you start the greater the rewards. *Talk to a reputable financial advisor right now!*

You Don't Have to Be Alone

As your work increases in intensity and sophistication the need will arise for outside help in several areas, some of which may not seem at first to be directly related to photography. It will become necessary to find skilled, reliable, and discreet people whose expertise is available on a part-time basis at short notice. This kind of help is not easy to locate in the phone book, and your competitors may be too self-involved or too insecure to reveal their own resources. In smaller centers those few people who possess the specialized abilities commercial photographers are willing to pay for may not even exist as "professionals" so the search becomes even more difficult.

THE PHOTOGRAPHER'S ASSISTANT

After a certain point in the development of a photographer it is no longer necessary or possible to take care of everything personally. One of the first signs of overwork is a feeling of dread associated with big location assignments: The money and the job might be great but the thought of packing, transporting, then repacking and retransporting all that heavy gear just does not appeal. It is absolutely delightful to walk into a location shoot to find that equipment and props and models have all been organized ahead of time.

An assistant can be a full-time right-hand person, but early on such a costly solution is overkill. It is likely that a part-time assistant will be able to provide all the support needed without straining the

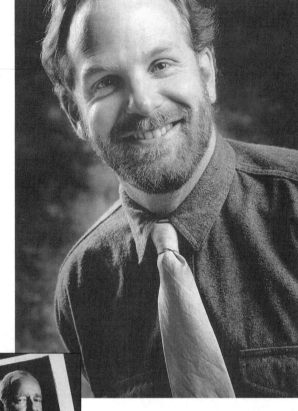

Figure 10.1
A client in a hurry required wholesome-looking working guys for a corporate brochure. My assistant, Bruce Spielman, was close at hand. He received fifty dollars for his trouble. The project, entirely peopled with nonprofessional models, recently won an award for best corporate brochure at an advertising industry competition. (*Mamiya 645 Super/ 150mm lens/Ilford FP4 film/Electronic flash.*)

Figure 10.2
This is a two page spread from the award winning brochure mentioned above. The man shown here is a local courier driver.

budget, assuming you can find someone with a flexible schedule who is enthusiastic, intelligent, physically fit, and interested in photography. The perfect assistant might actually be an underemployed photographer. In big cities one route by which such people begin a career is to work for more established professionals. Of course, there are some drawbacks to training your own competition, but in a part-time situation these are outweighed by the conveniences of working with a helper who is already familiar with the territory. Suppliers of professional

photographic equipment and materials usually know who might be in a position to assist a busy pro, and if they don't they'll post a notice. (Sometimes people who work for camera stores are interested in assisting, as well.) If this doesn't work, place an ad in the "cameras for sale" section of your local newspaper's classified ads. Wages are negotiable but for experienced assistants you can expect to pay between seventy-five and one hundred fifty dollars per day.

If you are prepared to invest some time teaching an enthusiastic tyro look for a willing photography student at a technical school or in the fine arts faculty at a university. Most beginners will be satisfied with minimum wage. Although previous experience in photography is desirable, it is not a necessity. One of my assistants is a rock musician by night.

Any assistant, whether experienced or inexperienced, will expect to be taught exactly what you want him or her to do. Everything from how to answer the phone to how to sweep the floor to how to load film should be described in painstaking detail at least once, and possibly twice — three times is likely a waste of time. After the equivalent of seven working days a promising assistant will start anticipating your needs, and you will begin to feel a lessening of the stress which compelled you to find an assistant.

MESSENGERS & COURIERS

Many photographers assume that their time is not worth anything when they're not behind a camera, though it really does not make any sense to charge big bucks to shoot fancy pictures and then run around doing errands for nothing. Your clients will recognize that your time is valuable and will not object to reasonable charges for pick up of layouts, props, and finished work. If they do object, the actual costs for these services are so low that they can be discretely folded into other fees. From time to time it will make political sense for you to personally deliver a finished job, but most often this will not be the case.

The packages that messengers move around have to reach their assigned destinations quickly. There is a lot of competition in this field, so don't be shy about switching around until you find a service that you can trust completely. Dispatchers and drivers must understand that your reputation and their incomes depend on always meeting deadlines.

Couriers that fly between urban centers are usually more professional and better organized than local messengers. Nevertheless, when you ship something to another city or when you are expecting something to arrive from another city make a note of the waybill number of the package to facilitate tracing in case of a mix-up. A timely phone call to your client to confirm delivery is prudent practice as well. Federal Express provides a free software package that allows real-time tracking of your packages via any modem-equipped computer.

HAIR, MAKEUP, & CLOTHING STYLISTS

Any sophisticated people photographs, from executive portraits to fashion layouts, can be enhanced by the skills of hair, makeup, and clothing stylists. These people know what looks appropriate according to current tastes. They work with faces and bodies the same way you do with lighting and props. Hair and makeup specialists can sometimes be located through the yellow pages or through friends who frequent trendy hair salons. Fashion stylists are even more difficult to track down. If another photographer will not or cannot recommend a competent professional try looking in the yellow pages under "fashion consultant." Sometimes the owner or buyer at a high-profile clothing store will be interested in freelancing for cash or in exchange for your services. Local newspapers or magazines often have fashion sections: The editors or writers may be willing to work for you or suggest someone who will. In a pinch, a friend or acquaintance whom you know to have a highly developed fashion sense can be enlisted.

Professional stylists with skills more specific to commercial photography often work for television stations as well as film, regional theater, and opera companies. A few diplomatic phone calls might put you in touch with a wealth of talent. Rates vary upwards from about twenty dollars per hour to as much as one hundred dollars, according to experience and ability and the nature of the job at hand. Recordkeeping is simplified if these people bill your clients directly, although some photographers prefer to submit a single all-inclusive bill, perhaps marking-up stylists' fees by 10% or 20%.

Hair and makeup stylists carry a supply of specialized tools and potions. They appreciate the provision of a more or less private workspace equipped with a shelf — mounted at waist height, at least two

feet by three feet—as well as a high, comfortable chair, one or two large wall-mounted mirrors, and ample nonfluorescent lighting. A handsink and a supply of soft paper towels are also required.

Stylists will be working quite intimately with the people in your pictures, consequently their behavior on the set is just as important as their professional skills. If the person responsible for makeup or hair is cheerful and friendly they will play a valuable role in establishing a relaxed atmosphere in the studio. You cannot afford to hire either a wimp or a prima donna, regardless of how talented they might be.

When discussing a job with a stylist be very clear about what look you want for your pictures. If possible, show sample photographs to illustrate precisely what you want. Tell the stylists ahead of time what type of light (i.e. hard, soft, tungsten, electronic flash) you will be using, what the color scheme of the shot will be, as well as what kind of skin and hair the model has. If you are expecting the makeup stylist to deal with serious blemishes or to produce special effects (such as a black eye), discuss it beforehand so that any unusual supplies can be obtained in good time. For high-profile, high-budget jobs stylists should be invited to attend a planning meeting or strategy conference with your client so that all expectations can be described.

PROP MAKERS, PROP FINDERS, & SET DESIGNERS

It is often necessary to find or fabricate artifacts and sets called for by creative directors and designers. Many photographers have the good taste and the knowledge of both materials and techniques that are fundamental to this work, but they do not always have enough time to properly follow through.

It takes a tenacious personality to rent, buy, or construct all the unlikely items that are necessary to help create convincing illusions. Such people are often employed as freelance prop masters and scenic artists for television stations involved in dramatic productions, in the feature-film industry, in live theater, or as window-dressers for big stores. They will take on projects for photographers between regular jobs or after hours. Charges are surprisingly reasonable since they are regularly compelled to work with very tight budgets. Again, it is desirable to have them bill your clients directly.

If large or complicated sets are involved, be prepared to allow the

scenic artist access to your studio after hours or on weekends. Typical building materials such as plywood, plaster of Paris, and foam-core board should be on hand. Give the prop maker or prop finder a supply of your business cards (or your client's business cards) and a letter of reference to make it easier for him or her to approach potential lenders or renters of needed props. It is considerate and reasonable to provide sufficient cash in advance to cover at least half of the expenses that are expected to be incurred on your behalf.

For complex jobs the props person should be involved early in the planning stages so that critical elements may be acquired or assembled without having to rush.

RETOUCH ARTISTS

There are definite limits to photographic technology and when those limits are reached the retouch artist takes over. Production managers and creative directors at advertising agencies, the people at large department stores who are responsible for flyers and catalogs, as well as high-profile commercial and portrait photographers will know where to find competent professional retouchers.

Inform your client that retouching will be necessary whenever you believe that the required image cannot be achieved with photographic techniques alone — this is best done before accepting the assignment so that the cost of image enhancement can be clearly identified as being the responsibility of the client. Unfortunately, it is not always possible to recognize technically troublesome jobs ahead of time, so the retoucher is sometimes called on to avert or mitigate a disaster in progress: In this scenario it is not always obvious who must pay the repair bill. A photographer is certainly responsible for his or her errors or lack of judgment, but clients sometimes inadvertently or deliberately misrepresent the parameters of a tricky project, in which case some intense — but diplomatic — discussions are called for.

Computers have diminished the traditional role of paint, dye, and airbrush techniques, but not the traditional role of the patient and meticulous retouch artist—even those photographers fluent in *Photoshop* will have to defer to the experts from time to time.

Here are some common photographic problems that may be solved with the help of a retoucher:

1. Replacing a gray sky with blue when an exterior must be shot in poor weather.

2. Eliminating unwanted elements that cannot be avoided any other way such as reflections, cluttered backgrounds, facial blemishes, or flaws from damaged negatives.

3. Restoring the lost edges of light colored objects photographed on white backgrounds.

4. Superimposing two or more images that were made at different times or locations.

5. Adding new elements to existing photographs.

THE FOOD STYLIST

Sooner or later all commercial photographers are asked to shoot food. It is both prudent and efficient to hire an expert to help cope with all the hassle of finding the ingredients, preparing the dishes, and displaying the results in an attractive and original way. Professional photographic food stylists are few and far between but independent film production companies often shoot commercials for restaurants, hotels, and food manufacturers and generally they will know of someone local who works with food. A really first-rate job with a decent budget may warrant flying in a specialist from out of town. Head chefs at fancy restaurants and hotels are often capable of good work in the studio, as are home economists and recipe testers from agricultural marketing boards and co-ops.

In Chapter 12 I describe my own kitchen arrangements. Food stylists need to know in advance what their working conditions will be. Many foods can be prepared elsewhere and then brought to the studio to be photographed, whereas some dishes must be created on the spot. Have the stylist look over your facilities and work out a practical strategy in detail. Most photographs of food have to be done fairly quickly so that everything looks fresh. If the job warrants the extra effort, commercial food preparation equipment or even complete kitchens can be rented.

COLOR LABS

If you don't maintain a darkroom the professional custom lab will be your most important supplier. To be of use to a busy photographer the lab must be technically reliable and flexible enough to accommodate tight deadlines. After a reasonable period of familiarization, the lab should consistently produce custom prints with the density and color you like.

If you are being well served by your lab, let them know. Pay your bills on time and allow them the use of your best shots for self-promotion. If your lab is not performing up to par, find out why. Technical problems or poor service at the counter should be brought to the attention of the manager. If he or she cannot offer any remedy, change labs. If there is only one custom lab in town you might call up the local Kodak technical representative (often the processor's exclusive supplier) who will likely pressure the lab to improve performance, hopefully without mentioning your name. If that doesn't work, locate an advanced amateur or a pro with his or her own color darkroom who might be willing to take care of you. If that doesn't work, reread Chapters 20 and 21.

CAMERA & COMPUTER REPAIR

Anyone who relies on technological tools to earn a living is automatically dependent on a small army of repair and maintenance specialists. The problem is that in this age of globalization the locus of competent technical assistance is often hundreds or thousands of miles away from the point of personal need. Federal Express and "1-800" numbers go part of the way toward damage control, but working professionals typically need help right now, not overnight or next week. It is wise to prepare for the inevitable crunch by cultivating local suppliers.

I bought my first computer in 1984 — an 8-bit, CPM-based Kaypro 10. It was also the first computer ever sold by my friend Nathan Zassman, who was at the time the principal trombonist for the Winnipeg Symphony Orchestra and a computer geek of the highest order. Since then I have purchased several more computers from Nathan, and Nathan has given up the Symphony to properly attend to his thriving computer consulting and sales business.

I run my business the same way Nathan runs his…lots of personal attention, long term and short term, as demanded by the particular circumstances. We price the same way, too…higher than the mail-order gunslingers, but flexible, as demanded by the particular circumstances. We both offer loyalty and support for clients and suppliers alike. The central myth of Internet thinking is that trust can be cultivated via keyboards linked over the phone lines, but the truth is that building reliable business relationships takes time, effort, and unrelenting good intentions.

MAINTAINING GOOD RELATIONS

Everyone wants to be appreciated. It is a simple matter to make sure that samples of your work get to all the people who helped you produce it. They will have something valuable with which to sell their own skills plus the good feeling that comes when they've done well.

Finding Affordable & Functional Equipment

HOW TO DETERMINE WHAT YOU REALLY NEED

Choosing sophisticated tools with which to undertake the craft of commercial photography involves a delicate tradeoff among simplicity, speed of operation, and cost. The irresistible temptation is to acquire the most modern toys available, despite their heavy prices, while clinging to the rationale that the investment will be recouped through increased productivity. Sometimes this actually proves to be true, but more often it is not. Careful, creative photographers usually find that in most instances technological restraint coupled with photographic cleverness permits the creation of a highly salable product, so long as certain basic requirements are met.

The first step in acquiring tools should be an analysis of the nature of the work you intend to do. If you specialize right from the beginning the selection process is straightforward and the mix of tools immediately apparent. For example, someone who is interested specifically in editorial work or photographing the performing arts needs a good 35mm outfit and two or three decent electronic flash units with appropriate reflectors. However, in more general commercial photography practice things aren't so simple. If your expectation is to be involved in advertising illustration, public relations, or audiovisual work, plus some corporate annual report or industrial photography, then the selection and acquisition of equipment is a complicated and costly exercise. Most beginners are uncertain of what constitutes the necessities and this uncertainty is typically accompanied by the impulse to buy too much stuff.

Be brutally realistic and suppress the urge to buy equipment in anticipation of work that you hope will come your way. This means that in the early stages of your business, discipline yourself to use whatever tools you already own to complete your assignments. When you reach the limits of your equipment, rent or borrow. After a few cycles of working in this manner it will become very clear what are, and what are not, necessities.

NEW OR USED?

Avoid buying anything new, at least at the beginning of your career. Good used equipment is easy to find in any city. By concentrating on preowned tools you will automatically eliminate two odious traps: (1) the very latest whiz-bang gadgets will not be readily available second-hand, so you cannot be seduced by the newest or the fanciest toys until they have been extensively field-tested and their value has been well proved and (2) selecting used goods over new goods will help you keep some distance from the cult of equipment, that sad group of materialistic photographers who substitute flashy machinery for good work.

HOW & WHERE TO BUY

Shopping for good used equipment takes a little longer than simply plunking down big dollars at the local professional supply house. Still, you should visit the camera stores in your area to see what they have accepted as trade-ins. This equipment will likely have been mechanically refurbished, or at least inspected, before being offered for sale, and will usually be covered by a thirty-, sixty-, or ninety-day guarantee. Expect prices to be about 50% less than new goods.

Classified ads placed by individuals in local newspapers and photographic magazines are another source. Prices will be lower than those typical over the counter at the retail stores, but expect no guarantees of any kind. Usually a vendor will be willing to allow you to run off a quick roll of film. A small deposit will hold the item while the tests are developed and examined. After a few transactions of this sort you will become an expert at recognizing signs of abuse, such as interior dirt, loose or scratched lens elements, as well as sloppy or nonfunctional controls. Expensive items that you find attractive should be checked

out by a competent service technician. Happily, most people who own professional level photo gear are very careful with it.

Specialty items are available used through the multipage advertisements placed in the big photography magazines by mail-order houses. I have purchased both new and used equipment over the telephone and have always found the service to be quick and honest. Warranty repairs are a pain in the neck, since whatever needs to be fixed must be shipped back and forth across the country. Nevertheless, good prices and the proliferation of overnight courier services make this less of a chore than it used to be. (Some suppliers very graciously pay for local repairs during the warranty period on receipt of an invoice. Check this option out before you buy.)

Finally, there is good reason to buy at least some of your equipment new over the counter at your local supplier. Everyone lives in a community, and a community requires local participation in order to flourish. As a local businessperson yourself, it is sensible to patronize other local businesses to ensure a healthy microeconomy and general goodwill. Mutual support is insurance against those stressful times when extended credit or an emergency equipment loan can forestall disaster. As regards prices, local merchants are sensitive to competitive pressures from the national chains and mail-order suppliers. Although local retailers cannot match deep-discount prices because of higher overhead and lower volumes, a little good-natured bargaining will often save 5 to 15%. Sometimes contra agreements can be negotiated that trade photographic services, testimonials, or in-store workshops for more substantial reductions. It never hurts to ask.

UNUSUAL & HARD-TO-FIND SOURCES

I enjoy the process of acquiring new tools whenever I have time, money, and a good idea where the equipment I want can be obtained. However, searching for some necessary item when resources and suppliers are scarce used to be something of a chore, particularly with a deadline looming.

Big manufacturers have refined a practice called *just-in-time delivery* of needed parts and materials as a way of reducing the costs associated with warehousing large inventories. These companies stay in close touch with suppliers, so that needed items can be shipped just in time

to arrive at crucial stages in the assembly process. Small manufacturers — like commercial photographers — benefit from the fact that the same overnight couriers and telecommunications that have appeared to facilitate just-in-time practices are also available to us for relatively reasonable rates. These resources provide easy access to a wonderfully wide range of materials and equipment that once required laboring through a maze of retailers and dealers. *Photo District News, Shutterbug* magazine, and a host of other photo-related publications are full of ads for all sorts of businesses and individuals who trade in the specialized items and services that we need. E-mail, fax, and toll-free telephone numbers permit quick access, while Federal Express and its competitors allow quick delivery.

Photography is an engaging combination of art and science, low-tech and high-tech, traditional and cutting edge. The people who are attracted to this field are often intelligent and deeply involved with the craft. Virtually every contact I have made while searching for some hard-to-find photo-related item has resulted in an enjoyable encounter with a being who is just as obsessed and eccentric as myself. A recent experience: I needed a 140mm condenser for a 1970s vintage Durst 5"x 7" enlarger that I was rebuilding to make enlarged gang-proofs from 35mm negatives — a two-line ad in the back of *Shutterbug* led me to Terry Seaman (217-359-2006), a cheerful and wonderfully knowledgeable private dealer of all things related to the darkroom. He had the item in stock and shipped it to me overnight for approval even before we exchanged credit-card information.

LARGE-FORMAT MYTHOLOGY

Large-format systems generate higher quality results than smaller formats, so long as variables such as light levels and subject movement are well controlled. This fact is sufficient incentive to propel the beginner into the camera store. Large-format camera systems cost more to acquire and operate than do small-format systems. This fact is often sufficient incentive to propel the beginner to the bank.

For most commercial purposes, I believe that cameras 4"x 5" or larger can be bypassed in favor of medium format, or even 35mm format, provided the best of modern films are used in conjunction with the techniques described in Chapter 14. This contradicts the popular

mythology that would have a typical commercial studio equipped with a comprehensive arsenal from all three formats. In this day and age, it is only the extensive perspective controls of view cameras that make them technically irreplaceable for certain specialized tasks. Unless you have a special interest and a ready market in architectural photography or very sophisticated product photography, delay the investment in large-format equipment as long as possible.

When the need becomes real, the focus and perspective controls needed for product work can be had relatively cheaply. Large-format systems are typically modular in construction. The basic camera consists of a monorail, two standards — one for the focusing ground-glass/film back and one for the lensboard — and a light-proof bellows to connect them. You will need a few sheet film holders and a lens of about 250mm focal length with sufficient coverage to permit the necessary movements. A Polaroid back is a tremendous help, as well. This setup will take care of more than 90% of large-format studio work. Those who venture outside the studio will need a 90mm wide-angle lens and a polarizing filter. Later it will be useful to add lenses of shorter (65mm or 75mm) and possibly longer (150mm and 360mm) focal lengths.

When the time comes, it makes sense to choose lenses made by the same manufacturer so that characteristics such as color transmission and contrast are consistent, although this is not in any way an absolute necessity. Only those who end up devoting most of their career to super-quality large-format shooting will invest in one of the upscale view camera systems and a complete set of matched lenses.

THE TRUTH ABOUT AUTOMATION

We live in a world revolutionized by electronics. Cameras have not escaped. Auto-film indexing, auto-focus, auto-exposure, and automatic fill-flash are common in cameras of all price ranges. There are two advantages to these remarkable developments that benefit the aspiring commercial photographer. First, the new cameras have displaced many excellent nonautomatic mechanical cameras so these older machines are now readily available second-hand. Second, the prices of older cameras have been significantly lowered because of the influx of the automatics.

I used to believe that automation had no role to play in commercial work. Consider the following: Cameras that focus and determine exposure all by themselves can speed up work in fast-breaking situations, such as those found in photojournalism or other documentary pursuits, but in almost every other circumstance there is plenty of time to think before shooting. Commercial photography is, at the core, an exercise in control. Control is based on sober thinking. Machines think, in a way. But machine thoughts are not necessarily a viable substitute for human thoughts, at least for photographic professionals.

There are problems associated with each type of automation. For example, auto-exposure cameras will do a decent job of estimating an appropriate setting for each frame exposed. In commercial work the basic exposure situation usually remains the same throughout the shoot, although the framing will be slightly different. However, as the framing changes, automatic cameras will compensate with small exposure adjustments. This is not a problem when the film is to be printed by another automatic machine. Unfortunately, in the nonautomatic darkroom each frame will have to be tested individually before being printed: This is very time-consuming and makes the creation of a set of matched prints difficult because color balance and contrast can change subtly with exposure changes. Contact proof sheets made from film shot with auto-exposure cameras look unprofessional, because every frame has a slightly different density. Similarly, auto-indexing cameras preclude adjusting film speed for personalized exposure indices, and auto-focus cameras sometimes react too slowly or simply pick the wrong subject.

It is for these reasons that one should use automation judiciously, rather than avoid it altogether. If auto-focus is inaccurate in 10% of shooting situations, it is wonderfully fast and convenient 90% of the time. Rapid-fire auto-bracketing for transparencies is irresistible. So is remote-control off-camera auto-flash.

EQUIPMENT MODIFICATIONS

Professionals use their tools so much that they become intimately aware of design flaws or any features that inhibit their personal working style. Some shortcomings are simply immutable aspects of the basic construction and must be tolerated; however other deficiencies

are easily corrected with the resulting benefit being greater efficiency and enjoyment on the job. Consider these examples.

My Nikon F3 came from the factory with a manually operated momentary-contact switch to turn on a miniature incandescent lamp that in turn illuminated the liquid-crystal exposure readout and the f-stop numbers on the lens barrel. Since I have a number of clients in the performing arts, I often find myself shooting in dark surroundings. Constantly depressing the switch became a real inconvenience, so I had a technician bypass the switch entirely and rewire the camera so that the viewfinder was illuminated whenever the camera was on. (Energy drain was not a problem with the motor-drive battery pack.) This was a simple and inexpensive change, but it saved lots of aggravation.

The fragile, finicky PC (this is an archaic term that means post connector) terminal is a vestigial relic of fifty-year-old photographic technology and a constant source of frustration. The Nikon/Minolta screw-type PC connector solves some of the problems by providing a secure mechanical connection with a threaded locking collar. I paid a technician to install Nikon-style sockets on my medium-format SLR camera bodies.

A different approach solved a problem with my large-format monorail system. The wide-angle bag bellows permitted full focus range for all lenses except the 250mm, which required a bellows with a longer reach. Inside the studio this was a minor hassle, but outside the studio it was more of a problem. I had to pack and carry extra gear, plus it took extra time to make the changeover whenever I switched lenses. Also, changing bellows meant exposing the inside of the camera to the elements which inevitably led to dust spots on the film. My solution was to have a machine shop build an extension lens board — the mirror image of a recessed board intended for use with a wide-angle lens. The extension board positions the 250mm lens 1¼" farther away from film plane than a flat board, which in turn permits almost full movements without having to change bellows.

Here is another story about large format: I fell in love with the Linhof Technikardan 45 because it is so lightweight and compact, yet so versatile. Its one flaw was a lack of rigidity, particularly for the rear standard. I solved this problem with two brass fittings that I designed and paid a local machine shop three hundred dollars to make.

I bought a second-hand Linhof Technika 23 (2¼" x 3¼", or 6cm x

7cm) for location architectural photography. My first attempt to shoot a building revealed that this wonderful machine was profoundly restricted by its limited front rise with wide-angle lenses. After some thought, it occurred to me that slicing ¾" off the top of this folding camera's shell would allow a more useful range of adjustment. Linhof did some of the work, but after some more experimentation I carefully extended the cut a little further with a hand file. Soon after this modification was completed, I realized that more front fall was needed in order to properly handle architectural interiors: I removed one of the struts that supports the fold-out focusing bed and added a tripod socket on the same side of the camera. These changes yield extended front shift that effectively becomes extended front fall whenever the camera is mounted on its side, a position that permits more convenient access to the controls than mounting the camera upside down.

Recently, I invested in a Fuji 680GX, a medium-format SLR with front-standard movements. This is a very well-designed and well-constructed machine, but its one flaw is the absence of a socket for a conventional mechanical cable release, a simple device that I much prefer over the high-tech electronic version that Fuji offers for the camera. My solution was to shape, drill, and tap a small aluminum block that I carefully glued to the camera body with epoxy cement. The block is positioned in a way that permits a mechanical release to be quickly attached or detached while still allowing easy finger access to the shutter release when desired.

Modifying new equipment will instantly void any warranties. Nevertheless, as your equipment ages and you become more familiar with it, the need to make a few changes will arise naturally. It takes a certain degree of courage to alter complex factory-built machines, but the effort is worthwhile.

WHEN TO BORROW, RENT, LEASE, OR BUY

Setting up a professional studio involves a substantial expenditure. Premises must be found, equipment obtained, and supplies purchased. Some of you may be able and willing to finance these necessities out of your own pocket, but my guess is that many cannot. The catch-22 for a beginner at commercial photography is that to attract decent work one must have decent equipment but to pay for decent equipment one

must have some decent work. Until your business grows to the point where new equipment can be bought with cash, the only alternatives are to borrow, rent, or lease.

Borrowing professional equipment is not as outlandish as it may sound. It's amazing how much quality camera gear is in the hands of upper-middle-class photoenthusiasts. During my first few years as a professional I regularly borrowed Leica and Nikon equipment from a dentist, an accountant, and a doctor. Their compensation was a few custom prints or use of my studio in the evening.

Renting equipment commercially for a day or two at a time is an affordable proposition, although you must expect some delays due to the running around involved in locating, transporting, and testing the gear you need. In smaller centers it can be difficult to find specialized professional tools. Sometimes well-equipped pros rent their equipment to trustworthy individuals, but usually such things as high-power studio flash gear and exotic lenses must be flown in from out of town.

Leasing is like a long-term rental. It is usually offered by distributors, manufactures, camera stores, and financial institutions. In most cases the lessee is responsible for insuring and maintaining the equipment throughout the term of the lease, usually one to three years. Costs are close to the rates for bank loans, with the advantages that the payments are 100% deductible and there is no down payment required, although there will be a thorough credit check. At the end of the lease the equipment may be purchased at a depreciated price, sometimes as low as 1% of the original retail cost. The big disadvantage to leasing is that such agreements are inflexible — you are locked in for the duration and a couple of missed payments results in repossession of the equipment and the loss of your investment. The leased equipment is the property of the leasing company and as such cannot be sold or traded should it become obsolete or redundant.

MAINTENANCE & REPAIRS

Some professionals have their gear checked, cleaned, and repaired if necessary every year or so; a prudent practice, although not absolutely necessary, provided a few simple rules of preventative maintenance are followed. First, keep equipment clean and dry, since dust and moisture are the primary active agents in the destruction of optical and elec-

tronic apparatus. Second, avoid hard knocks, which inevitably induce misalignments that reduce sharpness and shorten the life of otherwise precisely mated moving parts. Both these precautions are reinforced by the proper selection of equipment cases. I prefer well-padded, water-resistant nylon cases that open at the top as opposed to the hard-shell waterproof variety that opens like a suitcase. Soft cases provide plenty of protection while allowing rapid access on the job.

I don't bother with preventative maintenance, unless a piece of equipment has been accidentally banged around or exposed to some sort of hostile environment. Instead, I focus on the mechanical feel and characteristic sound of everything I use, in order to notice right away if anything changes. Such mindfulness allows problems to be detected early and consequently reduces repair costs and inconvenient downtime.

Some repairs or modifications cannot be properly handled by local technicians. I am not hesitant about calling the service departments maintained by the major distributors. When I have a technical problem that cannot be resolved near home, I call and ask for the service manager, and identify myself as a professional photographer. Not once have I received anything but courteous and efficient treatment. It is usually more expedient to ship damaged equipment by air courier yourself, rather than have a store do it for you. Distributors' addresses and phone numbers are available from the instruction books that come with new equipment, from your photographic retailer, or from advertisements in photography magazines.

The Small Commercial Studio

THE MYSTIQUE OF THE STUDIO

Like a good motion picture, a well-made studio photograph inspires the suspension of disbelief. The photography studio is a place where technology and imagination work together to generate convincing illusions. Inside the studio the photographer is a minor god playing at the construction and destruction of countless little worlds.

Clients love studios. There is something whimsical and exhilarating about a place in which everything they imagine can be materialized more or less on demand. Legitimized by the ostensibly sober pretext of doing business, normally reserved adults get to play like kids in a grown-up sandbox. Both photographers and the people they work for come to regard the studio as an exotic haven comfortably isolated from the often dreary trappings of the regular corporate environment.

FINDING YOUR OWN SPACE

Sustaining the mystique is not impossible even if the studio is a temporary mutation of your living room or basement. At the beginning of a career, any space capable of encompassing camera, lights, set, and a photographer will do. Most assignments involving a subject smaller than a domestic appliance can be shot in a room ten feet square if necessary, although the typical eight-foot ceiling places a definite limit on lighting possibilities.

Some professional photographers prefer to operate without a studio of their own. When they have to shoot in a controlled environment

they rent a space and lighting equipment to go with it. My own experience is that such an approach is impractical for someone working in a middle-size city doing a variety of commercial work. Sooner or later the inconvenience and emotional distraction associated with a makeshift arrangement will lead to a desire for something more permanent. This means renting, buying, or building.

Setting up a studio is a public act which signifies a real commitment, a marriage between you and the business community. Your bank, your suppliers, your customers, as well as your competitors will know that you have embarked on a serious undertaking and they will respect you for it. When others view you differently your own self-image changes. Taking on the long-term responsibility of maintaining a commercial space increases pressure but it also encourages sober and mature behavior.

Those engaged in commercial photography tend to be stubborn perfectionists and are highly involved in their work. Often they find it difficult to separate themselves emotionally from their professional obligations. This state of being can put personal peace of mind as well as harmonious family relations at risk. At first the added stress of running a studio might exacerbate this condition, but after a short while, having a separate physical space dedicated exclusively to business promotes the ability to separate oneself from worry. Simply walking out the door at the end of the day can be a therapeutic experience.

Don't set up a studio before you can afford it. You must have enough money set aside to carry the added costs until the studio begins to pay for itself. This may take only a couple of months if you have already established a flow of studio work using your home or a rented space. Nevertheless, if you are depending on the acquisition of a studio to expand your business, be prepared to cover several months' expenses with your reserves. The period of uncertainty can be reduced by careful marketing before the move.

For the short term, the least expensive way to acquire a studio space is to rent. How much you will pay is determined by location. Where you set up shop depends to a degree on how you intend to run your business. Commercial photography does not require a prime upscale address because there is virtually no retail component. If only couriers and the occasional client have to find you then you may quite happily locate well away from the city-center in an industrial park, a warehouse

district, or even in a residential subdivision.

For some photographers, a downtown location is desirable because the increased visibility and easy access for corporate clientele is an important marketing bonus, well worth the extra cost. Apart from high rent, a substantial investment in decorating and furniture will be required to maintain the appropriate image. Studios of this sort should include a small office or meeting room with a separate phone as an additional convenience for busy clients.

I recommend that you operate out of a rented space for sufficient time to acquire a thorough insight into what you really need. Then, if you find yourself totally and happily committed to one geographical area, and if the money is available, buy or build a space of your own. The cash required is significant, obviously, but the investment is returned in three ways. First, if you're the landlord you are free at any time to modify the structure to suit yourself. Second, the mortgage interest, the cost of improvements, and costs for repairs and mainte-nance are all deductible expenses when you file your taxes. Third, your own building is an asset which will most likely increase in value, inde-pendent of any fluctuations in the photography business. At the end of your career, or whenever you want to make a change, you'll be able to generate cash by renting, selling, or refinancing the property.

Regardless of whether you buy, rent, or build, you will have to deter-mine exactly how much space your operation requires. The critical dimension is ceiling height. For any flexibility in lighting, nine feet is an absolute minimum for tabletop product work, although eleven feet is infinitely more practical. Twelve feet is the minimum for photogra-phy which involves people or bulky objects like furniture. When really large sets are involved, like those required for shooting cars or fully fur-nished rooms, at least sixteen feet is mandatory. According to most building codes, sixteen feet is also the minimum when incorporating a mezzanine platform or balcony to facilitate shooting straight down or at an elevated angle.

The width of the studio should be about 33% greater than the width of the typical set, while the length should be twice the width to ensure enough room to maneuver with long focal length lenses. The usable dimensions may be extended by constructing a gently curved corner, called a cove, where the floor and the back wall meet. In narrow stu-dios, the vertical corners of the back wall may be coved; in studios

where height is a problem, the corner where the back wall meets the ceiling can be treated the same way. A cove may be constructed with thin plywood and plaster or else a commercial system may be obtained through one of the larger studio supply houses.

Absolute minimum studio dimensions for small-product photography might be eight by sixteen feet but a more practical size for general work is fifteen by thirty feet. Shooting fashion or furniture in a space smaller than twenty-five by fifty is not recommended. Extra space will be required for changing rooms, a washroom, as well as props and equipment storage and perhaps a workshop. A darkroom will need at least one hundred square feet to be useful.

THE PRACTICAL STUDIO

An efficiently designed studio is organized like a little ship and everything in it has a place and a purpose. The shooting area should be tidy, supplied with sufficient independently fused electrical outlets, and well isolated from extraneous daylight. Equipment should be arranged to be easy to reach and replace. A heavy-duty pegboard is great for accessible storage of cables, lighting hardware, and other tools. If you are building from scratch or renovating an existing space, make hallways, doors, and stairs wide enough to ensure that moving around with bulky equipment is safe and easy. Also, consider plywood rather than plasterboard for the walls of the shooting space. Taped and sanded plywood is almost as smooth as drywall, yet much more durable.

An overhead track system for suspending lighting instruments from the ceiling is extremely handy. A fixed grid can be made cheaply from metal electrical conduit, although a more sophisticated system with movable rails and adjustable light hangers is the best way to go if you can afford it. If you incorporate such a system in your studio, build a shelf to mount electronic flash packs a little below waist level in order to eliminate unnecessary bending and clutter. It is amazing how much bigger and more comfortable a studio seems when the floor is free of lightstands and wires.

A studio is a box in which objects and people are carefully placed and painstakingly illuminated. The main theme is control, especially control of light. Purists will argue that it is critically important to eliminate all uncontrolled reflections by painting the entire studio dead black, an

idea that I find depressing. I feel that a degree of built-in reflectivity is not a problem, in fact sometimes it is actually desirable. I have always painted my studio ceilings and walls white and most studio shots do not suffer from the ambient reflections induced by the white surfaces. It is easier to eliminate unwanted reflective fill with black cards and flags than it is to add additional light with more lighting instruments and reflectors. Colored walls or ceilings are an absolute mistake, however.

A white ceiling is very handy in combination with certain lighting fixtures. Some permanent source of light is necessary in any studio but the built-in lights in my shooting area serve a double purpose. My ceiling is thirteen feet high. Three feet below the ceiling and spaced equally around the walls I have installed four permanent light fixtures, each of which uses a 500-watt quartz element. They are individually switched and directed upwards so that the light bounces evenly off the ceiling for a very pleasant effect.

Because the quartz tubes are designed to radiate at 3200°K (the appropriate color temperature for tungsten color film), I'm able to use this broad overhead source for photographic purposes. With little or no modification, I've done large-scale copywork and successfully shot a variety of outsized products. The fixtures were originally intended to be used as outdoor floodlighting and sold for forty-five dollars with lamps included.

STUDIO ACCESSORIES

A number of nonphotographic tools and appliances are needed for your studio. The first is a reliable telephone answering machine with remote message retrieval capability. The typical one-person commercial photography operation cannot or need not pay for someone just to answer the phone and keep track of where the photographer might be. I have found an answering machine more useful than a pager or cellular phone, both of which are disruptive and distracting on location because they exert psychological pressure to return calls immediately. There is really no need to deal with all incoming calls instantly. If you do, your life will become awfully intense because people tend to take advantage of the overly eager. When you are away from the studio, check your messages around 11:30 A.M. and again around 4:00 P.M. By doing this, you will be able to return important

calls before lunch or before the end of the business day without having been harassed by high-tech bells and whistles. Write down your messages in your day book or enter them in an electronic organizer as the machine plays them back: Keeping such records will save much time and aggravation in the long run.

I believe that a decent stereo system is indispensable. Good music can be inspiring when it's necessary to work late or all night long, it can soothe nervous clients, and it can motivate awkward or self-conscious models. During long hours in the darkroom, or when you're stuck with some boring assignment, music can be a lifesaver.

A fax machine or a computer with fax capability is indispensable. Many users of photography have grown impatient with the delays and expense associated with intercity couriers and messengers, and instead they prefer to instantly fax copy, layouts, and shooting instructions directly to the photographer on the scene. If the expense of purchasing a machine is a problem, you might consider leasing or even sharing a machine with a business located near your studio. As with the telephone answering machine, an instant response to a fax message is not always required. If you can respond sometime during the same day most people will be satisfied.

An electronic air cleaner is another very valuable technological gadget, particularly if a darkroom is a part of the studio. These high efficiency electrostatic filters replace the conventional fiberglass filters in your furnace or air conditioner and do an amazingly thorough job of removing dust and other impurities. A one-time outlay of a couple of hundred dollars plus a few minutes' maintenance each month will prove to be a worthwhile investment, especially if you are a smoker. If you do maintain a darkroom, remember that your water as well as your air should be filtered with appropriate devices. (See Chapter 25 for more health and safety advice.)

Not many photographers would consider an air compressor as an indispensable tool, but I most certainly do. I bought one after having used up hundreds of dollars worth of canned air. I installed flexible self-storing coiled nylon supply lines in the shooting space, darkroom, workshop, and storage areas of my studio. A constant source of pressurized and filtered air comes in extremely handy for dusting off products, sets, cameras, lenses, equipment cases, and negatives. Once it served to make very convincing waves in a shot that required a sim-

ulation of the edge of a swimming pool.

A freezer is a relatively inexpensive appliance that makes life significantly easier for the busy photographer. Many professional films are intended to be stored at 40°F in order to guarantee consistent speed and color balance. To reduce time-consuming testing, it is a sensible practice to buy large quantities of favorite emulsions and store them at low temperatures for later use. This is particularly true of paper for color printing, which can often be purchased cheaply in bulk lots. Polaroid warns not to freeze their products, but I have often bought out-of-date instant film at a substantial discount and stored it frozen for months before using it successfully. Finally, film that has been exposed but for some reason cannot be processed immediately should be stored at a low temperature to preserve the latent image.

To do a proper job of food photography, a fully equipped kitchen should be constructed as part of your studio. Such an expense cannot be justified in most nonspecialized shops but there is a relatively economical alternative that requires only simple plumbing and wiring to install. About one thousand dollars will buy an integrated unit with a small oven, two or three adjustable elements, a stainless steel sink, a small refrigerator, and several square feet of stainless steel countertop. These clever appliances are intended for bachelor apartments, university residences, or motels. The unit I have in my studio is five feet wide by thirty-two inches high by twenty-eight inches deep and has a twenty-four-inch oven, a five-cubic foot refrigerator and a twelve- by sixteen-inch sink. Both smaller and larger versions are available. Mine has paid for itself many times, just in the lunches.

SETS & PROPS

Quite regularly you will be required to build or modify props and sets. Once I even constructed forms and poured cement for a simulated road and curb that served as the background for a shot of Puma running shoes. Hiring someone to do this kind of work is relatively expensive and usually unnecessary if the proper tools are available. Build a sturdy workbench five feet long by thirty inches wide and attach a solid three-inch vise on the right-hand corner. Put up a pegboard behind the bench and hang up a hammer, a ⅜" capacity power drill, a staple gun, a set of screwdrivers in various sizes, a set of wrenches sized from ¼" to ¾", a

Figure 12.1
The dramatic angle specified by the art director required Olympic cyclist Tanya Dubnikoff's racing bike to be solidly mounted three feet off the floor of my studio. The wheels are fastened to plywood saw horses and the column supporting the seat was clamped to one end of a steel rod, the other end of which was secured to the studio wall. I lay on my back to get the shot. (*Mamiya 645 Super/35mm lens/Kodak PRN film/Electronic flash.*)

set of jewelers' screwdrivers, a power jig saw, wire cutters, small and medium vise-grip pliers, and a variety of files and sandpaper. If you also have some duct or gaffer's tape, silicone rubber, five-minute epoxy, a roll of eighteen-gauge mechanics wire, window putty, and a spool of nylon fishing line, there will be almost nothing you can't fix, build, or repair.

LOCKING UP YOUR TOOLS

My final nonphotographic recommendations relate to security. Large free-standing safes are now out of style for banks; they can be bought used for surprisingly low prices and they're great for burglar-proof storage of cameras and lenses. I bought a second-hand sixty cubic foot safe with a four-hour fire rating for three hundred dollars. A walk-in cupboard with a sturdy locking door is a good idea for expensive and fragile photographic lights. It's also wise to invest in a steel outside door, a local alarm system, and heavy wire mesh for any ground floor windows. Look in the yellow pages for suppliers. No matter how well you are insured, a robbery is an incredibly disruptive occurrence.

CHAPTER THIRTEEN

Photographic Lighting

THE QUALITIES OF LIGHT

Literally translated, photography means drawing with light. Expert manipulation of light in all its subtle forms is the foundation of both studio and location practice: It requires a variety of special tools, some of which are quite expensive. Nevertheless, I have worked for many years with an uncomplicated selection of relatively inexpensive lighting equipment that has served me well in many situations. The reasons for my personal choices will be more apparent after a quick review of some basic principles.

Understanding photographic lighting begins with an appreciation of the technically variable qualities of light itself: color, intensity, direction, and specularity. Of these four qualities, specularity is of critical importance. In fact, most devices dedicated to the modification and control of light for photography are designed to somehow alter or enhance this trait.

Specularity is a function of the size of the light source in relation to the size of whatever is being illuminated. For example, the sun on a cloudless day is a highly specular light source, whereas an overcast sky is nonspecular or highly diffused. Among photographers, specular light is referred to as *hard* and nonspecular light is *soft*. An object illuminated by a hard light throws a shadow with hard, precisely defined edges. A source of hard light may be altered or directed by fresnel or condenser lenses, parabolic reflectors, grids, or mirrors. Umbrellas, diffusers, softboxes, and hundreds of different sorts of reflectors are used to

Figure 13.1
Small lamps located behind the banister of this curved stairway yielded a delicate pattern of light and shadow that I captured with a one-minute exposure for this architectural study. (Original in color.) (*ToyoView 45G/47mm Super-Angulon/ Kodak VPL film/Available light.*)

Figure 13.2
A single, artfully positioned focused spotlight and a sepia filter over the camera lens makes this study of a computer printout into a glowing homage to technology. (*Fuji 680GX/100mm lens/Kodak EPP film/Electronic flash.*)

113

change hard light into controlled soft light. The shadows from a soft light source are fuzzy and undefined.

SYNTHETIC SOURCES

The artificial light used for photography can be generated by one of four different sources:

1. A tiny coil of wire made white-hot by an electrical current. Because tungsten is the best material for the glowing wire, these are called tungsten or incandescent lights. Quartz lights are tungsten lights that use a quartz envelope rather than glass. These lights are also called halogen lights because the quartz envelope is filled with inert halogen gas, which permits a longer operating life, as opposed to a simple vacuum.

2. A small tube of gas excited to luminescence by a continuous electrical discharge. These can be sodium or mercury vapor or HMI (Hg Metal Oxide) lights, according to the materials from which they are made.

3. A long glass tube coated on its interior surface with a phosphorous material that glows when stimulated by an electrical discharge — commonly known as fluorescent lights.

4. A small tube of xenon gas excited to a bright, brief glow by an instantaneous electrical discharge. Because the xenon gas emits light for only the tiny fraction of a second during which it is energized, this source is called electronic flash or speed-light.

Tungsten, vapor or discharge lamps, and electronic flash tubes are relatively small so when they're used for photographic purposes without any sort of modification they are extremely hard light sources. All their other attributes are markedly dissimilar.

Incandescent, gas discharge, and fluorescent light is continuous; as long as electricity flows light is produced, unlike electronic flash which generates light only in very short, albeit bright, pulses. Here's how electronic flash works: Electrical energy is stored in a capacitor, a device that works like a rechargeable battery, except faster. It takes from one to thirty or more seconds to fully charge the capacitor with electricity, depending on the characteristics of particular flash units.

The stored energy is discharged rapidly through the flash tube when a small electrical signal called a trigger pulse is initiated by a switch built into the shutter mechanism of the camera. The flash must be synchronized with the shutter so that the pulse of light, which may be from $1/50$ to $1/10,000$ of a second in duration, occurs when the shutter is completely open.

The brevity of the xenon flash might seem at first to be a disadvantage but it is actually a blessing in disguise. The pulse of light is so short that both subject motion and camera shake are eliminated. In order to preview the effects of the flash and to provide sufficient illumination for focusing a small tungsten lamp (50 to 250 watts), called a modeling light, is mounted near the flash tube in professional studio flash units.

Due to the elaborate electronics involved, electronic flash equipment powerful enough for professional use is complicated, expensive, and heavy compared to tungsten lamps, which are simple in construction and very lightweight.

Unfortunately, tungsten lights are not very energy efficient. A lamp rated at 1000 watts will use 200 watts of electricity to make light and as much as 800 watts to make heat. Because of this inherent characteristic, incandescent lights are a fire hazard and destructive to heat-sensitive subjects. Generally speaking, these lights are awkward and uncomfortable to work with.

A conventional glass incandescent lamp darkens and changes color with age as metal evaporating from the hot filament condenses on the inside of the bulb. Quartz-halogen lamps are filled with inert gas and operate at extremely high temperatures so that vaporized tungsten does not condense on the envelope but instead is redeposited on the filament in a continuous cycle. In terms of both color-balance and brightness, quartz lights behave more consistently than conventional lamps. Life expectancy ranges from fifty to a couple of hundred hours. Both types of tungsten lamps are delicate and will burn out if they are jarred while operating. Photographers deal with all the inconveniences of hot lights because the lighting effects may be easily judged and very finely controlled. In addition, some people feel that the warmer incandescent spectrum renders a more natural look than the cool light from electronic flash.

Many high-resolution digital imaging systems require long exposures during which the light levels must remain constant in order to

avoid bands of uneven density across the final image. Tungsten lamps are difficult to regulate because they are so power hungry. Gas discharge and HMI lights are expensive, but are more efficient and more stable than tungsten lights. Banks of high-tech fluorescent lamps are gaining favor in this application.

QUANTIFYING COLOR

The color of both artificial and natural light is described precisely by the Kelvin Color Temperature Scale. So-called normal daylight is 5500°K but this varies with the time of day, time of year, geographical location, and air purity. A sunset at the end of a dusty prairie day would radiate very warm light, perhaps as low as 2500°K, whereas high noon up in the Rocky Mountains could register a very cool 20,000°K. Incandescent lamps for photography are rated at 3200°K. Electronic flash is designed to be 5500°K.

Daylight color films are balanced for 5500°K and intended to be used outdoors for exposures shorter than one second and with electronic flash. Tungsten-balanced films are designed for exposure under 3200°K incandescent lights. Most small-format transparency films, such as Kodak Ektachrome EPP, are intended for short exposure times, whereas some large-format tungsten transparency films, such as Kodak Ektachrome 6118 are intended for long exposure times. Although absolute color fidelity cannot be guaranteed, daylight-balanced and tungsten-balanced films may be interchanged, provided appropriate filters are used and the corresponding exposure corrections are made. Technical data sheets describing color balance and reciprocity corrections for specific professional films are available from manufacturers.

A SIMPLE RULE

How lighting equipment is used depends on the specific photographic problem at hand and the aesthetic approach of the photographer. I generally use tungsten light when photographing inanimate objects, unless working temperature will be a problem. For lighting people and other subjects that can move, I prefer electronic flash.

A BRIEF HISTORY OF LIGHTING

There have been a variety of fashions in photographic lighting. These evolving styles have tracked changes in picture-making technology at the same time as they paralleled the broader tastes of the entire culture. Early portraiture, for example, was lit by natural daylight from large skylights built into the studios of the time. At the beginning of photography, there were simply no artificial alternatives to sunlight. The subjects appeared rather rigid simply because they had to stay still for several minutes while the available light worked its magic on the slow emulsions. Later, with the advent of a multiplicity of marvelous incandescent fixtures, portraiture became an elaborate exercise where several types of hard sources were carefully balanced to build up a highly sculptured look. The glamour portraits produced in the 1940s by Hollywood's George Hurrel are examples of this heroic style. Later still, in the 1960s and 1970s, electronic flash and fast films ushered in a period of unprecedented spontaneity as photographers and their subjects were freed by technical advances to catch life on the run.

The period that's just ended in North America might be called the decade of the softbox. We have had ten or more years of pictures of both people and products lit by very broad sources—counterfeit windows, really—filled with reflected light, and occasionally enhanced with a touch of harder rim or backlight. The look recalls the natural light work of the very first photographers, exalted by the exceptional accuracy of modern color films.

CURRENT TRENDS

Today's consumers of still photography are continually inundated by a broad spectrum of superb imagery from TV, movies, and lavish magazines. Commercial photographers are expected to be able to reproduce and enhance the styles of the past as well as expertly mimic the newest visual offerings flashed by satellite from Los Angeles, New York, Paris, or Berlin. Even clients with the most modest budgets are subconsciously expecting the photographs they buy to compare favorably to those produced around the world.

Although composition and perspective are important, in the calculated world of commercial photography it is mainly through the

intelligent and sensitive use of light that a photograph is infused with a style. Nowadays, photographers need to know how to select and tastefully apply a multitude of lighting tools and techniques. It is absolutely essential to study the photographs that appear everywhere around you. Make it a habit and you will find that it becomes fairly easy to discern the size and placement of the lights. Your own emotional responses to the images you study will teach you how lighting works to evoke an astounding range of moods.

NUTS & BOLTS

After sensitizing yourself to the lighting skills of other photographers, acquiring an eclectic arsenal of both flash and tungsten hardware is an unavoidable necessity. In Chapter 1 I listed my equipment preferences. In Chapter 15 I will give specific, practical details of how these tools are used efficiently to light a range of commercial assignments. Now I'll outline my personal rationale for the selection of equipment.

I chose the Lowel tungsten light system because it is versatile and durable as well as lightweight and compact. It was designed by a working photographer, and there are appropriate bits and pieces available to solve almost any light problem. The Lowel DP light is the heart of my system. I am particularly fond of the DP's focusing ability. With a simple turn of knob, the light beam can be varied with precision from 15°–90°. This range may be extended with inexpensive snap-in reflectors. DP lights can handle up to 1000 watts each and typically use an FEL 50 hr/1000 watt lamp. However, I prefer the long-life 200 hr/750 watt EHG bulb. These lamps have a slightly warmer color — 3000°K instead of the usual 3200°K — which I find very pleasing, and they run a little cooler.

Multileaf barn doors and a variety of different size flags are easily attached. There is a simple but solid umbrella bracket available as well as a large, comfortably cool handle which allows the lights to be manipulated without burning fingers. A very clever system of clamps, adapters, and stands facilitates mounting the lights and accessories in all kinds of configurations. Sensibly priced fitted cases allow the entire system to be packed for traveling.

Although the Lowel system can be used in a hundred different ways, my favorite approach is to bounce the DP units off strategically positioned reflector cards of various sizes, using their focusing capability in

combination with the barn doors to surgically tailor the pattern and intensity of the light. By adding two little Photogenic focusing spots (sometimes called "needle lights" or "inkies," and a few small mirrors, I add highlights and accents when required.

I rely on tungsten lights and the system approach when elaborate and detailed lighting is required. Really fancy lighting, however, is not called for all the time. In fact, my favorite studio light was a device I built myself for less than twenty dollars out of four triangular sheets of foam-core lined with tinfoil, and covered with a tissue-paper diffuser. It couldn't leave the studio because it was too bulky and fragile, but for several years it was my first choice for many product shots and portraits. I used it when I wanted a soft, but easily directed source. It was simply a homemade version of the many commercially available softboxes. Nowadays, I use several different sizes of Chimera/Pro softboxes inside and outside the studio.

I use electronic flash wherever high intensities are needed and wherever subject or camera motion must be eliminated. Because the technology for generating electronic flash light is so complicated, the business end of these units, the "flash head," must inevitably be less flexible than its incandescent counterpart. Several well-developed professional flash systems, such as Balcar and Speedotron, offer a selection of reflectors and grids intended to fine tune the output of their flash heads, but the expense is unjustified if an investment has already been made for a sophisticated tungsten kit. In almost every circumstance I have encountered, flash heads bounced from umbrellas or through softboxes were sufficient. I have, however, modified a couple of my heads to take Lowel accessories for those occasions when some fine tuning must be done.

Many assignments can be handled with one big power pack and four flash heads. I think it is worthwhile to invest in a powerful and reliable system with a short recycle time. In the world of flash, power is measured in wattseconds (ws). A small unit might generate 100 ws, while a really large pack might be capable of producing 4800 ws. Twenty-four hundred wattseconds is typical for a heavy-duty professional power pack. Recycle time refers to how long the unit needs to recharge after each flash. Thirty seconds is a long time to wait between shots but two seconds or less is not. Big units draw heavy currents, up to 30 amps, when recycling fast. It's wise to buy power packs that have a switch

which permits slower recycling for those locations where the electrical supply is limited. I strongly recommend that you obtain a second pack as a backup against breakdown.

The heavy artillery is required outside the studio only sporadically, so save your back and obtain a bright camera-mounted flash and one or two small "monoblocks" (self-contained flash heads and power packs) in the 200–400 ws range. I have settled on the battery-powered Metz 60ct-2 for flash-on-camera, and my high-power flash heads do double duty with a couple of little 650-ws battery-powered generators that I clamp onto compact collapsible stands for location work. Two seventy-two inch umbrellas are my main light modifiers away from the studio, although surprisingly often, neutral colored walls or ceilings can be used for no-fuss bounce flash. I strongly recommend that infrared or radio triggers be used in place of endlessly troublesome synch cords.

A WORD ABOUT SAFETY

Never forget that professional electronic flash equipment operates at very high voltages and can be, under some circumstances, extremely dangerous. Read the manufacturer's instruction manual and religiously follow the safety recommendations. Check all connectors and cables often and replace any that look worn. Make certain that stand-mounted heads are secure and that wires are safely taped to the floor when working on location. Never allow flash equipment to be operated by people unfamiliar with it. Do not use flash equipment in a wet environment or in the presence of inflammable vapors. Extension cords for use with large flash generators should have heavy-duty fourteen-gauge wire. Make certain that flash units are supplied by well-maintained grounded receptacles of adequate size. Always switch power packs off before connecting or disconnecting flash heads. *Always leave flash units unplugged and discharged when unattended.*

Quartz-halogen lights operate at extremely high temperatures. Always watch out for fire hazards and possible heat-induced damage to props or equipment. Use gloves when adjusting hot lights. Make sure that models and assistants are not at risk of contact or radiation burns. Do not touch quartz bulbs with your fingers during installation — skin oils can cause uneven heating and may result in fractures or even explosions accompanied by dangerous flying fragments.

Basic Camera Technique

The bread and butter work in commercial photography requires straightforward technical competence rather than incredible virtuosity. In fact, virtuosity is impossible without a good basic technique. Those who are attracted to commercial photography will find that it is necessary to put in at least a couple of years playing photographic scales before being summoned for a command performance. Regardless of how mundane or exotic a particular assignment might be, all professionally made photographs must demonstrate technical excellence.

The fundamental elements of good commercial images are:

1. Proper exposure

2. High image resolution

3. Appropriate choice of lens

4. Perspective control

5. Appropriate choice of format

6. Appropriate composition

The goal of photographic efficiency is to consistently maintain high standards in the simplest, quickest, and most economical way possible.

EXPOSURE CONTROL

All the technical and aesthetic elements in photography are interdependent and interrelated. The design of an image depends to a large degree on the choice of optics, while the choice of optics will inevitably be limited by the choice of format, and so on. Nevertheless, everything depends on a few light-sensitive molecules receiving just the right amount of photochemical stimulation. Exposure control is the method by which this condition may be consistently achieved.

The duration and intensity of the exposure is a function of the level of light that falls on or is radiated by the subject of the picture. In order to make a correct exposure it is necessary to keep in mind the quality of the light, the f-stop required for depth of field, the relationship between shutter speed and subject motion, and the reaction of the film to very long or very short exposure times (reciprocity effect). Some indirect factors are also involved: For example, extreme wide-angle lenses cannot project an image of even intensity across the whole frame, while leaf shutters, because of their construction, are open noticeably longer at the center than at the edges for short exposure times.

Most everything to do with proper exposure is measurable and obvious. Controlled testing and careful evaluation of materials followed by accurate calibration of equipment will lead to predictable results.

Tools for Measuring Light

The initial question, "how much light?" is answered by using a light meter. The light meter is an electronic device consisting of a sensor that changes electrically in proportion to the amount of light striking its surface, and a meter scale or an electronic readout that displays those changes in numbers. A good light meter will reliably indicate the same reading whenever presented with the same intensity of light.

There are four categories of meters for measuring both continuous sources and electronic flash: reflected light meters, incident light meters, spot meters, and behind-the-lens (BTL) light meters.

The reflected light meter measures the light coming toward the camera from an object or scene. A simple lens or baffle arrangement in front of the sensor (or photocell) provides an angle of acceptance which is usually 15°–30°. Some units have an optical viewfinder, but most don't so that it is necessary to guess what the meter is looking at.

The incident meter does not measure the light reflected from the subject. Instead of looking through a lens the photocell is mounted behind a small diffuser — typically a white translucent plastic dome. The reading is taken from the subject position with the dome pointing at the camera. The diffuser integrates all the light falling on the subject (illuminance), and the resulting measurement describes the overall level of illumination independent of the reflectivity of the subject.

The spot meter is a specialized reflected light meter. Here, a sophisticated lens and viewfinder arrangement permit accurate measurements of the light coming off tiny areas of the subject. Spot meters usually provide a viewfinder image with a 10° visible angle of acceptance surrounding a 1° spot of sensitivity.

Like spot meters, BTL meters are specialized versions of the reflected light meter. In this case the sensing element (or elements) and readout are located on a camera. Behind-the-lens meters measure the light entering the camera through the taking lens. The reading is obtained from the ground-glass viewing screen, through minute perforations in the reflex mirror, from the first shutter curtain, or from the film surface itself. The beauty of the BTL approach is that all factors affecting the intensity of the light reaching the film, such as filters and lens transmittance, are automatically taken into account.

It Is a Gray World Out There

Refinements in technology have given us a wide choice of equipment, yet all light meters — past and present — have one common characteristic: they're dumb. Some manufactures and many photographers pretend this is not the case, but they are deluding themselves, microprocessors notwithstanding. A meter can tell you how much light it sees, and that's it. No machine can interpret quantitative measurements in a way that will guarantee the appropriate exposure every time. This decision is the responsibility of the photographer, and it involves some thought.

A particular film, exposed to a certain amount of light, and developed for a certain amount of time at a certain temperature will yield, when printed under controlled conditions, a tone equivalent to that of an 18% gray card. In other words, if every other step of the process is known and predetermined, exposure alone will determine the density

of the final tone. If a reflected light meter of known accuracy is point-
ed at an 18% gray card, then the indicated exposure will end up as a
print that looks exactly like the gray card. Light meters think the whole
visual world is one big gray card. The underlying logic is that all the var-
ious tones in a typical scene, when randomly scrambled, will average
out to the equivalent of 18% gray. Unfortunately, in the real world, such
an approach is not sufficiently flexible.

Consider the photographic implications of a man, standing in direct
sunlight, wearing a white shirt and a black suit. A reflected light meter
pointed at this scene from the camera position might indicate f11 at
$^1/_{125}$ sec for ISO 100 film. If a closer reading is made from the shirt, the
reading might be f22 at $^1/_{250}$ sec. Another reading made from a shadow
area on the dark suit might indicate f4 at $^1/_{60}$ sec. A comparison of the
two closeup readings indicates a span of eight f-stops. Negative films
cannot record detail beyond six f-stops and printing papers cannot
reproduce a range of tones beyond 100:1 under the very best viewing
conditions. This means the shadow side of the man's suit will drop off
the dark end of the spectrum and print jet black, whereas the sunlit
white of the shirt will shoot over the top of the reproducible tonal scale
and consequently print bald white. When working together, the human
eye and brain can tolerate a brightness range of almost 100,000:1,
which means that what we see in real life and what we see in a photo-
graph will not necessarily coincide. Some skill is required to reconcile
the response of the eye and brain to the film and paper.

The Truth About Film and Light Meters

Reflected light meters should be considered brightness meters rather
than exposure meters. Individual readings indicate specific intensities
of light but no single reading can be trusted as an overall exposure.
Instead, the meter must be used to measure around the subject in order
to determine the relative brightness of the significant tones. Once this
is obtained, a decision can be made as to whether or not the tonal scale
of the subject corresponds to the tonal range of the film. If the two are
desperately out of alignment, a decision has to be made as to which tones
in the subject are to be sacrificed to the shortcomings of the medium.

Many photographic materials are profoundly limited in ways that
cannot be significantly altered by the photographer. For example, most

color slide emulsions can faithfully record a brightness range of only three f-stops (±1½ stops), which means that the choice of tonal placement is drastically limited where light conditions are harsh.

THE FOUR LEVELS OF EXPOSURE CONTROL

The first level of exposure control is an awareness of the relationship between subject contrast and the appearance of the final photograph. An accurate knowledge of highlight versus shadow levels allows the exposure to be placed within the film's characteristic tonal range so that the main areas of interest will be satisfactorily recorded. The relatively broad latitude of negative films allows good results in a variety of common situations, however color slide materials are more difficult to manage. The exposure for transparency film is often determined by highlight levels alone, because overexposure creates terrible looking blank spaces on the processed slide.

The second level of exposure control is the selection and manipulation of lighting conditions. Just as one can acquire a knowledge of the properties of film, one can acquire a knowledge of the properties of light. Chapter 13 discussed the aesthetics of light in relation to photographic style. Now we must consider the technicalities.

During clear weather in areas of low pollution, light from the sun travels through the atmosphere to illuminate the surface of the earth with a sometimes painful precision. This harshness can be infinitely modified by the reflection, diffraction, and diffusion introduced by the weather, daily and seasonal variations in the sun angle, and dust particles or suspended aerosol pollutants. Large physical objects alter contrast by providing reflective surfaces or by creating shade. Under heavy overcast conditions the sky becomes a gigantic soft light that dissolves all shadows completely.

The brightness range can be significantly altered by moving the subject into or out of shaded areas or by placing the subject nearer to or farther away from a reflector such as a light-colored building. The same is true if one rotates the subject relative to the sun or if one selects a different camera angle. Subjects of moderate dimensions that must be photographed in harsh light can be accommodated with the use of portable reflectors such as white cards or foam-core covered with crinkled aluminum foil. Judicious use of fill-flash can reduce con-

trast to manageable levels without destroying the ambience of the available light.

In the studio the task of correcting, modifying, or compensating for existing conditions is superseded by the necessity to invent a lighting arrangement that will optimize the power of the image while remaining within the technical limitations of the film.

The third level of exposure control — processing manipulation — must be invoked whenever careful measurement of brightness levels and all possible modifications of the lighting are not enough. The Zone System is introduced in the chapter dealing with black and white (b&w) processing. Color materials cannot be manipulated chemically as easily as b&w materials. A few modifications can alter the characteristics of certain color films, and these will be described in Chapter 15.

Before trusting any exposure technique the actual sensitivity of any film must be determined. Manufacturers rate their products according to a methodology prescribed by the American Standards Association: The result is an ISO number (formerly an ASA number) for each kind of film. In real life, film sensitivity is not a constant. New emulsions need to be tested and evaluated under actual working conditions before a reliable exposure index (EI) can be determined.

The last option in exposure control is actually a group of several photomechanical and photoelectronic interventions that can save some poorly exposed negatives or slides. Some are quaintly traditional, dating from the earliest days of photography, whereas some are only a few years old. None are particularly convenient but from time to time in professional work situations arise where heroic efforts are required to salvage substandard or damaged work.

One remedy is a method of postexposure contrast control for color materials called silver masking or contrast masking. When printing a color negative that is too hard, the tonal scale can be compressed by masking with a thin b&w positive made by contact printing the original. The mask and the original are sandwiched together in a glass negative carrier so that the areas of maximum density in the mask coincide with the areas of least density in the original, thus reducing the exposure in those areas. The reverse is true for soft color negatives printed together with a negative b&w mask. The same techniques work when printing excessively high- or low-contrast transparencies except that the masking values are inverted. Well-done color masking can produce prints of

exceptional quality, although it is a job best done by a custom lab.

Really bad b&w negatives can sometimes be enhanced by chemical agents called reducers and intensifiers that dissolve away or build up density. The action of these chemicals is rather crude so don't expect miracles. A severely overexposed color transparency is inevitably a write-off but mildly over- or underexposed slides can be saved by rephotographing them. Sophisticated duplicating techniques can modify color balance and contrast as well. There are chemical reducers for transparencies that will lighten either specific colors or overall density. As a last resort, a botched negative or slide can be printed, then retouched and carefully copied.

Regardless of even the most heroic of remedial efforts, imperfectly exposed negatives and slides will never look as good as perfectly exposed negatives and slides, regardless of the degree of effort that goes into making corrections. The good news is that the increasing availability of computers and software like *PhotoShop* makes remedial or aesthetic modifications much easier to apply. By scanning and then electronically manipulating the offending negative, slide, or print, many outrageous errors can be corrected. However, even with today's sophisticated systems, the cost and time involved may be considerable. It is always better to get it right the first time.

Useful Definitions

Exposure latitude is the factor by which the minimum camera exposure required to give a negative with adequate shadow detail may be multiplied without loss of highlight detail.

Useful exposure range depends on the film and the degree of development and is measured from the least to the most exposure a film can receive and produce a printable tone.

Subject luminance range is a useful expression of subject contrast as it is a product of both the illuminance and the reflection range of the subject.

Density range is the difference between the minimum and the maximum density in the negative. The major effect in the variation of density range is degree of development.

Tone reproduction is the relation of the reflectances in the print to the corresponding luminances in the *subject*. The usual goal is to obtain an acceptable reproduction of the various luminances in the original scene.

Tone separation refers to our attempt to keep each tone in the original subject in approximately the same position in the tonal scale of the print. Because the luminance range possible in the print is less than the average luminance range in the subject, the optimum to be aimed at is proportionality as opposed to equality.

RESOLUTION: THE GRAND ILLUSION

The world is composed of dots. Photographic film records reality with dots of silver or colored dyes, electronic devices process discrete pixels, while the human eye registers dots as produced by a finite number of rods and cones on the retina. The brain, seeking as it does to harmonize the various elements of perception, automatically renders our microscopically fragmented vision into a seemingly smooth, continuous image.

Our perception of reality as a highly detailed visual field is an illusion. When looking at photographs, we make judgments about image quality. The brain's analytical power, though focused on what is really only a collection of speckles on a piece of paper, allows us to make an excellent approximation of reality. At some point on the visual spectrum from barely perceivable to infinitely perceivable, the brain sends a message; "Enough! No more information is required. This photograph looks the same as the real objects it represents." Such revelations do not occur at the same place on the perceivability spectrum for every image because many different visual conditions affect the exact go and no-go threshold. The notion of acceptable resolution can be induced by a range of surprisingly varied technical clues. The commercial photographer should always be aware of the outside limits of acceptable resolution and select equipment, materials, and techniques that will best maintain the illusion.

To get the maximum detail recorded on film and then reproduced on paper, everything must be right: the nature of the subject, optics, film, exposure, processing, degree of enlargement, paper surface and contrast, as well as correct conditions for viewing the final product.

Of all the characteristics that distinguish an amateur effort from a professional image, high resolution is the one most quickly recognized by nonprofessionals. "It's so clear! How did you do it?" How, indeed?

Resolution and Image Content

The physical nature of the subject is the first determinant of apparent resolution. For example, a very high degree of image integrity is required to make a true-to-life portrait of a child with flawless skin. Even the finest of fine-grain films will be hard put to record an unblemished cheek or forehead as a perfect, even tone. The best optics on both camera and enlarger will be hard put to project a perfect image of the iris, lip texture, or eyelashes. Now consider a photographic view of a craggy cliff at the seaside on a stormy day. The scene might be recorded with equipment and materials unsuitable for the perfect portrait but when reproduced on paper it appears more than acceptable to even a critical eye. The roughness of the rock and the coarse tonality of the water are communicated with less technical trouble than the subtleties of a face. The picture reads as rich in detail because a little grain, a little unsteadiness, and some extra contrast all contribute data that the brain expects to see.

Equipment Choices for Optimum Resolution

In photography, as in music reproduction, maximum fidelity is possible only with the best equipment. A top quality stereo will reproduce all the power and nuance of a symphony undistorted, yet the manipulation of a few controls will allow the broadcasting of the roughest, toughest heavy metal.

These days we are blessed with a plethora of fine optics. All modern name-brand equipment should perform well, provided that lenses are kept scrupulously clean, free of scratches, and in perfect alignment with the camera body and film plane. Focusing helixes should be smooth and snug with no side-to-side play. Lens mounts should be secure and positive in their action. Interchangeable viewing screens, viewfinder prisms, and reflex mirrors should all be seated in their proper positions. Mechanical changes that affect resolution are to be expected with heavy use, another argument for buying the highest quality equipment you can afford.

Selecting Film and Format for Optimum Resolution

The most efficient response to any assignment is to chose the smallest format and the fastest film that will provide the degree of resolution appropriate for the job. As film improves, choosing a format according to its capability to hold detail becomes more and more difficult. Nowadays, the 4" x 5" view camera is chosen mainly because of its focus and perspective controls rather than for its resolution. The once ubiquitous 8" x 10" view camera has all but disappeared from ordinary commercial photography. The distinctions between 35mm and medium format are shrinking with each new breakthrough in film technology. Most commercial jobs will be easily handled in medium format, and many can be well done on 35mm. Oftentimes, medium-format equipment will be used simply because art directors insist on contact sheets and transparencies that are easy to read. In almost every circumstance the best technical solution is a compromise between resolution and practicality.

In Chapter 15, I will deal with specific types of work and give my preferences for particular films and formats for each of them. As an introduction to the thinking involved in making an informed choice, consider the following comparison between miniature and medium formats.

The inherent optical and mechanical characteristics of 35mm equipment allow pictures to be made in astounding conditions. A well-balanced camera and the forgiving depth of field of short focal length optics offer the best chance at accurate focus and an acceptable degree of hand-holdability even under very low light levels. For a steady hand and a sharp eye f1.4 at $^{1}/_{30}$ sec might be the bottom end of the f-stop/shutter speed spectrum: Apart from the expanding grain pattern on enlargement, the technical performance can be superb. Short telephotos, say up to 135mm, can be hand-held with a modest increase in shutter speed. For example, a head and shoulders portrait can be safely made with a wide-open f2.8, 90mm lens at $^{1}/_{125}$ sec. The useful range of tripod-free photography has been extended by Canon with their introduction of a lens equipped with microprocessor-governed servo motors driving floating optical elements that actually provide real-time compensation for camera and subject motion. Other modern lenses and lovely high-accutance films like Kodak Royal Gold 25 or Technical Pan allow very fine 35mm work whenever technical cir-

cumstances can be carefully controlled.

Medium format is not very flexible. Straddling as it does the wide gap between large and miniature formats, roll-film equipment requires a hybrid of techniques from both ends of the spectrum in order to maximize results. The most obvious difference between 35mm and 6cm x 4.5cm, 6cm x 6cm, 6cm x 7cm, 6cm x 8cm, 6cm x 9cm, 6cm x 12cm, or 6cm x 17cm is that the larger image sizes require longer focal length lenses with greater covering power. Unfortunately, these longer lenses typically have smaller maximum apertures, making focusing more difficult. A common normal lens for 6cm x 7cm for is a f4.5/110mm. Assuming it could project a large enough image to cover the whole frame, an 85mm short telephoto on a 35mm camera, would create a slightly wide-angle image on a 6cm x 7cm negative.

Depth of field refers to the range of acceptable image sharpness around the point of perfect focus. For example, a lens set at a moderately wide aperture and focused on an object ten feet away, might render two other objects positioned nine and twelve feet away as acceptably clear; in this case, the depth of field would be three feet. If a smaller aperture was selected, objects located at seven feet and at fourteen feet might be in focus. The depth of field would now be seven feet. Depth of field is also a function of focal length and magnification. For the same image magnification and at the same aperture, a 110mm normal lens for 6cm x 7cm will exhibit the same depth of field as a 110mm short telephoto on a 35mm camera. However, for the same camera-to-subject distance the 110mm lens on the smaller format will cover less subject area than the 110mm lens on the larger format. When the subject-to-camera distance is the same, a shorter focal length lens is necessary in order to cover the same subject area on the smaller format—the shorter focal length lens on the 35mm will yield noticeably greater depth of field and consequently greater apparent resolution. Stopping down the lens on the medium-format camera to equalize the depth of field effect is expensive, exposure-wise.

Compared to sleek 35mm cameras, the bulkier medium-format cameras are indisputably awkward. An accessory handgrip makes things more manageable but the heavier, boxier, roll-film machines cannot be reliably hand-held for the same long exposures. The bottom line of f1.4 at $^1/_{30}$ sec for 35mm format corresponds to perhaps f4 at $^1/_{125}$ sec on 6cm x 6cm equipment.

To achieve the best results from medium format it is necessary to slow right down. Broad daylight or bright electronic flash will allow consistent hand-held results but everything else needs a tripod. The selection of roll-film cameras requires a more methodical regimen. It sounds paradoxical, but self-discipline leads to greater freedom. Once the basics of camera steadiness and relatively small working apertures are satisfied, the medium-format camera can do things that 35mm can only parody.

There is a roundness, a smoothness, and a silkiness to photographs taken from a medium-format camera. With 35mm, sharpness is defined as being able to see the clearly defined edges of everything. Larger images promote an appreciation of the insides of everything. There is a tangible peace of mind associated with the knowledge that the smooth tonal scale and the wonderful detail will not be disrupted by magnification.

Mechanical Considerations for Optimum Resolution

Optical systems should not be moving while images are being made. In photography, this means no camera movement whatsoever; consequently a tripod is the most important photographic accessory. It is very tempting to shoot with hand-held cameras but this temptation must be resisted if you want consistently sharp results. Only young people who practice meditation and never drink coffee can hope to reliably hold a camera steady, critically steady, for any longer than $^1/_{30}$ sec. When you must work with a hand-held camera, make sure you maintain an easy but solid grip. Before each exposure, let your breath be slow and even. Don't clench. Clenching makes you vibrate. Relax, then squeeze.

A gyroscopic stabilizer is like a legless tripod that allows extended hand-held shooting in low light or high-vibration environments. Starting at about two thousand five hundred dollars new, Ken Lab Industries offer three different size units that bolt up to the bottom of still, video, or film cameras.

Subject Motion

When slow exposures are dictated by circumstances beyond your control, image degradation due to subject motion inevitably occurs regardless

of whether or not the camera is mounted on a tripod. There are, however, a couple of nonphotographic techniques that can improve results.

First, study motion. During every action of a repetitive nature there is a place of transition where, momentarily, the object is at rest. A hand goes up, but just at the top of the curve, before the beginning of the descent, it stops. A sharp photograph can be made at that exact moment. You must be quick. You must be physically fit. Exercise hard for twenty minutes every other day. Eat simple foods and avoid caffeine and nicotine. Meditation and yoga are helpful because a body at peace with itself is steady and reliable.

Focus

Make the best of your equipment by focusing carefully. It is easy to pass over the significance of this critical procedure because of the apparent ease with which SLR microprism screens snap in and out of focus. Unfortunately, the tiny elements in the microprism grid are carefully ground to a certain angle which can be truly accurate for only one focal length of lens. If the plain ground-glass collar and the microprism disagree on the point of precise focus, the ground glass will be correct. Special screens for very short or very long lenses are available for some cameras. When focusing view cameras, always use a loupe. Many 35mm and medium-format cameras can be fitted with an accessory focusing magnifier. Have your eyes checked regularly.

OPTICS & THE PHOTOGRAPHIC POINT OF VIEW

The Biological Lens

Human vision is nature's almost perfect response to the visible portion of the electromagnetic spectrum. I say almost perfect because as spectacular as the system might be, there are a couple of limitations: The lens of the eye is not interchangeable and for all practical purposes it has a fixed focal length of about forty millimeters.

The eye's automatic diaphragm, the iris, changes its effective f-stop from about f5.6 in dim light to approximately f22 in bright light. Quick corrections are made according to the relative brightness of different

Figure 14.1 A–H

This series was made with a 4"x 5"
view camera an a full range of
lenses from 75mm wide-angle
to 360mm telephoto. The subject
is a rustically styled recreation and
conference center. These images
were published in full color by sev-
eral architectural magazines. They
show how the selection of differ-
ent lenses permits the selection
of different points of view, each
of which serve different aesthetic
and documentary purposes.

objects within a scene, allowing us to see a tonal range much wider than present-day photographic technology can accommodate. More amazing still is the fact that focusing is accomplished by actually changing the shape of the lens itself. This very useful mechanical process goes on continually and quite fast, yielding the illusion of almost infinite depth of field. Focus corrections are made spontaneously as one's attention shifts between different objects within the field of view. Overall angle of acceptance is very nearly 180° around an area of high resolution of approximately 40°.

So-called normal lenses in photography are related to this special concentrated area of ordinary vision in that they have nearly the same angle of acceptance. The focal length of a normal lens is determined by the length of the diagonal measured from corner to corner across the format being considered. For the 35mm rectangle, the standard focal length is 43.266mm, but most manufacturers use 50mm.

The most comfortable viewing distance for most people is about equal to the diagonal of the print. The appearance of natural perspective is preserved at this viewing distance by making the photograph with a lens having a focal length equal to the film's diagonal. Photographs made with wide-angle lenses are nearly always viewed from too far away, which is why it is often wrongly assumed that they are distorted.

It's a coincidence that the preferred normal lens for the 35mm format and the human eye have nearly the same focal length yet these similar focal length lenses don't see the world in the same way. This brain, like the computer that generates a full color map of Jupiter from a few electronic clues, processes the data relayed along the optic nerve and then reconstructs an image — the image we see mentally — so that everything looks fine. We are conditioned from childhood to expect the visual world to follow certain rules of perspective and it is one of the brain's main functions to enforce these rules. That's why optical illusions are possible. The brain, always attempting to keep things in some kind of order, may be tricked. This was demonstrated in a dramatic experiment during which the participants wore special glasses that made everything appear upside down. Within a couple of weeks the subjects of the experiment reported that the world righted itself and everything appeared normal. On removal of the reversing spectacles, everything again looked upside down. It took another couple of weeks

without the lenses for things to come right side up.

An effort has been made to illustrate some of the properties of human vision because the selection and use of various focal length lenses in photography are profoundly influenced by our conditioned physiological and psychological seeing. Some lenses, like the moderate telephoto in the portrait situation, are used to put the world right according to our optical expectations. Other lenses, such as the fish-eye, are used to shock and surprise because the images they yield are spectacularly different from what our brains keep trying to see. We use the full range of interchangeable optics to satisfy or tease our visual programming.

Point of View

It's easy to think of a wide-angle lens as a device to cram more into the frame without having to move back and to think of a telephoto lens as a device for getting closer to the subject without having to move forward. The mechanics of lens selection are significant but different focal lengths offer more than just different angles of view. In fact, they each offer a different point of view, both aesthetically and anthropologically.

Anthropologically? Indeed. A full-figure photograph of your average human made with a 50mm lens on a 35mm camera requires a separation of about eight feet between photographer and subject. This is just within the range that permits conversation at unstrained voice levels in a quiet room. A 90mm stretches this figure to fourteen to sixteen feet. A 135mm pushes it to twenty to twenty-four feet where voice communication is limited to shouting and visual behavioral clues like facial expressions and body language become diminished and confused. Switching to wide-angle optics moves the photographer and the subject to within five feet of each other. Personal territories intersect at such close proximity and many intimate channels of communication begin to operate. Directions may be given in a whisper. A twitch of the head or a raised eyebrow signals a new posture or perspective. This is anthropology in action, the naked ape syndrome of photography. Watch a photographer shooting people and you'll be able to name his or her favorite lens according to the distance he prefers to put between himself and his subject.

Wide-angle Lenses

My work is a mix of advertising, editorial, and publicity photography. Many of the people I work for are looking for environmental portraiture, photographs that place an individual within his or her milieu and illuminate character by including information about expression, posture, clothing, and physical surroundings all at once. For this work, a moderate wide-angle lens is not only an asset but a necessity, at least in normal size living spaces and offices. When shooting someone seated at a desk, for example, short lenses allow a pleasing view of the features of the face while important objects in the foreground and the background can still be included. Framing is easy because the wide-angle lens puts one close enough to the subject to allow significant alterations in composition with only a small amount of vertical or lateral movement. On a purely mechanical level the moderate wide-angle lens makes working with portable electronic flash a very speedy operation. Most camera-mountable flash units provide an adequate field of coverage without attachments, and the short distances involved allow energy-conserving thyristor units to recycle quickly.

A normal lens or short telephoto is preferred for shooting people from the waist up without including a lot of environmental features because the distortion introduced by moving close with a wide-angle lens sometimes makes the photograph clumsy and unflattering.

Perspective distortion is both the curse and the blessing of wide-angle work. The term perspective distortion, however, has very little meaning apart from the brain's response to the optical phenomena of nature. The eye actually sees parallel vertical lines of a building converging just as the camera does. The eye sees nearby small objects as large and faraway large objects as small, just as the camera does. Yet, unlike film, which simply records what the lens presents, our brains interpret and reconstruct the images streaming in from outside. The brain wants to see verticals that don't converge. The brain knows that the bee on the flower is smaller than the farmhouse at the other end of the field. By collecting the light coming off three-dimensional objects and then presenting the flat image out of context, we are working relative to our optical preconditioning. In real-life situations, the brain tries to correct apparent visual anomalies, and, up to a point, succeeds. But a photograph can only look how it looks.

The perspective offered by very-wide to ultrawide lenses, 24mm and shorter for 35mm cameras, pushes visual tension right to the limits of tolerance. We will accept a rather odd looking photograph when there is no choice in the matter; a fish-eye picture of the inside of a space capsule, for example. Wide-angle effects are often appreciated for dramatic views of buildings or natural panoramas. However, people and familiar objects pictured close up by extreme wide-angle lenses will never look natural. The commercial photographer has in the wide-angle lens a tool for presenting the wares of the marketplace in an interesting and exciting way. Like all good things in life, though, this technique suffers when used in excess. Not only do we grow tired of grotesque caricatures of people, but superelongated automobiles and girls with legs that go on forever begin to lose their visual excitement after awhile.

On a somewhat more sinister note, the common use of very wide optics in photojournalism can change what might have been an impartial witness to historically significant events into a sensationalistic extravagance. This effect is desirable in some circles: A few modern journalists of cynical bent use extreme wide-angle optics to make their subjects look awkward and ill at ease before the camera. Through a 20mm lens, an upraised arm looks menacing, the arrogant look unbearably corrupt, the weak and needy look irretrievably lost. Such imagery is effective up to a point. Beyond that point, established by good taste, the power of the photojournalist is eroded as his or her audience becomes visually jaded.

Telephoto Lenses

The wide-angle lenses are clearly the right tools in certain situations but constant reliance on perspective distortion effects means that the photographer has surrendered the content of his or her images in favor of form. When the design of the photograph is a consequence of the lens characteristics alone, the power of the imagery will decrease over time. Like the individuals with the upside-down glasses, we get used to sensational points of view. When this happens, our collective visual consciousness cries out for more natural perspectives and photographs in which form and content strike a harmonious balance.

Except for special circumstances with certain shaped faces and very special lighting, the moderate telephotos (85mm to 135mm for 35mm

cameras) are necessary for pleasing head and shoulders portraiture. These lenses put enough distance between camera and subject to render nose, chin, and ears in suitable proportions. They are long enough to give subjects a fair deal visually, yet short enough to keep the photographer within the critical psychic circle of influence, allowing the development of a working rapport.

A lens of longer focal length (180mm or beyond) is not quite as fine a tool for portraying the human face. This, too, is a problem of perspective. Whereas short focal lengths tend to emphasize the features closest to the camera, giving a swollen, bulging look, the distances encountered with long lenses tend to flatten facial contours resulting in an image with noticeable lack of depth. In photographing products the drama and exaggeration of the wide-angle approach is generally bypassed in favor of the more straightforward view offered by the longer lenses. Their clear and undistorted presentation allows the innate elegance of the pictured objects to carry the show.

Because 35mm and medium-format systems have a very limited choice of lenses offering perspective control, the long focal length lenses are necessary to help render parallel vertical and horizontal lines properly. Things appear correctly rectilinear only when photographed absolutely dead-on by shorter lenses. Without perspective control, objects photographed from below look to be tilted away from the camera, whereas objects photographed from above look to be tilted toward the camera. In the case of an elevated point of view, the top of the subject is closer to the lens than the bottom. The top is therefore rendered larger on the negative and the print looks top heavy. A long lens puts the camera far enough away to make the difference between the top of the object and the camera, and the bottom of the object and the camera, insignificant. This balances the perspective and makes the picture look right.

Image magnification alone can be the basis for choosing a long lens. When mechanical or geographical barriers separate photographer and subject, telephotos will pull in a decent image size. The degree of magnification is directly proportional to the increase in focal length. At the same camera-to-subject distance, a 200mm lens yields an image four times the size of a 50mm lens.

As image size increases, so does the significance of focusing error and camera movement. Depth of field is a function of aperture size, which in turn is a function of focal length. The longer the focal length

the shallower the depth of field at a given f-stop, all else being equal. At moderately wide apertures and close distances this may be a matter of inches or even fractions of inches. As focal lengths stretch, it becomes increasingly difficult to hand-hold telephoto lenses without a loss of resolution due to the magnification of camera motion. A rule of thumb is to never use a shutter speed slower than the reciprocal of the focal length of the taking lens: For a 135mm use $^1/_{125}$ sec, for a 500mm use $^1/_{500}$ sec, etc.

As we move up the scale past the medium telephotos, compression of natural perspective begins to dominate in a way that is opposite and complementary to the expansion of perspective yielded by short lenses. To encompass a given object we must move farther and farther away; the scene visible in the finder starts to bunch up and a view of fields, foothills, and mountains seems to grow out of one plane while blocks of city skyscrapers begin to look like pancake-thin copies of themselves pasted onto posterboard. Sports freaks and voyeurs accept this fact of super-telephoto life: Creative photographers make the most of it by watching for interesting juxtapositions of objects normally seen as greatly separated. Sometimes the combination of extremely long lenses and air pollution or thermal turbulence will introduce odd distortions or color shifts. Like the compression effect, such optical mutations can be photographically appealing; if not, they may be reduced somewhat by polarizing, ultraviolet, or color correction filters.

PERSPECTIVE CONTROL & VIEW CAMERA BASICS

The *Merriam-Webster Dictionary* defines perspective as *"the art of painting and drawing so that objects represented have apparent depth and distance... a view of things (as objects or events) in their true relationship and relative importance."* We have seen how point of view and the selection of lenses are used to manipulate the emotional and technical aspects of photographic perspective. It is a photographer's prerogative to choose how reality is to be represented in two dimensions.

The view camera has been a part of photography from almost the very beginning, and since its introduction, it has remained the premier tool whenever total perspective control is essential. Eventually electronic image processing will supersede the photomechanical sophistication of the view camera, but for now and certainly

for the near future, no professional photographer doing even a moderately sophisticated range of business can expect to function without it.

Most 35mm and medium-format cameras are constructed rigidly so that lens and film are always held in a particular alignment to one another. Although the lens is focused by varying its distance from the film, the mechanism by which it is moved is carefully designed so that the axis of the lens always maintains exactly the same orientation relative to the film plane. In all conventional solid-body cameras a line drawn through the middle of the lens will always be perfectly perpendicular to the film plane and perfectly centered within the image area. View cameras are also designed to be rigid and precise. However, the alignment between the lens and the film plane is not fixed but instead may be adjusted and then locked in position. These adjustments (movements) make the view camera a powerful and versatile photographic tool.

The modern view camera is constructed from a modular system of interlocking parts chosen according to the requirements of various types of work. The basic configuration typically consists of a square or round section bar or tube, the monorail, on which are mounted front and back standards linked by a flexible, light-tight bellows. (The flat-bed camera and the field camera are alternate mechanical configurations that are more portable but less adjustable.)

The standards are sophisticated supports that position a lens and a focusing ground-glass and film holder. They are built to allow all the movements necessary for complete image control. They can be moved forward and backward (focus and magnification), up and down (rise and fall), and side to side (shift). They can be rotated around a vertical axis (swing) as well as tilted forward or backward around a horizontal axis (tilt). On high-priced view cameras these movements are achieved by manipulating precision geared mechanisms with finely calibrated vernier dials, whereas less expensive versions use friction-dampened sliding controls. All view cameras have some method of freezing the adjustments (lock) so that nothing changes just before or during the actual exposure.

View camera movements have two main functions: control of perspective distortion and focus control. A typical tabletop product photo might require a degree of rise plus a backward tilt of the rear standard to center the object in the frame and restore a rectilinear look, in addition to a forward tilt of the front standard to optimize the focus. A

street-level wide-angle view of a tall building might require a perfectly vertical rear standard (confirmed by the built-in bubble level) to keep everything parallel, as well as a substantial rise on the front standard to bring the top of the building into the field of view. The variations are subtle and endless and magnificently effective.

Lenses for View Cameras

Solid-body cameras use lenses that just cover the frame corner to corner, but view camera movements work only if the image circle projected by the lens is big enough to accommodate an off-axis optical displacement that might exceed the dimensions of the film by 50% or even 100%. Lenses with good coverage and high resolution at the edges of the field are difficult to make and consequently expensive to buy. Today excellent used lenses are readily available at reasonable prices, whereas ten or fifteen years ago they were very hard to buy at any price.

Front Rise and Fall

When the camera is level and pointed at a nearby tall subject, part of the subject will not be visible in the finder. Tilting the camera upwards will bring the whole subject into view, but the vertical lines will appear to converge. If the camera is again leveled, raising the lens will extend the field of view sufficiently to include the whole subject while allowing the vertical lines to stay properly parallel. Front falls are used in a similar way when the subject extends below the uncorrected field of view.

Front and Rear Shifts

Displacing the lens horizontally accommodates wide subjects in the same way that front rise and fall accommodates tall subjects. Sometimes a dead-on rectilinear view cannot be achieved because the perfect camera position is blocked by an obstacle; in such awkward situations shifting the lens will allow an off-center camera location while still maintaining perspective integrity. This is very useful for architectural interiors. Bothersome reflections can often be eliminated in this way, as well.

Front Swings and Tilts

Lenses are designed so that the plane of focus is perpendicular to the lens axis. Focus problems arise whenever the plane of focus is not parallel to the principal subject plane. Such a misalignment occurs when the camera must be tilted to encompass a tall subject, for example. In a rigid body camera focus error can be minimized only by stopping down the lens to increase depth of field, but this approach is limited in effectiveness. View camera movements allow the axis of the lens, and thus the plane of focus, to be conveniently manipulated. Front swings and tilts are considered the most valuable controls on the view camera because depth of focus can be controlled without changing aperture. Close and distant subjects on the same plane may be reproduced sharply, without altering perspective, by simply tilting the lensboard. The degree of focus correction exceeds any increase in depth of field from simply stopping down the lens. Because very small apertures reduce lens performance due to diffraction effects, increasing the depth of focus with view camera movements is the preferred technique whenever maximum image resolution is important.

Back Tilts and Swings

Movements of the back standard are really movements of the film plane. To preserve correct perspective, the subject and the film plane must be parallel. Back swings and tilts are used to maintain this critical relationship when the camera must be tilted or angled to accommodate a particularly wide or tall subject that cannot be included even with fully extended front rise, fall or shift. In such a case appropriate front tilt and swings are used to restore proper focus.

FOCUSING THE VIEW CAMERA

Focusing is accomplished by viewing the reversed, inverted image on a ground-glass screen. The image is often dark and hard to see, particularly with wide-angle lenses. Various manufacturers offer pricey space-age, laser-etched screens that can be four times brighter than conventional ground glass. A loupe or flip-down jeweler's magnifier is indispensable, as is a large, light-proof focusing cloth. A few patches of Velcro on the edge of the focusing cloth and around the top and sides of the back standard will make life easier, particularly in a breeze. Both the cloth and

the loupe may be replaced by a reflex finder with a binocular magnifier and viewfinder for easier focusing in tight or dimly lit situations.

On a monorail view camera both front and rear standards can be used for focusing, although fine focusing should be done using the film-plane focus adjustment. Because magnification is a function of lens-to-subject distance, front standard movements will affect image size but this may go unnoticed with distant subjects. Flatbed or field cameras do not allow back focusing, so the whole camera must be moved to maintain exact image size in those situations where this is critical.

The vagaries of focusing a view camera under difficult circumstances often make Polaroid tests for focus and composition indispensable, but be careful: All the mechanical parts of view camera focusing systems — the ground-glass back, conventional and Polaroid film holders, as well as viewfinder accessories — can become misaligned and consequently misleading. Locking devices can become unreliable, the nylon bushings that position the standards on the monorail can become worn and slightly wobbly, even the springs and guides that position the film holders can wear over time and contribute to unsharp results. For best results, test your equipment regularly.

HOW TO SELECT A PARTICULAR FORMAT

Many 35mm systems offer a wide range of accessories but roll-film equipment encompasses nearly every innovation in modern photography, although you may have to spend twenty-five thousand dollars to acquire several different cameras to achieve total flexibility. One can obtain superwide, supertelephoto, macro, micro, perspective control, and panoramic lenses and cameras. You can get quick change backs for 70mm long rolls, Polaroid proofs, and ground-glass focusing at the film plane. Some medium-format cameras offer the swings and tilts of view cameras and adapters to accommodate 4"x 5" film.

There are limitations to medium-format systems — the most critical being speed of operation. Some high-profile professionals are able to demand enough time to work without distracting haste, but the rest of us are not so privileged. We must cope with the many idiosyncrasies of roll-film machines while hustling around in a photographic frenzy. For example, some medium-format cameras lack interlocking shutter cock-

ing film advance levers so it is entirely possible to expose the same frame several times. I've missed photographs because I forgot to remove the dark slide from a rapidly changed film back.

Most medium-format cameras are very well built but there is no doubt that they are noisy. A motor drive relieves some physical effort but generates enough noise to limit the usefulness of roll-film cameras on assignments where both rapid shooting and low noise are essential. Stopping to load film every ten or twelve shots is a pain in the neck, yet switching to 220mm or 70mm long rolls is an expensive way to extend shooting time. There is a problem in finding a lab to handle the long lengths of film as well.

View cameras require long setup times, and they are both expensive and painfully slow to operate. Nevertheless, they are sometimes indispensable.

Here is a rough guide that will help you choose between formats. I always choose 35mm in low-light fast-moving situations, in situations where 35mm transparencies are required for slide shows, and in situations that require quiet, unobtrusive shooting. If, however, in low-light situations speed of operation is not so critical and I am allowed some measure of control over light levels, I will switch to a 6cm x 6cm SLR on a tripod. Most magazine or publicity work is shot on 35mm slide film. However for relatively stationary or detailed subjects I switch to medium format, again on a tripod. All my work with color negative is done on roll film, unless I know in advance that small prints will be satisfactory.

All complicated photography that demands Polaroid testing, all work that requires both color and b&w simultaneously, and 90% of my studio work is done with medium-format cameras. The argument for using 4"x 5" to obtain higher resolution has been eroded by the introduction of films like Royal Gold 25 or Technical Pan. Many jobs that the client expects to see shot on 4"x 5" can be successfully shot on 35mm or roll film and then duped to 4"x 5" or even 8"x 10". Some clients specify medium format just to avoid the inconvenience of having to view small 35mm proofs or transparencies.

Large format is required whenever extensive perspective controls are an absolute must, when focus controls for extended depth of field are required, or for those times when a client (for whatever reason) personally demands big negatives or transparencies.

Many clients are now asking for images in the form of electronic files delivered via modem or magnetic media. An electronic file offers virtually no clues as to the format used to make the original photograph. Because a high quality 35mm photo can exceed the capacity of even very-high-resolution scans, some digitally fluent photographers are experiencing a sort of mechanical liberation.

IMAGE COMPOSITION & DESIGN

I do not feel competent to advise anyone on how to create a well-structured image. I have no formal training in design and no conscious design technique. I know I take cues from my clients and from the visual output of others, and then react intuitively to make something that has commercial value. How or why this works is quite beyond my ability to understand. I can only recommend that you try the same approach and see if it works. Maintain an active curiosity about what is happening in the visual world around you, because advertising art, the fine arts, as well as film and editorial illustration are constantly expanding our visual literacy. Become a student of the work of your inspired colleagues and experiment with the techniques that you find appealing. Your own style will evolve naturally.

Efficient Shooting Practices

Every photographer will develop a personalized technique for dealing with the amazing variety of commercial assignments. This chapter is not intended to diminish the value of such an evolution. On the contrary, by offering some practical insights into how I deal with the many categories of professional work I hope to provide you with a technical and aesthetic foundation on which to build.

STUDIO PRODUCT PHOTOGRAPHY

There are three physical categories for studio product photography: Pictures of objects that sit happily on a tabletop, pictures of objects that are too big for a table but are small enough for the floor, and pictures of objects that are too big for the studio. I generally deal with objects from the first category, although a small percentage of work involves the second category. I rent a big studio from a local TV station whenever I need to shoot a car or a large industrial machine under controlled conditions.

Usually I will first hear of a particular job over the phone. The work begins by trying to discover what level of photographic sophistication is expected by the client and whether or not the budget can support his or her expectations. If the job is straightforward, a face-to-face meeting is not necessary. A big budget or a sophisticated shot normally requires a trip to the client's office, although some people prefer to meet at the studio. In almost every case a detailed layout or at least a

149

Figure 15.1
The challenge of much commercial work is to raise the ordinary to the extraordinary... here is a modem dynamically electrified with light delivered by an ordinary penlight flashlight. (*Mamiya 645 Super/150mm lens/Kodak EPP film/ Electronic Flash and one-minute time exposure for light-painting.*)

Figure 15.2
Cokin produces a number of special effects devices, one of which created an illusion of "speed." I used two speed-filters for this image—they were taped together at a slight angle to one another, then taped to the front of the lens. (*Mamiya 645 Super/80mm lens/Kodak EPP film.*)

sketch is provided. No commitment should be made without first seeing some kind of drawing or perhaps a sample photo to narrow down the possibilities. It is unwise to take on work on the basis of the message "I'm sending down a (whatever). Do what you can with it."

Every object to be photographed has special attributes that are significant to the client. The preliminary discussion must uncover what these attributes are and how they are to be featured. It is advantageous to determine what lighting, format, and background the client expects and to argue civilly for any variations that might make the job easier or better without compromising those expectations.

I choose small-format equipment for product work only when 35mm slides are required or when closeups of very tiny objects are needed. I prefer Kodak Ektachrome EPY Professional (balanced for tungsten light, ISO 64) for slides, and I have had very good results with the Kodak Royal Gold 25 for very fine grain 35mm color negative, even under incandescent light. I favor Ilford PAN F, rated at EI25, slightly underdeveloped for contrast control in Kodak DK-50 diluted 1:1, for black and white (b&w). Because of its very high contrast, Kodak Technical Pan Film is much more difficult to work with than PAN F but it is worth the effort when exceptionally detailed b&w work must be done in 35mm. Specifications, instructions for contrast control, and a special developer for Technical Pan are available from Kodak.

My instinct is to use medium format for product work whenever possible. A reflex finder with a built-in meter prism plus interchangeable film backs makes my medium-format SLR fast, convenient, and inexpensive to operate.

Most product photos will be reproduced to fit a standard 8½"x 11" page or an 8" x 10" enlargement. Blowing up a 6cm x 6cm or 6cm x 4.5cm negative or transparency to this size is not a problem. My preferred film for this work: Kodak EPY120 for transparencies and Kodak Vericolor Type L for color negatives. Ilford FP4, rated at EI64, slightly underdeveloped in DK-50 1:1, will handle most black and white work although I will switch to Pan F when exceptionally fine grain results are required. I use ISO 100 Polaroid Polacolor Pro 100 (Type 668) for testing with color films and Polapan Pro 100 (Type 664), also ISO 100, for testing black and white. The ISO speeds of these new films are extremely accurate: This is particularly useful for exposure testing when the final shot must be made on ISO 100 color transparency films.

Type 665 produces an instant fine-grain negative that is useful if a b&w enlargement must be pulled in rush. The developer residue and anti-halation (flare reducing) coating must be removed. I coax all the goop off with a stream of water from a vinyl hose, agitate the film in a tray of paper fixer for one minute, and then wash and dry it conventionally before printing.

The main drawback to my medium-format system for product photography is the lack of adjustable perspective control. Virtually all product photographs are shot at a slightly elevated camera position, so the vertical lines of the subject appear to diverge at the top of the image. I find that in many cases this may be remedied adequately by using a long lens — at least 150mm for 6cm x 6cm format — to increase subject-to-camera distance. Well-heeled shooters may decide to purchase one of the perspective control (PC) lenses available for medium format. Hassleblad makes a pricey but effective PC 1.4X teleconverter that works with lenses 40mm to 150mm.

Because most of my work is shot on color negative and processed in my own darkroom I am able to use another simple technique to correct perspective. Tilting the easel when making enlargements is very similar to tilting or swinging the rear standard of a view camera and offers a valuable degree of correction for diverging or converging parallels. Eliminating distortion from typical product photos requires one side of my 11"x 14" easel to be raised about an inch. The resulting side-to-side disparity in focus can be corrected by stopping down the enlarger lens to f16 or so. Some enlargers have tilting negative stages and lens mounts to deal with the focus problem.

There is no question that the 4"x 5" view camera offers maximum photographic quality and control. The extra effort and expense involved is a fair tradeoff when first-class work is required. A well-made 4"x 5" transparency is the industry standard for the ultimate in technical performance, at least in the eyes of most clients and prepress service bureaus. I choose 4"x 5" whenever depth of field or perspective must be perfectly controlled or whenever a client insists for reasons of their own.

I use Kodak Vericolor Type L for 4" x 5" color negatives and Ektachrome 6118 for color transparencies — these are both tungsten-balanced films corrected for long-exposure times. Polacolor 64 Tungsten is now available for convenient testing. I use Ektachrome EPP or Fuji Velvia with flash.

Ilford FP4 makes truly lovely large-format b&w negatives. Polaroid 668, 669, and 665 films are available in 4" x 5" as Polaroid Type 58, 59, and 55. The negative from Type 55 is retrieved the same way as described for Type 665, although the larger negative has a more stubborn anti-halation layer which can be removed with a four- or five-minute soak in sodium sulfite solution. A properly lit and exposed Type 55 negative is sharp and grainless; however it has such a wide tonal scale that sometimes contrast can be too low, particularly with a light-colored subject combined with a light background.

A quick but crisp b&w negative can be made by exposing 4" x 5" FP4 at EI125 and then tray processing by hand in Ilfospeed Paper Developer for ninety seconds at 68°F with constant gentle agitation, followed by a thirty-second rinse in running water and a one-minute fix in Edwal Quick-Fix. A fifteen-second final wash, a dip in Photo-Flo, and a two-minute blast with the hair dryer delivers a printable negative in less than ten minutes.

BACKGROUNDS FOR STUDIO PRODUCT PHOTOGRAPHY

Generally a background color or texture will be requested or at least suggested by the client. For simple tabletop work, smooth-colored paper or plastic sheets are commonly used. Materials are available already imprinted with a graduated density of color to achieve a contemporary look without having to fuss with the lighting.

Larger objects can be set on nine foot or eleven foot wide seamless paper. The paper is available as thirty-six foot lengths in a variety of colors. It is expensive — about forty-five dollars per roll in my area — and fragile. I find it simpler just to paint the studio cove whenever I need a wide background. I can cover my 15ft x 15ft x 13ft shooting space with one gallon of decent latex paint in about half an hour.

Many different surfaces of plastic laminate (Arborite/Formica) are available in 4ft x 8ft sheets, as are paper-laminate boards and wallboard. Some of the high gloss or more heavily textured surfaces will require a polarizing filter to cut down unwanted reflections. You will find it convenient to shorten the sheets to 4ft x 6ft for storage and handling.

Photographs of products on pure white backgrounds are requested quite often. A white background makes close cutting easier. The original

method of close cutting actually involves sharp bladed instruments. Mechanical close cutting—just a few years ago a standard aspect of pre-press preparations—requires a thin red or orange plastic overlay, called a rubylith. A sheet of rubylith material is laid over the photograph and a hole is cut by very carefully tracing the outline of the product's image with a fine razor knife. The resulting mask is used to completely eliminate all background density during photomechanical reproduction of the image. Nowadays, most close cutting is done electronically.

A product photographed on a white background has a more contemporary look if it appears to have a small shadow. This slight shading, called a drop shadow, is not easy to achieve. In order to keep the background pure white, such photos are often close cut and the drop shadow is later added by airbrushing or by computer, but this never really looks quite right—a real shadow is always preferable.

There is an easy darkroom technique that preserves both a natural looking drop shadow and a clean white background. The object to be pictured should be placed on a white background and lit to advantage with a pleasing shadow. Once the film has been processed, test strips and test prints are made in the normal way; however, the final print is exposed through a paper dodging mask made by cutting a hole in a test print. The hole is cut by following a little bit outside the contour of the image with a razor knife, similar to making a rubylith. Cut around the shadow as if it was a part of the object. All traces of background tone in color or black and white prints can be eliminated, but the mask must be kept moving during the exposure for the drop shadow to have a soft edge. This technique takes about ten minutes and costs less than a dollar.

If the object must be photographed in a messy situation or if the background is visible through openings in the object, a retoucher can block out the offending detail with an opaque liquid. A light-blocking paint is applied directly to the surface of the negative with a very fine brush. Retouchers prefer to work on 4" x 5" or larger negatives, but uncomplicated shapes can be successfully opaqued on medium format as well. My retoucher charges twenty-five dollars per negative for this treatment. I charge twenty-five dollars for paper masking, as well. Even today these simple techniques are often faster, cheaper, and more visually appealing than electronic alternatives.

A pure black background is not needed very often, but there are a couple of variations on deep black that can be quite dramatic. The first

requires only black seamless and a light filtered to some appropriate color and focused on the background in such a way as to form a spot of brightness with diffused, or feathered, edges. The result is a very vivid background tone that deepens gradually through richer, darker color until it goes to black at the outer edge of the image. Filter gels that can withstand high temperatures are available from theatrical lighting or professional photographic supply houses.

The second variation has an even more contemporary look and works very well with objects that have interesting surface texture. The product is placed on a clean, unscratched sheet of glossy black acrylic plastic that has itself been placed in front of a perpendicular white card or white wall. A diffused spot of light is directed at the white reflector wall or card, and adjusted until the camera picks up the reflection of the light on the black plastic as a diffuse halo around the subject. An attenuated reflection of the subject will also be visible. The overall effect is quietly elegant particularly for jewelry, glassware, and industrial items made of polished metal. This technique works well with other deeply colored plastics.

LIGHTING FOR PRODUCT PHOTOGRAPHY

In Chapter 13 I introduced the two basic approaches to studio lighting. The first is a broad, soft light that simulates daylight from a large window or skylight and the second is a carefully orchestrated combination of small and large sources, each focused and directed to emphasize particular attributes of the subject.

The ersatz-daylight method is the easiest approach to product photography — the most common configuration being a single soft light positioned above and partly behind the subject. A white reflector, called a fill card, is usually positioned below the camera to reflect light from the overhead source back into the scene in order to open up the shadows. This arrangement gives a pleasing, gently sculptured look to the subject as well as a light foreground that gradually fades into a darker background. Scaled-down and scaled-up versions of this lighting setup are used to photograph everything from jewelry to food to cars.

Adding another lamp, in this case a slightly diffused hard light positioned behind and above the subject, will provide a rim light effect that enhances the illusion of depth by optically separating the subject from

the background. The rim light can be 50% to 150% brighter than the main light. Additional rim lights, positioned slightly above and to each side of the subject strengthen the feeling of three dimensionality by emphasizing the shape and surface texture of the subject. Most product photography uses variations of these techniques.

The basic lighting arrangement must be augmented with additional hardware when shooting either a complicated object or a still life that involves several different objects with a variety of textures and reflectivity. This is the crossover point between simple and complex lighting. I usually start with a soft light above or at one side but different parts of the set are treated different ways; the lighting is built-up, layer by layer, with small spotlights — also called baby spots or kickers — and larger lights like the Lowel DPs, perhaps softened with diffusers or feathered with barn doors or beam-narrowing devices, like snoots or fresnels.

Mirror fragments can be positioned with putty or plasticine just outside the field of view in order to reflect slivers of light into areas that are too tiny to be lit directly. Sometimes paper or tinfoil reflectors are cut to size and taped to the back of glassware to brighten up texture or contents. Similarly, light can be directed upwards through a hole in the base of the set to achieve an even more startling effect with translucent objects.

In this work you make your own rules. There are no secret formulas; however the Law of Extraordinary Effort (described in Chapter 19) begins to operate as you start attending to the subtleties of lighting in an imaginative way.

PROPS & SUPPORT SERVICES

Chapter 10 explores the many support services available to commercial photographers. You must decide for yourself if the budget and the level of sophistication of a particular job justifies calling for outside help.

In the beginning, you will be willing to find or make all the props needed for elaborate product shots yourself, but as your time becomes more valuable this may seem less appealing. Often clients can be enlisted to help. Ordinarily the client will supply the product to be photographed, and it is likely that some related objects and possibly a background material can be supplied at the same time. For example, if you have been asked to photograph a can of paint perhaps the client

has easy access to paintbrushes, stirring sticks, paint trays, etc. The same client might have a used painter's drop cloth which would make an interesting background. All you have to do is ask.

SETTING UP THE STUDIO FOR PRODUCT WORK

I have a copystand with a motorized shooting platform built into one wall of the studio. It's very handy for tabletop shots of small products because the fingertip control over the position of the shooting stage allows the selection of a comfortable working height. The platform is only two feet square, so for larger objects I extend its size by clamping on a larger piece of plywood. The edge closest to the camera is supported from underneath with a small light stand once the working height has been determined. A practical alternate is to make a shooting table with a Black & Decker Workmate, a very versatile portable workstand available at any hardware store.

Larger objects can be shot on ¾" plywood laid over a couple of Workmates or simple collapsible saw-horses. Bigger objects go directly on the floor.

As I mentioned in Chapter 12, a lighting grid suspended from the studio ceiling makes complicated lighting less difficult by eliminating the clutter of lightstands and wires. If such an arrangement is not possible, I recommend that in addition to several conventional lightstands you obtain a light boom that will suspend the main light above the set and allow precise manual remote control over its orientation. Actually, even with a ceiling grid, there are many situations where the boom will be indispensable for precisely locating a critical light or reflector.

After having created a couple of fancy lighting setups you will recognize the significance of my earlier suggestion to equip the shooting space with several independently fused switched outlets in strategic locations. Lacking such a luxury, make sure that only industrial-strength extension cords with reliable connectors are used to supply the electricity for those power-hungry incandescent lamps. Remember that quartz-halogen lights are fire hazards. A tightly focused beam from a 1000-watt lamp can easily ignite paper, cardboard, cloth, or wood. Keep an extinguisher nearby. Quartz lights will fail if jarred sharply while operating. It is a good idea to secure lightstand legs and power cables to the floor with gaffer tape.

All product photography with tungsten lights will involve sufficiently long-exposure times to warrant a sturdy camera support. Life is much easier if a studio camera stand, rather than a conventional tripod, is used for this important purpose. On location the tripod is a practical tool because it is lightweight and compact. In the studio, the main function of a camera support is to keep everything steady while allowing freedom of movement when necessary. Studio stands are designed with locking wheels for ease of travel around the shooting area and they have counterbalanced camera supports which facilitate quick and precise height adjustment. A good studio stand is a worthwhile investment, particularly for careful work with 4"x 5" equipment.

EDITORIAL PHOTOGRAPHY

Photojournalism is not included within the province of commercial photography because of the notion that news is not a product to be bought and sold. Photojournalists are supposed to be removed in some way from the corrupting influences of the marketplace. Editorial photography, the kissing cousin to photojournalism, is very much a part of the business world in that it supports and delivers two clearly defined products: entertainment and information.

Photographers who work for magazine art directors are expected to be sensitive to both editorial policy and design philosophy so as to produce work that fits into an ongoing format. Creativity, originality, and insight are expected and appreciated, provided the style of the publication is not compromised. The editorial photographer is an instrument of cultural propaganda, and as such, must go out into the world and extract from it images that fit a particular ideology. Diplomacy is as important as photographic technique.

The look of a magazine is the responsibility of the art director (AD). It is important to realize that photography, despite the fact that it may sometimes take up more space than the written work, is only one of several components. Once the writer, together with his or her story editor, determines the thrust and tone of the article, the art director will have specific ideas as to how the article can be reinforced visually, and the photographer will be expected to quickly produce stylish images that will enhance those ideas.

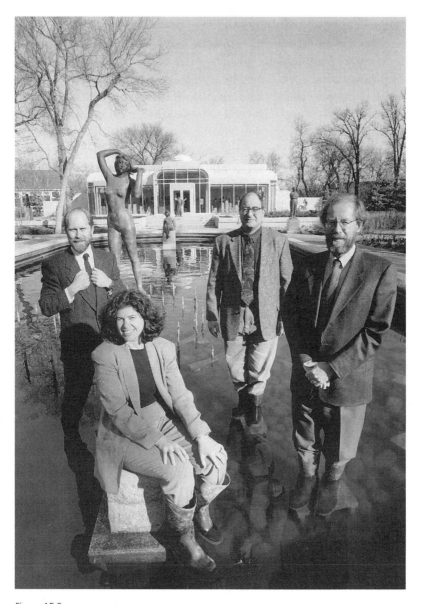

Figure 15.3

I placed this group of landscape architects in a reflecting pool that they themselves had specified for one of their award-winning projects. An architectural magazine had commissioned a cover photo, and I took a chance with this whimsical approach. The art director loved it. (*Mamiya 645 Super/35mm lens/Ilford FP4 film.*)

You will normally consult with the AD over the phone and a layout, and a few relevant tearsheets — printed samples of work the magazine has previously published — will be sent to you by courier. In very tight situations, a sketch may be faxed. It is important to study the tearsheets in order to fully understand what style of work is expected. It is prudent to obtain some back issues of the magazine for the same reason. Sometimes you will speak directly to the writer or editor in order to get a clearer idea of the purpose of their story, but always remember that your client is the AD.

Always find out exactly what timeframe you will be expected to accommodate. Deadlines are very, very important in the magazine business. Not all art directors have a clear understanding of photography so they sometimes make demands without regard to the technicalities. Right from the beginning of negotiations be realistic about deadlines and straightforward about limitations imposed by the medium itself.

Sometimes you will be asked to take care of processing, but very often undeveloped exposed film must be sent to the client by direct messenger. Good exposure technique will reduce the risk of a technical embarrassment: Always bracket at least ±⅔ stop with reversal film.

Virtually all color photographs reproduced in magazines come from 35mm or 2¼"x 2¼" slides. Events that must be documented on the run, such as political meetings or campaigns, sports, and the performing arts, can be shot on 35mm, but cover shots and important portraits will likely be requested on medium format. Some magazine work is done with b&w material, but more and more often b&w images are electronically derived from color originals.

Most of the editorial work I do is shot with ISO 100 Kodak Ektachrome EPP, perhaps half on roll film, and half on 35mm. Fast-moving subjects require higher-speed films, and even grainy super-fast emulsions are acceptable if important images cannot be made any other way. The selection of equipment varies according to the subject matter and the time available for shooting. Some sensitive reportage situations require very discreet 35mm work with available light and long lenses, whereas an environmental portrait of a businessman or politician might call for some heavy-duty lighting and medium format. Exotic editorial illustrations are sometimes shot on 4"x 5", as are most photographs intended for publication in upscale architectural maga-

Figure 15.4
Artful environmental portraiture is the heart and soul of quality location photography for industrial, editorial, and advertising purposes. In this photograph, a scientist is at work in a facility that manufactures drugs. The trick—or the art—to this work is to find an aesthetically appealing location in the midst of normally chaotic environments. Lighting is used to isolate and embellish the subject while revealing enough of the surroundings to make the point. Here a single light source is bounced off a conveniently located wall. Slight diffusion adds to the gleam of the uniform and stainless steel tubing. (*Hassleblad/60mm lens/Ilford FP4 film/Electronic flash.*)

zines. Expect to spend more time arranging access to people and places then actually shooting.

Some editorial assignments require studio and location still-life work. The techniques will be similar to those used for product photography. The selection of backgrounds, however, will require a slightly different approach because in editorial work the context is just as

important as the subject. For example, if an agricultural story requires a photo illustrating a particular kind of grain the AD would likely prefer a shot of a sunburned, callused hand holding the seeds in front of some interestingly textured sacks or farm machinery rather than a slick-looking seamless backdrop.

Unless isolation of the subject serves the purpose of the story, editorial portraiture is similarly contextual. Businesspeople are photographed in their office or factory, scientists will be shot in their labs, and athletes in the gym or on the playing field. Often such portraits will include other people, and your job will be to illustrate some sort of working relationship. If your diplomatic skills are good you will generally be quite free to orchestrate the photograph to suit yourself. Be selective about the background elements that are included in the photographs, and choose areas and objects that are editorially significant but also geometrically pleasing. Unless there is some purpose in doing otherwise, try to line up the camera so that vertical lines in rooms, buildings, and other structures appear vertical in the photos.

Editorial work involves photography of both people and objects so electronic flash is more useful than incandescent lighting. Nevertheless, don't forgo a tripod because many situations can be shot successfully with available light.

Magazine assignments must be done quickly because of tight deadlines and because the subjects of the photos often have little time to spare for posing. I have developed a very compact lighting kit that is easy to carry and simple to set up and tear down. I've permanently attached a 400 wattseconds (ws) flash generator with a large easy-to-grip handle to one leg of a wheeled, collapsible lightstand on which is also mounted a fan-cooled flashhead with an extra-bright (500 watt) quartz model light. A small tripod, a 72" silver and white umbrella, and a heavy-duty extension cord are secured to the lightstand with an elastic strap. In addition to two cameras bodies, lenses, and film, I also carry a flashmeter, a replacement model-lamp, and a remote infrared trigger for cordless flash-synch. In the car I carry a backup portable flash, a one hundred foot extension cord, and a folding reflector that I use to fill in harsh shadows.

If a light-colored wall or ceiling is not conveniently located for bounce flash, the large umbrella is an attractively broad light source with soft shadows. It also collapses quickly for easy movement through

doorways. The short flash duration and the remote trigger system allow fast and convenient hand-held shooting in either 35mm or 2¼" x 2¼" format. At 400ws the flash is usually bright enough to overpower the ambient light so color balance is not a problem.

In some circumstances, for example a portrait that includes a relatively dim computer screen, I put the camera on the tripod, and shoot by available light. Sometimes it is easier to simply turn off the room lights and use the model-lamp as the main source. If the room is lit by fluorescent lights a 30M (magenta) gelatin filter, available in various sizes from Kodak, will correct the greenish color-cast for Ektachrome daylight film. Usually no filtration is required with daylight film under mercury-vapor lamps, although I have used as much as 30R (red) in some locations. Yellow sodium-vapor lamps, ordinary tungsten fixtures, and the model-lamp by itself all work fine with unfiltered tungsten-balanced Ektachrome.

From time to time a shot of a person or an important object within a large fluorescent lit room requires balanced flash — a combination of available light and filtered electronic flash. In this technique, the camera is placed on the tripod and a 30M filter is used over the lens. A 30G (green) gel is positioned over the flashhead in order to match the color temperature of the flash to that of the ambient fluorescent lights. The camera aperture must be adjusted to give the correct flash exposure, and the shutter speed is adjusted to accommodate the fluorescent lights. A typical exposure for EI100 Ektachrome might be f11 at ¼ sec. With a little coaching, people are quite good at remaining still for up to one second. No color correction is necessary when using this technique to balance flash and daylight or when shooting in black and white. Unfiltered balanced flash is commonly used to preserve a natural look when working in a room with large windows and an interesting view of the outside.

Most editorial clients will be satisfied with sharp, well-exposed slides that show what they asked for so most assignments can be shot with the imaginative use of a single flash in combination with the available light. Nevertheless, any extraordinary effort will be immediately noticed. Magazine art directors are very talented people but they are constantly frustrated by the hassle of having to find competent photographers in distant places that can be trusted to do even marginally acceptable work. Competent work, delivered on time, is very much

appreciated. If you go farther and produce a few clever variations in lighting and composition in addition to fulfilling the basic requirements, you will delight your clients and assure your place in an exciting market. This may require hauling around a more elaborate lighting kit or some diplomatic begging for more time from busy people but it will be well worth the effort.

EDITORIAL ARRANGEMENTS

Magazines spotlight intense, controversial, and very contemporary people and issues. It is not always easy to get close enough fast enough to produce timely photographs.

If clients are not prepared to make introductory calls or help you work through the inevitable glitches, much time will be wasted and the effectiveness of the photography can be compromised. Unfortunately, some editorial clients fade into the background after initial telephone contact. They feel they are buying an aggressive point-man and a hotshot photographer in one stroke. By taking such an unsupportive tack, clients are avoiding their own homework and demanding a service that they don't really pay for. If the AD, the writer, or the editor refuse to help arrange access to difficult people or locations, try and persuade them to free up a lesser personage, perhaps a research assistant or even a secretary, to do a little work on the telephone in aid of your project.

In the case of demanding clients that you wish not to offend, do all the legwork yourself or hire an assistant to do it for you. Happily, that's not the only type of support that an assistant can render. Enthusiastic help on location can mean the difference between ordinary and extraordinary photography.

An intelligent and self-motivated assistant can not only arrange the necessary approvals in advance of a complicated shoot, but can also have the appropriate equipment in place before you arrive and then tear it all down after you're done. You won't have to search for cameras, lenses, and loaded film backs during the shoot either, so the distractions will be at a minimum. Busy subjects will appreciate the fact that someone is on-hand to take care of the technical details and will consequently relate to you as more of an equal: The better the rapport, the better your work can be.

When people are to be photographed in the studio, have everything prepared ahead of time so that they will not be inconvenienced or irritated. Clothes and accessories should be discussed in advance, but have them bring extras, just in case. Most subjects, including hard-nosed business types, are soothed and relaxed by the attentions of a hair and makeup stylist.

Magazine clients expect the studio portraits they commission to be stronger and more exotic than conventional portraiture. This might mean specially painted backdrops or high-contrast lighting or simply an unusual point of view. Sometimes, conflicts can develop because the approach that best serves the editorial purpose may not always be the most flattering to the subject. It takes some skill to smooth ruffled feathers, and you might have to deflect a little anger on behalf of your client in such circumstances. This is not an occupation for the squeamish. As a rule I avoid working for those art directors who expect me to be unkind on their behalf.

Every magazine has its own payment schedule, either a day-rate or page-rate, plus expenses. Magazines are very forthright about rates and rather inflexible so you will not have to guess what your work is worth to them. Editorial assignments for national magazines pay about half of what is typically paid for commercial advertising photography in big cities.

National magazines will pay four hundred to five hundred dollars plus expenses such as film, processing, and travel for a typical assignment that might involve a day's work yielding anywhere from one to five specific images. Expect 50% more for a cover. Local magazines pay about half the national rates, or even less, and they are usually more than willing to trade advertising space in exchange for photographic services.

ANNUAL REPORTS & EXECUTIVE PORTRAITURE

Working directly for corporations is much like editorial photography. There is a similar mix of studio product shots, location portraiture, and industrial views; however the financial stakes are higher. Rates are often double the amounts paid for editorial assignments. The philosophical approach is unashamedly partisan, with the emphasis on a stridently positive presentation.

The work will be assigned by an independent designer retained by the corporation, by an advertising agency AD, or by someone in-house, perhaps an executive-assistant in charge of public relations (PR) or human resources. In the first two instances, all the familiar rules of working with visually literate professionals apply, but in the case of the in-house AD, some extra attention is required. Corporations look carefully at each other's annual reports and a particularly lavish production by IBM or Xerox, for example, will inspire many enthusiastic PR people in smaller firms. Since they are sometimes unaware of the real costs and effort involved, my first question to such people is always, "Are you working with a designer?" If the answer is "No," I try to convince them of the advantages of hiring a professional designer, and I recommend two or three of my designer clients.

If the professional design route is rejected, your job will now involve much more than photography. If the client recognizes and respects good work and is willing to take some advice, the project can be good

Figure 15.5
Many commercial images used for business and institutional purposes include computers and women. Here is a location solution involving only one light. (*Mamiya 645 Super/80mm lens/Kodak EPP film/ Electronic Flash.*)

fun and professionally stimulating, although it is unlikely that any nonphotographic design services you provide can be billed directly. When the client is unable to make decisions based on photographic realities, or if every aspect of the work must be approved by someone high up in the corporate structure, the assignment can be a nightmare of false starts and reshoots. It is difficult, but prudent, to determine in advance exactly who will be evaluating the photography and what criterion will apply. A policy should be developed to deal with reshoots and cancellations requested by the client or the client's superiors. Tact is of the essence as corporate politics can make people very touchy.

Deadlines are just as important in annual report work as for editorial work. Businesses are obliged by law to produce financial information at specific points in their accounting cycle. Make certain that corporate clients are aware of how long it will take to produce decent photography. If clients ask for additional work during the course of the project, they should be clearly told how delivery times will be affected.

The tools of choice for annual report photography can be similar to what one would select to do good editorial shooting; however higher budgets and longer lead times make larger format and slower films the favorites. That is not to say that 35mm is unacceptable, but simply that all small-format work must be technically first class.

I have found that corporate assignments that originate out of town must usually be shot on transparency film. On the other hand, annual reports that are designed and printed locally can often be shot on color negative, with the big selling point being the economic advantage of having prints made to size for gang-separation.

The photomechanical process for color printing requires the preparation of three individual black and white separations which represent the cyan, yellow, and magenta components of the image to be reproduced. In four-color process printing, these colors, plus black, are laid down one at a time with different inks. Nowadays, separations are made electronically on a precision laser scanner. Color prints or color transparencies can be accommodated with the flick of a switch. The typical industrial-size scanner will accept images up to twenty-four inches square. The separations are made the same size as the final size for reproduction. Significant savings are realized if several small images are scanned together and gang-separated, rather than doing just one at a time. Because color balance and size are adjusted during the separa-

tion process, the individual images to be gang-separated must be color matched and sized proportionally, i.e. all photographs made to 100% of the final reproduction size, all 150% of the final size, etc. This is easy to accomplish with color prints.

Generally corporate work proceeds at a more dignified and deliberate pace than editorial shooting. There will be more time and more cooperation because the client will have a fairly clear notion that your purpose in being in his or her office or factory is beneficial. Whenever management communicates a willingness to cooperate, shooting in the workplace can be a morale raiser for everyone. Some individuals, for their own mysterious reasons, resent any sort of interruption: You will just have to work around these people.

You will have enough time to work, but you will still be expected to work efficiently. Both executives and production workers have busy schedules so time-out for photography costs money. A shot involving a machine inside a manufacturing plant might temporarily shut down an entire assembly line and idle many workers.

Annual reports are meant to glorify corporate activity, and this often demands sophisticated lighting and some site preparation. In an industrial situation this means transporting and setting up light-stands, umbrellas, and big power packs, cleaning up grimy machines and floors, as well as keeping an eye out for safety hazards; not a one-person deal. It is inefficient and possibly dangerous to try to do this sort of work without help.

My assistant and I work as a team. We have found that a collapsible two-wheeled dolly is very handy for transporting heavy gear through corporate offices and factories. The flash generator is strapped in at the bottom for balance, with camera and film bags on top. A tripod, three or four lightweight wheeled lightstands and umbrellas are attached to the back with elastic straps. We carry long extension cords in crank-operated wire caddies.

A typical corporate or industrial scenario begins with the creation of a timetable for photography. This might be arranged after a walking tour of the facility a few days earlier, but often the site is previewed the morning of the shoot and a logical shooting schedule is mapped out at that time. The client will then tell people when they will be needed for pictures and what preparation their work-area requires. Even the Chief Executive Officer (CEO) needs to clean up his or her desk.

Color Figures 1A & B

Many exotic effects can be created using computer technology, but I prefer to go as far as I can in the camera. These two images are the unretouched results of controlled double exposures. I created the various light beams by covering slits cut in black matte board with filter gels. Pencil sketches on the ground glass of my 4"x 5" camera allowed precise positioning.

Color Figure 2

This collage of medical/research related items was part of a series that was used in a well-produced government publication promoting health-related industry in my home province, Manitoba. All the items were carefully placed on a back-lit acrylic sheet. The specimen dishes, etc., were filled with water dyed with food coloring. A soft-light above and to the side provided some modeling.

Color Figure 3

These cheerful guys were shot for a national magazine that focuses on successful young entrepreneurs. The two distribute fresh fruit and vegetables. I used their product for the foreground and one of their tractor trailers as a background.

Color Figure 4

This image was used to feature the human resources department of a large corporation. The designers specified a three dimensional cut-out, which was fabricated by a props maker from acrylic plastic. The little man and the hand were lit with warm light, and the blue paper background was enriched with blue filtered light from below.

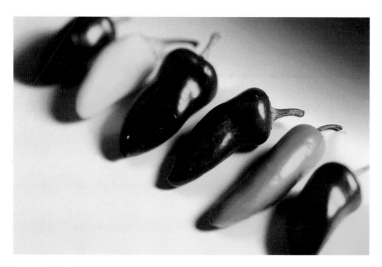

Color Figure 5

Here is one of a series of images on the theme of HOT! HOT! HOT! which were created for the call for entries for the Signature Awards, sponsored by the Advertising Association of Winnipeg. I produced the pictures for the cost of materials only, and for my trouble had my name attached to a beautifully designed and printed piece that went directly to every advertising professional in my market. An added bonus — I entered the project in the photography category, and it won the Signature Award for best use of photography.

Bird's-eye views of large industrial installations are just too complex to light, at least when working to a normal budget, but most machine-level shots involving one or two people are manageable. I talk to whoever is to be in the photo at the same time as I am setting up the lighting; just a breezy patter to set a relaxed mood, intermixed with questions about the purpose of the machinery and safety precautions that need to be observed while we are working.

Typically a main light, most often a 72" umbrella or large softbox, is placed slightly to one side of the subject and angled carefully to spill some light onto the background. A second light, also a fairly big umbrella or softbox, is positioned somewhere behind and above the subject to provide some backlight on both the person and his or her tools. Reflectors or additional lights to fill shadows and highlight important details are positioned as required. A vise-grip pliers with a ⅝" stud welded to it is handy for securing lights in tight corners. Care must be taken to avoid distracting reflections from shiny metal surfaces and flare from lights positioned just outside the image frame.

While I arrange the lighting and find an interesting point of view, my assistant finds a power outlet, checks on the location of the circuit-breakers, connects the flash generator, and cleans up the shooting area. We always carry paper towels and spray cleaner with us. The scene is metered with a flashmeter, and a Polaroid test is made with my assistant standing in for the machine operator. The real subject is actually needed only for the few minutes during which two or three rolls of film are fired off. Exposures are bracketed ±⅔ of a stop for transparency film and not bracketed at all for negative film. Once I'm satisfied that I have a good shot all the stuff is wheeled to the next location.

White-collar corporate work unfolds in exactly the same way, except that site cleanup consists of rearranging office furniture and accessories rather than scrubbing grease off machines. Very busy executives and the CEO will have been informed well in advance of the session, but you can expect only ten to fifteen minutes of their undivided attention for the actual shooting. Group shots are even worse because the behavioral age of people in groups decreases in inverse proportion to the number of people involved. Sometimes one has to be quite stern. Call in the most senior people just before you're ready to shoot: They are usually the most impatient but their appearance inevitably has a disciplinary effect on their colleagues.

Portraits of CEOs and other executives require special attention. Whether they are male or female they must appear to be strong, honest, bold, sensitive, kind, generous, intelligent, healthy, and attractive. This is not always easy to achieve. The environmental elements must be carefully chosen. Good taste and a harmonious balance of textures are important. Watch out for objects in the background that might appear to grow out of the top of a head, such as plants, pole lights, window mullions, or vertical seams in walls. Even the jazziest offices have lots of silly collectibles laying around — avoid including anything shabby, worn, or vulgar in your shots. Clothing should be conservative and properly fitted. Hair should be neat without any stray strands. A little pancake makeup will disguise most facial blemishes.

There are a number of sturdy-looking postures that will work for ¾ length portraits, but whatever the pose make certain that the subject's back is straight as this will contribute to a look of sincerity and alertness. Men should keep their hands away from the crotch; women should make sure that their legs and necklines are organized in some dignified way. A slight forward lean, combined with a warm expression gives either gender a look of quiet strength. Slight diffusion is sometimes appropriate for informal working portraits. Something to hold makes people feel and look more in charge — try pens, eyeglasses, business-related books and folders, or even one of the firm's products if the scale is appropriate. The mechanical aspects of holding something (i.e. the position of fingers and arms) should appear natural and unobtrusive.

Lighting for executive portraits can be unconventional for younger individuals or companies, for example strong, unfilled side-light combined with hard, bright rim light adds energy to an executive portrait. Older executives and conservative firms prefer to forgo drama in favor of a more classic look.

Your assistant is your main helper while on corporate assignments, but it is necessary to have an authoritative executive somewhere in the background to call on in case of difficulty. This person will most likely be the executive immediately superior to the PR person who is your escort at the site and he or she should be the one to put pressure on any uncooperative types. Every job will have a tense moment or two when access to some important person or location is unexpectedly blocked. Life is much easier if the political clout is on your side.

PUBLIC-RELATIONS PHOTOGRAPHY

Public-relations photography is underrated. The noisy paparazzi who pursue the rich and famous are regularly ridiculed, whereas corporate or institutional grip and grin shooting is considered in some circles to be just too ordinary for words. But think about this: PR photography is one of the few profitable photographic disciplines that can be undertaken with small-format equipment and the most basic of electronic flash lighting. This work is perfect for aspiring professionals or photography students in search of supplementary income.

Public-relations photography is a utilitarian hybrid of editorial and corporate work. It requires a supercharged version of the optimistic boosterism of an annual report in combination with a rapid fire editorial technique. Budgets are smaller, and most assignments focus on one-time events such as press conferences, awards presentations, or trade shows.

After television, the most direct conduits to the public are newspapers and popular magazines. The main vehicle for delivering everything besides hard news to the print media is the press release, which invariably consists of a few hundred words of prepared copy plus one or more photographs. These photographs are the heart of PR work.

Two factors make PR work accessible for beginners. First, PR photographs are not usually the focus of a press release, but rather are regarded as support materials for the copy. Consequently, PR images are not judged the same way as feature photos for a conventional ad campaign or editorial piece. Second, the conventions of the business preclude elaborate lighting setups and highly choreographed shooting sessions; consequently 35mm cameras and direct flash are the main tools.

As a result, anyone who can catch flattering expressions during brief photo opportunities has a decent chance to make money. Naturally a good measure of tact and some technical insight are required, but a big investment in large- or medium-format cameras and studio lighting is not.

Elaborate PR work is technically similar to annual report photography. Most often, however, simple flash-on-camera lighting and a 28-90mm zoom lens on a 35mm camera will do the job. Color negative, from which both color and b&w prints plus the occasional color slide can be pulled, is the film of choice. I find that the low contrast of Fuji Reala works well with direct flash. Processing and printing one's own

work is a guaranteed way to speed up the learning curve. Making multiple prints, the main currency of PR work, is like printing money.

Because many of the events that must be recorded occur in small rooms, bounce flash can be used to give a more professional look to what might otherwise be very ordinary snaps. A small flash-mounted softbox can make the light more flattering when the room is large. Public relations events usually require the photographer to wear a suit and tie.

To get started in the PR business I recommend developing the necessary quasi-journalistic skills by shooting for the many small business newsletters and in-house magazines that are published in every community. The basic requirements are fluster-free management of the equipment and quick, accurate reflexes. Cheerfulness and a diplomatic way with people are also essential. Practice is the key.

Once sufficient self-confidence has been built up, a small portfolio of successful images can be shown to the people in charge of PR, community relations, or information services at larger business firms, government agencies, or cultural institutions. Even in modest-sized communities there are agencies that specialize in PR and spin control. These people all need the same thing from their PR photographers: politeness and efficiency.

Curiously, for the very few minutes during which PR photos are made, the photographer will often be granted control over the arrangement and behavior of the subjects: The unspoken understanding being that the photographer is a professional interested in producing the most effective and flattering image possible. The first time this transfer of power occurs — brief though it may be! — is usually something of a shock, particularly if the subjects are powerful or famous people. Remain calm. Breathe deeply. You will get used to it. I was hired to produce PR photos of the Prime Minister of Canada during a short political stop in my city. I found the work remarkably similar to shooting ordinary presentations, speeches, and press conferences for regular executive types — easier, in fact, since all the security police guaranteed lots of working space and the Prime Minister, at 17% in the popularity polls, was extremely motivated to help produce useful images.

While seeking work and undertaking assignments, it is important to remember that PR work is not photojournalism. Public-relations specialists are always advocates for their clients. I emphasize this point

because even subconscious resistance to the idea will introduce a noticeable degree of negativity in your photos.

Income is related to the affluence of the clients one serves and the use to which they put the pictures. The paparazzi are a mutant strain of PR photographers whose clients, the glamorous and not-so-glamorous tabloids, pay big bucks for shots obtained by methods that are often something less than ethical. A single image of some hapless celebrity in a compromising circumstance may net thousands of dollars. Mainstream public relations work might bring in anything from twenty-five to one hundred dollars per hour, depending on the significance of the events and the people being recorded. The range is wide because PR shooting is an integral part of so many aspects of business, political, and cultural life. The person who photographs the presentation of a gold watch to a retiring middle manager is doing a similar job to the personal photographer of the President of the United States. It's simply a matter of scale.

AUDIOVISUAL PRESENTATIONS

Audiovisual (AV) work is another hybrid style that requires the techniques of product, editorial, and PR photography. Until recently, all AV shows were 35mm slide shows, but now video and multimedia presentations are almost as popular. The electronic media works best for individuals and small groups so there is still a considerable demand for conventional photography. Many video presentations are, in fact, based on electronic reproduction and manipulation of 35mm slides.

Shooting for AV is like making a little movie. The work is scripted and a detailed shot list, or storyboard, will be provided. Some studio photos will be necessary, but because AV shows are typically intended to sell a service or to teach someone how to perform a service, there will be a greater proportion of location shooting.

Most AV budgets are on the slim side so expect to work quickly. The slides need not look as slick as those intended for a magazine or an annual report; nevertheless, on-camera flash lighting will not do. One umbrella or flashhead on a rolling light stand will be satisfactory, however, as will zoom lenses and a moderately fast film, such as Ektachrome 200. From time to time some extra lighting may be required for complicated shots, but most often, a single light or available light will

suffice. (Fluorescent lighting should be corrected with a 30M filter, as discussed earlier.)

Because AV presentations are supposed to be shot according to a predetermined plan, the production company will have one or two people accompany the photographer on location. These people will assist during shooting, so an official assistant will be unnecessary. Tactfully inquire ahead of time as to whether this will in fact be the case.

Slide shows tend to be quick and dirty projects characterized by long hours and relatively low remuneration, sometimes only a couple of hundred dollars per day. On the plus side, you will come in contact with many business people whom you may wish to contact in the future (provided there is no objection from the AV firm), and you will get a thorough technical workout. The production people, being highly skilled in location diplomacy, know how to organize things efficiently so watching them in operation will be a valuable learning experience. Audiovisual shows require hundreds of slides so a certain degree of experimentation is welcome, and a few reshoots are not unexpected.

CATALOG PHOTOGRAPHY

Almost all catalog work will be done in the studio. The market encompasses a tremendous range of technical and aesthetic approaches, with budgets to match. Middle and high-end catalog photography has seen the rapid encroachment of digital imaging technology, since electronic processing, retouching, separations, prepress assembly, etc., can be done quickly, economically, and consistently where a high enough volume of work justifies the costs of equipment and training.

The most basic catalogs are shot in black and white on conventional film. Relatively high-contrast prints with plain white backgrounds are favored for reproduction on newsprint. It is not unusual to shoot dozens of objects, perhaps packaged food or hardware items, one after the other, with virtually the same lighting and camera position. Such consistency is actually preferred and most catalog shots are routinely retouched to eliminate distracting reflections or shadows that result because of the lighting constraints. Sometimes 4"x 5" Polaroids are satisfactory as final prints. Very short deadlines are normal.

In my area, low-budget studios charge as little as twenty-five dollars per shot and a photographer working for fifteen dollars per hour might

be expected to produce forty or fifty pictures in eight hours. From my perspective, this is basically the rock bottom of commercial photography, although many hard-working photographers rely on annual catalog accounts for survival.

Moving upward on the catalog scale takes us into color books with higher production values. A more sophisticated approach is needed, with more individual treatment for each item. The point of view might be more or less the same for every shot, and one background color or texture might be used throughout as a stylistic device. All photography is expected to tastefully demonstrate the important attributes of the product being sold. Rates here start at about four hundred dollars per page, with anything from one to ten photographs, each shot to exact size for gang-separation. A major catalog could be two hundred pages, so sometimes the photography will be split between several studios. Because many catalogs feature light-colored objects such as jewelry, tools, and chrome appliances, transparencies are preferred, so even today the 8"x 10" view camera is of value. Catalog clients will expect any photographer that takes on their work to accommodate all items, big or small. A large studio with a loading dock to handle truck-loads of merchandise, including appliances and furniture, is a necessity.

Smaller scale specialty catalogs are more manageable for the one-person operation. Such pieces are produced by some of the high-profile retail chain stores or even well-heeled industrial supply houses of various kinds. All that is required, aside from the basic skills for high-quality product photography, is a sympathetic approach to the needs of the target market and a willingness to learn enough about specialized products to shoot them in an imaginative but appropriate context. Usually a designer will be involved before the photographer, but if not, the client should at least be informed of the value of professional design and provided with a couple of names. Sometimes the photography will involve one relatively contemporary background, say high-gloss black plexiglass, used in several slightly different ways with an assortment of products. Sometimes more elaborate sets must be built and propped, perhaps weathered barn-wood shelves for fancy kitchen utensils or chrome-wire grids for computer hardware.

As a rule catalog photographs will be reproduced side-by-side and slight variations in color balance will be painfully obvious and quite distracting so consistent color balance is a subtle but important

consideration. It is therefore extremely important to stick to one emulsion batch and the same processing lab when shooting a multishot job. Similarly, it is best to use the same lighting fixtures and bulbs throughout. The color response characteristics of film, particularly reversal film, change with temperature, so make certain that materials taken from the freezer have enough time to warm up to room temperature. A fifty sheet box of 4" x 5" film will need at least four hours to get from -10°F to +70°F.

If several white objects, such as running shoes or dinnerware, have to be shot on transparency film with different color backgrounds, the objects will pick up a color-cast from the background and no two whites will appear the same. This is very unprofessional looking, and it is worth some effort to talk the client or designer into selecting a single color for all the shots. If this is impossible, however, some improvement can be effected by raising the objects off the background by an inch or two. Changing the angle of the object relative to the plane of the background surface can also reduce color contamination. As a last resort, each photo can be filtered slightly to bring all the whites to one color. This will require some testing and a selection of Kodak gelatin color correction filters. Obviously, it is much easier to fix the color by individually balancing prints made from color negatives.

COPYWORK

Some types of photography are not very glamorous, and copywork is a good example; the skills required are very simple, the time involved is negligible, and the necessary equipment is inexpensive. Nevertheless, refusing work because it is too ordinary is just not sensible.

Copywork, also referred to as flatwork, is the reproduction of existing two-dimensional printed material through photographic means. The image to be reproduced could be a photographic slide or print, an architectural rendering, or even an illustration from a book or magazine. The copy itself might end up as a 35mm slide, an 8" x 10" print, or a wall-size mural. The basic criteria are sharpness, color fidelity, and contrast control. There are a few simple tricks that can make the work easier.

I prefer tungsten light for copywork because a bright, continuous source speeds up both focusing and lining up the camera. A little

care must be taken with heat-sensitive originals, but usually there is no problem.

The basic arrangement for flatwork places the camera exactly perpendicular to the material being copied. Lights are positioned at 45° on either side of the camera to project an even field of illumination while avoiding reflections. A single light is perfectly acceptable for copywork as long it can be adjusted for uniform brightness over the whole image area: I have found that the focusing capability of the Lowel DP lamp is very handy in this regard.

When the material to be photographed is not perfectly flat, changing the angle of the light will sometimes eliminate unwanted reflections and hot spots; but some shiny, irregular surfaces — an oil-painting, for example — cannot be accommodated in this way. In difficult cases the only remedy is polarization.

HOW POLARIZERS WORK

Light is composed of energized particles, called photons, that vibrate as they travel along an otherwise straight path. The frequency (the number of vibrations per second) determines the color of the light. The plane of the vibrations relative to the direction of travel determines the polarity of the light. Generally, the polarization of light is more or less random, which is to say that the photons vibrate in any and all directions as they travel along. A polarizing filter has the wonderful ability to transmit only those photons which are vibrating in one particular plane, called the axis of polarization. If two polarizing filters are placed so that their respective axes of polarization are oriented at 90° to one another, the resulting sandwich will be perfectly opaque to all light. This property may be invoked electrically in certain materials: Liquid crystal displays operate on this principle.

Many materials reflect or absorb light of only one polarity. For photographic purposes the reflectivity of such materials may be reduced by controlling the polarity of the illumination. Polarizing filters for lights are available in heat-resistant sheets from suppliers of theatrical lighting equipment. Polarizing filters suitable for use with photographic lenses are made of optical quality glass and are available at any camera store. Virtually all troublesome reflections may be removed when both the copy camera and the copy lights are polarized, although slight inef-

ficiencies in the filter materials sometimes result in an attenuated deep blue or purple color cast to very bright hot spots that cannot be completely eliminated.

LENSES FOR COPYWORK

There is no such thing as a perfect optical system, and each photographic lens will excel at some particular task. Most lenses for general shooting, including wide-angle, normal, and telephoto types, are designed to be used in situations where the size of the subject exceeds the size of the image at the film plane by a factor of at least ten to one. This means that for precise copying of small images a special-purpose lens is recommended. The 55mm Micro-Nikkor is such a lens. For the larger formats, lenses specifically designed for copywork are designated as process lenses or apochromatic (apo) lenses. They are usually quite expensive. In most circumstances, however, any good quality-taking lens will do a reasonable job if the image to be copied is 8" x 10" or larger, and if the lens aperture is set two or three stops smaller than maximum. Stopping down in this way increases depth of field and reduces aberrations — optical deficiencies — that exist at maximum aperture. Moderate apertures minimize image degradation due to the diffraction effect (the bending that happens when a beam of light encounters a sharp edge).

As I mentioned, the camera must always be positioned exactly perpendicular to the surface of the material being copied. Of course it must be held very still for maximum definition. The most reliable method of achieving this precise condition is to use a copystand, which in its simplest form has a baseboard and a column much like an enlarger's. The camera is attached to the column by way of a mounting plate that can be adjusted for height with a knob or an electric motor. Two or four lights are permanently attached to the baseboard at the prescribed 45° angle.

This setup works fine for most copywork, but when shooting many different size originals the constant variation of camera height can strain your back. I prefer to have the camera at a fixed level which lets me keep my back straight, so I built a copystand with an adjustable baseboard. The copystand is suitable for originals up to 24" x 36" but for really big drawings and posters I find it is more convenient to tape

them to the back wall of the studio and line up the camera with a spir-
it level. In Chapter 12 I described how I mounted ceiling lights in my
shooting space that also work as copy lighting. A wheeled studio stand
makes it easy to change the position of the camera.

The selection of film and format depends on the intended use of the
copy photo. Vericolor Type L negative film is so good that I am able to
handle most of my copy work in medium format. I frequently use copy
negatives produced this way to make multiple 8"x 10"s of architectural
renderings. To copy artwork or graphics that will end up as large display
panels or backlit Duratrans posters in bus shelters, I always use 4"x 5"
Vericolor L. I make very presentable copy slides from color prints
and drawings with Kodak EPY tungsten-balanced Ektachrome. In this
case I use a gray card in combination with the camera's built-
in meter to determine the starting exposure. Extreme closeup work,
with an image-to-subject ratio of 1:2 or less, will require some exposure
compensation. This is automatically taken into account with behind-
the-lens (BTL) meters, but for 4"x 5" I start with an incident light meter
reading and then confirm with a Polaroid test.

Excellent duplicate transparencies can be made very inexpensively
at any professional lab, but from time to time I make them myself by
inverting my Chromega enlarger's color head and shooting Ektachrome
EPY in my Nikon. The Micro-Nikkor must be used with an extension
tube, a carefully made cylinder which fits between the lens and the
camera body to permit close focusing, in order to achieve the necessary
1:1 magnification. Although EPY is sufficiently sharp for this purpose,
copy slides from anything harder than moderately contrast originals
tend to be unattractively harsh. I have found that contrast may be mod-
ified by introducing some controlled flare. For low-contrast originals I
mask off the part of enlarger light source not covered by the slide itself;
for high-contrast originals I omit the masking because the subtle flare
produced by the spill light has exactly the right contrast-reducing
effect. Low contrast, high-resolution duplicate slides may also be made
with Kodak Direct Duplicating Film.

COLOR FIDELITY

As we have seen, sharpness is a photomechanical problem that can be
resolved by keeping the camera properly aligned and very steady, by

focusing accurately, and by using a fine-grain film. Maintaining color fidelity, however, is a matter of understanding the spectral response of photographic materials, rather than something that can be accomplished by a particular technique.

It is necessary to understand that color fidelity is not the same as color balance. Correct color balance is a subjective and imprecise notion that describes a print or slide which has no perceived color bias: When grays are gray and skies are blue and grass is green and skin looks normal, color balance is said to be neutral. On the other hand, color fidelity has to do with accuracy and implies that the film and film processing, as well as the enlarging paper and paper processing, will respond in a linear and predictable manner to a full color palette. In other words, true color fidelity is achieved only when all colors are reproduced on photographic materials exactly as they appear in reality. Unfortunately, this serendipitous state of affairs will never happen because the color we see in prints and slides is generated by organic dyes that are physically limited in their ability to imitate the real world. An extreme example: A fluorescent yellow tennis ball will never look anything but a dull yellow-green when photographed because the colors in a print or a slide can only be a chemical approximation of real-world colors. Ektachrome will never glow in the dark.

All this can be expressed in numbers with graphs of spectral sensitivities and responses, but the bottom line is simply that photographic materials are not honest about some colors. This can be very bothersome for precision copywork, particularly architectural renderings, where color fidelity is extremely important.

Problems arise when certain paints and inks trigger the wrong response. One type of green used by a certain manufacturer of popular felt pens reads as yellow with Ektachrome and lavender with Vericolor Type L printed on Ektacolor paper. The probable explanation of this is the addition of ultraviolet or infrared optical brighteners to various pigments and dyes. Sometimes the solution is to switch films; for example Fujichrome Professional handles many blues and greens much differently than Ektachrome and Vericolor.

Any client who expects copy prints that closely match their originals should be informed of the limitations of the medium. Comprehensive testing, by photographing color swatches with a variety of film types, is the only way to achieve totally predictable results. Once the value of

color testing is understood, the artists who produce renderings and perspectives that are intended to be copied will select colors according to how well they photograph. Photographers are not responsible for photography's technological shortcomings as long as clients are kept well informed.

CONTRAST CONTROL

In Chapter 20 I describe the value of contrast masking for difficult negatives. This technique may also be used for controlling excessive contrast in copywork, although such an inconvenient and expensive approach should be considered only as a last resort.

Every copy photo will pick up a little contrast, and in the case of soft, pastel-like originals, like faded photographs, this is not an alarming situation. When contrast does become intrusive, the introduction of controlled flare is the easiest remedy. This technique can be used with reflective originals by simply selecting a white background on the copystand, rather than black.

Although conventional practice officially precludes the manipulation of contrast in color materials by chemical means, I have found that both Ektachrome and Vericolor films respond well to slight changes in processing. With color negative materials a reduction of fifteen seconds in the first developer can induce a significant drop in contrast without any particularly noticeable color shifts; the slight drop in density may be corrected by increasing the exposure by 25%. Transparency materials behave the same way, although a slight decrease in maximum density (D-max) can be expected because development must be reduced by forty-five seconds. Conversely, contrast can be increased in reversal films by extending developing times. Variations of more than ±20sec for negatives and ±60sec for transparencies are not recommended.

Usually I charge twenty-five dollars for a single 6cm x 6cm or 4" x 5" copy negative, but offer a reduction if several are to be made at the same time from similar-sized originals. I charge ten dollars for a 35mm copy slide from originals 16" x 24" or less in size, and twenty-five dollars for slides of larger originals. A 4" x 5" copy transparency is worth forty-five dollars. Prints from copy negatives are billed the same way as prints from ordinary negatives.

Copywork is often required in a hurry, particularly by architects and real-estate developers. Extreme situations may require working extended hours or even all night long. I apply a rush fee of 25% to 100% over and above the regular costs in such circumstances.

High-end high-tech copywork uses precision large-format copy negatives or slides which are scanned at high resolution and then manipulated electronically using *PhotoShop* or some other sophisticated image-manipulation software. The range of control is limited by the skills of the operator, the speed and memory capacity of the computer, and the capabilities of the output device. Costs for this work can range from one to several hundred dollars.

ARCHITECTURAL PHOTOGRAPHY

Architectural photography is used to sell, promote, or document the work of architects, interior designers, and developers. Everything depends on making whatever is to be photographed look good. The same skills are of value to heritage preservers, city planners, engineers, and landscape architects.

The proper practice of architectural photography demands that the photographer be empathetic to all the nuances of architectural style. Every architect and every architectural firm has their own design rationale. It is only through extended conversation with the client that the subtleties of the various design philosophies will be understood. Many architects, accustomed to producing pretty renderings of buildings with idealized skies and uncluttered surroundings, are blissfully unaware of the realities of location photography. It is therefore just as important to inform them of what is and what is not possible as it is for them to explain what they expect from you.

There are five categories of architectural photography: exterior views, interior views, documentation and dramatization of architectural models, progress photos, and copywork. Shooting architectural models and flatwork is a variation of conventional practice, but shooting actual buildings inside and out involves specialized skills.

Although there is a great deal of work that is best done on 35mm format, the industry standard is the 4" x 5" view camera. Architectural photography requires perspective and focus controls and a full range of lenses, particularly wide angle. A sturdy but luggable tripod is a neces-

Figure 15.6
Architects require photographs of miniature buildings as well as full-size structures. Here is an image (original in color) of architect Clifford Wein's foam-core and plastic model of a proposed National Gallery for the Canadian government. A single light with reflector fill was used for dramatic effect and good modeling. (*ToyoView 45G/150mm lens/Kodak VPS film/Electronic Flash.*)

sity, as is a lightweight but strong carrying case for lenses and film. A bag bellows for use with wide-angle lenses, a Polaroid filmback, an incident light meter, polarizing filters to fit all lenses, a darkcloth, a magnifying loupe, and a professional bellows-type lens shade are also basic requirements. Each lens should have its own cable release.

The Schneider Super-Angulon 47mm is the widest lens available for 4" x 5". The original version doesn't quite cover the corners of the format, but the new (and expensive) XL version does, allowing about 8mm of vertical or horizontal displacement. I carry one for use in really tight situations. Most wide-angle work involves a 65mm or 75mm plus a 90mm, with the 90mm being the workhorse.

For details or shooting at a distance, a 150mm and a 250mm are sufficiently long. From time to time a 360mm or 480mm might be called for, but this is an expensive luxury that may be satisfactorily

emulated by simply cropping the 4"x 5" negative or transparency.

All wide-angle lenses suffer from an unavoidable condition called edge fall-off in which the intensity of the image-forming light is greater at the center of coverage and less at the edges. This is not a really overwhelming problem when shooting on color-negative film because the change in density can be accommodated when the prints are made. Unfortunately the narrower latitude of slide films accentuates the falloff to an unacceptable degree, especially when vertical or lateral shifts are used. The solution is a simple but expensive accessory called a center-graduated neutral density filter. It is essentially a piece of optical glass with a fuzzy gray spot in the middle. This filter is designed to balance the light over the whole image area. As with any filter placed over wide-angle lenses, there is some loss of coverage. The Schneider filters are in the five hundred dollar range, but I have found that the three hundred dollar Fuji 77mm graduated filter intended for the Fuji G617 Camera works fine. I use a 77–67mm step-down adapter ring to attach the filter to my 75mm lens. The same filter fits on the back of my 90mm.

I used to have a rigid plywood and metal-clad case for my lenses, film, lightmeter, Polaroid back and filters, but now I use a large (10"x 10"x 18") soft case, which accommodates my amazingly compact Linhof Technicardan 45, as well. The entire kit is small enough to carry onto airplanes. While on location the camera stays mounted on the tripod and travels in the back seat of the car or over my shoulder with the dark cloth as a shoulder pad. Inside the case, the various objects are separated by thin dividers.

Medium-format equipment used to play only a limited role in architectural work because of the lack of lens movements, but now many medium-format systems offer a moderate wide-angle perspective-control (PC) lens. Special-purpose panoramic cameras with some shift and rise capability are available, but at astronomical prices. When budgets are tight the economy of medium format often overrides the desire for perspective integrity. Happily, a variety of architectural shots, such as simple interiors or small-building exteriors can be done with conventional lenses.

The economies and convenience of roll film may be realized by using a roll-film back with a 4"x 5" view camera. This clever device can be fitted in place of regular 4"x 5" film holders. Some roll adapters will accommodate multiple formats, although 6cm x 7cm is typical. A tem-

plate must be used to mark off the smaller image area on the 4" x 5" ground glass.

Most architectural clients have a need for 35mm transparencies. The 28mm Nikkor-PC Lens allows a remarkable degree of shift and rise. It is wide enough for most interior and exterior applications where perspective corrections are required. The 24mm PC lens from Olympus is an excellent optic with a wide field of view; however it does not have as wide a range of movements as the Nikkor 28mm PC. Because of the mechanical complications, most PC lenses do not have automatic diaphragms so the f-stop must be set by hand. Canon has introduced three impressive, but expensive, PC lenses in different focal lengths that incorporate automatic diaphragms and tilt capability.

A tripod is necessary to maintain precise framing alignment in dim light or small f-stop situations. A 17 or 20mm rectilinear wide-angle lens — a lens that maintains straight verticals and horizontals, as opposed to a distorting "fish-eye" — does the job of the 47mm in 4" x 5". For dramatic closeups and compressed perspective effects I have a 300mm tele. A 24mm-85mm zoom is the lens I use most when shooting for slide presentations.

Film for architectural work varies with shooting conditions and the needs of the client; however the vast majority of my 4" x 5" work is done with Kodak Vericolor Type III (VPS). For tungsten or sodium vapor light, as well as for very long exposures at night, I will switch to Vericolor Type L. For transparency shooting in 4" x 5" I prefer Kodak Ektachrome, balanced for tungsten or daylight as required. Polaroid tests are generally made on Polaroid Polapan Pro or Polacolor Pro. Color negatives shot on 4" x 5" material are so rich in detail that special provisions for b&w are unnecessary — I print directly onto Panalure paper when b&w enlargements are requested. Vericolor Type S and Type L are also fine for medium-format applications.

Both Kodak and Fuji market 4" x 5" films in preloaded Polaroid-like packaging. In fact the Kodak system — called ReadyLoad — can be used in the same film holder as regular Polaroid materials. Kodak offers Ektachrome EPP, Type PRN color negative, and T-Max b&w in ReadyLoad packets. Film packaged in this way costs more than boxed film, but for jobs with moderate to good budgets I find that the reduced bulk and the elimination of dust makes the extra cost worthwhile.

Small-format architectural photography had an incredible shot in

the arm with the introduction of Kodak Royal Gold 25 color-negative film. This 35mm material represents the ultimate in fine grain and resolution, and some are saying that it even rivals the legendary Kodachrome 25. When the technical precautions for preserving sharpness are scrupulously observed, Royal Gold 25 is capable of results almost as good as 4" x 5". I believe that Royal Gold 25 will have a significant role in the production of professional portfolios for those architects that cannot afford the expense of full-scale large-format documentation.

I favor the Kodak Ektachromes for 35mm slides because of the convenience of in-house E-6 processing. I have been trying the new Fujichrome Professional slide films (also processed E-6), and I have found that they sometimes do a better job than the Kodak materials with certain types of foliage. Kodak has introduced several varieties of Ektachrome that provide other alternatives. For really careful work I use the slowest films available. Often my clients like me to produce a series of preliminary 35mm snapshots and then go back and reshoot selected images on 4" x 5". For these hand-held quick and dirty assignments the higher-speed films like Ektachrome 400 are more than satisfactory. My standard for copywork remains EPY Tungsten Ektachrome. From time to time b&w slides of line drawings are requested, and I have found that Kodak Technical Pan Film processed for high contrast does an excellent job — most architects are not bothered by the reversal of tones; for those that are I use Polaroid 35mm High-Contrast Reversal Film.

EXTERIOR VIEWS

Most people think of architectural photography as being photographs of the outsides of buildings and certainly location shooting of completed and landscaped projects is a major aspect of the work. The majority of such photographs are made by daylight although some dramatic results can be achieved with artificial lighting at night. In either case, after the job has been discussed with the client, the actual site must be visited to determine the best vantage point and the best time of day to do the photography.

It will save some grief later if the client comes on the scouting trip and participates in the resolution of some of the problems.

Architectural photography is related to photojournalism in the sense that the conditions under which the job is performed cannot be controlled by the photographer. It is important for the client to understand the limitations imposed by the orientation of the building and its situation in relation to other structures and the landscaping. In some cases, even the time of year is significant. Where I live, buildings that face north receive direct sunlight for only a short period during the summer. Seasonal variations in the density and color of foliage must also be taken into account.

Although I am becoming skilled at predicting how buildings will look at different times of the day and different times of the year, I still make several visits to check exactly when the sun will be shining at the perfect angle to maximize the appearance of important design elements or textures. Some urban downtown areas are so crowded that sunlight might penetrate the concrete clutter for only minutes at a time. If I am to photograph several buildings at once, I make a schedule indicating the best shooting positions marked off in twenty-minute intervals starting from a little before sunrise and ending a little after sunrise.

If the only decent vantage points from which to shoot are located on private property such as the roofs, fire escapes, windows, and balconies of adjacent buildings, permission from owners or managers must be obtained beforehand, particularly if late or very early shooting is anticipated. In some after-hours situations a security guard or custodian will have to be hired at overtime rates. Making all these arrangements is a time-consuming process, and it is a good idea to convince the client to take care of these arrangements if possible. When that can't be done, make it clear that the time spent over such arrangements will be billed at a reasonable rate and then have your assistant do the phoning. If the shooting positions are not at ground level, an assistant will be required to help move the gear, as well.

I can't tell you how to deal with the aesthetic aspects of the work except to say that architects view their projects in the same way that most people view their children — they should all look beautiful in a picture. Some heavy thinking is required in order to produce photographs they will find acceptable. Fortunately nature supplies an infinite variety of lighting and sky conditions, so once the geometrical composition of the shot is determined, it is just a matter of waiting for the other variables

to line up appropriately. Patience is the main attribute of good architectural photographers. While waiting for the sun to come around or for clouds to waft into position, walk around the site and pick up bits of litter that might otherwise clutter up your image. (Cooperative clients can sometimes be persuaded to arrange a cleanup the day before the shoot.)

Every city has an airport with some kind of aeronautical weather service listed in the phone book. Usually whoever answers the phone will be quite generous with information about cloud conditions and wind, the two main elements that affect photography. It is very difficult to keep a bellows-type camera steady in a breeze, even with a heavy-duty tripod, and of course the sky and clouds will constitute the background for all outdoor photography. Cloud conditions also determine the quality of available sunlight, i.e. color, specularity, direction, all critical factors in daytime work.

Direct sun at an appropriate angle makes most architectural design in stone, concrete, and wood come alive, whereas diffused light is often the kiss of death. I take pictures of buildings under overcast skies or undershaded conditions only if there is no other option. I might be forced to work with poor light if clients have called me at the wrong time of the year, if the building is completely surrounded by other tall structures, or when deadlines are tight and the weather is bad. Low-contrast light makes color mushy and reduces apparent resolution, which in turn yields a weak and unflattering impression. One remedy is to push-process the film, just like for low-contrast copywork, to give a little more snap. This technique goes a long way to restoring a look of solidity and strength; unfortunately the skies remain deadly white or dull gray. For some important jobs, I have a retoucher airbrush in a nice blue sky. This is not an expensive process because the geometric silhouette of a building is simple for the artist to deal with. Another approach is to switch to black and white material, if the client is willing, which allows much greater contrast control.

Shooting at night will sometimes yield exciting photographs of structures that happen to look less dramatic in the available daylight. Color-negative film is a logical choice for nighttime photography because of its wide exposure latitude and its ability to accommodate a wide range of color temperatures. The best photograph might be made with a carefully timed combination of twilight and artificial illumination from streetlights or floodlights.

Sometimes direct sun is avoided for aesthetic reasons having to do with the texture of the building's exterior. Some glass, tile, and metal-clad buildings look best reflecting the luscious colors of a cloudy sunset, a sunrise, or a presunrise or postsunset horizon.

Once the aesthetic considerations have been dealt with, the simple mechanical steps of location work with large-format equipment must be attended to. The procedure is more or less a methodical routine which must be repeated over and over, with the intention being to establish an efficient pattern in order to produce predictable results.

As I described, for local location shoots I prefer to carry the camera mounted on a tripod over my shoulder with everything else in a lightweight case. Once a suitable camera location has been found, I set down the case and set up the camera at the appropriate height. Most architectural exterior views are made at eye level, which yields a natural perspective and makes operating the camera physically easier. Some fine-tuning will of course be necessary so a tripod with a gear-driven center pole is very handy. A tripod with the capability to disengage or extend secondary leg supports to allow very low vantage points is useful as well. Whatever the height and location, care must be taken to ensure that the tripod will not slip. The camera should be carefully leveled with the built-in bubble indicators. A small mirror and a little flashlight are handy for viewing the shutter and aperture controls when the camera is positioned awkwardly or when light is dim. For really awkward camera positions I use a very heavy-duty camera mount made out of a spare tripod head and a large pair of vise-grip pliers.

The right lens must then be selected and secured on the camera. All movements should be zeroed before setting up the controls for the shot. You will find that the most commonly used movements are front rise and horizontal shifts, which allow the image to be centered while maintaining vertical and horizontal perspective. Occasionally the lensboard will be tilted forward a little to maintain focus all the way from the foreground. With extreme rise the lensboard may be tilted backward very slightly to maintain coverage. A slight swing will do the same thing in the case of extreme sideways shifts.

Check the focus with a loupe, particularly when using wide-angle lenses which tend to project an annoyingly dim image at the edge of the frame. The final camera adjustment after the image is corrected for perspective and focus is the correct positioning of the lens shade.

Large-format lenses have an amazingly wide angle of acceptance, so extra care must be taken to prevent flare-inducing stray sunlight or bright reflections from striking the front lens element at odd angles.

Next, a meter reading is taken and a decision made on the f-stop, bearing in mind that lenses for large format are optimized for best optical performance at around f22. As a final check, a Polaroid test is exposed, processed, and evaluated. (Always carry a small plastic bag for the Polaroid litter.) If you are working onsite with your client, it is prudent to view the Polaroids together and explain the reasons for selecting a camera position, lens, time of day, etc. If the Polaroid is satisfactory, make the exposure on conventional film. I always expose two 4" x 5" negatives (i.e. both sides of a film-holder or ReadyLoad packet) for each shot. The two pieces of film are processed separately, thus minimizing the chances of chemical or mechanical damage. It is hard to eliminate dust on location, but one of the two negatives will always be cleaner than the other.

The film-holders should be placed in the case with the white dark-slide tabs up. After the exposure they should be replaced with the white tabs down and the black tabs up. Some care must be taken to avoid shifting the darkslides inadvertently — if you are a worrier, use masking tape to secure them. I tape the ends of exposed ReadyLoad packets as a matter of course.

Precision 35mm architectural work proceeds in much the same way as for 4" x 5", except that it is a little trickier to level the camera without a built-in bubble indicator. Aftermarket levels are available that mount on the accessory shoe. When shooting slides, the lack of Polaroid capability must be compensated for by framing very carefully and by exposure bracketing. Although clients won't be able to see instant test prints, they will find the bright and life-like viewfinder of an SLR much easier to read compared to the dark, up-side-down and reversed image on a 4" x 5" camera's ground glass.

Slides made as photographic notes can be shot quickly and informally with fast film and a hand-held camera. I still bracket, but only ±1 stop on either side of the exposure suggested by the BTL meter. Density and color are less important with this kind of work because what is required is simply a rough preview of the point of view and the available lighting.

INTERIOR VIEWS

Shooting indoors is complex because working space is limited and lighting conditions can be problematic. Scouting the location is the first job. It is always advantageous to have the client on the walk-through so that any access or logistical glitches can be worked out cooperatively before the shoot.

Shooting by available light is the simplest and fastest way to handle interiors. A pleasing color balance is not difficult to achieve if only one source provides the primary illumination. Interior spaces without windows are simpler to deal with than spaces that combine artificial and natural light. Lighting headaches arise when sources of different color temperature are mixed because photographic film exaggerates discrepancies that are automatically accommodated by the human eye and brain.

Many modern offices have no windows at all, just banks of fluorescent fixtures in the ceiling. Sometimes tungsten pot lights provide visual accents but these are normally switched separately so they can be turned off during the photography. If the tungsten lights are wired to dimmers, it is possible to reduce them to a faint, more photogenic, glow. Overhead fixtures equipped with plastic diffusers provide broad and consistent lighting, but to prevent flare it is important to mask-off any bright sources outside the image area with a lens shade or dark flag.

Offices and other spaces that combine fluorescent lights and day-light require more work. If the windows have blinds and if the room lights are bright, closing the blinds will at least make color photography possible. Unfortunately, the windows and their immediate surroundings will appear quite magenta because the overall color balance must be adjusted to eliminate the green cast characteristic of fluorescent lights. Waiting until it gets dark outside will eliminate the problem; however if the client insists on pictures that include some natural light a more sophisticated approach will be necessary. If the windows are accessible and not too big, they may be masked with large colored gels that are available from theatrical or cinematic supply houses. Alternately, the lighting fixtures may be filtered to match the daylight. Preformed filter tubes can be slipped over fluorescent lamps or appropriately sized sheets may be laid down on top of the plastic diffusers. Finally, the fluorescent lights may be switched off and the

interior lit entirely by balanced electronic flash. Obviously, any lighting approach other than available light entails a significant investment in time and equipment. The one exception to this rule occurs around sunrise and sunset, when daylight is dim and a magenta color cast outside looks natural.

The geometry of interior shots is mainly determined by what is popularly referred to as wide-angle distortion. The exaggerated perspective that results when wide-angle lenses are used in confined spaces is unavoidable but it can be minimized by carefully positioning the camera and by very carefully arranging the position of objects in the foreground. Such things as chairs, plants, floor lamps, and tables must be moved around inches at a time to achieve the most tasteful, or simply the least jarring, effect. Polaroid tests are necessary for compositional fine-tuning.

Exposures indoors are typically very long — 15 to 120sec at f32 — so the film of choice is Kodak Vericolor Type L. VPS or PRN is useful for available daylight with or without flash fill. Ektachrome indoors on large format is expensive. To save both time and money I try to test the lighting and determine exposure and filtration on 35mm slide film before going to 4" x 5".

A practical alternative to shooting 4" x 5" transparencies is to make large-format slides from color negatives. I do this by projection printing with an enlarger onto Kodak Duraclear. This RA compatible material is available in sizes ranging upwards from 8" x 10" and is intended for display applications. I usually make 5" x 7" transparencies, and when carefully done they are virtually indistinguishable from original slides while preserving the color, density, and cropping controls of color negatives.

PROGRESS PHOTOS & MECHANICAL DOCUMENTATION

Making a visual record of a building under construction or documenting engineering details of existing structures is not necessarily the most creative of photographic activities but, like copywork, it can be a straightforward and lucrative commercial activity.

Progress photos may be requested by architects, engineers, contractors, developers, building owners, or even a financial institution. From

1988 to 1989, I documented the construction of a very large office tower. My client, the contractor, received monthly disbursements of hundreds of thousands of dollars from the developer based, in part, on photographic evidence of work completed. I received four hundred dollars per month to make photographs every two weeks from three predetermined vantage points. The shooting took only half an hour each time and only one roll of 120 color-negative film. Three 8" x 10"s were made from each of three negatives.

The main requirement for documentary shooting is accuracy. The exact degree of detail to be recorded depends on the final use of the photos. For example, my contractor client wanted to show only the major structural elements of a steel and glass skyscraper, something easily photographed from a distance. In another situation, an architect needed photographs to defend himself in a lawsuit that hinged on some improperly installed cedar siding: The request was for closeup photos showing the exact condition of the defective materials.

Color is not always required for photographs used in litigation, but prints must be sharp and clear. Whether b&w or color, all prints must be dated, and the negatives filed for easy access. Medium-format equipment is a suitable choice for documentation of details and for shooting progress photos, which do not normally require perspective control — my high-rise shots were not corrected for parallel verticals.

ARCHITECTURAL MODELS

There are three interrelated factors that determine the photographic approach to architectural models: scale, point of view, and the degree to which real-life conditions are simulated. The most sophisticated models cost several thousand dollars and are large, highly detailed, and meant to be examined at every angle from street-level to bird's-eye. Miniature cars, trees, people, and even plexiglass water contribute to a realistic appearance. At the other end of the scale are unpainted and unadorned assemblies made of foam-core or cardboard that are intended to represent only a building's basic shape and orientation.

Depending on the scale and the fragility of the model, photography may take place on location or in the studio. I prefer the controlled conditions of the studio because I can do a better job with less effort; after all, a model is only an exotic product. As a rule, architectural models are

expected to be lit in a way that mimics sunlight. This is easy with a slightly diffused tungsten light mounted on a boom in combination with some large reflector cards to fill in the shadows. Ask the architect from what general direction he wants the sunshine to come — such things are incorporated in the site-plan specifications when the building is designed.

Several points of view may be required. The street level view is the trickiest to perform convincingly. The center of the lens will be just a fraction of an inch off the "ground" in order to duplicate an eye-level perspective. Miniature obstacles, such as elements of the landscape and other buildings are sometimes more difficult to deal with than their real-life equivalents. Nevertheless, the same camera movements are required to maintain the parallelism of vertical and horizontal lines. Front tilts and swings are very useful since depth of field becomes a problem with extreme closeup work.

A technique that adds credibility to color photos of models is the creation of an artificial sky as background. This is done by painting the studio cove blue or by taping a length of seamless paper to a wall. A tone that's slightly denser than the real sky works well if it is lit from the bottom to give a graduated effect. Once in a while I get ambitious and make cotton-batten clouds, which look surprisingly realistic when shot slightly out of focus. To achieve a highly dramatic ambience I project a slide of an exotic sky condition, such as a sunset, onto a white backdrop behind the model.

PHOTOGRAPHING THE PERFORMING ARTS

The performing arts include theater, dance, film, television, and live music of all kinds. The design and content of the pictures must harmonize with the aesthetic intentions of each performance and still be strong enough to hold up on a theater marquee, a performer's portfolio, or in a newspaper advertisement. The very existence of the cultural institutions we take for granted may in part depend on the photography that is used to support funding applications to government and philanthropic agencies. Photography plays a big role in developing an educated audience through clever advertising and visual outreach programs.

Figure 15.7
Late night alternative radio host Ralph Benmurgi needed a powerful image for a direct mail promo-tion. In consultation with designer Steven Rosenberg of Doowah Design, Winnipeg, I proposed an outdoor venue on the waterfront, with vintage radio equipment as props. A single direct flash was bright enough to overpower the available sunlight, further enhancing the energetic composition. *(Hassleblad/60mm Lens/Ilford FP4 film/Daylight and Electronic flash.)*

The traditional promotional vehicle for the performing arts is the 8" x 10" b&w glossy, but 35mm slides and color prints are very much in demand, as well. The b&w 8" x 10"s end up in performers' portfo-lios and newspaper ads, while the slides are used for TV promotion, ads in four-color process magazines, and fund raising or educational AV shows. Color prints are sent to newspapers and magazines as well, but more commonly they are used for lobby or window displays.

The key to successful performing arts photography is the under-standing that virtually everyone in the entertainment business is sensitive about something. Tact, discretion, and the ability to work unobtrusively are the critical skills. It is true that there is some need for assertiveness whenever the photographer is expected to manage some

Figure 15.8
This image was produced to satisfy a request for an eerie visual to publicize a play about a violent separation between the province of Quebec and the rest of Canada. Small replicas of Canadian and Quebec flags were secured inside the eyepieces of a World War II surplus gas mask which itself is stretched over a translucent glass globe scavenged from a light fixture. (*Mamiya 645 Super/150mm lens/Kodak EPY film/ Tungsten illumination.*)

aspect of a *photocall* — a photocall is to theater what a photo opportunity is to politics — but whatever direction is given must be couched in diplomatic language.

Performing arts institutions are divided organizationally into administrative and artistic camps. Usually the PR section of the administration hires a photographer and the photos are selected from contact sheets by people whose work is publicity. The appearance and staging of the production are the responsibility of the artistic director and his or her colleagues, the lighting and set designers. It is the function of the director to set up the appropriate mood and pacing of the show, so his interpretation of the work being presented determines the type of photographs that may be produced. All this adds up to a dilemma. The production photographs must satisfy the flashier, more expansive tastes of the publicity people; at the same time, however, they are expected to truly represent the subtleties that the director has built into the show. Consultations with both groups are necessary and everybody must understand that producing such photographs under typically difficult technical conditions requires cooperative effort, a reasonable length of time, and quite a bit of film.

Some well-established companies expect to pay normal commercial rates for good photography but many high-profile cultural organizations and most smaller performing arts companies are financially

strapped. Barter arrangements that exchange photographic services for tickets or advertisements in programs are not uncommon. Just like working gratis for charities, working for reduced rates on behalf of the local theater, symphony, or opera company will expand one's reputation while supporting positive aspects of community.

Making good pictures in the theatrical environment does not present overwhelming difficulties. The "better-living-through-chemistry" people have surpassed themselves recently with the creation of exceptional new high-speed emulsions. Even so, it is the work of the lighting designer that ultimately sets the technical limits.

Contemporary theatrical lighting instruments generally employ a one or two kilowatt 3200°K quartz-halogen lamp as the active element. Although color temperature changes toward red and orange as these units are dimmed, all color slide films balanced for tungsten work well for the stage. Nevertheless, I have found it convenient to shoot mostly with three daylight films, Fuji HR 400, 800, or 1600, from which I make color prints, b&w prints, and the occasional 35mm slide.

There is no standard color temperature or flesh tone on the stage. Lighting designers use colored gels, diffraction screens, special reflectors, and a variety of lenses and masks to create and then subtly alter the visual mood. When evaluating color balance, it is necessary to keep in mind the objectives of both the AD and the lighting designer. I have never found it necessary to resort to filtration. In almost every case, alterations in color balance due to stage lighting are registered pleasingly by today's films.

There are two photographically significant approaches to theatrical lighting design, the first of which creates a basic, all-encompassing mood for a particular scene. By selecting appropriate filtration, intensity, and location for each lighting instrument, the designer sets up a visual baseline from which the audience may experience what it is they have come to see. Here, there are no obvious effects, no heavy-handed manipulation of color or brightness for the sake of demonstrating technical virtuosity. Any effects are introduced by skillfully modulating the various elements making up the overall quality of the light falling on the set. What is required to complete this approach effectively is restraint, sensitivity, and good taste. The results can be very beautiful and the lighting values can be easily accommodated by current films.

It is much more difficult to work with lighting of the second type

in which all the same lighting tricks are applied, but more intensely. In this instance a collection of strong effects are scattered across the stage. Lots of hard side-lighting, sharply focused lights overhead, and follow spots are used for emphasis — the general impact is harshness. When visual moods are constructed from a series of excessive visual effects tied together, photography can barely keep up. Exposures bounce all over the place, and the too-wide brightness range causes facial highlights and dark backgrounds to disappear off their respective edges of the density spectrum. All this has led me to the following conclusions:

1. It is very important to watch at least one rehearsal in order to anticipate changes in lighting and the physical position of the performers on the stage (blocking).

2. Push processing is not a solution to dim lighting because contrast becomes unmanageable. It is better to shoot film at the rated speed while paying careful attention to those techniques outlined in the section in Chapter 14 dealing with sharpness.

A spotmeter is the most accurate instrument for measuring light onstage. It is slower than the BTL meter but it is infallible at a distance. For b&w, color-negative, and slide films, a direct reading off a facial highlight with the meter set at one-half the film's rated iso will guarantee an acceptable exposure. Once a feel for the lighting changes is acquired, the camera's built-in meter can be used to quickly guess the exposure for fast-changing situations. I have to admit that I have had considerable success simply relying on the nonmatrix auto-exposure function built into my cameras.

For many years I used Leica M4 rangefinder cameras for theatrical work. I had two sets of everything — one for b&w film and one for color slides. When I started to use color-negative films exclusively I switched to Nikon F3s with 28, 35, 50, 105, 200, and 300mm lenses. Now I use autofocus cameras, usually with an 80-200mm f2.8 zoom or a 28-105mm f3.5 zoom.

I prefer to work with shorter lenses right at the edge of the stage, that way I have a greater choice of shooting angles. Early on I worked with Leica rangefinder cameras because they were so quiet but I switched to motorized Nikons because they were faster to focus. Even

actors had become habituated to the whir and clank of motor-driven SLR cameras so I got only a few complaints about excessive noise. (A few free prints will smooth the most ruffled feathers, although discretion is always advisable when shooting very quiet dramatic scenes.) Happily the microprocessor generation of automatic cameras are lightweight, quiet, and able to focus reliably in low light. For set shots and cast photos I use medium format and Vericolor Type L.

I never use flash for shooting any theatrical performance, although I do carry a portable unit with me to take care of the inevitable head shots required for programs and lobby displays. Sometimes its possible to set up photographic lighting for rock concerts because the overwhelming visual effects used by the performers themselves are not diminished by the occasional flash from a strobe.

SHOOTING FILM & TELEVISION PRODUCTION

Shooting on a television or motion picture set involves a slightly different technique because, aside from the rare live show, there is no continuous performance, just a series of short rehearsals that alternate with on-camera takes that are not necessarily arranged in chronological order. This disjointed schedule makes some of the participants impatient, but more importantly, it disguises the plot. Some research, such as reading the screenplay or talking to the person in charge of continuity, is required to make still pictures that are contextually relevant.

In television work the floor director knows where and how much time will be allowed for stills: This is the contact person who will point you to the right place at the right time to get the necessary shots. In film, a production assistant will have the same responsibility. The drill here is to stay out of the way of the technical people while shooting discretely from behind the cameras during the brief rehearsal periods. Some extremely cooperative directors will allow time to set up scenes just for the still camera but most often budget and time restraints don't allow this luxury. In film or television, absolutely no noise or movement is permitted while the cameras are running. Violations will not be tolerated, but the patient photographer will be accommodated. If the set is particularly tense because of missed deadlines or the bad behavior of some incorrigible actor, extra sensitivity, and perhaps a thicker skin will be required.

On-set backgrounds and props are provided by nonphotographic professionals and are not originally intended to be used for photos. Be aware that at any film or TV location the exact position of these elements on the set is critical in order to maintain continuity from scene to scene. If you are allowed on the set don't move anything before checking with the floor director or the production assistant. Probably a union worker will have to move anything that needs rearranging.

The exact working procedure must be negotiated with each production company. Shooting during a take happens very infrequently, but when it is requested a flexible, sound-absorbent camera shroud, known as a *blimp*, is absolutely essential.

All drama depends on a condition called the *suspension of disbelief*. This requires that the audience discard their day-to-day notions of reality and become deeply involved in the action unfolding on the stage or screen. Patrons of live theater automatically accept the traditional conventions: The story is told from only one physical location — under the proscenium arch — with a minimum of props and a limited, often symbolic or metaphorical simulation of the natural world. The opposite is true for film production, where every effort is made to simulate real life for the camera.

In live theater absolutely everything technical must be hidden from the view of the audience in order to sustain an illusion of reality. This means that all lighting equipment must be well above the stage or in the wings. Since theatrical lighting instruments are always highly specular sources, moving them far away from the stage and positioning them at steep angles relative to the performers automatically creates contrast problems. For nonspecular effects many instruments must be used together, but this introduces multiple shadows — another impediment to the establishment of quasi-realistic conditions. On the other hand, most film and video projects are produced without an audience and the restrictions on lighting techniques that an audience imposes.

On the set the only limitation is that lights be located outside the field of view of the camera so that a wide variety of instruments can be used, positioned very close to the performers. It is not a coincidence that many accomplished cinematographers are former still photographers and that many of the most effective cinematographic lighting tools and techniques evolved in sophisticated still photography studios.

Since film and video are reproduction oriented, that is to say the final product is to be displayed or reproduced on a screen, their lighting parameters are by necessity more compatible with photography than those of live theater. This means that technical conditions during filming must be adequate to permit the recording of full-tonal-range images. Consequently, overall levels do not change as dramatically as onstage — the darkest scenes in a film or video will be lit more brightly than they would be for the stage, and the brightest scenes will be less brightly lit than a stage production. Typical contrast levels are much more moderate and special effects are likely to be less extreme, as well.

All this, of course, makes life easier for the still photographer. Under typical conditions, good results are achievable with 400 ISO materials; under extreme conditions virtually anything that can be filmed can be photographed relatively effortlessly with 1600 ISO material.

Another bonus for still photographers arises from the similarity of "optical aesthetics" among still, movie, and video cameras. In fact, cinematography operates under the same rules of scale and lens performance as still photography: what the cinematographer sees through his or her Cinemascope camera the still photographer can see through his or her single lens reflex. Assuming production politics are favorable, this visual affinity permits and encourages some wonderful photography. Remember also that the lighting designer is working to support the vision of the director and the cinematographer and videographer so a complete appreciation of moviemaking requires an appreciation of the lighting setup for each scene, as well.

All this does not mean that still photography of video or film productions is trouble-free. The permissible technical conditions for film are more extreme than for photography, and video is even more tolerant than film. There are at least three reasons why this is so. First, on a simple mechanical level, fleeting moving images will never be viewed as critically as still photographs. Second, film and video capture all those lighting effects that depend on movement — effects that are more or less invisible to still photography. And finally, cinematographers and videographers rely on *postproduction controls*, many of which are electronic in nature, to ensure that extremes of lighting and special effects are accurately reproduced.

The mechanical work of film or videomaking proceeds outdoors in much the same way as indoors although the visual tapestry expands

dramatically. Even so, those scenes involving people which are sufficiently important to be documented photographically are lit and shot on a manageable scale — the process of production in such instances reduces the sun to the status of just another lighting instrument to be modified by diffusers, reflectors, and filters, while the landscape becomes just an element of the set. Whenever production values actually do shift to emphasize or exploit the truly grand view — whether inspired by a natural or a man-made vista — the still photographer must switch gears as well. Like a jewelry photographer who is asked to photograph a building, one must learn to think big. I don't mean to say still photos must be rigid reproductions of what the film or video cameras are looking at, but rather that it makes creative sense to synchronize visual perspectives, if only for the sake of a stylistic accord between the images that will be used to promote the production and the images that will actually appear on the screen.

In order to discover some of the interesting possibilities hinted at above it is necessary to become a student of the cinematic gestalt and keep in mind that individual scenes often make little visual sense except from the point of view of the film or video camera. At a casual glance, a crowded set presents the confusing complexity of a misaligned hologram, but like a hologram, when studied from exactly the right angle, it all comes together in exquisite harmony. Try to visualize what the cinematographer or videographer is working to create. Happily, this process becomes more and more exciting to experience according to the level of sophistication of the film makers.

MODEL & ACTOR PORTFOLIOS

Shooting photos of people who make their livings with their appearance lies somewhere on the middle of the scale between executive portraiture and fashion photography. Anyone who expects to excel in this work should have a real appreciation for people and an ability to tune into nuances of character and personality.

The model's portfolio and the actor's head shot are not usually seen by the general public, but they are the internal currency of the fashion and theater worlds. My advice is to directly approach talentfinders in the model agencies and casting or public relations people in live-theater companies. Explain that you are interested in acquiring work in

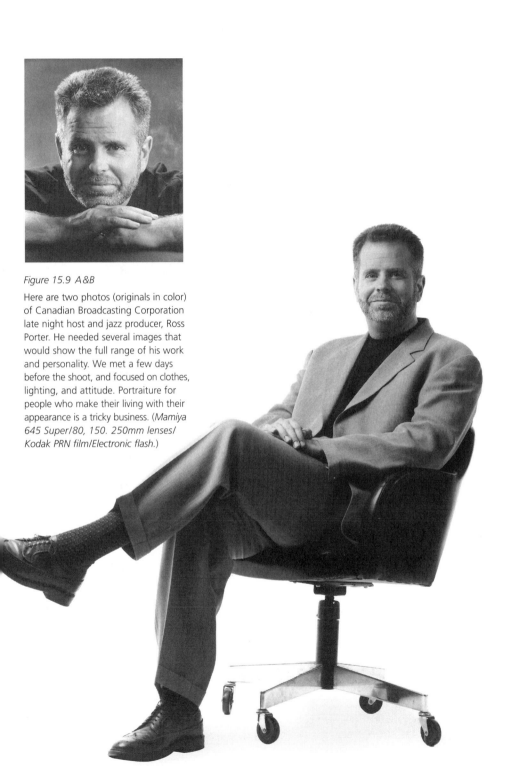

Figure 15.9 A&B

Here are two photos (originals in color) of Canadian Broadcasting Corporation late night host and jazz producer, Ross Porter. He needed several images that would show the full range of his work and personality. We met a few days before the shoot, and focused on clothes, lighting, and attitude. Portraiture for people who make their living with their appearance is a tricky business. (*Mamiya 645 Super/80, 150. 250mm lenses/ Kodak PRN film/Electronic flash.*)

Figure 15.10

Actors and models need head shots that will attract the attention of art and casting directors. Unusual techniques will help only if they are tastefully applied. This appealing romantic portrait was shot with a deep red filter, infrared sensitive film, and electronic flash. Exposure Index was predetermined by experimentation. (*Nikon F2/105mm lens/Kodak 35mm Infrared film/Electronic flash.*)

this area, and show them your best portrait efforts with the explanation that you would like to tailor your skills to fit the specifics of their businesses. Usually they will respond positively — after all, good portfolios and head shots will only make their lives easier. But be brief — these people are very busy. If you make a good impression you can expect to be shown typical photographs that in all likelihood you will feel quite capable of emulating. If this is so, make an offer of a costs-only session to a model or actor. If this works out satisfactorily, referrals will follow.

Rates for this work are modest, certainly at the local level, but as your reputation expands rates can climb. After all, the bottom line is that your good photographs will help get people work. Typical low-budget sessions might attract twenty-five to seventy-five dollars plus prints, more sophisticated sessions might attract one hundred to two hundred and fifty dollars, plus film, processing, and prints. There is also decent money to be made in the production of multiple prints, particularly if you are willing to generate a high-contrast negative and burn in names and addresses. (People expect to pay between twenty-five and fifty dollars for this service.)

There is a chance that a year or two of low-budget shooting will lead to more highly paid fashion work for catalogs and magazines, in the case of models' portfolios, or higher-profile publicity stills and production photography, in the case of actors' portfolios.

FOOD & FASHION PHOTOGRAPHY

Both food and fashion photography are actually exotic forms of product photography. The food photographer makes attractive photographs of food. The fashion photographer makes inspiring photographs of clothing. The operating principle is good taste. Every aspect of the work, from the selection and preparation of the model or ingredients through to presentation and lighting, is geared to evoke an involuntary response: "this food tastes good" or "these clothes look great." Unless the photographer is very unusual, the specialized expertise that supports this work has to be obtained from outside. In some areas, professional food, fashion, hair, and makeup stylists can be hired, but failing that, talented amateurs can be recruited. The degree of refinement and sophistication will be limited by the budget, the

deadline, and the imagination of whoever does the styling and finds the props. The food and fashion client usually has very specific ideas of how the presentation should look. Some kitchen and dressing-room facilities are required. Rates vary between those paid for editorial work and those paid for the fanciest of commercial illustration photography, depending on the end use.

Generally, food is expected to be photographed in fine detail so slow emulsions and large formats are favored. Transparency film works best to capture the delicate highlights in liquids, the translucent greens of leafy vegetables, and the subtle textures of meat, bread, or pastry. Medium format is acceptable for simple setups, like shooting straight down on a single plate, but the corrections and large film area of 4" x 5" are required for most assignments. Electronic flash is favored because hot tungsten lights shorten the life of perishable props.

In sophisticated markets those who make their living shooting food exclusively usually have an understanding of food preparation that goes beyond mere cooking. The work is enjoyable because people who care about good food are usually fun to be with and because in these days of truth-in-advertising all the food must be the real thing. One real danger: an expanding waistline.

Big-budget food photography is never practiced in isolation. In the major centers there are full-time food stylists, prop finder and fabricators, and specialized suppliers of produce, kitchen paraphernalia, and elegant tableware. The art directors and editors who commission the work are generally experienced as well. Fast custom labs are close at hand so that transparencies can be processed before perishable setups deteriorate.

All this might be intimidating to the beginner, but consider the following: I am a commercial photographer practicing in a midsized prairie city and from time to time, as you can see from the samples, I am called on to produce high-quality food photos. My clients have been conditioned like all of us by the many wonderful images of food that are such integral components of our visual culture — they expect spectacular results despite restricted budgets. I have had to learn the necessary techniques by trial and error.

There are no full-time food stylists in my town, and I cannot afford a lavish in-studio kitchen. Happily there are skilled chefs everywhere, and though they may not be trained in the particular skills of food

Figure 15.11
This is elegant food photography that is deceptively easy to do. Shot from straight above, with one main soft light and white reflector fill, these plates were prepared by an accomplished chef. These are two in a series of twelve produced for the Fresh Water Fish Marketing Corporation of Canada. (*Mamiya 645 Super/55mm lens/Kodak EPP film/Electronic Flash.*)

preparation for the camera, they certainly know how to prepare food that is appealing to the eye. It is not too big a leap from the table to transparency — typically food must be slightly lighter in color for the camera than for the palate. Many dishes can be prepared outside the studio and transported for photography. Alternately, the studio can be moved into a commercial kitchen. Fancy restaurants are generally empty in the early morning.

Restaurants, even the most modest, always need pictures for menus, advertising, and point-of-sale pieces. Trade photographs for meals at the beginning and work up to real money as your skills improve. Once a portfolio of good color work is in hand, hit the streets and visit advertising agencies and food-related manufacturers and distributors. Established independent food photographers in big cities can expect to make decent money after having made a sizable investment in tools and facilities plus a long period of practical experience. Even so, paying dues isn't too bad in a photographic specialty where you can eat your props.

Fashion photography began at the turn of the century with a formal technical approach, but today it has evolved to the point where a wide array of styles and techniques are used freely. Magazines, catalogs, and

point-of-sale posters are reproduced from super-sharp 8" x 10" transparencies, color copies of grainy super-speed 35mm negatives, and anything in between. Perhaps the most common configuration is a motorized medium-format SLR loaded with a fine-grain transparency film, such as Kodak Ektachrome EPP in combination with powerful, rapid-fire electronic flash directed through large softboxes. The texture and detail of clothes, accessories, skin, and hair are easily recorded with this kind of equipment.

The fashion industry exists at many levels of sophistication, from high school fashion shows to textile and clothing manufacturing to haute couture and ultra-upscale magazines. Occasional entry-level work can be solicited from retailers and manufacturers almost anywhere, but the most direct route into the business is as an assistant to a busy fashion photographer. This work involves a tremendous amount of coordinating of merchandise, of models, of stylists, etc. so busy professionals need lots of helpers. The industry is a convoluted maze of cliques and extravagant personalities, and experience is the only road map.

ADVERTISING ILLUSTRATION & STOCK PHOTOGRAPHY

Advertising illustration and stock photography have something in common: They both draw on the techniques, the equipment, and the materials regularly used in pursuing work of each and every category already described. Stock houses and advertising agencies expect competent photographers to be able to generate images of any kind, anywhere, any time. Of course they consider variations in style and preferences, but once an assignment or request is agreed to, the photographer is expected to deliver original and technically excellent work.

Four main differences distinguish these two jack-of-all-trades genres from each other. First, stock photography inevitably has a long lead time but advertising clients are always in a hurry. Second, stock shooting may entail creating dozens, or even hundreds, of thematically related images, whereas advertising illustration requires only a few images at a time, and often only one. Third, the advertising agency is the client and end user so it pays directly, whereas stock houses are really image brokers that sublet images to dozens of clients; consequently

they pay more slowly and only after deducting a sizable percentage. Finally, the income from an advertising image is typically a one-time proposition, whereas stock photos can generate money for years.

Stock agencies rent images to clients who come to them with specific needs. The agencies must maintain large well-organized libraries of strong photos. Photographers are chosen on the basis of an imaginative portfolio and the proven ability to produce. Usually a minimum number of new images are demanded each year. The agency will maintain a want-list of current popular subjects — for example, the environment, teenagers, or biotechnology — and photographers must by themselves arrange, produce, and finance self-assignments that will generate exciting images that illustrate the topics in question. Any and all formats are used but the final product will be either a 35mm or 4" x 5" duplicate transparency. Income will be a percentage of sales. This field is for self-motivated people.

The rise of digital imaging has had a negative impact on the middle and low end of the stock photography business. The Photo CD has spawned the photo-disc crammed with clipart images available for unlimited use for only a few dollars each. At first the phenomenon of ultra-cheap electronic stock caused considerable worry in the industry. It has become apparent that the electronic flood might very well obliterate some traditional markets while enhancing others. In response to the new environment, high-end stock users are demanding that the images they lease be strong and distinctive. This has nurtured the growth of assignment stock, a discipline closely related to advertising illustration in that stock shooters are assigned particular subjects to cover, complete with deadlines and technical specifications.

The increased sophistication of the Internet and commercial on-line services is creating a new stock market. Individual photographers are posting their own collections of stock images for customers to download anywhere in the world. See Chapters 7 and 17 for more information.

SCHOOL & TEAM PHOTOGRAPHY

In Chapter 20 I describe a simple method for making multiple prints. Having mastered this technique, you will know that any market that requires lots of prints from the same negative is a very lucrative market. School and team photography is one of these photographic gold

mines: Once you have established a clientele they will want you back year after year. Schools and community sports groups are everywhere, and the technical requirements for shooting are minimal. This work may not be exotic, but it will keep you in contact with the community and it will pay the bills.

My advice is to stick to medium format for this work—the increased definition will set your work apart from most of the low-ball competition. No artificial light besides on-camera fill flash is required outdoors in decent weather. Indoors take the trouble to use a couple of electronic flash units high up (to avoid reflections from eyeglasses) and situated about 45° to either side of the camera. If you have lights that are powerful enough to bounce from the ceiling or from a couple of big umbrellas, all the better. When shooting space permits, abstain from extreme wide-angle lenses because they introduce unflattering distortion at the edges of the frame. Watch for reflections from shiny surfaces or windows behind the groups.

On the business side, you will find it a nightmare to deal separately with each individual from a team or class. It is always better to make an arrangement with one reliable person—trade cash or services (extra prints, a personal or family portrait) in exchange for their help organizing the schedule, handling the print orders, and collecting the money. It is reasonable to provide decent sized proofs in advance but it is prudent to collect your money at the time of the print order.

Many school and team markets are already served by mass-production specialists. The only way in is through competitive pricing and improved service. One incentive could be an offer to produce gratis a dozen or so images to illustrate the school yearbook. Shooting the school play or Christmas pageant is another irresistible gift. The community club or amateur athletic association might need portraits of their board of directors or volunteers. Be generous and friendly and new business will come your way.

AERIAL PHOTOGRAPHY

There are some things that cannot be adequately photographed from the ground. These might include buildings and large construction projects, industrial sites, agricultural scenes, geographical topography, and even entire cities and towns. The solution is to use a helicopter or

small plane. This does not have to be an expensive production under-
taken by experts only. Like other photographic techniques that seem
intimidating at first, aerial photography can be straightforward and
economical if the proper preparations are made in advance.

It is wise to start organizing an aerial shoot at least a week or two
beforehand. Air traffic is tightly controlled by many regulations so
pilots will need a few days to obtain the necessary permission from reg-
ulatory bodies to fly low, especially in urban areas. Generally it is not
too difficult to arrange to fly at fifteen hundred feet or higher, but to
get lower involves a fair amount of red tape.

The yellow pages of the phone book or a few calls to local television
news producers will yield a list of flyers experienced in working with a
cameraman. Call ahead and arrange to inspect the plane or helicopter.
Generally a door or window can be removed for unobstructed shooting.
Some aircraft have removable panels in the floor. Take along your
equipment. As you sit in the passenger seat familiarize yourself with
the limitations imposed by the structure of the aircraft and the safety
harness you will be required to use. Discuss with the pilot how you will
communicate during the flight (a headset or hand signals will be nec-
essary under some conditions) and what maneuvers can be safely
carried out while airborne.

Photographic preparations begin with deciding the time of day to
shoot. Dust and smog reduce contrast, so strong side-lighting is often
important to increase contrast and subject definition. This means
early morning or early evening are usually best. The air is cleaner in the
morning, but the evening light is sometimes more interesting as a
result of the coloration which atmospheric contaminants produce.

Film and format are dictated by mechanical limitations—aircraft are
always moving, so quick and easy operation is the rule. Small- or medium-
format motor-driven cameras are best. If you can rent a gyroscopic
stabilizer that screws into the tripod socket of the camera you will be
able to control the major gremlin of aerial work—vibration. Helicopters
are particularly bad but turbulence can disturb even the most stable
craft. Fast shutter speeds are necessary to counter both mechanical
vibration and horizontal movement through the air. It is best to use
the highest shutter speeds available. Apertures can be wide, since
depth of field is not a problem. It is sensible to actually tape focusing
rings at the infinity position.

Shooting on the fly requires that the photographer pan the camera to keep the subject framed in the viewfinder. This is accomplished by shifting in the direction opposite to that of the movement of the aircraft. Higher contrast negative films like Kodak GPX or PRN, or the slower Ektachromes are the best choices. Ultraviolet filters improve haze penetration and increase color saturation.

All this might sound exotic to the beginner, but it will be a lot of fun if properly planned. Costs can be controlled by making certain that arrangements can be changed at no cost and at short notice in accordance with the weather. Plan your flight so that time in the air is minimized — the helicopter service I use actually charges by the minute. Plan your shooting angles ahead of time and work out a sensible flight pattern with the pilot on the ground. Take along spare equipment as insurance against breakdowns in the air. Check with your insurance agent to make sure you are covered for aerial work.

The costs vary according to the type of aircraft. I prefer small helicopters because of their maneuverability — in my area they rent for about three hundred dollars per hour. With a cooperative pilot I can fly from the airport to downtown, shoot half a dozen different views of a building or an industrial site, and be back at the airport in about forty-five minutes. A small plane is cheaper — seventy-five to one hundred fifty per hour — but considerably less flexible in the air. The same assignment might take up to an hour and a half in a plane. A good way of reducing costs is to solicit work from more than one client. There is very little traffic at fifteen hundred feet so it is easy to shoot half a dozen different sites during the same session. Many people believe that aerial photography is prohibitively expensive, so an offer of reasonably priced shots is difficult to resist.

Remuneration for aerial work can be higher than regular commercial work when clients recognize that both costs and risks are greater. A rule of thumb is to add 50% to your normal hourly or day rates. Earnings are further enhanced by print sales. Aerial views are striking if properly done, so large display prints are often requested. Commuting time in the air can be put to good use by shooting 35mm slides for stock.

HOBBY & SPECIAL-INTEREST GROUPS

Many people participate in activities outside of work, school, and family. These groups range in sophistication from model airplane clubs all the way to national-level political organizations. In every case an appropriate photograph is considered a valued tool or memento, but organizing really good photography is commonly neglected, and the work is normally done by the nearest amateur. It is a simple matter to make your services known to the organizers. Watch the local newspapers for announcements of upcoming events such as craft fairs, meetings, conventions, and fundraisers — there will always be a telephone number.

Many groups will be surprised at the services a reasonably priced professional can offer. Your most effective selling tool will be offers of no-charge photos of special events or special people in exchange for access to the membership. Profitable areas will be multiple print sales of group photos plus well executed images of whatever the membership is interested in; model airplanes, arts and crafts, antique cars, etc. Secondary markets for the same images might be local or regional newspapers or specialty magazines and newsletters. Many groups on the local level are strongly interconnected with like-minded groups on the national or international level. Take good care of everyone and you will be pleasantly surprised as your market naturally expands.

BOUDOIR PHOTOGRAPHY

Many mystical traditions warn that it is unsafe to pursue the secrets of the cosmos until one is at least forty years old and in possession of good measures of both maturity and wisdom. The same proviso applies to those who would pursue this most intimate realm of specialized portraiture.

Boudoir photography is a novelty in the commercial photography world, unless you happen to be working for such publications as *Playboy*, in which case we are talking about very big business. I will leave matters of taste to individuals and their customers, but let's assume that something a little less explicit than the aforementioned publication is typical for local glamour shooting. In any urban area there is some market for this kind of work — generally speaking fun, good taste, and soft lighting are combined in the making of images that are playfully seductive.

The subjects are almost always women, and the photos are inevitably gifts for boyfriends or spouses. Such work, when undertaken discretely and in good taste, is not undesirable as a sideline or specialty within a commercial photography practice. However, I recommend against shooting images involving nudity. The potential for messy misinterpretations is not worth the trouble. In any case, the presence of a third mature person in the studio during the shoot will provide a measure of protection against unsavory rumors, etc.

Practically speaking, all the techniques of Hollywood-style glamour portraiture apply here. Studying how the masters do it is probably the quickest route to technical and aesthetic control—many excellent books have been published on the subject. Some sessions will go better if a friend, spouse, or parent is present during the shoot; some will not. Sensitivity to the fears and desires of the subject is of course the key to success. Everyone you shoot will have special features—legs, face, hair, body—that can be emphasized photographically.

Rates for this work are higher than normal portraiture. The preparations beforehand and the typically challenging shooting conditions warrant the extra charge. You will find that those who seek out such photographs are happy to reward consideration, professionalism, sensitivity and tact.

LEGAL, SECURITY, INSURANCE, & ACCIDENT PHOTOGRAPHY

Attention to detail and a minimum of equipment will go a long way in this business. The job essentially requires documentation of physical conditions as they exist—or existed—in the real world. Everyone in the insurance and legal fields has a need for clear photographs (often, but not necessarily in color) whenever disputes of various kinds arise. Those who own objects and real estate that must be insured also benefit from a photographic record. This is not glamorous work, but it can be quite rewarding for the persistent and the methodical in search of extra income. Advertise your professional capabilities to the major legal and insurance firms in your area. Small ads in local papers will start the ball rolling with private citizens. Upscale retail stores might be willing to give your business cards to customers making major purchases in exchange for photos for their inventory.

Technically, the requirements are straightforward — decent 35mm equipment, fine-grain film, and portable flash will handle most situations. A macro-lens is useful for shooting coins, stamps, or jewelry. Most customers will be satisfied with machine made 3½" x 5" prints, although the occasional client will need 8" x 10"s as supporting documentation in court or arbitration proceedings.

There is one consideration in this work that must not be overlooked: accurate notes. All negatives and prints must be annotated with shooting date, location, and other particulars as specified by the client. Data backs are a relatively inexpensive way to take care of some of the paperwork, but there is no substitute for written records.

Rates vary all over the scale, but a starting place might be fifty dollars per hour plus a 50% markup on drugstore photofinishing rates for your area. Heavy-duty legal work for a large firm might bring in one hundred dollars per hour plus expenses. You will be worth more as you become fluent in legal jargon and the protocol around various kinds of litigation.

SMALL MAGAZINES & WEEKLY NEWSPAPERS

In the section on editorial photography I outlined the standard of work expected by national and international magazines, however a surprisingly accessible local market permits the aspiring photojournalist or editorial shooter to learn and earn at the same time.

Most communities support small weekly papers that feature local political, economic, social, and cultural events. When advertising revenues support the expense, these newsprint tabloids evolve into modest glossy magazines featuring some color photography. The realities of their markets dictate very tiny budgets for photography, and this fact is a blessing in disguise for ambitious photographers.

Anyone who takes the trouble to bring in printable photos of the events that interest these publications is guaranteed publication plus enough money to recover shooting costs. This is an easy way to break through the classic paradox of big-time publishing which mandates no assignments without experience, but no experience without assignments.

Working for small papers and magazines hones photojournalistic reflexes and technical skills while building credibility with local movers

and shakers. Good work submitted on speculation will lead to one-shot assignments and eventually feature stories. After a couple of years of conscientious shooting you will have an armload of tear sheets and samples, possibly enough to warrant the trust of some nervous editor at the assignment desk of a big city paper or national magazine. Another advantage: The weeklies usually have decent circulation and are willing to trade advertising space for photographs. This means that you can promote and expand other aspects of your commercial photography business while you train for wider horizons.

PEOPLE & PET PORTRAITURE

This book is mostly about commercial photography, a business that in some circles has a fairly exotic reputation. Although there is a certain caché to shooting celebrities, politicians, and exotic products, ordinary portraiture has charms of its own. The work takes patience and affection for regular human beings but if your disposition is suitable there will always be customers.

Portraiture is a practice where you can set your own schedule. Another plus: portrait income is derived mainly from the sale of a number of relatively pricey prints. Darkroom work is easy money.

There are many excellent books available on portrait technique and marketing. Kodak publishes a very useful pamphlet that by itself covers most conventional practices.

DEALING DIRECTLY WITH PRINTERS

Some buyers of printed commercial materials choose to retain more control over expenses and aesthetic matters by taking their work directly to printers rather than to designers or advertising agencies. This scenario leaves a very interesting door open for ambitious photographers.

Printers come in all sizes. Just like small magazine and periodical publishers, the smaller printing outfits are willing to try relatively unknown photographers that demonstrate basic skills and enthusiasm. Printers use photography as components in commercial projects rather than journalistic projects so they can afford higher input costs.

Other substantial opportunities flow from direct association with printers. The projects that result from successful collaborations can be

as lucrative and as technically sophisticated as any agency extravaganza. Working closely with printers will provide immediate feedback about what photographic solutions work in print, and why. This knowledge is invaluable to those who want to do the very best work at any level.

FINE ART PHOTOGRAPHY

I was an unhappy kid. I grew up in the barren suburbs of a midwestern city and I didn't realize I was bored silly until out of the blue my grade eight teacher, a radical soul in 1962, gave me her camera and ordered me to go take pictures. I discovered I had a natural gift. My very first photos were good.

After this serendipitous initiation I pursued a career as a fine art photographer. I devoured books by Ansel Adams and Andreas Feineger and magazines like *Life*, *Look*, and *Camera 35* for inspiration as I struggled through trials and errors. My camera accompanied me everywhere. I spent hours and hours in my modest darkroom under the basement stairs. Back then beautiful photographic papers like Ansco Cycora cost only ten cents a sheet, so the raw materials were not out of reach.

After two or three years of solitary labor I made a contact that widened my horizons: I answered a small advertisement in a Canadian photo magazine. The ad, placed by the Still Photography Division of the National Film Board of Canada, asked for submissions of original images made by contemporary Canadian photographers. They took an interest in what I was doing, and their interest gave me the credibility and confidence that ultimately led to one-person shows at the University of Manitoba and at the University of Winnipeg. By the time I was nineteen I had satisfied my strongest creative urges and my ego. In another market in another time fine art work could have been more lucrative, but even though resources were scarce I gained a measure of national recognition, made some money, and laid the groundwork for a lucrative career as a commercial photographer.

Commercial photography is a very bold exploitation of creativity in exchange for cash. The relationship between fine art and money is a little less direct. Presently the market for works of photographic art is shrinking due to a collision between two decades of economic excesses and the recent conservative backlash. Twenty years of remarkable pub-

lic and corporate support for the arts is being eroded by right-wing anti-art attitudes. Nevertheless, large sums are still paid by a mixture of deep-pocketed aficionados and high-rolling corporate speculators, in addition to more modest amounts dispensed by individual collectors and smaller businesses looking to nurture a contemporary public image.

Outstanding commercial shooters — Richard Avedon and Annie Liebovitz come to mind — have been elevated into the world of fine art by virtue of the quality of their imagery and the wide exposure afforded their work for hire. Many earnest students of photography have progressed through the fine arts faculties of many prestigious universities and are now looking to make a living with their art. One very practical change: These people are no longer automatically condemned as sell-outs when they accept commercial assignments. Fine-art photographers are actually being sought by users of commercial photography in search of fresher, less jaded approaches to advertising illustration.

THE **BIG** SHOT

Advertising illustration encompasses virtually every photographic skill. Ninety percent of commercial photography is simply the intelligent and consistent application of basic technique. However, with increasing frequency as one's reputation grows, producers of advertisements come looking for the big shot, a particularly outstanding image that is a combination of imagination and technical virtuosity. An example became the central element of a national campaign for a major airline. The evolution of this assignment involved the cooperative efforts of several people.

The original idea was a response to Canadian Airline's intention to contribute financially to worthy cultural institutions. The campaign, entitled The Art of Flying, was intended to inform travelers of the fact that, for a certain length of time, Canadian would donate five dollars from every ticket sold to performing arts groups. The campaign would involve a number of elements, notably direct mail brochures, four-color process print ads in national magazines, and backlit posters for airports.

The AD envisioned a still photograph as the main graphic element. She wanted a romantic, delicate image of a pastel-colored surrealistic room with arched windows, a parquet floor, and a clear blue sky for a

ceiling. Various items symbolic of the performing arts were to be float-
ing or flying gracefully through this room, thus "The Art of Flying."
There was concern that the image was going to be extremely diffi-
cult to produce. The AD proposed a large set, perhaps six feet wide,
that would have to be built from scratch and then photographed with
an extreme wide-angle lens to achieve the exaggerated perspective.
The floating objects would be shot separately and stripped in elec-
tronically. The AD didn't know how the undulating ribbons she
wanted could be incorporated.

I attended a meeting to see the mock-up comp (composite render-
ing) and to discuss the technicalities. It took only a few minutes for me
to realize that it would be difficult to create an image that evoked a feel-
ing of flying by assembling components photographed at different
times. I asked for a day or two to come up with an alternative and an
estimate of costs.

From my experience shooting the performing arts I knew that set
makers often created rooms with odd proportions and I reasoned that
a small room could be built to scale using the same methods. If the var-
ious props could somehow be suspended invisibly the whole thing
could be lit and photographed together as one convincing illusion. I
wasn't yet certain how to deal with the ribbons, but I was quite sure
that a single image was the best approach.

I called the master prop maker at the Manitoba Theater Center. He
agreed to build a room-to-scale for less than eight hundred dollars. It
would be about three feet wide and would be built to incorporate the
perspective effect we needed. The back wall of the model would be lam-
inated to a piece of ¾" plywood so that it would support stiff wires from
which I proposed to hang the props.

During another meeting I convinced the AD that a single photo
would work. The savings on electronic retouching alone would amount
to many hundreds of dollars, which she appreciated. A mask, a ballet
slipper, an ornate picture frame, and a violin were chosen to be the
floating elements. The problem of their relative sizes was not resolved
until I remembered having seen very small $\frac{1}{16}$ scale violins intended for
use by children studying the Suzuki Violin Method. The art director
had a miniature picture frame made up, and a child's ballet slipper was
found next. An appropriate mask was located at a toy store and some
pretty sequins were glued on by the AD.

My assistant came up with a clever idea for the floating ribbons. He suggested that two identical ribbons be sewed together, back to back, over a slightly smaller strip of thin sheet metal. They could then be coiled and looped gracefully through the other props and still retain whatever shape was required. The art director did the sewing herself.

The miniature set was commissioned and constructed. It arrived in about one week, and I had very little trouble mounting the four main props to stiff wire projecting from the back wall as planned. The AD came to the studio and together we placed the ribbons. From the camera position none of the supporting wires were visible, and the floating objects looked absolutely magical. The lighting took about an hour to organize, and the photo, shown on the front cover, was made on Kodak VPS Type III 4"x 5" film. A 16"x 20" color print was retouched to correct some small imperfections in the set. All the print materials for the campaign were derived from the retouched enlargement. The campaign was a success. In addition to pleasing the client, the print materials won several awards.

Working Outside the Studio

In medium-sized cities, where specialization is more or less an impossibility, much of the commercial photographer's work must take place on location away from the studio. This work includes editorial, industrial, and audiovisual photography, together with executive portraiture, corporate brochures, or annual reports, and much more. Advertising illustration involving a product that is extremely big, delicate, or valuable will have to be shot on location as well. All this can be very trying but there are a few practical guidelines that will make the work flow more smoothly. The following advice is intended for those who must undertake assignments anywhere from within a few blocks to a few hundred miles away from home.

Travel photographers and internationally oriented photojournalists cover a much wider and more exotic territory. Because I have never been involved in these occupations, I lack the expertise to counsel anyone interested in such work. Ken Haas has written a comprehensive guide to working around the globe called *The Location Photographer's Handbook*.

LOCATION WORK & THE ONE-PERSON OPERATION

The commercial photographer outside the studio is a technical one-person operation totally responsible for selecting, transporting, erecting, and tearing down an appropriate collection of tools. In addition to packing and using the gear, location shooters must guard against dam-

age and theft, as well as ensure that their work doesn't cause any undue wear and tear at the job site, which could be anything from a fancy executive office to a high-tech scientific laboratory to a retail store full of valuable art objects. The only way to maintain one's composure on location is to plan ahead. Remember, life on the road can be hard at first, but the discipline and experience that comes from doing it alone will prove invaluable as the scope of your work expands to the point where one or more assistants have to be managed efficiently.

WITHIN DRIVING RANGE

Try to find out as much as possible about the place where you will be working. During the initial telephone contact with your client inquire about ceiling height, the size and location of windows, the nature of the available artificial light, the availability of electrical outlets, and the placement of circuitbreakers. Determine the most efficient access from street level and the proximity of elevators. If you are at all uncertain about the nature of the environment, make a personal visit.

Next, decide on how much equipment is required and how it will be moved. Much of the location work can be completed adequately using equipment that can be carried by one person, usually this means one camera bag containing a 35mm or medium-format system and a compact lighting case. A more elaborate job might need a 4" x 5" kit, a high-power flash generator, three or four heavy-duty stands and heads, and some cloth or paper background material. The bigger load can be handled by one person if it is cleverly packed onto a two-wheel dolly and secured with elastic cords.

A complicated job will require all your heavy equipment but it will also require a photographer that is alert and well rested. Use a messenger or courier service to transport the equipment: It is cheap, and no special skills are needed just to transfer stuff across town. Save your energy for setting up and shooting.

Always make sure that adequate backup equipment is close at hand. For example, if you are shooting with medium-format cameras and a sophisticated electronic flash system, keep a tripod, a 35mm kit with some fine-grain film, and a portable flash in the trunk of your car. It's always better to provide something reasonably acceptable, rather than have to cancel a job because of a technical problem.

WORKING STYLE ON LOCATION

Management usually responds to the presence of a photographer in the workplace in one of two different ways. The first and least attractive reaction is to treat photography as an unproductive interruption by applying pressure to complete the whole process as quickly as possible. It is not hard to understand this point of view, considering that thousands of dollars worth of person-hours can be wasted by an inefficient shooter who ties up a high-speed assembly line, for example. The second reaction is no less realistic, but certainly much more positive from the photographer's point of view. In this case the presence of a skilled professional photographer is seen as a morale booster for the workers being featured in the pictures, and the resulting psychological boost is recognized as ultimately good for the bottom line. When you encounter the first reaction, take a few moments to tactfully point out the benefits of the second.

A wise old Inuit was asked what he considered to be the main survival technique for living in the high arctic. He answered simply, "Never sweat." The same advice applies to location photography. The studio is a place where careful photographers can exercise total control over their work, but away from the studio photographers are pressured to work less methodically. Most people, including clients, have virtually no knowledge about how commercial photography is properly done. On location, most civilians quickly grow impatient with the many small adjustments and arrangements that are at the heart of excellent photography. This impatience can become infectious, but it must be resisted by the photographer. Whenever possible, a measured pace is the key to success.

Before the job begins, prepare your client with a reasonable estimate of the time the work will take. While shooting, keep clients and both nonprofessional and professional models informed about how much time things will take overall, and approximately how long their individual involvement will be required for each shot. Once an agreement has been reached regarding how much time is available for the shot, calmly assume that everyone will cooperate for the duration. Don't lose your cool in the face of recalcitrant behavior, just keep pressing diplomatically for whatever you need to get the job done right. Make sure to thank everyone who helps you and leave everything just as you found it before moving on.

WORKING OUT OF TOWN

The potential for grief escalates when you have to fly. Airplane travel usually means physical separation from one's equipment and increased risk of theft or accidental misdirection. Hotel rooms and rental cars are vulnerable in the same way. Don't advertise your valuables: Make, or have made, some nondescript cases — locked, well padded ⅜" plywood boxes are great — and avoid labeling the contents. (I use nondescript Coleman camping coolers secured with three nylon straps for my equipment.) Use your own name on baggage stubs, rather than your business name. Keep cases and gear covered or locked away in the rental car trunk. Check with your insurance agent to make sure your stuff is covered for travel by air in general, and mysterious disappearance in particular. If equipment is lost on location, phone your agent right away and report the loss. Rent whatever is necessary to complete your work, and keep all receipts plus a detailed account of the extra time you had to spend — you will be reimbursed if you have a policy with a business interruption clause.

Generally speaking, airlines will permit photographers to carry on a moderate complement of equipment. Cameras, lenses, and film should be the priority. X-ray-proof bags for film are a waste of time, since carry-on luggage can be inspected by hand on request. When asking for this service, indicate that you are a professional photographer and have your business card and some other identification ready. It may require a few extra moments to explain that 4" x 5" film boxes can't be opened in daylight. Carry a ten-sheet box with few pieces of film in it to demonstrate the construction and contents of the boxes you are trying to protect. Diplomacy is the key to success. One sure-fire way to beat the X-ray menace is to buy fresh film at your destination. This is a little inconvenient, but it will save aggravation at high-security airports.

Many airlines provide special treatment for the luggage of first-class passengers. This is the best method to ensure that your equipment arrives at the right place at the right time if you can convince your clients that the extra money is worth the reduced worry and that their photographer needs to arrive on location rested and unflustered.

When I travel, I take along a sturdy collapsible two-wheeler dolly to help make long airport treks more manageable. On jobs where several cases of equipment must be moved, an assistant is a necessity, for

security as well as for energy conservation. Someone should always watch the equipment, even if this means eating in turns, and moving equipment in relays. When I travel with an assistant I prefer to rent a car with a hatchback for easy access; when I work alone I prefer a car with a lockable trunk or a fully enclosed van. A few short lengths of light metal chain and two or three small keyed-alike padlocks will go a long way toward deterring pilfering when gear must be left unattended in hotel rooms or vehicles.

I have several friends who travel as representatives for various camera manufacturers, and I rely on their advice about decent hotels and restaurants. Generally the people you work for don't want to know the details of your accommodations, although some corporate clients will have their local staff help you get organized.

Up to date knowledge of the weather is critical for outdoor location work. The most reliable source will be the meteorologists at the airport listed in the phone book under *"Weather information, aviation."* On complicated jobs allow at least a day for orientation and scouting. Architectural work in a strange city can be tricky to orchestrate, since navigation around the city and the selection of appropriate sun angles depend on one's knowledge of the local geography.

Work extending over several days should be processed on location to alleviate worry over the success of the shoot and to eliminate the possibility of accidental damage to unprocessed film while traveling. Divide the shoot into two batches and have each lot processed on different days, or at least different film runs. (Check with the local Kodak representative to find the best professional lab available. Save time by doing this at home before you leave.)

REASONABLE CLIENT EXPECTATIONS

First-class travel plus time allocated for orientation are very helpful, but some clients aren't so sure about the value of any sort of special treatment. It is necessary to set a few limits on clients' demands while on the location or else working conditions can quickly degenerate to unacceptable levels.

Perhaps the most abused parameter is the length of the working day. At home, an eight- or nine-hour period is naturally assumed to be the maximum for a specified day-rate, but out of town sometimes ten,

twelve, or even fourteen hours are expected. This expectation is aggravated by the fact that extended days are sometimes necessary photographically for outdoor work, since the most pleasing light conditions typically occur around sunrise and sunset. It is best to negotiate working hours before the job is started. For your own peace of mind and physical health, ensure that there is adequate time for rest on any prolonged location shoot. Financial compensation for unavoidably long days should be part of your business arrangement.

How to deal with delays due to weather or other conditions beyond your control should be discussed beforehand, as well. One third or one half your normal day rate, plus expenses, is reasonable to expect for holdovers and travel time. Similarly, any camera repairs or cleaning that are necessitated by adverse conditions (such as sand or salt spray) encountered on location should be considered. Most clients will not object to such costs if they are factored in during the planning stages, but they will inevitably object after the fact.

MINDING THE STORE

Some local work will inevitably be lost when you are out of town on assignment. If the absence is to be a lengthy one, it is considerate to inform your regular clients about how long you will be gone, and arrange with a trustworthy professional colleague to be on standby while you are away. This is a prudent practice when you take a vacation as well.

Short trips can be managed by simply checking your answering machine or service a couple of times each day. When things are very active at home, use the hotel fax service or bring a fax-equipped laptop computer so that you can continue your quoting. If calls are answered promptly, new work can be handled by careful scheduling.

RECOVERING TRAVEL COSTS

When quoting any location job, stipulate a satisfactory day rate plus a reasonable estimate for expenses such as car rental, hotel, meals, and film processing. It is a simple matter to keep receipts and provide photocopies when the final invoice is submitted. All expenses are fully deductible at tax filing time. I believe that it is unreasonable to expect

long-distance charges unrelated to the job at hand to be considered a billable location expense.

SELLING BY DESTINATION

A few weeks before I leave for a scheduled out-of-town assignment, I call some of my other clients to let them know where and when I will be working. Several architects, developers, and a high-tech window manufacturer headquartered in my home city all have projects in other centers across the country. An offer from me to split or reduce travel expenses often results in additional assignments.

Making It Happen

ATTITUDE

I have lots of fun, I make a decent living, and my clients like me. Lately people have been attaching notes to their checks: "Good work, Gerry!" "Always a pleasure working with you!" "Thanks again for your help!" My voice mail regularly collects similar kind comments and heartfelt thank yous. From time to time I get so busy with interesting and lucrative photographic assignments that I am forced to adopt the personal working schedule of designer, architect, and futurist Buckminster Fuller—two hours sleep every six hours, around the clock.

A business consultant would say that success of this sort must be the result of intensive marketing. Conventional wisdom, backed up by scientific studies, says that direct mail followed by telephone calls and personal visits are the most effective marketing instruments for service-oriented industries like commercial photography. In twenty years of business I have never done a direct mail piece and I don't maintain a formal portfolio either.

All this is not to say that excellent direct mail, a solid portfolio, and good telephone technique are unnecessary. Those of you who are breaking into the business, and all of you who are seeking to expand an existing operation cannot lose by putting creative energy into self-promotion initiatives. Circulating a strong portfolio and clever, tasteful mailers will certainly get your name out there.

You must understand, however, that these advertising devices are only part of the art of marketing and that their effectiveness will inevitably diminish as mailers and portfolios from your competitors

increase in sophistication. In fact, I envision a time, perhaps not far away, when frantically creative self-promotion pieces might even have a negative effect on prospective clients.

In light of my own feeble efforts at formal self-promotion, you might well ask what exactly do I do that keeps me so busy? First, my work is always technically and aesthetically satisfactory—how I am able to do this consistently is described elsewhere in this book. Second, I maintain telephone contact with my clients — mailers or no mailers, there is no substitute for regular, sincere demonstrations of interest. This is a fast-paced business. Couriers, fax machines, and computers have the unhealthy effect of reducing personal contact between photographers and their clients. I check in via the telephone to make sure that my customers are happy with assignments recently completed and to chat about work that might be coming around the corner.

Notwithstanding all of the above observations, there is a powerful marketing tool that eclipses both technical and artistic achievement and timely talks on the telephone. To put it simply — be nice.

I don't mean nice as in good manners and clean clothes, although these are certainly a part of effective marketing; nor am I talking nice as in returning phone calls promptly and being honest when billing for travel expenses. Although it is certainly nice to attend properly to deadlines, to keep to quoted estimates, and to follow layouts exactly, there is a larger, transcendent dimension to niceness.

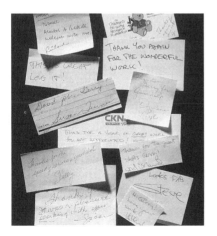

Figure 17.1

This collection of unsolicited thank-yous proves I must be doing something right.

Here is how *Webster's Dictionary* defines "nice":

1. Fastidious, discriminating, well-executed

2. Pleasing, agreeable, well-bred

3. Virtuous, respectable

4. Marked by delicate discrimination or treatment.

Point one refers to craft—doing the job well makes your work attractive to your clients. Point two has to do with manners, personal deportment, and tact — things that will make your clients respect you as a person. Point three addresses issues of honesty and reliability — conditions that lead to long, productive business relationships. The first three definitions of niceness are powerful and fundamental elements of successful marketing. Point four, however, surpasses them all in significance.

What is *delicate discrimination*? I define it as the development and practice of insight, good judgment, precise discernment, and sensitive observation of human interactions—all of which are the necessary precursors of *delicate treatment*. What is delicate treatment? To me, delicate treatment — i.e. consideration, compassion, cheerfulness, helpfulness, even affection — is the ultimate marketing technique.

MARKETING & PROMOTION

Marketing Strategy

The definition of fame is that a lot of people know your name, regardless of what you do or how well you do it. There is some comfort in this notion for newcomers to the photography business since it means that it is not necessary to be Richard Avedon or Pete Turner to attract attention. A marketing strategy is a plan to effectively spread your name around.

Direct Mail

Your client list will build gradually if you establish a reputation for doing good work. This is psychologically satisfying but, in a small or very competitive market, business may expand too gradually if word-

Figure 17.2 A&B (See also Color Figure 5)

Here is the front and back of the call for entries for the Signature Awards, sponsored by the Advertising Association of Winnipeg. I produced the pictures for the cost of materials only. I had for my trouble my name attached to a beautifully designed and printed piece that went directly to every advertising professional working in my market. An added bonus—I entered the project in the photography category, and it won the Signature Award for best use of photography in an advertisement or collateral material. Peter George of Taylor-George Design was the designer and art director. (*Fuji 680GX/100mm lens/Fuji RVP film/Electronic flash.*)

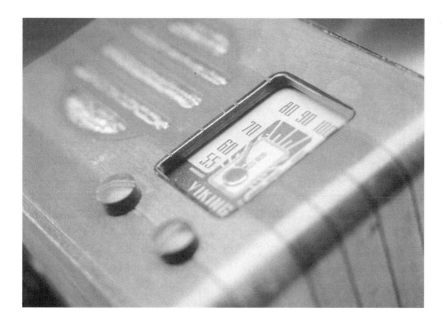

of-mouth advertising is your only public-relations (PR) vehicle. Self-promotion with direct mail is relatively inexpensive and highly efficient whether you intend to solicit new customers or to simply keep those customers who have already used your services informed and interested.

A straightforward method of producing a memorable mailer is to photographically reproduce a striking image together with some suitable copy on 8" x 5" paper (half of a standard 8" x 10" sheet) that can be addressed and mailed like a postcard. You might offer your services to a graphic artist or designer in exchange for advice on a stylish layout. For one mailing you will likely need less than one hundred units. They can be made at low cost in your own darkroom or at a commercial color lab.

Dean Collins is a successful west coast photographer who has researched the effectiveness of direct mail. His informal studies revealed that most unsolicited promotional material is received — and immediately discarded — by secretaries and receptionists, mostly females 18–25 years old, whose main interests are girlfriends, men, sex, and babies. Politically correct or not, Collins tailors his direct mail items to please these people, ensuring a higher than average retention rate for his promo pieces. I don't endorse the perpetuation of sexual stereotypes, but his reasoning makes sense.

If your mailer is sufficiently eye-catching it will be tacked up on walls and bulletin boards where it will quietly broadcast your skills for days, or even weeks. In highly competitive markets it helps to send out a new mailer every couple of months.

Press Release

Modesty is an impediment to good marketing. Follow Hollywood's example and abandon your reservations about self-praise. The press release is an instrument that can generate free advertising.

To get your material into the papers or on the air it is necessary to make a study of the local media. Ask yourself the question, what events are of sufficient interest to be published or broadcast? The types of items picked up by the papers, radio, or television depend on the size and sophistication of their markets. Your local neighborhood media are most accessible, so start with them.

Suppose you have been hired to make PR photos of a state or federal politician in town for some special event, perhaps the announcement of some new policy initiative. Ask someone to take a photo of you while you are working. After completing your assignment sit down and type a few paragraphs under the heading "Local Photographer— Witness to History," with the subheading "For Immediate Release." The text should be double-spaced and no more than one to two pages in length. Include human-interest details about the event gleaned from your special perspective. Be interesting, but not gossipy. At the end of the text type "-30-," press release language for "the end." Send a photocopy of your press release, a photo of the politician, and a picture of you at work to every local paper.

You will be surprised at how often your material will be published and how quickly your reputation will expand in the community. Be alert to angles that will make your work a subject of interest to others. As the scope of your endeavors expands you can submit press releases to larger media outlets.

Telephone Technique

After having paved the way with a mailing or a piece in the local paper, use the telephone to set up a personal meeting with prospective clients. All the businesses and institutions that commercial photographers can work for are listed in the phone book. It is easy to call general office numbers and find out the names of art directors, communications officers, and chief designers. When you call to arrange an interview, ask for them by name. In simple language, say who you are and what you want. You will be surprised at the number of positive responses. People are very busy these days, but many wise professional communicators want to meet new people and see new work, if only to stay abreast of current trends.

On the day of your meeting, call to confirm that your future client is available before you leave for the meeting. Although you can expect civilized treatment, you are a low priority and your visit may have been forgotten or preempted. If you are forced to reschedule once or twice, be patient. If you are stonewalled three times in a row, try someone else.

Portfolio

A successful meeting with a potential client requires decent manners and a carefully edited "book," or portfolio, consisting of some of your best work.

The perfect portfolio is not necessarily a showcase for your favorite shots. Find out the kind of photography your potential customer usually buys. A designer who specializes in corporate annual reports wants to see several first-class industrial location shots, five or six formal and environmental executive portraits, plus a handful of striking product photos. Some innovative architectural shots of office towers and factories would also make sense. It would not make sense to show photographs of food, the performing arts, or women in fancy clothes, regardless of how well executed they may be.

I've found that it is most effective to show no more than fifteen pieces at once. It helps if everything in your portfolio is of a uniform size. Laminated but unbound 11" x 14" prints with two- to three-inch white borders are striking to look at, satisfyingly substantial to the touch, and durable. They fit nicely into a briefcase and are easy to edit and assemble for specific purposes. Tearsheets of printed ads and magazine layouts can be copied and reprinted to the same format. Include current work only, since designers and art directors work very much in the present. Regularly replace any samples that become damaged or discolored. (Should you have to submit a portfolio by mail or courier, include return postage or offer to send a messenger to retrieve it.)

In order to stand out from the competition, some photographers create exotic portfolio cases using materials like leather, wood, cloth, ribbons, plexiglass, or even metal. This is fine, to a degree. Should you decide to take this approach, be sure the material inside matches the packaging in visual strength. Avoid complicated bindings and fasteners. Ensure that whatever you build is sturdy enough to survive normal handling. Do not use a lot of bubble wrap and shipping tape. The final package should not weigh more than five or six pounds and should not exceed the dimensions of a standard FedEx box.

Make sure that you arrive on time for your appointment. During your presentation, remember that you are talking to an experienced professional who will judge your work quickly. Each photograph might be reviewed for only a few seconds but don't take offense. These people

are busy and fifteen minutes of their time is the maximum you can reasonably expect. Have your pitch well rehearsed and do not repeat yourself. Should your work be praised, respond with a simple thank you. Don't point out favorite images or assignments — the viewer may disagree. If a particular photo attracts negative attention ask why, but don't solicit advice on how to improve your work, and definitely do not argue. Do not overstay your welcome. When you are done, leave gracefully.

Free Radio, Television, and Print Advertising

Commercial photographers make a living mainly from the advertising business. They rely on advertising when they want to buy or sell equipment or a vehicle. They rely on advertising to find a studio location, and they advertise to sell their business or building when they retire. Whey then do photographers resist advertising their own services? Modesty might have something to do with it, but cost might also a factor. There is a painless remedy for the latter restriction: Contra — bartering between businesses — is a powerful mechanism for maintaining an effective advertising thrust with little or no cash investment.

Contra is different from the press release method of obtaining publicity, because it involves a different group of people and different reasons for their involvement. A press release will be published whenever it appeals to those in the media concerned with editorial content — if a story is of interest to readers, listeners, or viewers it is accepted. Bartering for advertising space or time requires the support of an advertising sales manager. They are enlisted by making a proposal that helps them do their job better. It works this way: Offer to provide a promotional package such as an executive, family, or pet portrait or a glamour makeover. The promotion might involve some kind of contest or competition that would attract attention to a newspaper, radio station, or television station. The event could be designed to last for several days or weeks, keeping your name comfortably prominent in the community with a minimal investment of time and materials.

An alternate approach involves trading services. You could provide at cost, or for a reduced fee, photographs illustrating the products, services, or locations of businesses that are paying for advertising space or air time — in exchange you could receive a free television spot or a print ad.

Early on, these angles are easier to pitch to local media but the very same principles apply to sophisticated national and international promotions involving famous products and big corporations. It is only a matter of scale, with the dimensions of the project tied to the reputation of the photographer.

Recently, beautifully printed full-color brochures featuring some of my most cutting-edge work were mailed to everyone in the advertising business in my geographical area, and it did not cost me a cent. How did this happen? I volunteered my services to the Advertising Association of Winnipeg, the professional group that sponsors the Signature Awards, the regional advertising awards program. The request for entries was designed by a prominent firm, and the printing and paper — both of which were first rate — were also donated. I created the ten photographs that were incorporated in the mailer during a six-hour day working shoulder to shoulder with the designer. The Signature Awards committee paid for the materials and processing.

Query Letter

Some photographers are not content to wait for clients to come to them with assignments. Such people see photographic projects all around but the problem is finding the right client to pay for the work. In this age of instant electronic communication it is comforting to note that an effective technique for making proposals to potential clients is an ordinary letter — typically a one- or two-page document in which a specific idea is pitched to a specific client.

The best query letters are simple and short. The format is easy to master. For example, let's assume you are interested in producing a photoessay on a subject such as the advantages of high-tech garbage incineration over old-fashioned landfills. What sort of client would be as interested as you? Why not think big? Every city has the same garbage problems — therefore the issue is of concern everywhere. A national newsmagazine with an environmental section would be a potential client. A query letter is your method of entry.

Include the following elements: Describe why you are writing (the landfill crisis), what you want (an assignment, film, processing, and a letter of reference for reluctant city officials), and who you are and why you are the best choice for the job (lots of experience, connections at

city hall, you live next door to an incinerator). In closing say that a quick response would guarantee an exclusive on this particular story...and that is it. Use clear, economical language.

Follow up your proposal with a phone call if you have not received a reply within three or four weeks. Be prepared to take no for an answer six or seven times out of ten. Keep writing, however, and you will soon be shooting what appeals to you on a regular basis.

ELECTRONIC MARKETING

The Internet is not the whiz-bang marketing vehicle that some enthusiasts would have us believe. Success has been spotty for those who have committed to electronic marketing, and startup costs remain high. The information superhighway is more like an ocean — individual sites are like dust motes floating on its vast surface. Pointing potential buyers to your particular address requires, ironically, a marketing effort that encompasses the techniques described in the preceding pages. A personality-based business like photography inevitably demands personal contact and individualized service; still, any art director who hopes to compete, even in the near future, is learning how to navigate the Internet and its child, the World Wide Web (WWW). For those of you who are so inclined, an e-mail address and a web page may produce results.

You will need an Internet service provider. A local provider is the best choice, assuming one is available where you live, since ongoing technical support is more readily available. Local providers can be found through newspaper advertisements or by polling friends or business associates who are already on-line. Look for a provider that offers easy access and high-speed modems. Modems are the electronic devices that interconnect your computer, the phone lines, and the Internet. You need one to connect to your computer, and your provider needs many to connect each client or user to the net in real time. Modem speed — i.e. how quickly they transfer data — is critical. The absolute minimum speed nowadays is 14.4 baud (14,400 bytes per minute). Your provider should have a sufficient number of modems and a sufficient number of phone lines to ensure that individual users do not have to wait long for a connection. A ratio of twelve phone lines per modem is not unreasonable.

If a local provider cannot be found, then choose a national provider, like MCI (800) 779-0949, Prodigy (800) 776-3449, Delphi (800) 695-4005, Genie (800) 638-9636, America OnLine (800) 827-6364, or CompuServe (800) 848-8199. Service will be slower and technical support harder to come by. Costs will be higher as well.

Your provider will supply an e-mail address, space on their server (a sort of drone computer) for your Internet site, and software that will let you send and receive e-mail messages, browse the www, and participate in newsgroups and chat lines.

Your place on the Internet is called a home page. Browsing the web means looking at the home pages of other Internet users…the more interesting, attractive, or useful a home page is, the more visitors or "hits" it will receive. Web sites are constructed using a simple programming language called HyperText Markup Language (HTML) and can be enhanced using other technologies like Java. If this is beyond your expertise, then hire an Internet-literate student or a professional programmer. Invest a few hours examining as many photo-related home pages as possible in order to familiarize yourself with the possibilities. Your page must look good but it should be compact enough to download within a minute or less…people will not wait any longer.

Do not expect immediate results. Launching a home page is much the same as tossing a message in a bottle into the sea. Eventually it will be seen, but by whom? The vast percentage of Internet users have no interest in commercial photography. Attracting visitors to your site involves some work. Printed materials like mailers or ads in photo-related publications work best. Fax your e-mail address to your existing clients, and include your www address on stationery and business cards.

The Internet is served by yellow pages-type directories such as Yahoo, Infoseek, Webcrawler, Excite, and Lycos. Some will list your address free, others charge a small fee. It is sensible to track down these directories and get your address added to their listings.

Different web sites can be linked interactively. Links to your home page might be established whenever someone thinks your site will be useful or entertaining to visitors to their own site. Lots of links mean lots of hits. You can make your site interesting by focusing on some specialty and by offering something back to visitors, such as a free CD featuring your work. Begin this process by participating in photo related newsgroups and chat lines.

REPRESENTATIVES & AGENTS

Shyness or lack of motivation prevents some photographers from marketing their own creative talents. If the aesthetic or technical challenges are one's only interest in commercial work, and if one's work is sufficiently sophisticated to sell in the big-city markets, then a fruitful business involvement with a marketing specialist is a possibility.

Representatives and agents take 25% to 45% of the fees that flow from the work they obtain for their clients. They offer advice or participate directly in the creation of mailing lists, mailers, portfolios, and web sites. They research photography markets in order to connect the particular abilities of the photographers they represent with appropriate clients. Representatives assume responsibility for initial telephone contacts and make personal portfolio-carrying visits to likely prospects. A pro-active representative will negotiate rates, contracts, and working conditions, and some will assist in organizing actual jobs. All responsible representatives follow up on completed assignments and keep in touch with clients between jobs.

If your temperament precludes enthusiastic selling, look for a representative. Some agents advertise in Photo District News, some can be found in the yellow pages of big-city phone books, and some are on the Internet. In smaller centers that do not support representatives who specialize in photographers, one might be able to share the services of someone who sells for printers, production houses, paper suppliers, graphic artists, illustrators, or musicians. Make a decision about a three- or six-month trial association by paying attention to your gut instincts and by obtaining personal references.

I live in a city of 600,000 in central Canada, and I have a representative in Toronto, a cosmopolitan center with a population of 3 million located 1500 miles east. Toronto is home to the head offices of many big companies, and my representative solicits work for me from national concerns that need photography done in my geographical area. Every year I get a significant number of editorial and corporate assignments in this way at a cost of 35% of shooting fees, exclusive of materials and expenses.

An Introduction to Pricing

A young man who had worked for a time as a financial advisor with a large and respected accounting firm decided to strike out on his own. He approached two brothers who ran a big factory and offered to present a proposal for improving their operation.

The brothers had offices located side by side. Sam, brother number one, was in charge of financial matters, so he met with the young man first and was impressed. Sam asked the young man what he would charge to implement his ideas. The would-be consultant knew that his old firm would charge about eight hundred dollars for the job, but because he was just starting out, he figured that he should ask for less. "Five!" he blurted. Sam then hollered to his brother in the next office, "Dave, how does five thousand sound?" Immediately Dave answered, "Sounds good to me!" "You're hired!" said Sam.

In most transactions the consumer pays a markup over the manufacturers' price for a given product. Photography is priced like that in some low-end markets, but generally the price of commercial photography is not directly related to the cost of production. In other words, it is not uncommon for the value of commercially made photographs to greatly exceed the input costs that were incurred during their creation. Regardless of what level of expertise you have, how you charge determines how well you live, assuming your work is good and that you are not wasteful. There are no set rates; what you get is always negotiable. Despite downward pressure on prices because of the competition, be

assured that if you attend properly to your clients, the upper limit of your fees should reflect what your customers can afford rather than how much the competition wants for the same work.

Negotiations begin by cultivating the notion that what you offer is special and that you are hard to replace. This chapter offers some ideas about how this is done. Service, quality, and good people skills will attract offers of work, but patience is required when actual fees are being discussed.

Here is a fundamental truth: The budget is probably predetermined. If the client is experienced and fair-minded, the budget will be reasonable. If the client is inexperienced, greedy, or cheap, the budget will be unacceptable. You must find out which of these conditions prevail. When a preset fee proposal is so low that making a profit is impossible, refuse the job as diplomatically as possible. The only exception should be those situations where a reliable client specifically asks you to accept a modest fee as a professional courtesy, with the understanding that the favor will be repaid sometime later — this is good business, if it doesn't happen too often and if the client occasionally reciprocates.

Some clients know that they will prosper if the people they hire can also do well. Respect their egalitarian spirit by being straightforward. Make it clear you do quality work and let them know you are willing to be flexible.

During the initial discussion you might say, "I'd like to take care of as many of your photographic needs as possible. Even if you think the budget is small, run it by me anyway. I can always refuse!" In this way you will acquire a sense of what is considered to be a small job, and by extrapolation, you will learn what is considered a large job. Over several months you will see that each client functions in a unique milieu. Once you've established harmonious relationships with a variety of clients, you will have an idea of the state of the marketplace and your place within it.

You will most likely face one of four opening scenarios: The first is rare: "I don't care what it costs, just do a fantastic job!" Much more often it will be, "Here's what I need, what will it cost?" With regular clients, sometimes you will be told what to do and when to deliver, without price being mentioned. Previous levels will be assumed. And finally, some clients will have several photographers offer competitive quotes.

In every case the same information must be divined:

1. How are the photos to be used?
2. What format is required?
3. Who owns the negatives or transparencies?
4. Will you be required to oversee printing?
5. Will the client find and pay for models, props, and stylist?
6. Do you have a week to deliver, or only twenty-four hours?
7. Will retouching be your responsibility or the client's?
8. Will the client arrange access on location?

Keep asking until you know exactly what is required. If you know that a similar job was previously shot by another photographer you can ask, "Do you recall what you spent last time?" followed by, "Do you feel you got what you needed at that price?"

Because the desire for a good deal is an indelible aspect of human nature, the most difficult questions are always about money. Don't be shy. It can't hurt to ask, "Is there a comfortable budget?" Or more directly, "What can you afford?" If your client is civilized and you are polite, a beneficial exchange will take place.

A call to quote means one of four things. First, the client may simply want a bargain basement price. If the quotes are different but the photographers' skills are similar, the lowest quote gets the job. In extreme cases, price supersedes ability, and poor work can result. In some markets this is the predominant, unavoidable mode. When breaking into such an environment, the instinctive response is to undercut. Don't do it. You will shoot yourself in the foot, albeit slowly.

There are many photographers who are incrementally pricing themselves out of business by whittling away at already meager profit margins rather than improving their shooting skills or cranking up their marketing techniques — a destructive process that eventually lowers the income of everyone else in the industry. This depressing scenario demonstrates the value of photographer-to-photographer communication through professional organizations — together we

should be able to set reasonable rate schedules. If orthodontists can do it, why can't commercial photographers?

Second, the client might be inexperienced, ignorant, or lazy, and consequently unwilling or unable to fix a proper value to the work. Asking for a quote is an easy way to get the benefit of a good photographer's advice for free. Beware of those cynical people who are willing to let others do their homework for them.

Third, the client could be respectable but hard-nosed. Competitive quotes from competent photographers guarantee prices will be fair, all things being equal. You should find out if the other competitors are in fact your equals, and if not, why not. You can ask directly who else is quoting, but do not expect an answer every time. When it is not appropriate to press for names, you might ask how many others are involved or if the quotes are from local suppliers only.

In the fourth variation an agency or a designer produces a project for a third party who insists on competitive quotes. The contract may ultimately be awarded without regard to the lowest tendered price. It's unlikely that you will be told outright if you are the favored supplier, although you may be given some clues such as, "be sure to mention that you specialize in (whatever) when you quote!" or "be sure to ask for enough to guarantee a quality job." In this situation a professional proposal will help your client justify a choice based on style, ability, or experience, rather than price.

Client Relations &
Professional Standards

RULES OF THE GAME

A commercial photographer provides a service for a fee. Although there are technical and aesthetic standards by which the quality of the service can be judged, it is difficult to describe the interaction between photographer and client except to say that it is unusually intimate for a business relationship. Marketing efforts will lead to assignments with new clients, but what follows depends as much on your ability to deal with people as on your photographic skills.

Photographers interpret and record reality on behalf of their clients. There are three steps in the process. Because each and every client has a different worldview, the first task is to determine what the client wants. Next, the photographer must conjure up an appropriate mental image. Finally, a range of photographic techniques are applied to produce a tangible product.

To find out what the client wants, it is necessary to pay attention. Ask questions and listen carefully to the answers. Generally, a rendering or layout will be provided to make the exercise a little easier. Study it well, if only because graphic artists are not constrained by the optical laws that govern photography: Surprisingly often they will produce a drawing that cannot be duplicated photographically. Don't be shy about clearly calling attention to any limitations imposed by the medium. Prevent unrealistic expectations and you will save yourself grief later on.

Having paid attention, the photographer must previsualize a creative photographic solution. Whether it is to be a variation based on

past experience, or an original product of the imagination, the image must be both aesthetically suitable and practical to produce. Before you start shooting, take the time to discuss your intentions with the client. Make rough sketches or use existing images to demonstrate what you propose. Keep in mind that it is not enough just to understand what you are being asked to do: The perceived need must be taken seriously. The client must feel respected.

Actually producing the work can be easy or difficult, but remember one basic principle: Your standards of quality must always exceed those of the client. In other words, always give more than required. The question of how much more is determined by two corollaries derived from the first principle; the 90% rule and the law of extraordinary effort.

Assignments fall naturally into two categories. Ninety percent of what you are asked to do can be performed to the satisfaction of all concerned, provided you make good use of the skills, experience, and tools you already have. The remaining 10% of what comes your way will require a stretch, such as learning or inventing new techniques, acquiring new equipment, hiring an assistant, or just working extra-long hours. Extending oneself in this way might seem intimidating, but consider that assignments successfully completed will offer professional and personal rewards. In exchange for the time and energy you will make a financial gain, embellish your reputation, and enhance your self-esteem.

All the costs and benefits of a complex project are impossible to anticipate in advance. Should you become involved in an undertaking that proves more difficult than anticipated, take comfort in the knowledge that any extraordinary effort made with wholesome intentions always yields a positive result.

Take proper care of your clients and they will be happy to recommend you to others in the industry. You will find that business which is referred to you is very good business in that the new client, having sought you out, will be predisposed to like your work. This does not mean you can lower standards, but simply that you can expect the relationship to begin on a cordial and respectful note. Keep in mind that the reputation of whoever recommended you will be affected to a degree by your performance.

MANAGING PROFESSIONAL RELATIONSHIPS

An astonishing variety of people will want your services but it is not always possible to predict if a new client will turn into a good client. Because a few unsavory individuals exist in every industry, you will occasionally encounter someone who is impossible to work with. Even for an established professional the continuing challenge of client relations is to quickly recognize and defuse potentially troublesome situations. Of course, you can't deal with anyone who is abusive or dishonest, but thankfully most clients are easy to cope with.

Difficulties with first-time clients vary in significance according to the size of the job. The prudent buyer of photography will not risk offering a large project to an unknown. If you are approached to do a substantial assignment by someone you don't know, ask how they got your name and why they want to work with you. Trust your instincts as you listen to the reply. Sometimes a solid referral will connect you with a bona fide prospect who needs a job done in a hurry, but sometimes a less than legitimate outfit is simply looking for a one-shot special. All first-time clients are short-term clients until you get that second call, so don't commit valuable time and resources on unsubstantiated promises of future work. When in doubt ask for a part-payment in advance. This will discourage triflers.

First-time clients offering modest assignments are much less of a risk. Again, ask all the proper questions, but don't be afraid to take a few chances. You will find many individuals worth investing in. It is exciting and satisfying to trust and be trusted. People have long memories, so a small job well done could lead to substantial work six months or a year later. Those customers that rely on you over the long term will be the foundation of your security. They will need special prices and preferential service from time to time, but such accommodations are natural in a stable, mutually beneficial relationship. Discomfort arises when a client makes too many demands and abuses your loyalty.

The secret to ensuring that your regular clients don't become too cavalier with your energy is to keep them well informed about what it is you actually do for them. Tell them when you acquire new equipment or skills on their behalf. If certain jobs are particularly expensive or complicated to produce, let them know, but don't whine. When a job is particularly rewarding, either financially or professionally, tell your

client in some dignified way. The idea is to demonstrate your satisfaction with the work, but not to brag about your profit margins.

Always watch for the indicators of a downhill trend in clients' attitudes. Unexpected objections to your pricing or inappropriate demands for free services are indicators of dissatisfaction. Inconsiderate behaviors, such as calling at the last minute for time sensitive assignments, appearing late for shoots, or losing invoices, are all potential irritants. As long as you are certain that your work is properly professional, the remedy for a deteriorating rapport is honesty. Set up a meeting with your client. Make it clear that you value the work that comes your way, but as diplomatically as possible point out the things that you find discouraging. A concerned, conciliatory attitude will usually be respected. In most cases your client, perhaps having been spoiled by your consistently competent service, will need only the most gentle of reminders. Nevertheless, there is always the chance that even the mildest of protests will be viewed as cheeky and misplaced, in which case you will have to decide for yourself if you want to work under less than optimum conditions.

COPING WITH DIFFERENT TYPES OF CLIENTS

Demanding clients come in a variety of types. Most of them expect miracles, even when time and money are tight. Some are congenitally insensitive and simply enjoy throwing their weight around, whereas others are neurotic perfectionists and assume you are as well. There are people who create artificial deadlines as a way of reinforcing their own importance. Somehow, there's never enough time to do the job properly the first time, but there is always time to reshoot when things screw up. Don't allow yourself to be rushed into things that you suspect will not turn out right. This requires some strength, but an inarticulate response will mark you as incompetent. Avoiding the issue altogether will lead to undue stress. Experience and common sense will tell you if a client's demands are reasonable. If a demand seems unreasonable, say why, and offer an alternative.

To be fair, competent clients are demanding only because they are completely committed to producing excellent work. They will understand and welcome your desire for manageable working conditions. Usually, even incompetent or inexperienced clients will be grateful if

you can put forward an obviously rational method of achieving their objectives, but when clients ignore good advice it is better to turn down the assignment rather than participate in a fiasco.

Nervous clients buy emotional support and photography simultaneously. There are two types of nervous clients: consolable and inconsolable. Because the role of the advertising and public relations professional is very stressful, most complaints and worries are understandable and completely normal. It is an everyday part of a commercial photographer's job to reassure clients, but the ability to reassure effectively is related to one's own self-image. There is a kind of psychic radio by which both worry and inner strength are communicated. If you are certain of your own abilities, and patiently address concerns one at a time as they arise, the consolable client will eventually relax.

The inconsolable client is another matter altogether. Here, the nervousness is either a manipulative game that's intended to keep you on your toes or a debilitating character defect. Conflicting feelings arise because such people transmit a double message. They want you to do the work but for some unspoken reason they want you to worry about your ability to do it successfully. Fortunately, the appropriate response is always the same — do your job well and allow the emotional noise to recede into the background.

Your clients will vary in intelligence and, of course, there are special considerations when dealing with people at either extreme on the scale. Intelligent people are stimulating and frustrating at the same time. While an encounter with a powerful mind can be a delight it can also be a challenge because intellectual power and the ability to communicate do not necessarily go hand in hand. It is sometimes difficult to understand what a really intelligent person wants, especially when their ideas are extremely sophisticated but poorly expressed. Complicating matters is the very human aversion to looking foolish, a condition which inhibits the asking of necessary questions. Remember that there are different kinds of intelligence and that it takes some effort to transpose concepts formed by one type of mind into concepts that another type of mind can grasp. Your clients want your special intelligence.

The word that best describes a healthy relationship between intelligent people working cooperatively is engagement. Although much of the work of commercial photography is done in solitude, there can be many

harmonious moments of engagement with bright and inspiring people.

Less intelligent clients tend to slow things down a bit. Communicating is again the key issue, but in the case of obtuse or unsophisticated customers, information moves mainly from photographer to client rather than the reverse. The problem is that commercial photography is often complicated but the degree of complexity is not readily apparent just from looking at a photograph. Some clients simply cannot figure out why a photograph might be worth several hundred dollars and many hours of effort. Such clients need and will pay for your services but you must help them understand what it is you do, how you do it, and, most importantly, why you do it. Generally speaking, your patience and respect will be repaid with loyalty.

The aggressive client is in single-minded pursuit of business objectives, often at the expense of his or her personal life. As is the case with most strong personalities these (usually) high achievers expect to enlist your total support by virtue of their own enthusiasm and intensity, although other kinds of emotional pressures are sometimes brought to bear as well. Their habitual assumption that money and professional status are the only motivations of those who strive for excellence often grates on those who are in fact motivated differently.

Aggression is a major component of the sales-oriented personality, and as virtually all of commercial photography is dedicated to selling, aggressive people are everywhere. They range in disposition from sweetness and light to obnoxious; the determining factor being your usefulness to them. The truly aggressive have no loyalty. To them you are only as good as your last job. They are interested in what you do rather than what you are. Harmonious relations with such people require you to consistently produce good work under pressure while maintaining a degree of detachment. Detachment is not disinterest or disrespect, but rather being able to fully perceive complicated situations as would a dispassionate observer. It is possible to maintain a very productive relationship while keeping a little distance.

It is likely that you will have to treat wealthy clients differently than less prosperous clients, but that is only because they are likely to treat you differently. As a rule, clients with deep pockets pay their bills regularly, so work for them proceeds on an orderly and predictable basis, financially speaking. This may not be the case for poorer clients, so greater caution is called for in pricing and collecting.

The value of your work varies according to the size of the projects of which it will be a part. Because well-heeled customers are more likely to be working on a larger scale, your fees to them will inevitably be higher. Both poor and rich clients might value your work equally, but tight budgets automatically put a cap on fees. The quality of your work cannot change, so your expectations must — unless you are overwhelmed with business you cannot be a snob. Price flexibly, but be sure your lower paying customers are aware that they're getting reduced rates and that they can expect reasonable increases as they grow. This notion is not as unpalatable as it may at first sound. By accommodating smaller clients you will be contributing to their future success and you can reasonably expect to benefit when it arrives.

When the Client Is a Friend

The discussion so far has presupposed that the typical relationship between client and photographer is strictly business, but it is unrealistic to believe that a client cannot be, or will not become, a friend.

Although I lack the patience to work for nonprofessional people on a regular basis, when a friend or colleague asks me to photograph their wedding or family my response is always yes. I never take any money for the work. If they insist, I ask them to donate it to charity.

I always refuse to shoot for acquaintances or friends of my friends. I say I am so busy with commercial work that I cannot take on any other obligations. Although the answer is truthful, I have also learned over the years that friends are easy to please, while those one knows less well are much more picky. It is just not worth the aggravation. I refer these jobs to a friend who does photography part time and has a more suitable disposition.

Things are easier to manage in the case of a regular client who, over time, becomes a friend, in that a basic pattern of behavior for doing business will have been already well established. Try to maintain a slightly detached attitude when in the business mode. It is unfair, unprofessional, and ultimately self-defeating to expect preferential treatment.

The Commercial
Photographer's Darkroom

WHY PROCESSING IS NECESSARY

At the heart of photographic technology is an amazing chemical event that occurs when photons of light impinge on crystals of certain silver salts (or halides), usually silver bromide. When these crystals, also called grains, are exposed to sufficient light they are subtly changed at the molecular level. If the activating light has been projected by a camera lens onto a surface coated with these crystals the changes form a pattern called a latent image. The latent image is not visible until chemical development separates the silver from the bromine at the latent image sites. Fixing the image dissolves away unexposed, and consequently undeveloped, crystals. What remains is a relatively permanent image — longevity depends on storage and handling conditions — made of metallic silver. This is what we see on black and white (b&w) negatives and prints.

Color films and papers also depend on this silver-halide mechanism, but in a more complex configuration. Additional chemical manipulations link special dyes to layers of light-sensitive material which become the magenta, cyan, and yellow components of the image. By the end of processing all silver will have been removed. The final image is composed entirely of organic dyes and is consequently much less stable than its b&w progenitor.

A RATIONALE FOR IN-HOUSE PROCESSING

Commercial photography is a technological exercise that requires an understanding of dozens of variables. To do the job right it is necessary to exercise control over all aspects of the technology, but this is obviously difficult if the last few operations are surrendered to others.

Photographic efficiency demands the streamlining of all technical procedures. A color darkroom saves time and allows me to make more money while maintaining consistently high standards of quality. The same logic applies to b&w processing, a service which is actually unavailable in some markets.

If the technical and financial arguments are not sufficiently convincing, consider the psychological advantage. A darkroom of one's own can be a much needed refuge from the frantic intensity of business deals and complex assignments. Under the amber glow of the safelights, the distractions of the outer world fade and are replaced by simpler satisfactions. Even after twenty years in the profession I am still amazed by the magical transformation of film and paper into real images.

OVERVIEW OF DARKROOM PROCEDURES

A darkroom is divided into wet and dry areas. Wet-side procedures include mixing solutions, washing equipment and containers, plus all the chemical steps of processing. Dry-side procedures are slide mounting, film sleeving, print trimming and mounting, as well as loading of exposed film into reels or hangars for development. The enlarger and all the operations associated with it require dry conditions. Conventional practice says that the wet and dry areas should be several feet apart or even in different rooms so that liquids or chemical powders cannot contaminate dry-side materials. Kodak publishes an excellent book on conventional darkroom layout which includes several detailed floor plans. It is worth reading.

My Darkroom

A darkroom is typically used for the following procedures:

1. Loading unexposed film into filmholders

2. Loading exposed film onto hangars or reels

3. Black and white and color film processing

4. Editing, mounting, and sleeving of processed film

5. Black and white and color print processing

6. Minor print retouching

7. Packaging of processed material for shipping

Ergonomics is the science of organizing the human environment so that necessary tasks may be executed precisely, efficiently and comfortably. The driver's position in a BMW is ergonomically designed. So is my darkroom.

Each darkroom operation involves a logical sequence that can only be performed properly if the right tools and equipment are close at hand. Because I like to work quickly and hate cleaning up, I have incorporated several unusual innovations.

To begin with, nothing in my darkroom sits on the floor. All counters and sinks are mounted firmly onto the walls so that the floor is unobstructed to make mopping up simple. The floor is covered with a sheet of industrial grade linoleum intended for commercial kitchens, scientific laboratories, and hospitals. The edges of the flooring extend six inches up the walls to form an easy-to-clean seamless baseboard.

The same people who argue for totally black studios say that darkrooms should be all black as well. My darkroom is entirely white. I've eliminated all light leaks by carefully sealing up the enlarger and the doors, so the white walls are not a problem when the lights are off and they are pleasant when the lights are on. To further guarantee creature comforts, the darkroom is well heated in winter and air-conditioned in the summer. The thermostat is mounted within easy reach. In addition to heating and cooling, some means of ventilation is essential; I installed an air-to-air heat exchanger into an outside wall to provide economical fresh air all year round.

The counters and sinks are mounted at desk height (30") so that I can work while sitting in a comfortable chair. Some people might consider this an indulgence but I consider it a necessity, particularly when I have to work for an entire day or night. My chair has rollers so that I can move quickly between workstations. The layout approximates the

shape of a capital "G." The first leg (moving counterclockwise) is a 30" x 72" sink for processing both color negative and transparency films. It is made of No. 618 chemical-resistant stainless steel, insulated with one inch of styrofoam. In the sink are several stainless tanks each of which holds 1¾ gallons, half as much as the more typical 3-gallon tanks used in larger commercial labs. The tanks are immersed in a 100°F water bath.

Next, continuing counterclockwise, I have a film-drying cabinet with removable racks for paper. It is 18" square and 6' in height. I made it out of ½" thick Melomine, a high-density particleboard that is laminated on both sides with a thin but very tough layer of formica. I used the same material for the darkroom walls. Traditional wisdom says that hot air drying is bad. I have found that modern photographic materials tolerate such treatment without any ill effects. I have a squirrel-cage blower and a heating element mounted near the top of my dryer. Film and paper need about five minutes to dry in the stream of 90°F filtered air.

Adjoining the dryer, and forming the north–south line of the "G," is another stainless steel sink. It is 7" deep, 30" wide, and 6' long. I use it for processing b&w prints, color prints, and b&w film. (Processing techniques will be described in detail later in this chapter.)

At right angles to the printing sink is a counter that holds three paper-safes and my Super-Chromega 4" x 5" enlarger. To prevent sharpness-reducing vibration, the enlarger column is bolted directly to the counter at the bottom and to the wall at the top. It is very uncommon to have a dry counter right next to a processing sink — I tell you later why I've set things up in this way.

Perpendicular to the enlarger counter is another counter with a built-in light table for editing negatives and slides. Underneath it are a couple of filing cabinet drawers for current negative files. This counter is joined by another smaller one, again at right angles, and separated by a double-sided pegboard wall that runs up to the ceiling. The smaller counter is used for loading color film before processing. It is oriented parallel to the film processing sink from which it is separated by three feet. The pegboard holds film hangers and reels on one side, scissors and various kinds of tape on the other.

Above the two sinks are specially designed formica-covered shelf units for chemical containers, measuring graduates and other tools. Temperature-controlled water (68°F for b&w; 100°F for color) is piped

underneath the shelves and controlled by valves mounted on panels that drop five inches down from the bottom of the units. The water is routed to where I need it through ⅜" flexible vinyl tubing. Two safe-lights and a bright white light for viewing prints are mounted under the printing sink shelf, as well.

Above the film editing counter is another shelf unit that holds a stereo, film sleeves, paper cutter, slide mounts, retouch colors, shipping envelopes, labels, and several other dry-side necessities.

BLACK & WHITE FILM PROCESSING

Through the years I have tried to reduce every photographic operation to its simplest form. Black and white processing, a fairly straightforward affair to begin with, now takes me only a few minutes and costs only pennies.

Earlier I mentioned that I develop color film in stainless steel tanks with a capacity of 1¾ gallons. They accommodate a rack (available from Kinderman) that holds nine rolls of 120 film or eighteen rolls of 35mm. The tanks and stainless steel sinks were constructed at a very reasonable cost by a metal shop that specializes in stainless steel fixtures for restaurants and hospitals. I have eleven tanks for color work and another three for b&w. For b&w film runs of more than two rolls of 120 or four 35mm rolls, I mix up enough developer to fill one of the tanks sufficiently to cover all of the processing reels I happen to be using.

Quite often I have only a couple of rolls of 120 film to process, so a big container is not necessary. Daylight film tanks are a pain in the neck, so I use ordinary two-liter plastic graduates instead. Since my darkroom is absolutely light-proof, I just dip and dunk the film reels (stacked on a Kodak stirring rod) exactly as I do for the 1¾ gallon tanks.

I've settled on one developer for all b&w films: Kodak DK-50. This may strike some people as a surprising choice since it is a very old formula. In fact, it is the only chemical I still mix from a powder. I accept this inconvenience because DK-50 has several very useful characteristics. First, it is a wide-scale developer that yields very printable negatives. Second, it stores very well. In my lab, one gallon of stock solution gets used up in about two months, although it can sit on the shelf for much longer without any noticeable deterioration. I dilute the concentrate 1:1 with water to make a one-shot working solution

Figure 20.1 A–C
Convenience and control are two compelling reasons to operate an in-house darkroom. Chemistry is subtle, but learning what the process does is a worthwhile exercise. These three simple images illustrate what I mean. Photos A and B were made from an Ilford FP4 negative processed in Kodak Microdol-X, considered a "fine-grain" developer. Image C was made with the same setup, but the film was developed in Agfa Rodinol, a "high-acutance" developer. The Microdol-X images are smoother in appearance, but less sharp. The Rodinal images are coarser in appearance, but sharper. My clients like my work, partly because I assume control of all aspects of the process. The savings in time and cost compensate for the effort involved in learning the various procedures and processes.

which is discarded after use to ensure consistent results. Third, DK-50 appeals to me because it is a high-energy formula requiring short processing times. Finally, it works well with several different b&w films in the same processing run.

After the choice of film and developer, the most important variables in b&w film developing are those that determine the degree of development. These variables include the length of time the film is immersed in the developer, the temperature of the developer, and the pattern and frequency of agitation during development.

Time and temperature are the primary factors in determining *densi-ty* and *contrast*, the main technical attributes of image quality. I will discuss image quality and the range of choices for time and tempera-ture manipulation in another chapter. Under normal conditions I use DK-50 diluted 1:1 at 68°F for 6 minutes for most films.

Variations in agitation, developer dilution, developer temperature, and developing time affect density and contrast. (Density is the unit of blackening employed in sensitometry and is the result of the degree of development and illumination.) Agitation is extremely important, in fact critically important, because it determines the uniformity of devel-opment, as well as the degree of development. Film that has been improperly agitated during development may be mottled, streaked, or stained, and consequently difficult or impossible to print. As a rule, once a satisfactory agitation technique has been achieved it should not be altered.

My method of agitation is the same for tanks and graduates. During the thirty seconds following the initial immersion, the film is gently agitated by lifting it right out of the developer and then replacing it a total of six times — that is five seconds for each agitation cycle. Two of these five-second cycles are required every thirty seconds thereafter. In other words, agitate by raising and lowering the film six times in the first thirty seconds, then wait twenty seconds, then agitate twice dur-ing the next ten seconds, and so on. When ten seconds remain of the predetermined developing time, lift the film one last time, tilt about 15°, and allow to drain. When time is up, transfer the film to a water bath of the same temperature as the developer and agitate continu-ously using the same five-second cycle for one minute.

The film is then fixed to dissolve away those parts of the emulsion that will not be part of the final image. I use Edwal Quick-Fix diluted 1:5 for 3 minutes. Occasional agitation is satisfactory.

Fixer does not deteriorate over time, and I do so little b&w film processing that one batch lasts for six months. The working strength of fixer, or hypo as it is sometimes called, is easily verified by adding a drop of hypo checker, which forms a white precipitate if the fixer is exhausted. A simple method of determining fix times for b&w films is to observe how long it takes for an undeveloped piece of film to clear — the proper fix time is twice the clearing time. When the clearing time finally equals the original fix time, the solution is exhausted. Small

users generally discard spent chemicals, but larger users regenerate both b&w and color fixers by recovering the silver that has been leached from film and paper during processing. The metal is harvested by electrolysis and resold. In addition to the removal of the silver, regeneration requires adjustment of the solution's pH by adding acetic acid and fresh fixing agent. Kodak has published extensive literature on this subject.

Agitation intervals vary a little in each of the three chemical steps of b&w film processing, but the technique of agitation remains the same. The key to completely uniform film development is a delicate touch. Don't yank the film out of the solutions, do it smoothly. Don't just drop the film into the solutions, lower it gently. Guarantee repeatable results by always agitating the same way.

After fixing, the film must be washed in running water at the same temperature as the processing baths in order to remove chemical residues that could otherwise damage the images over time. Commercial work has a life of only a few weeks, so washing thoroughly is not as crucial. Ten minutes is adequate. If the photos are to be preserved it is important to wash for at least thirty minutes. Hypo clearing agent will shorten wash times when archival permanence is desired. After washing, film should be rinsed for thirty seconds in Kodak Photo-Flo 600, a wetting agent that breaks down the surface tension of water to prevent drying spots. Photo-Flo itself will cause streaking if it is improperly diluted. I use a 1:1200 concentration, half the strength recommended by the manufacturer.

In a clean darkroom with properly filtered water supply and dryer, film will dry without blemishes. Negatives are delicate when wet, so handle them by the edges only. Film should be edited for technical flaws and sleeved immediately after it comes out of the dryer. Hands must be free of dirt and grease. Lint-free cotton gloves are available from Kodak. All unsharp or poorly exposed negatives should be discarded before proofs are made. This will guarantee that you are never in the position of having to explain to a client why the photo he or she has ordered is not suitable for enlargement.

A GOOD PRINT

Producing a negative is a process that begins in the camera and finishes in the darkroom. Producing a print is a process which occurs entirely within the darkroom, and consequently is very easy to control. Once the techniques are mastered, print-making becomes a profoundly enjoyable and highly profitable enterprise. The key to making good prints is to first know what you're after. In other words it is necessary to understand what technical elements should be present in any good enlargement. This understanding is not difficult, but it is subtle. If there is any place where aesthetics and technology obviously intersect, it is at the point where b&w images are evaluated.

The densitometer is a scientific device that precisely measures certain properties of photographic images — it is actually a special type of light meter designed to measure densities. In the case of negatives, the densitometer quantifies the amount of light transmitted through various points on the film. In scientific terms density is the common logarithm of opacity (opacity being the ratio of light incident to the negative to the light transmitted through the negative). For prints, *reflection density* is the measure. This system works because over a wide range of viewing conditions the response of the human eye is approximately logarithmic.

The *brightness range*, the range of tones from very light to very dark, may be plotted on a graph according to the densitometer readouts. These graphs, called *characteristic curves* are different for various films and paper types, and they may be further altered by variations in exposure and development.

A scientific appreciation of image quality takes years to achieve. Some dedicated photographers are followers of an elaborate system of image control called the *Zone System*, invented by Ansel Adams. This system divides the photographic image into eleven zones, from deep black to pure white, and describes techniques that enable the photographer to fit real-life subjects onto the photographic tonal scale. Those proficient in the Zone System can exactly *previsualize* how any negative and print will look before the shutter is tripped.

Although I've never owned a densitometer, and I've never practiced the Zone System, I have read two books by Ansel Adams: *The Negative* and *The Print*. Together, these densely written tracts are an intense les-

son in how far photographic technique can be taken in pursuit of beauty. I highly recommend them.

How does one know when a print is beautiful? Even in commercial work the design of the image is paramount, but technically speaking, a beautiful print is one that may be properly reproduced in a newspaper, magazine, or poster. Such a print must be sharp and free of mechanical defects like fingerprints, dust spots, and scratches. However, a wide range of tones with significant details visible in both highlight and shadow areas is the most important factor for reproducibility. Happily, these conditions can be achieved by straightforward means.

Nowadays, most commercial photographs are made in color, and most commercial photographers do not process their own work. This is a sad state of affairs. I believe that a working knowledge of b&w technique and a deep appreciation of a beautiful print are indispensable fundamentals.

THE TECHNIQUES OF PRINTMAKING IN BRIEF

The chemistry of b&w printing is basically the same as for film, although the hardware is different. Developer and fixer are set out in trays rather than tanks. Unlike film, which is processed in absolute darkness and never touched while wet, prints are moved from tray to tray by hand under the surprisingly bright illumination of orange safelights.

Earlier I mentioned that my print processing sink is directly adjacent to the dry counter where my enlarger is located. I have things set up this way because it is mechanically efficient. Printmaking is essentially a few simple motions that are repeated exactly the same way over and over again. To my mind, the risk of occasional contamination is insignificant compared to the convenience of having all necessary tools within easy reach.

To begin the printmaking process, a negative is selected from a file, inserted in a negative carrier, dusted with compressed air, and then placed in the enlarger. A lens of appropriate focal length is selected. My enlarger has a three position turret that holds 50mm, 80mm, and 150mm lenses for 35mm, 6cm x 6cm, and 4" x 5" respectively. The image is projected onto an easel that has been preadjusted to the correct size.

A piece of enlarging paper is inserted in the easel and exposed for some appropriate time, usually between five and thirty seconds. Using tongs, the paper is immersed in the developer and agitated to ensure uniform development. Because the whole operation is done by safelight, it is possible to actually see the image appear on the blank paper. This takes about two minutes, and then the paper is transferred to a *stopbath*, a dilute solution of acetic acid, which immediately halts the process of development. The print is moved to a tray of fixer after thirty seconds of continuous agitation in the stop bath. Following a short time in the fixer, the white lights may be turned on and the print can be evaluated. If it is satisfactory, the paper is then washed and dried.

It takes hardly any more time to make a print than it does to read this short description.

BLACK & WHITE PRINTING IN DETAIL

The Negative

I've arranged my workspace so that the printing process moves smoothly from left to right. Negatives to be printed are placed to the left of the enlarger.

Some negatives will have mechanical deficiencies that show up in enlargements. Prints made from negatives that are streaked or mottled due to improper agitation in the developer and negatives that are torn or badly scratched cannot be saved in the darkroom and must be retouched. Fortunately, because most negative streaks are a result of improper washing, careful rewashing with a little judicious scrubbing by water-softened fingertips will put things right. Exhausted fixer can stain film but this can be remedied by refixing in fresh fixer followed by rewashing.

Small scratches can be masked by the ancient "nose-grease" method. Touch the side of your nose and transfer a little of the thin natural oil from your skin to the negative. Gently rub the stuff into the scratched area. Clean the negative with film cleaner after you're finished printing.

Except for one, all my negative carriers are glassless — simply two hinged pieces of smooth metal with holes cut out of them to match the

negative size. The exception is a glass carrier that I use for critical 35mm work where the need for edge-to-edge sharpness supersedes the inconvenience of cleaning and dusting the four extra surfaces of optical glass. Several negative carriers of different sizes are hung on a pegboard behind and to the left of the enlarger.

The Enlarger

My enlarger is a 4" x 5" Super-Chromega. Like almost all color enlargers, it uses a diffused light source rather than a condenser light source. Black and white purists argue that a condenser enlarger produces a sharper image because the hard light from large condenser lenses is more organized and directional than the soft light created by the light-mixing chamber in a diffuser enlarger. This may be true to a degree, but the cost is too high. Hard sources amplify every dust particle and mechanical flaw on the negative, and they require the insertion of individual color filters for color printing — both major inconveniences. Condenser enlargers are, in fact, unsuitable for printing color negatives because dye images (including Ilford XP-2 b&w film) do not scatter light the same way as conventional black and white negatives. Diffuser enlargers tend to de-emphasize negative faults, and color correction may be conveniently selected with adjustable filters built into the light path, rather than the optical path. As a result, most commercial work is done with diffusion enlargers.

The enlarger is a precision optical instrument so it needs proper installation and periodic maintenance to perform its job well. Mine is bolted directly to the countertop, thus eliminating the need for a baseboard. The top of the column is attached to the wall behind it with two struts in order to prevent vibration. The whole machine, including bellows, light mixing chamber, and filters, is regularly dusted with blasts of compressed air. Moving parts are lightly lubricated with machine oil or thin grease as required. I have a small level for checking the alignment of the column, the enlarger head, the negative stage, and the lens carrier. The enlarging lenses are cleaned periodically with lens-cleaning fluid and lens-cleaning tissue.

The Chromega, like other similar enlargers, uses a low-voltage quartz-halogen lamp with an integrated reflector. The lamps supplied by the manufacturer are rated at 150 watts at 21 volts and last for about

seventy-five hours (about two months' use for me). Every new lamp has a slightly different color temperature and they are expensive to replace. To avoid the hassle and expense of frequent replacement, I have been using a lamp that has the same mechanical configuration, but a different electrical configuration. The EJL bulb has a filament rated at 200 watts and 24 volts. It costs 50% more than the recommended Omega lamp and produces about the same amount of light when installed, but because it is considerably underrated in this application, its lifespan is about fifteen times longer.

Many lamp failures occur because terminal pins overheat. Low-voltage lamps require high currents that cause overheating if the electrical connections are poor. Gently clean the terminals and the socket contacts with fine emery paper whenever lamps are replaced. The ultimate solution to lamp terminal failure is to replace the stock socket with a durable aftermarket part from Focal Point Industries. For twenty dollars, they will give you a teflon socket with Allen-keyed locking screws for fail-safe electrical and mechanical connections.

Flatness and Focus

A finely tuned enlarger is useless if it's not precisely focused. Sometimes blurring caused by vibration is confused with improper focus, but if the enlarger is properly anchored, and if you allow it to settle down for a few seconds before each exposure, the problem is likely optical rather than mechanical in nature.

Blowing up a negative is equivalent to photographing a very small object, a situation governed by the inviolable optical law which states that *depth of field*—the range of acceptable sharpness around the point of perfect focus — is inversely proportional to magnification. Since an 8" x 10" print made from a 35mm negative represents a magnification of over ten times, the margin for error when adjusting the focus of an enlarger is minute. A negative that isn't flat, or paper that buckles in the easel, can affect sharpness.

As I mentioned earlier, glass carriers guarantee absolutely flat negatives. However, they are difficult to keep clean and dust free. They can also cause trouble in inducing the strange optical phenomenon called *Newton's rings*, a series of irregular concentric circles of alternating light and dark that form around the point where two very smooth surfaces

are separated by a distance of less than a few wavelengths of light. This condition can exist where glass contacts the glossy, nonemulsion side of photographic film. One remedy is to use glass with a slightly irregular surface, called anti-Newton ring glass, but such glass degrades the image somewhat. The real cure is a wet carrier that uses an optically transparent liquid between the film and the cover glass. In most circumstances all this is not worth the effort so glassless carriers are virtually standard in the industry. One precaution when using glassless carriers: Negatives will buckle a little when slightly heated by the light from the enlarger, so always recheck the focus just before making an exposure.

The remedy for paper that won't stay flat is a device called a *vacuum easel* which, as the name implies, uses differential air pressure to suck enlarging paper down against a platen perforated with dozens of tiny holes. Like glassless carriers, however, these Cadillac systems are used only by perfectionists. Today, most enlarging papers are resin coated, which means the emulsion is coated on a paper base that has itself been coated with a layer of epoxy or some other plastic. In 8" x 10" size these papers may be expected to lie acceptably flat when secured at the edges by the frame of an ordinary easel; 11" x 14" paper is less predictable and sometimes needs help to flatten out by patting down with a clean, dry hand.

Accurate focusing is of the utmost importance. But enlargers project relatively dim images so it is difficult to see where the exact point of perfect focus occurs with the unaided eye. Brightness at the easel is a function of the light emitted by the enlarging lamp, the efficiency of the mixing chamber, the density of the negative, and the aperture of the enlarging lens. The lens aperture is the only readily adjustable condition. Just like all other lenses used in photography, enlarging lenses perform best when used two or three f-stops smaller than maximum, and it is best to focus with the lens stopped down. I recommend a grain magnifier to make focusing as precise as possible. A *grain magnifier* is a special purpose microscope that is placed directly on the easel. By way of a front surface mirror, a sliver of the light beam projected by the enlarger is diverted upward through a magnifying lens and an eyepiece. With this wonderful tool, you will know that focus is incorrect if the grain looks mushy and indistinct. When the crystal structure of the film is sharp and clearly visible, focus is bang on. It's quite dramatic.

Safelights and Other Conveniences

The limited sensitivity of printing papers allows the use of filtered light in the darkroom to facilitate navigation through the various operations of printmaking. The typical safelight uses a low-wattage tungsten lamp enclosed behind an amber filter. Very bright (but much more expensive) safelights are available that use filtered fluorescent tubes or yellow sodium-vapor lights. I prefer the incandescent variety because the light output can be adjusted with a light dimmer.

Fog, an unwanted light gray tone that veils highlights and otherwise white margins, will occur if safelights are too bright. My safelights are wired through a small *variable transformer*, a type of dimmer switch that allows very fine voltage control. The standard Ilford safelight takes 15 watt bulbs and 5"x 7" type "OC" amber filters. I have three such safelights in my darkroom and I run them at about 70% capacity for multigrade paper. Kodak Panalure paper is supposed to be handled in total darkness; however I have found that by dimming the safelights to 20% of maximum, there is just enough light to see, but not enough to affect the paper. A simple test for safelight-induced fogging is to leave a coin on a piece of paper for ten minutes. If the outline of the coin is visible after normal development, the safelights are too bright or to close. (Safelight fog is unrelated to *chemical fog*, produced by overactive developer.)

To the right of my enlarger is a *voltage regulator*. This clever electrical gadget ensures that regardless of fluctuations in the power lines, the electricity supply to the enlarger is always steady. This is a necessary condition for consistent and repeatable results. Built into the same box as the voltage regulator is an adjustable timer that turns on the enlarger lamp for a length of time that can be preset from $\frac{1}{10}$ sec to 90sec. The timer also operates a switched outlet that turns off the safelights whenever the enlarger is on so that the image on the easel is more easily visible when focusing.

Paper Choices

Once the negative is set up in the enlarger, an exposure must be made on light-sensitive paper. On top of the voltage regulator I have secured a *paper-safe* with two light-tight compartments, each of which can hold one hundred 8"x 10" sheets. Each compartment has a fold-down door.

When the door is opened a single sheet of paper is automatically dispensed. This is very handy when working quickly, although care must be taken to ensure the door closes perfectly each time a piece of paper is used. I keep Ilford Multi-grade or Kodak Polycontrast III glossy paper and Kodak Ektacolor Supra RA "n" surface paper in the safebox.

Beside the voltage regulator sits two other paper-safes of a different type than the one I just described. These are really just light-tight boxes accessed by hinged lids, rather than pullout drawers. I have stacked one box that holds 8" x 10" Kodak Panalure (now available in three contrast grades) on top of another larger box that holds fifty sheets of 11" x 14" Ilford Multi-grade "pearl" surface or Kodak Polycontrast III "n" surface and fifty sheets of 11" x 14" Kodak Ektacolor Supra RA "n" surface. The Panalure paper is used to make b&w prints from color negatives. The two types of 11" x 14" paper are separated by a sheet of stiff cardboard. I simply flip over the entire hundred sheet pile to put whichever type I need on top. This sounds a little silly, but it is easy enough to do.

I prefer Ilford Multi-grade paper for b&w work because it has several characteristics that fit both my personal tastes and the demands of commercial work. It is mechanically durable and stands up well to tray processing and hot air drying. Its high-gloss surface reproduces fine detail accurately and is well received by my clients. It is also quite sensitive to light, which allows conveniently short-exposure times. Processing times are also short. Multi-grade's characteristic image is an attractive warm tone with deep black shadows and brilliant highlights.

Ilford Multi-grade, like Kodak Polycontrast, is a *variable-contrast* paper. This means that the separation between light and dark tones can be varied by changing the color of the light with which the paper is exposed. Yellow light lowers the contrast of the image, whereas magenta light increases the contrast. These colors can be easily accessed using the adjustable filters built into the enlarger. Exposure times remain relatively constant throughout the whole contrast range. The variable-contrast feature is convenient and economical.

Really good variable-contrast papers became available only in the late 1980s. Before that, it was necessary to stock quantities of several papers, each with a different grade of contrast. Graded papers are still available in grades "oo" (very low) through "6" (very high). Multi-grade and Polycontrast both do an excellent job of matching grades "1"

through "5," a range that is more than adequate to deal with most negatives. The continuous variability of the adjustable papers is a bonus when the required contrast falls between the fixed contrasts available with graded paper.

Purists say that archival or exhibition quality prints are best made on superior quality fire-based graded paper, and I agree. Single-graded papers are inevitably richer in tone than variable-contrast papers. The bond between the emulsion and the paper is much stronger for fiber-based materials. After prolonged exposure to ultraviolet light, emulsions may separate from plastic-coated stock. Fiber-based papers are available in beautiful and subtle surface textures. Nevertheless, the new variable-contrast resin-coated papers are so good and so convenient that they are the only practical choice for commercial printing. Fiber-based variable-contrast papers are available for archival work.

I stock 8" x 10" b&w paper in glossy surface because it is what most clients expect. The glossy surface is attractive, but it is too slick for retouching. As it happens, there is a great deal of b&w work I do that does not need retouching, aside from occasional spotting to eliminate the small white dots caused by dust on the negative.

Retouchers prefer a rougher surface (called "pearl" by Ilford, "n" by Kodak) that more readily absorbs dyes and paint. Most b&w shots are reproduced to be 8 ½" x 11" or smaller, but because retouchers prefer to work on prints larger than the final reproduction size, 11" x 14" paper is required quite often.

A Rationale for Tray Processing

Developing prints in trays is a technique that is as old as photography itself. It may seem anachronistic at a time when small but sophisticated processors are readily available. The fastest b&w machines use the *stabilization* process to make a print in about 3 ½ minutes. This method is technically inferior to tray processing in terms of print quality and the developing image is hidden inside the machine so early evaluation is not possible. The prints have to be normally fixed and washed in order to last more than a few weeks without fading. Unwashed stabilizer prints will contaminate clean prints if they are stored together. Multiple prints must be made sequentially. Rollers, chemical troughs, and fittings must be kept clean if processing is to be uniform. Chemical

and paper costs are a little higher than those used for manual methods. Automatic machines that use conventional chemistry take up to fifteen minutes per print, dry to dry, and require meticulous cleaning and maintenance. They are, of course, expensive to buy but for mass production of very large prints or continuous processing of long rolls, operating costs are small. Low volume work, however, is slow and inefficient.

I use trays because they are the fastest and most efficient way to produce the quantities of prints I need. The tray advantage flows mainly from the fact that an image is visible almost immediately after the print has been immersed in the developer solution. Under the light of safelight an experienced printer can make a judgment and discard an unsatisfactory print without waiting for the rest of the processing to finish. Even taken to completion through stopbath and fixer the whole process takes only 2½ minutes with my favorite chemistry. Including time for a couple of tests, I usually have a final print in six minutes at a cost of about fifty cents. Using rubber gloves I can process fifteen or twenty prints at a time. Tray maintenance is limited to a quick rinse in running water after discarding used chemicals, plus a good scrubbing every six months or so.

Nuts and Bolts

I use 11" x 14" trays for developer, stopbath, and fixer, plus a 16" x 20" tray for the wash. As I mentioned earlier, processing prints involves moving them by hand from tray to tray. It is not possible to actually use your hands. Black and white chemistry is relatively mild, but prolonged exposure will eventually lead to dermatitis. Encasing the hands in rubber gloves will protect them, but as I will describe a little later, this approach is impractical except for batch processing of ten or more prints at a time. For normal work the tool of choice is the lowly but indispensable print tong.

Several types of tongs are available, and like all tools one uses repeatedly, it is prudent to select the most comfortable and the most reliable to be found. Agitation is just as important for prints as for film, and agitation while printing is achieved by manipulating the paper with tongs. Throughout the process the tongs must be opened and closed continually as the developing print is gently lifted and shifted in the tray. I have found that common bamboo tongs, one-piece plastic tongs,

and one-piece stainless steel tongs are unpleasant to use for more than a few minutes because they resist closing. I prefer the type of stainless steel tongs that are hinged at the top and held open with a light spring.

Tongs must have soft tips so as not to scratch the delicate surface of the wet paper. I buy cheap bamboo tongs and harvest their rubber tips to replace the ones on my stainless tongs as they wear out. When handling paper it is extremely important to avoid making creases in the paper's surface.

In the Trays

There is a wide range of processing chemistry available. Ilford naturally recommends their Multi-grade Rapid developer for Multi-grade paper. This developer takes only one minute to work. A distinct image pops up in the first fifteen seconds and then slowly darkens to completion in the next forty-five seconds. Extending development up to three minutes adds a little more highlight density.

Once a print has been exposed it must be quickly and completely immersed in developer so that processing begins uniformly across its entire surface. This is facilitated by providing an ample portion of liquid — 6 liters in an 11" x 14" tray — and by inserting the paper under the surface of the solution with a smooth sliding motion. Agitation begins immediately and lasts for the whole time the print is in the developer. Once the print is submerged in fluid, the tongs are used to gently stir the developer in a broad "s" pattern for about ten seconds. Then the print is pulled sideways out of the developer and returned with the same smooth motion by which it was initially inserted. This should take about six or seven seconds. Then the developer is stirred again, followed by another cycle of removal and reinsertion, and so on, until the development time is past. After a ten-second drain period, the print is moved to the stopbath where it is agitated continually for thirty seconds. Stopbath is a weak solution of acetic acid that arrests the activity of the developer and prepares the print for the acidity of the fixer.

From the stopbath the print is moved to the fixer where it is agitated continuously for thirty to forty-five seconds, after which the room lights may be turned on and the image carefully examined. Wet prints appear about 15% lighter than dry prints — this "dry-down" effect is most noticeable in the highlight areas.

If the print is to be discarded, it goes right into the garbage at this point. If it is to be saved it must be moved directly to the wash tray. Overfixing will cause fading or staining. Resin-coated papers require only a ten-minute wash in running water. I use cold water for washing and usually allow twenty or so prints to accumulate before I load the dryer. On the end of the printing sink shelf nearest the dryer I have attached a manual squeegee — by turning a short hand-crank two rubberized rollers twelve inches wide strip off excess moisture so that prints dry quickly and evenly without spotting from mineral residues. The addition of some diluted Photo-Flo at the end of the wash guarantees a slick, high-gloss finish.

Testing

Making an acceptable b&w print takes only minutes once the basic technology is understood. Making a superb print takes a little longer. The key to perfection in printmaking is the ability to recognize an outstanding print when you see one.

Good prints have a wide tonal range plus a wealth of detail in both highlight and shadow areas. Blacks should be rich, whites should be clean, and gray areas should look smooth. A good print appears natural and unforced while creating an illusion of three dimensionality. The realization of these subtle qualities is related to the specific choice of paper and chemistry, but whatever the inherent characteristics of the materials might be, selection of the correct contrast grade and exposure time, together with proper development are absolutely necessary for first-class results.

The most easily achieved condition is proper development. Three elements are necessary: (1) a supply of fresh chemistry diluted to the manufacturer's specifications, (2) gentle but constant agitation to ensure a good flow of chemistry over the surface of the print, and (3) sufficient time to let the chemistry do its work. If a print has been overexposed, it will darken too quickly in the developer. The natural response is to yank it out and slap it into the stopbath right away. The inevitable result is a mottled, streaked, and flat-looking print. It is true that extended development will add some density in highlight areas, but errors of overexposure cannot be fixed by shortening development times. Prints developed in Multi-grade paper developer require a min-

imum of sixty seconds processing at 68°F. I have a Gra-Lab timer with glow-in-the-dark numbers mounted right above the developer tray.

Photographic paper is too expensive to waste so it is sensible to make a *test strip* to determine what exposure time and contrast settings best suit the negative being enlarged. I make test strips by first tearing up a sheet of enlarging paper into eight pieces that are stored in the same paper-safe as the Kodak Panalure. I then make a guess about the settings for the enlarger and the timer — say f11 at five seconds with fifty units of magenta filtration — and then place the test strip on the easel in an area that encompasses a representative tonal range. After exposure the test strip is secured in a simple clamp made out of a stainless steel tong so that it can be handled without being lost in the trays of chemistry. Usually two or three tests are required to fine tune the settings before a full sized print is attempted.

Special Skills

Contrast and exposure adjustments are not the only variables that the skilled printmaker must manage. Very often the local density of certain areas within a photograph need special attention. If a highlight is lacking in detail, it can be darkened, or *burned-in*, by giving extra exposure in that location. A tool for this purpose is made by cutting a hole of the approximate size and shape of the area to be darkened in a piece of thin but opaque cardboard. After the initial exposure, an additional exposure is made with the cardboard held in place an inch or two above the surface of the easel. The cardboard must be moved about slightly in a random pattern so that the extra density at the edges of the burned-in area are *feathered*, or graduated, in a natural looking way. I only use cardboard tools for burning-in very tiny or irregularly shaped areas. Most often I can quickly arrange my hands into a suitable shape.

Reducing local density is called *dodging*, or *holding back*. It should be obvious from a test print which areas need holding back. For part of the time during the basic exposure one's own hands or specially formed cardboards tool are used to prevent light from striking those areas of the print that are too dense, such as deep shadows or dark clothing. The idea is to preserve some realistic modulation in tone and detail in areas that would otherwise look unnaturally heavy and featureless.

It is impossible to know what areas need burning-in and dodging using test strips alone. Sometimes it will be necessary to discard several test prints before exactly achieving the proper density manipulations for a difficult negative.

Multiple Print Processing

Earlier I mentioned that tray processing lends itself to batch processing of ten to twenty prints at a time. This method is quite straightforward, provided that a consistent agitation and development routine is followed.

To make several prints at once from a single negative, first determine the correct exposure and contrast with test strips and confirm any burning-in or dodging with test prints. Then, as the multiples are exposed, place each sheet face down in the Panalure paper-safe right on top of the test strips that were put there earlier.

With the white lights on, put a rubber glove on your right hand. Set the left-hand glove on the counter near the paper-safe. Turn off the lights, and remove the pile of exposed paper. Place it emulsion side up on top of the paper-safe. You will be able to tell where to divide the exposed Multi-grade from the unexposed Panalure by locating the test strips.

Set the timer to 90 seconds. Start feeding the paper into the developer tray with your left hand at a rate of one every three seconds. With the fingers of your gloved right hand, gently submerge the prints as they arrive. When all the prints are in the tray, put on the left-hand glove by sliding your hand into the glove as far as it will go without assistance, and then pull it on the rest of the way with your other hand. Avoid wetting the skin of your left wrist with developer. This operation may be a little ungraceful at first, but with a little practice it becomes automatic.

The paper, emulsion side up, will now be sitting in a pile with the first sheet at the bottom. The prints must be agitated evenly while maintaining the order in which they were inserted into the tray. This is done by curling each print up successively so as to cause a small wave of developer to flow over its surface. When all the prints have been curled this way, rotate the whole pile and repeat the procedure with the opposite edge. For a pile of fifteen prints, this cycle of agitation should take about thirty seconds. Be careful not to crease the paper. Try to get a feel for the fastest rate at which the paper can move the developer without deforming. I have found that working with the long edge of the

paper yields the most even development. Because the prints must be agitated intermittently during batch processing, an additional thirty seconds is added to the development time for a total of 1½ minutes.

When time is up, turn the whole pile over with the up-side being down in the developer tray. The print that was placed in the tray first will now be at the top of the pile. Move the prints one at a time to the tray of stopbath. Care must be taken to keep your left hand out of the stopbath in order to prevent contamination of the developer. This is done by using the left hand to start the prints sliding into the stop-bath but letting go before actually touching the chemical. Use the right hand to ensure that each sheet of paper is covered with liquid before the next print arrives. If this step is carried out at a rate of one print every two or three seconds, then all the prints will have been developed for exactly the same length of time.

Use the same method to move the paper to the fixer after the first print has been in the stopbath for forty-five seconds. Agitate prints in the fixer for at least a minute before turning on the room lights. Keep the developer free of contamination from fixer and stopbath by thoroughly rinsing your gloved hands in running water. Dry the gloves carefully with a clean towel before removal.

Big Dollars from "Low-Tech"

The hands-on method of batch processing has been around since the turn of the century but even today I find that it is fast, convenient, and economical. I can expose and process twenty prints in about fifteen minutes at a cost of ten dollars. I charge five dollars each for multiple prints so twenty prints are worth one hundred dollars which means a profit of ninety dollars, or six dollars per minute! (Washing and drying add approximately fifteen minutes to the processing time, but other darkroom tasks can be done while this is going on.)

Some jobs involve a number of different negatives made under identical conditions. Such negatives can all be printed the same way after testing just one of them. Because I charge twenty dollars for the first 8" x 10" print from each individual negative, batch processing prints from several different negatives becomes even more lucrative.

Evaluating the B&W Negative

Many of the skills in photography are interlocking. Refinement of one particular ability leads to or requires advancement in other related areas. For example, someone who regularly makes b&w prints inevitably acquires a thorough understanding of what constitutes a good b&w negative because bad negatives are extremely difficult to print. What is not present in the negative to begin with cannot be added in the darkroom.

A scientifically minded lab manager or photographer would describe a good b&w negative qualitatively with the aid of a densitometer. Although this is certainly the ultimate in precision, other more intuitive judgments can be made as experience is accumulated.

In general terms, a negative is too thin when shadow areas appear clear and devoid of any detail. A negative is too heavy when highlight areas are completely black, or *blocked up*; it should be possible to read newsprint viewed through the darkest part of the negative. A normal negative would print easily on a No. 2 contrast paper.

The contrast of photographic paper is a built-in characteristic determined at the time of manufacture, whereas the density of an image on photographic paper is primarily a function of exposure. This is not the case with film where both exposure and development work together to establish the density and contrast of the negative. Film can record a range of brightness of greater than 128:1. Black and white negative film will record texture over a range of five or six f-stops, or about 64:1, and a subject brightness range of 512:1 or greater. Black and white printing papers, however, produce a reflection density or brightness range of about only 100:1. Because neither the response of the film nor the paper is linear, there will be considerable compression in both the shadows and the highlights with some subjects.

An *incident lightmeter*, the kind with a white diffuser dome over the sensor, measures the brightness of light falling on a scene, and recommends an exposure to put an "average" subject, such as an *18% gray card*, right in the middle of the useful density range on the negative. A *reflected light meter* would give the same reading under the same light provided that the reading was taken with the meter pointed directly at the 18% gray card.

The gray card is a manufactured object, a standard target that is used for testing photographic film and equipment. But objects from real-life exhibit a wide range of reflectivity. If the subject brightness range exceeds the nominal 128:1 capability of the film, it is said to be a *high-contrast* subject. If the subject brightness range is substantially less than 128:1, it is referred to as a *low-contrast* subject.

If exposure of the film is always based on an average reading, and if development and printing are normal, prints made from both high-contrast and low-contrast negatives look unnatural. Within certain limits the contrast range of such negatives can be expanded or contracted by selecting a different grade of paper, but outside these limits the remedy for both excessive and insufficient contrast is based on manipulation of the relationship among exposure, development, and density.

When film development is extended, density continues to build up significantly; however the density of the highlight areas builds up faster than the density in the shadow areas. This allows contrast to be controlled photochemically. The credo of Zone System aficionados says *expose for the shadows, develop for the highlights.* In other words, a high-contrast subject can be compressed by overexposure and under-development, whereas a low-contrast subject can be expanded by underexposure and overdevelopment. Again, Ansel Adams' books *The Negative* and *The Print* tell the whole story.

In general, commercial photography is performed under controlled conditions so that negative quality should be consistently high. I received a phone call from a designer client who had incorporated some of my b&w prints in a brochure. She told me that while creating the layout she had automatically opened up *PhotoShop* to perform remedial work on scans made from the photos I had supplied, when she suddenly realized "nothing needed at all to be done to those images. You produce beautiful prints that are a pleasure to work with."

CHAPTER TWENTY-ONE
Darkroom Techniques for Color Processing

Clients want professional photographers to deliver high-quality results quickly. This requires control of a long list of variables, the last of which is processing the exposed film. In my area, color prints are popular because the best retoucher in town will not work on transparencies and because many clients like to save money by gang-separating color prints that have been color balanced and printed to size. Turning exposed film into enlargements that meet these specifications is not considered a very profitable enterprise. There are two problems here, both having to do with time.

Unless the color lab is next door, it takes time to transport the film and to view proofs and test prints. Presumably the time is billed to the client through a markup on the price of the prints, but this is often only a break-even proposition rather than a moneymaker. Most commercial jobs require only a few excellent prints: Even if a competent lab can be found, they, rather than you, will make the major money from photofinishing because you are organizing and supervising the processing for them.

In most cities the business of processing film, viewing proofs, and supervising enlargements requires three to four days, or more. Faster service attracts rush fees. Maybe the direct costs and time lost running back and forth are not unbearable, but consider the indirect costs. If the job involves a complicated setup in the studio you must leave everything in place until the processed results have been approved by your client. Your client is on hold while the color lab does its work. If your

276

client is an advertising agency or designer with print deadlines, their client, their printer, and their target markets are on hold as well. This scenario can be irritating, but there could be problems associated with processing color in-house, as well. Is it best to set up a film line for color-negative developing? Best to process prints in tubes or buy a small processor? Should someone be hired to do all this? Would this person work full- or part-time? Could all this be expected to make a profit or would it be a break-even proposition intended to increase convenience and reduce turnaround time only?

I started in photography because I loved the medium. I continue in commercial work because I want to make money and spend as little time as possible doing it. Commercial lab time and lab costs are fixed entities — to reduce either or both I would have to process my own work but the advantages would have to be substantial to make it worthwhile. The procedures would have to be simple, reliable and satisfying in order to justify the investment.

I analyzed my business and realized that a good day involved one, two, or perhaps three jobs and yielded seven hundred and fifty to fifteen hundred dollars in fees. Even a busy work day normally involved four hours or less of actual photography and four hours or more of running around, including trips to and from the lab. A day's work might produce one to ten rolls of film from which one to ten prints might be made. I wanted to handle this work at a profit while maintaining a manageable schedule for the rest of the time.

I did find a way to do what I wanted but first I had to overcome some common fears about color work. At first I believed that the procedures were time-consuming, expensive, and complicated. But research revealed that this was the case only when conventional practices were followed. Processing film or prints in tubes was inefficient, at least compared to the traditional methods for black and white (b&w) prints.

In addition to the time problem, there was the problem of low volume. The machines are pricey and hungry for expensive chemicals when only a few films or prints were to be processed each day. Maintenance was also a consideration. Drums or tubes seemed economical for small-scale work but they, as well as machine processors, needed too much cleaning and handling.

As I thought about exactly what was required chemically for color-negative film and print processing I realized that the actual steps were

simple and that the problem was the hardware and its attendant house-keeping. I found an unbelievably simple solution to the color processing dilemma. Processing up to eighteen rolls of 35mm color-negative film now takes me about twenty-five minutes and processing a color print takes three minutes. Costs are about fifty cents per roll or print. The system can be set up for under a thousand dollars using easily obtained equipment. Three days of waiting and running can be reduced to a couple of hours. I often make a hundred or more dollars an hour in the darkroom. Now I take care of my own needs faster and cheaper than an outside lab, with the bonus of reduced worry and aggravation.

COLOR MYTHOLOGY

The simplicity of color processing is obscured by commonly held misconceptions. Many believe that color work requires a degree in chemistry and a substantial investment in temperamental machinery, but nothing could be farther from the truth. The complexity of color theory and the difficulty of preserving the correct color balance have always been greatly exaggerated. This negative bias has evolved because the technology employed by large-scale processors is in fact complex, expensive, and often temperamental. Equally significant is the fact that commercial processors have a vested interest in maintaining an intimidating illusion in order to preserve their position in the market. As well, some photographers are reluctant to assume full responsibility for the work they do, preferring instead to criticize the technology while allowing the lab to take the flak for a marginal product.

In reality, the theoretical foundation of the technology is not as impenetrable as all the elaborate machinery it has engendered, and a much simpler production approach is possible for small-scale operations.

CHARACTERISTICS OF COLOR FILMS

Two different families of film are available for color photography: one for color slides and one for color negatives. Each type requires different chemistry for processing and different materials and procedures for printing. I process both types of film in my own darkroom, although 90% of my work is shot on color negative films, and I print from negative films exclusively. A brief explanation of the functional distinctions

between negative and transparency films will clarify my preferences.

Today's color materials are vastly superior to the films available even a few years ago. There is, however, a prejudice in the nonphotographic printing business that says that transparencies are superior to prints from negatives. This was true ten years ago but now a color transparency has only a marginal edge.

Color negative is a tremendously flexible medium. It has a much wider exposure latitude than reversal films so exposure bracketing can be eliminated. Color balance, density, and cropping are easily controlled in the darkroom so extensive color tests to determine filtration for exotic light sources are unnecessary. Multiple copies can be made quickly at a reasonable cost. Retouching a large print is easier and safer than fiddling with an original slide. Similarly, prints can be given away or lost, but the original remains secure because it never has to leave the darkroom.

Transparencies have a psychological advantage. Because they are viewed by transmitted rather than reflected light, transparencies appear richer than an otherwise identical print. Nevertheless, the irrefutable fact is that when a transparency is reproduced on paper, whether photographically or photomechanically, its brightness range is reduced: It becomes a print like any other.

In most circumstances a color negative and a color transparency record exactly the same degree of detail. In other words, the resolution of a negative and of a transparency can be identical. A print made from either medium loses some information by virtue of the fact that a print is one generation away from the original image. A well-made original transparency, however, may be reproduced directly, eliminating losses associated with the enlarging process.

Transparencies have another technical advantage: They record delicate highlight details more accurately than prints made from negatives. This subtle superiority is important when dealing with light or pastel subjects, such as ice cream, silverware, snow, or glass.

Finally, small-format transparencies are popular because they are handy. For example, slide files — 8 ½" x 11" plastic sheets with twenty 2" x 2" pockets — are the standard in the magazine and stock photo businesses for convenient viewing, shipping, and storing of 35mm transparencies.

I shoot negative whenever possible. Those clients who ask for transparencies get a brief pitch about the alternative, but I don't push too

hard if they are clear on what they want. I always use reversal materials when shooting high-key subjects or editorial assignments. As electronic scanning of photographic images becomes commonplace, color negatives are becoming more universally accepted, but for now it is prudent to stay fluent in both reversal and negative techniques.

C-41 Processing for Color Negatives

In Chapter 20 I described my stainless tanks and the insulated sink that holds them. I use eleven tanks — three for C-41 processing of color negatives and seven for E-6 processing of transparencies. One additional tank is used for the final wash in both processes. This last tank has a double bottom with a stainless pipe connection. During film washing, water is directed to the bottom compartment through a vinyl hose. The water exits through little holes that create small fountains under the film. Chemical-laden washwater flows over the top of the tank; the level in the sink is maintained by a standing drain connected to the sewer. The washwater is kept at the same temperature as the rest of the chemicals.

My method of processing C-41 has six steps: develop for three minutes and fifteen seconds, bleach for six minutes, wash for one minute, fix for six minutes, wash for ten minutes, then dry. White lights may be switched on after the film has been in the bleach for two minutes. Agitation is exactly the same as for b&w processing except that film is agitated twice every fifteen seconds in C-41 developer rather than twice every thirty seconds. Aside from the time required to load reels or hangars, the entire process takes only twenty-five minutes dry to dry.

Kodak calls for a pre-wet before the developer but I have found this step to be unnecessary. I don't use stabilizer either, even though Kodak says it makes color dyes more stable. I believe formaldehyde, the principal component in stabilizer, is a health hazard. Longevity, archival processing, and the safe storage of color materials will be discussed later.

Color-negative films consist of three separate b&w emulsions layered on top of each other. Each layer is cleverly designed to react to only one of the three primary colors: red, blue, and green. (Equal intensities of the primary colors combine to make white light. Any color can be created by adding the primary colors in appropriate proportions.) The developer in the C-41 process works on the three b&w emulsions and

causes color dyes, incorporated in the film at the time of manufacture, to couple with the silver images in proportion to the density of the silver. The dyes are complementary in color to the primary colors so the red sensitive layer accumulates cyan dye, the blue sensitive layer accumulates yellow dye, and the green sensitive layer accumulates magenta dye. (Any color can be created from white light by subtracting appropriate proportions of the complementary colors.)

The bleach removes any unused dye and the developed silver image. The fixer dissolves away all traces of the undeveloped parts of the black and white emulsions. What is left is a color negative made of organic cyan, magenta, and yellow dyes. When printed, these layers transmit light disproportionately so an overall corrective red and orange caste that equalizes the color densities is built into the plastic film base.

E-6 for Color Transparencies

The E-6 process is more complicated chemically than C-41 because the final image must be a positive rather than negative, hence the term reversal film.

Again, I ignore the Kodak recommendation for a pre-soak and instead put the dry film directly into the first developer for 6½ minutes with normal agitation. Next comes a two-minute wash in running water followed by two minutes in the reversal bath. The film is agitated continuously for the first twenty seconds and then allowed to soak without agitation for the remaining time. After thirty seconds in the reversal bath the room lights may be turned on.

From the reversal bath the film goes to the color developer for six minutes, again with normal agitation, followed by two minutes of constant agitation in the conditioner then six minutes in bleach, then six minutes in fixer and finally ten minutes' wash in running water. As with C-41, I omit stabilizer.

The E-6 color developers perform the same functions in two steps as the C-41 developer does in one; the tasks of b&w development and color-coupling are divided so that in between the reversal bath can change the way the film and the dyes will interact. Thus, in reversal films the color builds up in inverse proportion to the density of the silver, resulting in a positive image. Because transparencies are primarily intended for direct viewing, slide film has an untinted film base.

Timing and Temperature Control

There are two different types of reactions involved in color process-ing: those that continue as long as the film is in contact with the active solutions and those that proceed up to a certain point and then stop. Developers work progressively while reversal bath, conditioner, bleach, and fixer all react strongly for a predictable length of time after which their activity tapers off dramatically. The speed of the chemical reactions is dependent on temperature. Predictable results can only be achieved if the processes occur at the same temperature every time. For this reason my film sink is well insulated; I keep thick plastic lids on the processing tanks and the temperature of the water bath in which the tanks are sitting is precisely controlled by sub-merged heaters.

The temperature of the first developer in both the C-41 and the E-6 processes is critical due to the progressive nature of the chemical activity. For this reason just before processing I always check the tem-perature on a digital thermometer with a stainless steel probe. A variation of only ±1°F is allowed. (It is wise to check the accuracy of the process thermometer itself from time to time.) Because the develop-ing time is just as critical as the temperature, I have a Gra-Lab timer with an easy-to-read luminous dial mounted on the wall above the film sink.

The time and temperature recommendations for the other chemi-cals are less critical. However, if the temperature is low or the processing time too short, the reactions may not go to completion. Film that has been incompletely bleached or fixed may be returned to the appropriate tanks until fully cooked.

COLOR PRINTING THE SIMPLE WAY

I indicated above that I've devised a fast, reliable, and inexpensive sys-tem for making color enlargements. I have also presented a number of arguments in favor of tray processing b&w prints. Perhaps you have already figured out that tray processing is my secret weapon for color printing as well. Low-tech solutions might appear tacky to those peo-ple who have succumbed to microprocessor fever, but I prefer a simple and direct approach whenever possible. The logic that justifies b&w

printing in trays also applies to color work. Moreover, there is a power-ful technical advantage to trays over machines which is unique to color processing for the low-volume lab.

In b&w printing the main variables that must be attended to are contrast and density. When making enlargements in color these factors remain important but they are significant only after the correct color balance has been achieved. Unless intentionally altered to achieve some special effect, the correct color balance is a specific state in which people and familiar objects appear natural. There are several color markers that all of us look for unconsciously; for example, sky blue, leaf green, and normal skin tone.

The venerable 18% gray card can be used to quantify the process of evaluating color balance. After having been photographed and repro-duced, the color of the original and the color of the print can be compared using a densitometer equipped with sharp cut-off red, green, and blue filters. If the gray card and its copy are shown through accu-rate measurement of the primary colors to be identical, then the film, the paper, and the processing are said to have worked together to pro-duce a perfect result.

Commercial labs use fancy equipment and rigorous testing to ensure that the various chemical parameters which affect color bal-ance never change. Machines are relatively slow but they operate continuously so large numbers of prints can be processed each hour. Professional printers expose test strips or test prints from many neg-atives, run them through the processor, evaluate them, and then come back to process final prints after another hour (or two or three) of work in the darkroom. The machine must be consistent so that adjust-ments based on the test results still apply at the time the final prints are run.

In trays a test can be processed and evaluated in less than three min-utes, and a final print can be achieved after a test or two. With feedback this fast the exact state of the chemistry at any given time is unimpor-tant. Changes sufficiently gross to alter the appearance of a print simply don't occur in ten or twelve minutes. In one stroke this ultra-low-maintenance method reduces processing time by 80% and completely eliminates the need for chemical monitoring. These economies also apply to batch processing of multiple color prints.

Special Considerations for Color Printing in Trays

There are two significant differences between color and b&w printing: The latter takes place at 68°F under the light of bright safelights, whereas the former is intended to be processed at 95°F in total darkness. The technical requirements for color would seem to make tray processing awkward but there is a trick that makes color printing almost as easy as b&w printing.

Working in the dark can be frustrating. Processing prints in trays involves a series of mechanical steps that have to be performed over a fairly large work area. Very dim safelight will not affect color paper if exposure to the safelights is kept short. You will recall that I equipped my b&w safelights with a variable-transformer type light dimmer. This device allows the safelights to be set low enough to work with color materials. The supply voltage must be reduced by about 80% to prevent fogging. After a little time for acclimatization, this low level is enough to safely navigate around the enlarger and printing sink.

Temperature Control

Some simple technology is required to keep color processing solutions at the right temperature. I made a long shallow tray out of ½" thick plastic. At 48" inches long, 16" wide, and 5" deep, this sink-within-a-sink accommodates three ordinary plastic 11" x 14" trays placed two inches apart. The trays sit snugly on the upper edge of the larger tray, leaving a two-inch gap at the bottom. Hot-tempered water is circulated through this space by a 750-watt Calumet Temperature Regulator connected through vinyl tubing to pipe fittings tapped into the side of the larger tray.

The first 11" x 14" tray holds 6 liters of Kodak RA (Rapid Access) Color Developer, the next tray holds an equal amount of the same acetic acid stopbath used for b&w processing, while the third tray is filled with Kodak RA Bleach/Fix, or "blix."

I removed the internal temperature sensor from the Calumet heater (anyone knowledgeable in electronics can do this easily) and secured it with silicone rubber inside the smallest Pyrex test tube I could find. The encapsulated sensor sits right in the tray of developer and is connected to the regulator with an appropriate length of wire. As a result,

the temperature of the water jacket is automatically adjusted to maintain the developer at the desired temperature. The actual temperature of the developer is continually monitored by a digital thermometer with a red light-emitting diode (LED) readout. The display is visible in the dark but harmless to paper. (LEDs will fog film.)

The Calumet recirculating heater is a precision industrial-quality unit and costs more than five hundred dollars. If this is too expensive, an acceptable low-cost alternative is untempered hot water and an ordinary hand operated mixing valve: Once brought up to temperature, the thermal inertia of the chemicals and the water bath is sufficient to allow things to remain fairly steady with only occasional manual adjustment.

Kodak recommends that RA paper be processed for 45 seconds at 95°F. Higher temperatures cause edge staining or cyan fog in highlight areas as well as possible emulsion separation.

New Variables

As discussed previously, color printing is more complicated than b&w printing because the color balance of the image must be controlled along with density and contrast. Unlike b&w processing which allows a tremendous degree of control over negative contrast, the contrast of color materials is predetermined when they are manufactured. This limitation has been imposed as a consequence of the chemical complexity of color materials in general: It is just too difficult technically to guarantee that color film will react to all colors in a linear way whenever contrast is tinkered with. The main variable affecting contrast that is actually under the control of the photographer is lighting; specifically the lighting ratio at the time the photograph is taken. Kodak has introduced Ektacolor RA papers in three contrast ranges: Portra is lowest, Supra is normal, and Ultra is highest. These papers are powerful new tools.

Density is an important consideration in color printing, just as in b&w work. Beyond the lightness or darkness of the image, variations in density have a noticeable second-order effect on color balance. With Kodak Ektacolor papers, building density by longer exposures tends to move color balance toward yellow. This can be problematic when burning-in a highlight, for example. To minimize the uncertainties some people rely on an electronic device called a color analyzer, a

highly evolved color-sensitive light meter. Because tray processing is so fast, my method of choice is still the test strip or test print.

The Color Enlarger

In the discussion about b&w printing, I mentioned that filtration for variable-contrast papers could be selected using the built-in filters of the Super Chromega enlarger. All enlargers intended for use with color materials must have some way to change the color of the light they project because this is the only way to adjust the color balance of the print.

Two different systems of manipulating photographic color have evolved out of the basic physical properties of light. The simplest to understand is the additive system, which uses combinations of the primary colors to generate all other colors. Enlargers that use the additive system, such as those made by Phillips or Nord, combine light from individually controlled red, green, and blue sources in a mixing chamber. Perfectionists say that this approach produces the purist and most saturated color; however the attendant optical and mechanical complexity adds considerable expense.

Almost universally accepted as the most practical solution, the subtractive system requires only one white light source — usually a low-voltage quartz-halogen lamp with a built-in reflector — modified by highly efficient yellow, cyan, and magenta dichroic filters. Dichroic filters work by reflecting, rather than absorbing, unwanted colors. They are much more efficient and their characteristics are more stable over time than cheaper dyed glass filters. All enlargers based on the subtractive system have some precise mechanical means of controlling the degree to which the filters intersect the path of the light beam so that the projected color can be carefully fine-tuned.

Selecting the Correct Color Balance

Some effort is required to learn what corrections to make when color printing but first it is necessary to understand how changes in the color of the light from the enlarger affect the print.

In the negative, primary colors from real life are represented by their complementary colors: Red objects result in a cyan image, blue objects

appear yellow, and green objects are magenta. In the print, these values are again flopped, so that images look natural once more.

To determine what needs changing in an off-color print first decide in which direction the colors are skewed. Is the print too red, green, blue, cyan, magenta, or yellow? Even for experienced printers it helps to have on-hand several properly balanced prints for comparison. The trick is to remember that to reduce a color cast in the print either increase the color in the filtration or carefully reduce the complement. Thus:

Magenta light from the enlarger induces green in the print.
If a print is too magenta, increase the magenta filtration.

Yellow light form the enlarger induces blue in the print.
If a print is too yellow, increase the yellow filtration.

Cyan light from the enlarger induces red in the print.
If the print is too cyan, increase the cyan filtration.

Only two of the three subtractive filters are used at one time. The third will only add neutral density. There is an exposure factor associated with changes in color filtration.

Learning how to balance color is like learning to run a personal computer: At first it seems absolutely bizarre, but after some hard work the underlying simplicity becomes apparent. Take heart in the thought that filtration varies relatively little between negatives made on the same type of film exposed under similar conditions. For example, a typical Kodak Veri-color III Type S negative exposed by electronic flash in my studio might print properly with zero cyan filtration, seventy units yellow filtration, and thirty-five units magenta or 0C 70Y 35M. (The digits are the numbered intervals on the Chromega dials.) With a different emulsion batch of the same film under the same conditions the settings might change to 0C 68Y 39M. The necessary adjustment can be quickly pinned down by starting with the old settings and making a test strip or two. After exposure and color balance are determined, test prints are used to ascertain exactly where and how to burn-in and dodge.

Basic Steps of Color Printing

The technique already outlined for b&w tray processing is employed without much modification for color. One significant fact: Color materials are much more sensitive to chemical contamination and mechanical stress than b&w materials. Always handle paper at the edges only. Keep hands clean and dry. Avoid creasing or even flexing the paper. For some reason, most kinds of abuse registers as cyan stains or marks on the finished print.

Development must be carefully timed. (I bypass the water pre-soak called for by Kodak.) Agitation is the same as for b&w prints. After a few minutes under the attenuated safelights it is just possible to distinguish the positions of the trays and the enlarger. Because of the low safelight levels and because color developer turns dark with use, it is not possible to observe the image actually forming. (Even if it were, the print does not look right until bleaching and fixing is completed.) After thirty seconds' continuous agitation in the stopbath, the print is transferred to the bleach and fix. As its name implies, this chemical does the work of the separate bleaches and fixers found in the E-6 process. Prints are pulled from the bleach/fix after 45 seconds, rinsed with running water, and evaluated by white light. For the reasons I stated earlier, I omit the stabilizer recommended by Kodak. Washing and drying is the same as for b&w prints.

There is a problem with color printing in trays that does not occur when using b&w materials: dog-eared prints. Color paper is not as physically durable as b&w paper; even gentle bumping of the paper against the walls of the trays during agitation and washing damages their corners. To rectify this situation I trim about $\frac{1}{16}$th of an inch off all four edges of each print with a rotary paper cutter.

The chemical steps of tray processing require only two minutes. Costs are about 50% higher than b&w printing due to the more expensive chemistry. Batch processing of color prints is exactly the same as for b&w, and all the previously described economies of this technique remain. (I recommend reducing the processing temperature so that multiple prints can be processed for longer times: Forty-five seconds is too short for adequate agitation.) My clients are all hopelessly dependent on my super-fast service.

Evaluating Wet Prints and Test Strips

I mentioned earlier that wet b&w prints appear lighter than they do when dry. This is because the silver image is suspended in a gelatin emulsion that expands when saturated with water: The particles of silver are spread apart, therefore their ability to absorb light is reduced. The gelatin contracts as it dries, and the image becomes denser and therefore darker. This effect is most obvious in the highlight or middle-gray areas. It takes experience to correctly second-guess the exact degree of change. The evaluation of color prints is a more complicated business. Overall, wet prints look more blue and somewhat less dense than dry prints. This effect is more prominent in dark areas. There are, in fact, no real blacks apparent in a wet color print so it is difficult to gauge how much dodging is required to properly lighten excessively dark shadows. Keep a 1500-watt hair dryer nearby.

HOW TO BUY & MAINTAIN COLOR PROCESSING CHEMICALS

There is no need to be a chemist to properly maintain a color darkroom. All the active ingredients are available in liquid form, and they are relatively inexpensive in terms of cost per print or film. Most of the chemicals come divided into two or more component parts which must be mixed together before use: This promotes long shelf-life which, in turn, allows large, economically sensible quantities to be stored safely.

Because processing chemicals come in liquid form, preparing working solutions from the concentrates is simple. All the products are packed with mixing instructions and safety hints; follow them faithfully. It is possible to split the contents of bottles proportionately and prepare only the exact amount necessary for immediate use. Color chemistry is expensive when purchased a little at a time so I buy some concentrates to make five gallons and some concentrates to make twenty-five gallons in order to benefit from the lower prices.

All chemicals lose potency with use and some degenerate over time whether they are used or not. Unopened concentrates are safe on the shelf for months. However, for consistent results, it is necessary to either discard or replenish working solutions according to the manufacturer's instructions.

The various developers are the most unstable chemicals and, as indicated earlier, the most critical. E-6 first and color developers can sit unused in tanks for about a week before they must be discarded. Because I do so little work with color transparencies and because I usually have to process several rolls or sheets at a time when the work does appear, I generally mix fresh developers for every run. For small runs which are only a day or two apart, I will process a test roll to check the condition of used chemistry. Every second time I change developers, I change the reversal bath. Every third time I change developers, I renew the other chemicals as well.

Color negative is a forgiving process technically, and Flexicolor developer is considerably more stable than the E-6 developers. I run C-41 almost daily so it is more practical to replenish than to replace partially exhausted working solutions. I use the Kodak guidelines which indicate how much fresh chemical to add to compensate for the number of square inches of film processed. Note that developer replenisher is mixed from the same chemicals as the developer but the developer starter is omitted. I replace all C-41 chemistry every ninety days.

If your business requires regular processing of transparency materials it does not make good economic sense to discard used chemistry. However, the replenishment regimen must be followed exactly as laid down by Kodak if the line is to be reliable. A test roll or sheet should be run before processing critical work. A really accurate measure of the state of your line requires densitometric analysis of *Kodak Control Strips* (Ektachrome film preexposed with grayscale and color patches). Kodak publishes a comprehensive guide to the E-6 process called the *E-6 Process Control Manual* which describes the proper maintenance and testing procedures in detail. The guide also includes charts showing possible problems and their solutions.

Because there is a constant flow of visual feedback during printing, the replenishment technique can be quite relaxed. I keep a four-liter graduate of developer replenisher near the processing sink and periodically use it to top up the level of solution in the tray. The developer will last virtually indefinitely with replenishment, although I usually replace it once a week due to sludge buildup. (This period can be extended by decanting and filtration.) Stopbath has a much greater capacity than developer and does not require replenishment. Bleach/fix may be replenished or regenerated but I prefer to discard it when

cyan or magenta staining begins to occur (after about one hundred 8" x 10" prints per 6 liters of solution). Stopbath is changed at the same time. (Note: Please refer to the extensive Kodak and Ilford literature for advice about the safe disposal of photographic chemicals.) The color print trays remain in the processing sink all the time. When not in use, I cover them with sheets of ⅛" Plexiglas to prevent oxidation and evaporation and to provide a surface on which to set the trays for b&w printing.

HOW TO CHARGE FOR PROCESSING

Clients benefit from the quick personalized service provided by an in-house lab so the need to compete in pricing with other processors is reduced. As a rule I charge 30% more than the local professional custom labs in my area charge. For special services, like same day or overnight processing, I add an additional 25% to 50%, depending on the size of the job and the degree of inconvenience. From time to time I will reduce my regular rates as a promotional strategy or when clients are on a tight budget. In these cases I mark the invoice "courtesy discount" or "no charge for rush service (this job only)."

Protecting Your Work

COPYRIGHT

Creativity is hard to define in any language, but the language of the law is particularly limited. Those of us who make a living inventing visual work must rely on a much amended set of regulations to protect our ability to profit from that which we create. The main instrument in our struggle is copyright, a collection of six basic empowerments: The right to reproduce a work, the right to prepare derivative works, the right to distribute copies of a work, the right to perform a work publicly (important for video, broadcast, and multimedia technologies), the right to display the work, and the right to authorize someone else to exercise the first five rights.

One might think that such rules could be clearly defined and simply enforced. Unfortunately, this is not always the case. In the United States the original copyright law of 1909 has been challenged many times and substantially revised in 1976. Under the old law all rights to an image passed to the purchaser, whereas under the new law rights to all images made after January 1, 1978 remain with the creator unless specified differently in a contractual agreement. Exceptions and variations are still being worked out legally.

Copyright comes into existence automatically as soon as a work is created, however copyright may be lost or attenuated if a widely published work does not bear a notice of copyright and if the work is not registered with the copyright office. Notice of copyright consists of the word "copyright" or the copyright symbol — a lowercase letter within a circle "©" — as well as the name of the owner of the work. Registration

requires filing two copies of the work in question and a completed Application Form VA with the Registrar of Copyright together with ten dollars. Forms may be obtained by calling (202) 287-9100 or writing Information and Publications Section, LN-455, Copyright Office, Library of Congress, Washington, DC, 20559. Completed applications should be mailed to Registrar of Copyright, Library of Congress, Washington, DC, 20559.

A serious exception to the creator–copyright convention arises in the scenario called *work for hire*, where the image was made by an employee. Here the employer owns the copyright. Many clients now specify on their purchase orders that all photographs they commission are to be considered works for hire, and there is considerable tension developing over this practice. The courts have said that in the case of commercial photography such practices are valid only if the parties have signed a written agreement and if the work is specially commissioned to be part of a larger collective work to which others contribute.

Safe passage through all this demands clear, written agreements between clients and photographers.

CONTRACTS

A contract is a promise that carries legal weight. The terms and conditions specified describe in detail the obligations that exist between two people, between a person and a business, or between two businesses.

Legal enforcement is based on proof. Memory is sufficient for some but not all circumstances. A written agreement is better. A written agreement is actually required by law in two circumstances: when the agreement will extend longer than one year and when the money involved exceeds five hundred dollars.

A contract must include the following: a description of the product or service, the price, the date, the names of the contracting parties, and the signatures of the contracting parties. Clarity is the key. Remember that the language of contracts is not limited to legal jargon. Ordinary people who are capable of stating their intentions in straightforward language can write binding contracts. For absolute peace of mind have a lawyer review your final draft.

RELEASES

A release is a document that gives someone the right to make commercial use of a photograph of another person. It is not generally necessary to obtain a release in order to take a picture of someone, but a release is necessary in order to use the picture to make money.

The wording of a release is critical. A release may be revoked at a later date if irrevocability is not included as a condition in the original document. Money or some other consideration may or may not be part of the agreement. The name, address, age, and signatures of the parties involved must be included, as should the name, address, and signature of the parent or guardian of a minor. The photograph in question must be clearly identified, as should the person or business that will be using the photograph.

A release is not required when a photograph is used for news, editorial, or fine-art purposes. A photograph may be displayed in your own studio without permission from the subject. A photograph of a manufacturer or dealer in some product can be used without a release in connection with the sale of that product. A photograph of an author, artist, or composer, can be used in connection with the sale of their work without a release.

Sample contracts, model releases, and other forms useful to photographers can be found in several books. I recommend *The Photographers Business and Legal Handbook*, by Leonard Duboff, Images Press, New York and *Business and Legal Forms for Photographers*, by Tad Crawford, Allworth Press, New York. Another very useful guide is *Professional Business Practices in Photography* from the American Society of Magazine Photographers, 419 Park Avenue South, New York, NY, 10016.

CLIENT BANKRUPTCY

A threat to your income and control over your images occurs whenever a client goes bankrupt. If this should happen to a business you work for, any photographs or payments that belong to you will be automatically withheld by the bankruptcy court, possibly forever. In fact, it is illegal for you to try and collect money directly from someone involved in a bankruptcy, and it is illegal for someone involved in a bankruptcy to try to pay any debt without the approval of the court. You may even

be instructed by the court to return fees you might have received up to three months before the bankruptcy occurred.

Protecting oneself against these disturbing possibilities involves thinking ahead. First of all, clearly identify the client in your contract, and be sure to include a clause that says all rights to your photographs remain with you unless payment is made in full. These conditions will afford at least partial protection should the court require fees to be returned or if your photographs are in the hands of a third party—your client's client, in the case of an advertising agency, for example—at the moment proceedings start. Second, always try to obtain your expenses and part of your fee in advance. Finally, register your copyright before or immediately after film is delivered.

Try to keep careful track of your clients' payment practices so that any deviation from normal patterns will be immediately obvious. Troubled companies pay very slowly and typically offer to send partial payment or postdated checks in response to legitimate collection efforts. Your bank, a credit-rating agency, or even other suppliers to the firm in question may be able to help ascertain the true state of your client's affairs. If things are tight but not terminal, it may be worth-while — in terms of future considerations — to assist a client during a rough period. (Three times during the last five years I have responded compassionately to personal requests from clients in financial trouble, and I am glad I did, even though it took a year or two for a healthy balance to be reestablished.) When conditions are very serious, some-times more hard-nosed collection efforts or even a collection agency may help cut your losses.

If you should hear of a bankruptcy involving a client, quickly find out exactly which court is in charge, make a note of the case number, and make sure you are included on the list of creditors. It is important to be vigilant, because some firms make a fake announcement of bank-ruptcy in the knowledge that many creditors will simply walk away.

Filing for bankruptcy under Chapter 11 means that the company is trying to get back on its feet. The court decides which creditors are to be paid in part, which are to be paid in full, and which are to be ignored, all with the intention of allowing the company to rehabilitate itself. A Chapter 7 bankruptcy means game over. In either case, a commercial photographer will be pretty low on the food chain. Banks and other institutional lenders will get the first slice of the pie, the IRS will get the

next, followed by employees, and finally suppliers.

In a Chapter 11 filing, the company may be able to prove to the court that some income could be generated by proceeding with the campaign involving your images. In this case you can petition the court to convert your fees from an old, preexisting debt to a new, postfiling debt, in which case sufficient assets may be released to pay your bill.

Legal & Ethical Considerations

COMMUNITY STANDARDS & ETHICAL PRACTICE

Our culture is inundated with photographic imagery that some consider to be unsavory, degrading to women, or simply obscene. It is difficult to establish ethical standards governing the production and use of photographs, particularly commercial photographs, because photography itself has an ambiguous relationship to the truth. Contrary to what many people believe, photographs do not always accurately record objective reality. In addition, whatever the reality reflected in particular images, those images may serve many purposes, not all of which are wholesome. We all want to believe that we know right from wrong, yet what is perceived to be a moral absolute varies from place to place and from one historical period to another.

In my view ethical standards for commercial photography are shaped by the reactions of the photographer to the demands of the client, and then further shaped by the treatment or modification of the resulting images by the designer, the retoucher, and the production house. The integrity of the process is hard to gauge. To make a proper judgment, one needs to know how the viewer's response to the final image would compare to the viewer's response to the real-life situation that the image purports to represent. I believe that if the image was produced in an ethical manner the trusting viewer will benefit. If the image was produced in an unethical manner the trusting viewer will be harmed.

The entire process is further complicated by the likelihood that the viewer is not entirely innocent. Almost all of the target audiences for commercial photographs are jaded to some degree, depending on age,

Figure 23.1 A&B
Times change, and so do social conventions. The photo of two lovers in bed caused a big fuss when it was used as a poster illustration for a play. A few years later the photo of the two dancers appeared on the cover of a local entertainment magazine without creating any comment at all. (*Photo 5: Hassleblad/80mm lens/Ilford FP4 film/Electronic Flash; Photo 6: Mamiya 645 Super/80mm lens/Kodak PRN Film/Electronic Flash.*)

intelligence, and life experience. This is why photographers need a good education — we must understand the social milieu in which we work. Like lawyers, doctors, judges, journalists, and politicians, photographers are charged with serving the public well. Even though this obligation is not defined by law it is morally binding. Photography is, of course, only a part of the vast advertising machine, and individuals can only be responsible for their own deeds. However, if during the normal course of business a moral lesson is to be taught, I believe it is best taught by example. Sometimes this means refusing an assignment.

Commercial photography is deeply involved in the dissemination of basic cultural values. Many fundamental precepts of public morality were once taken for granted but are now being hotly debated. Violence, sex as a selling tool, the manipulation or exploitation of children, etc., cannot be safely left only to others to consider. There is no question that photographs advocate, educate, manipulate, and stimulate. Strong images are active catalysts for both good and evil. Photographers who work without conscience or consciousness inevitably become unattractive propagandists for those who have a stake in molding public

Figure 23.2
A picture of a topless aboriginal woman would not likely have worked as a promotional image for the Seven Oaks Hospital Wellness Institute. However, this picture of a topless aboriginal male elicited only admiring remarks. (*Mamiya 645 Super/150mm lens/Ilford FP4 film.*)

opinions and public desires, benign or otherwise. The responsibility for ethical photography is, of course, split between the users of photographs and photographers themselves. Nevertheless, the photographer is the main creative instrument and the fundamental ethical filter. We are obliged to consider the implications of our work.

Free expression is a constitutional right, but there are legal limits. It is essential to maintain a working awareness of what is acceptable and what is offensive to those with whom you must live. Common sense will tell you when your work might be considered obscene but it is impossible to be absolutely certain exactly where the boundaries are. One's best defense is to contact a lawyer familiar with the issues before getting involved in questionable projects.

OBSCENITY

The exact definition of obscenity is legally uncertain. The Supreme Court has provided three guidelines:

1. A work is obscene whenever an average person, applying contemporary community standards, "would find the work to appeal to prurient interests." (Prurient is defined as something that "beckons to a shameful, morbid, degrading, unhealthy, or unwholesome interest in sex.")

2. A work is obscene if it depicts or describes in a patently offensive way, sexual practices specifically described by state law.

3. A work is obscene if it lacks serious literary, artistic, political, or scientific value.

The Supreme Court has declared that the United States is too large and diverse a jurisdiction to permit the establishment of a national standard as to obscenity so it does not dictate limits to individual states. The Court does offer the following suggestions as to what could be regulated:

1. Patently offensive representations or descriptions of ultimate sex acts, normal or perverted, actual or simulated.

2. Patently offensive representations or descriptions of masturbation, excretory functions, and lewd exhibition of genitalia.

The Court invented the term "hard core" to describe these two situations. Outside of these specific prohibitions, nudity is not generally considered obscene.

It is illegal to mail obscene materials in the United States, although it is not illegal to receive obscene materials in the mail or to have obscene materials in a private home. (Sexually explicit materials that are sent through the mail must be clearly identified on the outside of the packaging. Individuals who do not want to receive such materials through the mail can inform the Post Office, who will prevent delivery.)

Because the definition of obscenity is so broad and because it is dependent on local "community standards," it is necessary to seek the advice of a lawyer familiar with applicable legal precedents in questionable circumstances.

LIBEL LAW

Since photographs are very public documents, all photographers should have a basic understanding of the risks of publishing material that might be considered damaging or harmful to individuals or commercial entities.

To defame a person means to harm someone's reputation by subjecting them to ridicule, hatred, or contempt in some public way. If the act of defamation is verbal in nature it is called slander. If the act is written or printed it is called libel. Photographs that are defamatory fall into the latter category. Simply showing a defamatory picture to a third person is a sufficiently public event to trigger legal repercussions — i.e. a lawsuit. There are variations of libel which consider whether the libelous work does the damage on its own or in conjunction with other contextual factors such as captions, text, or other pictures. Advertising materials can be libelous if they impugn the quality of commercial merchandise or the practices of manufacturers.

Defense against an accusation of libel revolves around several powerful concepts. If an otherwise defamatory photo depicts a real event then it is not libelous. If the photo clearly represents an opinion, it is not libelous. Obtaining consent for publication relieves the photographer of responsibility so long as the consent is given with a knowledge of how the image is to be used. Accurate reports of official proceedings or public meetings are exempt, as well.

If a person is defamed, but allowed to reply in the same forum, then the libel is canceled. If it can be demonstrated that the defamatory material was used to clarify or amplify some debate or process of public interest without "a reckless disregard for the truth" then libel is not an issue — this defense is called *absence of malice*. Finally, public figures who launch libel actions are required to provide very substantial proof of damage or malice, since their high visibility elevates their personal lives into an arena of public concern.

There is a statute of limitations regarding defamation. Libel actions must be initiated within two years of publication.

Some publishers insist that the photographer assume all responsibility when a libel action is triggered by a photograph. This is a potentially dangerous situation. Consult a lawyer if you suspect that an impending job might result in the creation of an image that could be considered libelous.

PRIVACY

Privacy can be defined in two ways. First, it is the right to be left alone, to enjoy one's own solitude. Second, privacy is the right to control the use of one's own image for commercial purposes. In law, the first instance is self-explanatory, but in the second instance some clarification is provided. The use of a photograph without written permission from the subject (i.e. a release) is actionable if:

1. The photograph is put to some meaningful or purposeful use.

2. The person is clearly identifiable in the photo.

3. The photograph is used in an isolated manner. (Not just a face in a crowd, for example.)

COMMUNITY RELATIONS

I spend about 20% of my time working for nothing. During the last few years I've shot significant projects for the United Way and for the Children's Hospital Research Foundation. These projects are produced *pro bono publico* — jobs done free, for the public good.

Figure 23.3
We are not just commercial photographers. Our work is, after a fashion, a historical record. This portrait of folk music legend Stan Rogers was made at the Winnipeg Folk Festival just a year or two before he died while heroically helping fellow passengers aboard a burning Air Canada jet. (*Linhof Technica 70/100mm lens/ Polaroid 655 PN film/Electronic Flash.*)

Wealthy people can donate money and receive a tax deduction, but when we donate our time there is no possibility of tax relief. Even so, there are rewards that make the exercise very worthwhile. First, the work is appreciated by the users and beneficiaries. Second, the work has a direct and profound effect on the community. My work has helped raise almost $30 million for the United Way. (Three successful annual campaigns involved direct mail, posters, bus cards, billboards, TV commercials, and handbills that were designed around my photographs.) Third, this work allows an intimate entry into a world where compassion overshadows avarice — a tonic against the hectic pace and the sometimes abrasive personalities of the advertising world.

Happily, there is a significant marketing benefit for any photographer who contributes in a wholesome way. Major charities are supported by governments, large and small businesses, and prominent citizens from all walks of life. The best of the advertising and design community are always strongly represented. Advertising and information pieces produced for nonprofit enterprises and institutions are distributed and displayed universally. Contributors are always clearly credited. Here is an account of how one design professional, with the help of professional photographers, has made a difference:

During a period of depression following a major illness, award-winning art director Sue Crolick decided the best way to quit worrying about her own problems was to help someone else. She downsized her commercial activities and organized a program devoted to strengthening the self-esteem of inner-city children by introducing them to the making of art.

With the enthusiastic assistance of seventy-five friends, Sue orchestrated an event that brought together children in tough circumstances with creative people from the world of advertising and design. The project was so successful that Sue was inspired to start a nonprofit organization called *Creatives for Causes*. Its main program, *Art Buddies*, pairs inner-city kids with design and advertising professionals: Together they make life-size self-portraits that portray the children as they want to be when they grow up. The results are then exhibited for family and friends.

Professional photographers are asked to document the events on a no-fee, expense-paid basis, and the resulting images are shown at design conferences to recruit more volunteers, as well as for general publicity.

Creative types consistently find their involvement to be a valuable experience on a number of levels. Naturally, there is a feeling of well-being associated with working for the wider community, a feeling reinforced by documentary photos that remind participants that "this is what I felt, this is what I did." Participants also report that business relationships are strengthened when colleagues work together on noncommercial projects. The "open atmosphere of goodwill" is also conducive to the establishment of new business linkups. Sue says that people can be quite competitive at design shows but at a public service event the same people are "more ready to engage, more receptive to reaching out."

Sue uses slide shows to spread the word because "photographs have the power to move others to contribute, without guilting." In selecting photographs she avoids the artificial and the sentimental. Skillful newcomers are very welcome. "Photography is perhaps the most powerful medium for communicating reality," Sue says. "It can change the world."

Beyond Photography

The skills, experience, and equipment that animate a successful professional photography business are transferable to other enterprises. There are a number of reasons to explore additional professional activities. During times of declining economic activity a variety of ways to generate income will be welcome. During expansive times the ability to choose among a variety of disciplines can be stimulating, even inspiring.

TEACHING

Professionals do not hatch out of eggs. Sophisticated skills are learned somehow and somewhere. I learned by reading, by trial and error experimentation, and through the generosity of others with greater experience who had the willingness to share. There are three benefits derived from teaching: (1) contact with enthusiastic students is refreshing; (2) the intellectual exercise of reframing basic principles in language that is comprehensible to others is illuminating, even exhilarating, like pumping mental iron; and (3) teaching can be lucrative.

Working photographers spend a great deal of time cloistered in a studio or darkroom. Their relations with clients and suppliers tend to be intense and specifically business oriented. Interactions with models, assistants, sales reps, or customers, can also be rather one-dimensional, especially when deadlines are tight. It is unfair to expect friends or family to be one's only pipeline to the real world but, happily, teaching others opens new doors. This is because students of pho-

tography are mainly undamaged by the cut and thrust of competition in business. Consequently, their insights and enthusiasms are relatively undimmed.

If you are an empathetic person, and if you take the time to learn a few basic teaching skills, you can expect to be effective and have fun in a classroom setting. I am married to an elementary school teacher, and I have successfully adapted a number of the techniques she uses in her classroom.

There is a Chinese proverb that says: "I hear — I forget; I see — I remember; I do — I understand." Good teaching is just the imaginative application of telling, showing, and doing. In the classroom this means incorporating methods that address all the basic modes of learning:

1. Clear and informative language

2. Good visual presentations — useful drawings, illustrations, and photographs

3. Good physical props — real objects that students can handle

4. Lots of student–teacher interaction: brainstorming, role-playing, questions and answers

Boredom is the enemy of learning. Students will want to learn from real-life examples. Your personal experiences as a working professional are your most valuable teaching tools.

TEACHING OPPORTUNITIES

Cultural or charitable institutions will always have volunteers who do some sort of photography for newsletters or whatever. These people will be very grateful for advice and constructive criticism. Enthusiastic amateurs at camera clubs or community centers make appreciative audiences as well. These venues will offer a small gift or gratuity in exchange for technical advice, but the real reward will be the good feelings and the experience of teaching.

Challenging and financially rewarding opportunities exist at high schools, community colleges, technical schools, and universities. Enlightened institutions recognize that full-time teaching staff cannot always keep up with the very latest technical developments. In addition, the practical aspects of operating a business are discussed only

rarely in academic settings. Consequently, there is a need for reputable professionals with good presentation skills to give lectures or seminars in the classroom in support of existing curricula. Fees vary according to the time involved and the level of sophistication of the teaching.

A letter to a dean, principal, or curriculum director may result in a phone call or meeting to discuss a short-term teaching engagement. Long-term positions normally require a formal degree or certificate of accreditation. If a very attractive opportunity arises, it may be possible to upgrade your credentials at evening courses or during the summer. Don't expect to make the same income teaching as shooting, but all benefits are not measured in dollars.

The most lucrative of all teaching formats is potentially the professional development seminar. Success in this field requires that one's reputation and business practices be outstanding and that other professionals in your field, or in related fields, will benefit from learning about your particular approach.

If you have something special to offer, begin by attracting small groups of students through newspaper classified advertisements and one-page instant-printed flyers distributed through photographic suppliers. At first, the lectures and workshops can be held in your studio. For example, in my own studio I have taught architects and interior designers how to shoot their own projects ($195 per person for a one-day session), and I have taught aspiring professional photographers and advanced amateurs some of the nuts and bolts of real-life business practices (same rates).

WRITING FOR MONEY

Commercial writing is very similar to commercial photography. In both instances carefully tuned communication skills are bought and sold. I say carefully tuned because in all cases buyers have very specific needs that their suppliers must cater to; only the willing and the adaptable need apply. In addition, a good vocabulary, an appreciation of grammar, and an economical writing style are also required.

Begin by studying existing published material to find out how your personal interests and abilities fit into the larger picture. Book and magazine publishers have precise editorial policies. Here are some sample categories: "how-to," general interest, academic, niche-market,

and technical review. There are lots more. A useful way to explore the possibilities is through *The Writer's Market*, which lists book and periodical publishers by their area of interest. In addition to very practical technical and business advice there are samples of successful query letters as well as essays from editors and publishers about what they want from writers.

This is my fifth photography-related book. All were sold by following the guidelines to professional writing practice I learned from reading *The Writer's Market*. It is not necessary to stick to photographic topics — any subject that requires lots of good photographic illustrations is a possibility. Writer-illustrators are very attractive to publishers.

PHOTOJOURNALISM

The book business is a slow business. It requires a patient, methodical approach. If you are interested in quicker feedback and more excitement, consider taking responsibility for both the photographic and journalistic aspects of photojournalism. Earlier I discussed how to break into newspaper and magazine editorial photography. My advice was to start with local community-based weeklies and newsletters. My advice for breaking into photojournalism is essentially the same. Start small and start local. Assignments will be manageable and the editors will have time to critique your work.

No big-city editor will consider your story ideas unless you have a substantial list of previously published prose. Even if you are an experienced editorial shooter already you will be approaching former clients with a new product so you will be obliged to establish a track record.

Figure 24.1 A–E

It is possible to raise one's image in the community and be a contributor to the life of the community at the same time. I proposed a photodocumentary series about noteworthy citizens to the editor of a local newspaper: Called *Good Faces*, each feature consisted of a 200-word profile and studio portrait. (The photos depict, in the order shown: the mother and daughter team that run an art gallery featuring aboriginal art; a family of environmental activists; a photographer who provided images for a gay-rights poster campaign; an outstanding foster mother and her current charges; and a university professor and environmental activist. (*Mamiya 645 Super/150mm lens/Ilford FP4 film/Electronic flash.*)

Small magazines and local papers are much more willing to take a chance on someone new. The financial rewards are significantly less, but the opportunities are greater.

PHOTOGRAPHIC FIELD TRIPS

Nothing comforts the photographically oriented tourist like the presence of a professional photographer. Field trips range in scope from jaunts through the local heritage district all the way to safaris in Africa. The skills involved are a combination of social director, travel agent, and photographer-confessor. Acquire experience by starting small — I wasn't kidding about the heritage buildings. Offer your services to the historical society, or the naturalist society, or an environmental group. Learn people skills and photographic patter. If you are suited to this work then a combination of word-of-mouth and increased self-confidence will lead to larger expeditions.

RENTING YOUR EQUIPMENT & STUDIO

So far we have explored diversification in terms of professional and intellectual assets alone, but the typical commercial photographer owns a lot of stuff that other people will pay to use. Some costs are involved in becoming a supplier of rental equipment— special insurance charges, more time devoted to scheduling arrangements, as well as extra repairs and maintenance— but the benefits for someone willing to assume the added responsibilities are worth considering. Equipment and facilities that might otherwise sit idle when assignments are scarce can earn hundreds of dollars per week if properly managed.

Rental rates are easily established by polling the competition— start lower and work up if the market is strong. My studio is a fairly modest room and I am able to get one hundred twenty-five dollars for a day, camera and lighting gear not included. I don't usually rent equipment because of fears about wear and tear or theft. Possibly you will feel differently.

PHOTOFINISHING & CUSTOM PRINTING

Earlier in the book I made a strong case for maintaining film and print processing facilities as part of a commercial photography business. If you follow that advice, and if the work proves profitable and interesting, you might consider taking on outside photofinishing jobs. Just like renting your studio or equipment, custom photofinishing means coping with a degree of hassle, but some inconvenience is insignificant if the additional income is significant. By following my methods for efficient darkroom practice, you will make processing profitable. The only real risk is taking on more work than can be properly handled while attempting to simultaneously manage your other responsibilities. Unlike the rental business where scheduling conflicts are tough to deal with, excess photofinishing can simply be sent to another lab. At worst, such a remedy might be a slightly less than breakeven proposition involving no loss of face for anyone.

VIDEO, FILM, & MULTIMEDIA PRODUCTION

Some of the most accomplished cinematographers and some of the most innovative producers of music and commercial videos are former

still photographers. It's not hard to understand why this is so. At the peak of a high-profile career an expert still photographer has learned to manage all aspects of artificial light, learned to manage a team of highly individualistic creative people, learned how to manage substantial production costs, learned to sell abstract concepts to unimaginative people, and learned how to be consistently creative under severe physical and emotional stress. All these skills are needed for successful film, video, and multimedia producers, as well.

In rare cases the shift from still to video is a natural extension, a kind of professional evolution. This might happen when an upscale buyer of commercial photography — a supermarket chain, for example — asks their photographer if he or she will produce TV commercials that have a look consistent with their photography-based print campaign. All beginnings are not so grand, but the nature of the change is the same. It is necessary to take all the skills so carefully acquired and extend them into the dynamic realms of time and movement and sound.

How to best accomplish the change and maintain one's professional standards requires some planning. Acquiring new skills means training; either school, apprenticeship, or just research and reading. I recommend university-level film-making courses, especially those that emphasize commercial applications. Apprenticeship need not be entry level only — many reputable film companies regularly require high-quality skills and may be willing to trade services for training. Much can be learned by simply keeping one's eyes open while on a film set or location shoot.

Hands-on experience begins with renting, borrowing, or buying an amateur-type camcorder. After a month or two of experimentation, rent some professional level video equipment and familiarize yourself with its potential. Multimedia production combines what used to be called audiovisual production with video and computer technology. You can start with a community college course and work up to buying a computer of your own.

The next big step is a reassessment of your supporting cast. Consider the following: Good commercial still photography can be produced by an energetic person working alone. Film, video, and multimedia, on the other hand, is never a one-person endeavor. It is interesting to note that many of the professional support services employed by still photographers engaged in big-budget work are useful in the film and video business. In fact, your regular makeup stylist, prop maker and prop

finder, food stylist, location scout, and model agency will inevitably have experience working for your counterparts in the movie picture business. That means they can help you by providing technical advice or simply by helping you connect with the other knowledgeable people necessary for the work. Additional support people — the film crew— will deal with lighting, sound, costumes, and maintaining logical continuity between scenes. Multimedia support can be drawn from those educators, designers, and graphic artists who have a special affinity for high-tech.

I don't think it is unreasonable to spend a year of diligent part-time work getting ready to launch a career in professional film, video, or multimedia. As in other cases we have examined, volunteer work is a good entry point. Many well-established charitable organizations have sufficient budgets to cover the production costs of television commercials and educational films but still depend on volunteers to do the creative work. Schools and various cultural institutions are in the same circumstances. Small, independent television stations often have the same attitude toward aspiring filmmakers as community newspapers have toward aspiring photojournalists. This means that one's first commercial efforts will have an audience. An added bonus — such stations will often provide loaner equipment, support staff, and editing facilities for promising freelancers with good story ideas or a creative approach to commercials. With a videocassette or CD full of interesting work the upper limits are really only a matter of marketing.

MANAGING OTHER PHOTOGRAPHERS

Successful photographers find that after a certain point the business of photography becomes so familiar that their expertise is of value to other working photographers. Since specialization is the rule in large urban centers, the possibility exists for well-connected pros to direct certain assignments to others working outside their own specialty. It is becoming more and more common for two or more photographers to share office and shooting space. Temperament often leads one member of such informal collectives toward a quasi-managerial role. The performance of small administrative services under these circumstances, professional courtesies really, do not generally involve a fee or commission. However, when developed further and coupled with

a concerted marketing effort and a clear-headed business plan, the referral business is called professional management or professional representation. Fees are typically 25% or 40% of billings, after expenses are deducted. At rates like this it is fairly obvious that someone with entrepreneurial and management skills and an in-depth knowledge of the market can make a fair amount of money. The more aggressive among you can expect to eclipse your incomes as photographers if market conditions are right.

I believe success in this field demands a financial version of the golden rule: Keep in mind how you would like to be treated if your client-photographers were managing your affairs, and act accordingly.

SALES

Photographers seeking representation are not the only ones with an interest in the specialized business acumen of working photographers. Selling photographic products comes naturally to some shooters who might be disenchanted by the deadline pressures and intense personalities associated with the advertising business. In fact, some of my favorite photographers are in sales.

Commissioned sales people earn some of the highest incomes in North America — their earning potential is, strictly speaking, unlimited. In reality, limits are set by macroeconomic conditions and the competitiveness of the products they have to flog. Still, with a case full of innovative camera gear and a moderately healthy economic environment, six figure incomes are not uncommon.

Successful sales people are friendly, persistent, and good talkers. An internal marker of the sociable, outgoing personality may be persistent loneliness during those long, solitary hours in the studio. Some salespeople are perfectly capable of meeting all the aesthetic, technical, and business demands of professional photography yet they miss the social interaction of doing deals daily, face to face.

In the sales business, perks and big bucks are associated with the best territories and respected product lines, neither of which is instantaneously attainable. The typical first step, however, is some experience behind the counter in a retail photo store. High performance in any sales position will move one upward and onward toward a managerial post or one of the coveted jobs as sales rep for a world-

famous manufacturer. Although the sales floor is one of the only true egalitarian arenas left in the western world, former professional photographers can expect their experience to be a real advantage.

MANAGING A CORPORATE OR INSTITUTIONAL IN-HOUSE PHOTO DEPARTMENT

Here is a true story: I have a friend who learned photography at a reputable technical college in London, England, and then returned home to Canada to shoot products for a big catalog house servicing a department store chain. He quickly realized that the road to independence and a fully equipped studio of his own would be long. After a year as a typical wage-earner my friend noticed an ad placed by INCO (International Nickel Company) in the careers column of the local newspaper. They were seeking a photographer to manage the in-house photography department associated with their vast mining operation many hundreds of miles north of the Canada–United States border, in the small one-industry town of Thompson, Manitoba.

A little investigation showed that INCO had had very little response to the ad since most fully qualified photographers were not interested in living in a tiny community, particularly under arctic conditions. My friend applied for the position and, even though he was not exactly trained for it, he got the job and headed north.

The work was physically demanding and involved all kinds of photography: scientific documentation, public-relations shots for the company newsletter, some advertising illustration, architectural treatments of huge special-purpose structures, photojournalistic stories about mining operations and procedures, even executive portraiture.

Through four years the young photographer labored at a wide variety of photographic tasks, upgrading his skills using excellent equipment that he was permitted to requisition as required. All the while he saved his money — there was nowhere to spend it really — and he planned his return to the more cosmopolitan south. At the end of his four-year contract he returned to his home city with enough cash in hand to purchase a house and a fully equipped commercial studio. One of his first projects was a successful exhibition of large-format black and white portraits of hard-rock miners that he had made a mile underground in his spare

time! Now he does commercial photography at a leisurely pace during six months of the year, taking on only those projects that interest him.

Not all corporate connections are such a perfect fit, but this story dramatically illustrates the point that in exchange for some restrictions on personal freedom it is possible to make some money, acquire some experience, and build for the future. Institutional environments demand a degree of tact, a willingness to accommodate orders from above, and the self-discipline to do good work under sometimes emotionally sterile conditions. Even so, when the market for freelance shooters is tight, an in-house photography position can look attractive. If your temperament fits the corporate profile there is no shame in making a career of this work, either.

THE COMMUNITY ADVOCATE

Most of the alternate occupations I have discussed in this chapter are attractive because they have the potential to increase a commercial photographer's income. I have suggested several times that community service work is an excellent way to build up credible experience and a decent portfolio. I also believe that it is appropriate to talk about social responsibility as well. At the risk of sounding preachy, I want to say that those of us who regularly sell our skills in the marketplace also have the opportunity to make a contribution that extends beyond the strictly financial. I think it is only right to help others by volunteering our professional services to those agencies who do good in the community. Working in a highly competitive field we tend to forget how valuable we are to those who can't afford the stiff rates we must charge our commercial clients.

Figure 24.2 A–G

For several years I have provided photography *pro bono* for the United Way of Winnipeg. Here is an example of a location photo made for the agency, shot at a sheltered workshop. It portrays two old friends in front of a huge stack of newsprint ready for recycling. Two lights were used. One portable flash unit provides the main and background light, while a second unit provides some backlight and edgelight. (*Nikon F3/28-70mm Zoom/Ilford FP4 film/Electronic Flash.*) The following images are studio portraits of some of the recipients and providers of United Way services. These images were used for posters, mailers, bus shelter ads, and for the United Way annual report.

319

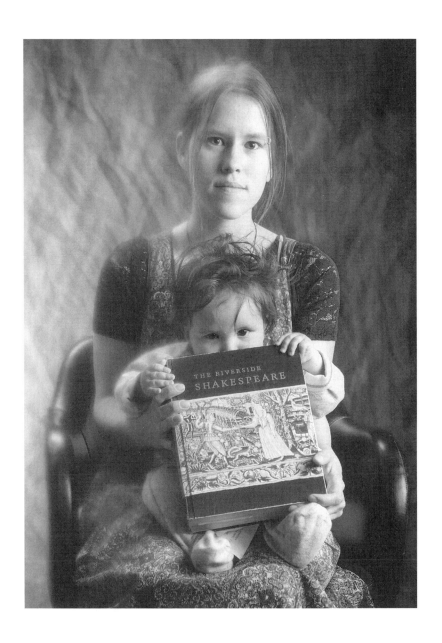

The Greening of Photography

PHOTOTOXINS & WASTE

A very strong argument put forward by advocates of digital imaging technology says that electronic photography is cleaner than conventional photography. If we ignore the appalling environmental conditions in the Second- and Third-World countries where much of our high-tech electronic imaging hardware is manufactured, it is true to say that as far as North America is concerned, chemical-based photography does exact a higher toll on the environment.

Almost everywhere in North America it is against the law to dispose of toxic chemicals by pouring them down the drain. Municipal sewage systems are designed to handle biological and household waste materials, not industrial by-products: Strong chemicals inhibit or destroy the bacteria that break down sewage, and they also corrode pipes, pumps, holding tanks, and other pollution-control hardware. Avoiding treatment systems altogether by pouring waste into storm sewers means that the fluids travel directly into waterways without any treatment at all.

Many photographic chemicals alone or in combination with one another are dangerous to human, animal, and plant life. Some of these materials are also corrosive, and many are persistent, which means that they hang around to do their damage for a very long time. Typically these chemicals will accumulate in the mud, silt, and sand at the bottom of lakes and rivers. Low concentrations of dangerous chemicals might not kill aquatic micro-organisms and plants outright, but a process of concentration begins as these simple life forms absorb for-

eign materials and are then themselves ingested by larger creatures. As the poisons climb up the food chain by way of the digestive tracts of more and more sophisticated animals, toxic and mutagenic effects begin to emerge. Cancers, deformities, and fertility problems increase when humans drink contaminated water or eat contaminated food.

Common sense and the law both say that something has to change. A first step is to consider how the three R's of good environmental practice — reduce, reuse, and recycle — apply to the practice of commercial photography.

We can reduce our use of chemicals by simply using less — less fluid and more careful agitation while processing prints in trays, for example. Film should be processed in sufficiently large batches to make efficient use of the tanks and solutions. Hypo-clearing agents will cut down on washwater. Using small test strips rather than full-size test prints will save both paper and chemistry.

Not reclaiming the silver dissolved in used fixer and bleach and fix is like throwing away your pocket change at the end of each day, especially when you consider that these solutions can be reused after chemical or electrolytic regeneration. Other chemicals can be replenished, filtered, or simply stored in carefully sealed containers for reuse at a later date. One can choose rechargeable batteries rather than disposable types and try to buy quality used equipment rather than new.

Many manufacturers in the our industry are now set up to assist in the recycling of photographic related materials. Film canisters, spools, and cartridges can be returned to distributors or labs. Spent rechargeable battery packs can go back to the factory to be remanufactured. Outdated unprocessed film and paper, as well as processed black and white (b&w) materials, can be chemically stripped of their silver content before disposal. Leftover materials can be donated to schools for students to work with.

The three R's can be applied to electronic equipment, too. Reduce energy consumption by turning off equipment when not in use. If you don't want to switch off your computer, at least switch off peripherals like the monitor, printer, or modem. Buy equipment that has been engineered specifically for energy efficiency. Reduce paper consumption by using a fax/modem board in your computer rather than a dedicated fax machine — this allows the exchange of electronic files rather than hard copy output.

Computer technology is changing so fast that many perfectly service-able devices are available used for very modest prices. If only the newest machines will do for your operation, make sure that whatever you discard goes to an individual or an institution that will make good use of it. Recharge rather than discard your printer and photocopier ink and toner cartridges. Use recycled printer paper. Collect paper waste for recycling.

SAFE DISPOSAL

No matter how carefully you run your business, there will be waste materials that have to be disposed of, but nowadays this need not be the ethical conundrum it once was. In many large centers industry has realized that good environmental practice is profitable.

A little research will tell you what safe disposal resources are available in your area. A call to a local photofinisher or your Kodak technical representative will likely lead you to a company that specializes in processing spent photochemicals. If your volume is small, you may have to pay them to pick up your waste if you can't deliver it yourself. If your volume is large, they may pay you for the privilege of hauling it away. If you generate only small volumes of waste but have lots of space you may want to store old chemicals for a few months until you have a large enough quantity to interest an industrial recycler.

Many local governments now operate hazardous waste disposal sites. Your waste materials can be dropped off—properly packaged and labeled—and presumably treated in an environmentally sound way. Some sites operate exchange programs through which the waste of one industry becomes the raw materials of another. If neither an industrial recycler nor a public facility exists in your community, pressure your politicians to get something established.

HEALTH & SAFETY

Photographers who do their own processing are at risk for a number of unpleasant ailments, including asthma, emphysema, bronchitis, dizziness, headache, memory loss, eczema, skin cancer, reproductive disorders, as well as heart, kidney, and bladder diseases. Acute symptoms may appear after a catastrophic exposure to a large amount of toxic material; chronic symptoms may appear after years of frequent

exposure to relatively tiny amounts.

Twenty-five percent of photographers who do their own processing have some sort of breathing problem. No three R's-based program will protect you from exposure to materials and processes that are dangerous: You must do that yourself. Read and understand instructions and labels before using any product. Remember that manufacturers are obliged by law to label dangerous materials, but they will use the least alarming warning they can get away with. Take all warnings seriously.

Here are some of the chemicals you might encounter in the darkroom:

1. *Black and White Chemistry*

a. Diaminophenol hydrochloride can cause bronchial asthma, gastritis, convulsions, and coma

b. Hydroquinone can cause changes in the skin and eye problems

c. Sodium sulfite can cause diarrhea and gastric and circulatory problems

d. Sodium thiosulfate can cause bowel and lung problems

2. *Color Chemistry*

a. Dye couplers, glycol ethers, benzyl alcohol, para-phenylene diamine, succinaldehyde, sulphamic acid can cause skin and respiratory irritation and allergies, eye irritation, lung damage, birth defects, and reproductive damage

3. *Instant Film Chemicals*

a. Highly caustic alkaline jelly containing sodium or potassium hydroxide can be corrosive to the eyes, skin and mucous membranes, and, if ingested, can damage mouth and esophagus.

Detailed information on product safety is available under the *Workplace Hazardous Materials Information System* (WHMIS). By law, standardized *Materials Safety Data Sheets* (MSDS) for all hazardous materials must be provided by manufacturers on request. Careful reading of the MSDS will clarify the proper use and handling of the material, chemical content and concentrations, toxicological data and effects, chemical and physical properties, first-aid information, and conditions under which the material is chemically unstable.

Here are a few simple safety precautions:

Don't eat or drink in your workspace.

Don't store chemicals near food preparation areas or in a refrigerator that contains food.

Don't put your working tools in your mouth.

Wash your hands after working and before eating, drinking, or using the toilet.

Use liquid chemistry wherever possible.

Use a ventilator, glove box, or exhaust fan when mixing powdered chemicals.

Keep your workspace clean. Wet mop rather than sweep.

Don't allow small children or pregnant women into the darkroom.

Have special clothes for darkroom work and wash them often.

Use protective clothing, like rubber gloves or an acid-proof apron whenever necessary.

Avoid fabric floor coverings in your workspace.

Mark all containers clearly and carefully.

Store materials in unbreakable containers on shelves that are sturdy and easy to reach.

Close all containers when not in use.

Stock hazardous materials in the smallest quantities that are practical for your operation.

Store large or heavy containers as well as acids and corrosives on or near the floor.

Keep all liquids well away from electrical equipment and outlets.

VENTILATION

Ventilation is very important. Industry experts say that darkroom air should be exchanged with fresh air every six minutes during b&w processing, and every three minutes for color processing. Here is the standard formula for calculating your specific needs in cubic feet per minute of air exchange:

$$\frac{(\text{ROOM VOLUME IN CUBIC FEET}) \times (\text{AIR CHANGES/HR})}{60 \text{ MIN/HR}} = \text{CFM}$$

Vents should be arranged so that contaminated air is sucked away from the worker's face and vented directly outside.

EMERGENCY RESPONSE

Prepare for the worst. Have ample first-aid supplies and a fire extinguisher on-hand at all times. Learn basic first-aid techniques. Rehearse procedures for dealing with a chemical splash or fire. Plan an escape route and keep it clear of obstacles. Install a smoke detector. Avoid working alone or when fatigued. Keep MSDS information handy, together with phone numbers for emergency advice. A basic rule: Flush chemical splashes with running water for at least fifteen minutes.

Kodak's twenty-four–hour emergency hotline: **(716) 722-5151**

Body & Soul

PROFESSIONAL DEVELOPMENT

It is human nature to resist change. In the business world, resistance to change manifests as a reluctance to alter traditional practice. Having worked out a methodology that has proven profitable in the past, the instinctive urge is to hold fast and do the same thing over and over. This approach should be avoided if continued success under current market conditions is expected. There have been periods in the history of commerce when conditions were stable and it would have been prudent to cling to tradition; however today conditions are not stable, so we must adapt.

Happily we live not only in a time of change, but in a time of rapid dissemination of knowledge. Information that a hundred years ago would have been hoarded by learned societies dominated by the aristocratic classes is today available through books, magazines, public seminars, and the Internet. Professional journals, trade magazines, computer networks, electronic mail, and satellites bring us what we need, so long as we are receptive and at the same time discriminating. It is necessary to intelligently discard junk data from the truly useful.

START A PROFESSIONAL ASSOCIATION

Optometrists do not seem to have any trouble forming groups dedicated to professional development, so why not photographers? In my town, none of the good shooters belong to national organizations — we are all a bunch of strong-headed eccentrics, I guess. Yet a couple of years

ago I felt the need to exchange information in a noncompetitive atmosphere. Instead of complaining, as we had done many times in the past, a colleague and I simply called up a dozen people who we identified as our competition and invited them to a meeting at my studio. The result of the meeting was the creation of an informal professional association that meets from time to time in various studios and homes. It turns out that there is a lot that like-minded competitors can share over some nonthreatening beer and chips. For example, what clients are going the rounds ripping off unsuspecting suppliers of photography with untruthful promises of future work?

My experience tells me that competition is not so fierce that well-served clients will abandon respected suppliers on the basis of price alone. That means that we can relax and enjoy each other's company and share some technical information without a lot of anxiety. The collegial process strengthens rather than weakens any particular individual's position in the business world. The critical mass for such an enterprise is nine or ten people — not an inconvenient number of calls to make.

COURSES, SEMINARS, LECTURES, & CONFERENCES

Boredom and intellectual stagnation go hand in hand. Resist these conditions! Commercial photography is too sophisticated a profession to support the dull and the apathetic. But self-motivation techniques do not work in a vacuum — there is a requirement for some outside stimulation, some outside inspiration.

Many of us are predisposed against formal learning situations because of bad experiences in schools. Watch for and struggle against self-limiting conditioning of this kind, since opportunities for growth exist in various kinds of classrooms.

Here is a tip: Make certain that you are on several different photo-industry mailing lists. Large and small distributors and manufacturers publish monthly newsletters. Get the addresses of these organizations from your photo retailer and subscribe. Things move quickly these days. The industry has responded by offering a plethora of educational programs for professionals. There are tradeshows, speakers, and short courses happening all the time. Many of these events are free, or nearly so. Intense and artistically sophisticated workshops led by

world-class photographers are advertised in the big photography magazines. Sessions can be up to three weeks in length and tuition might be hundreds of dollars per participant, but expenses related to professional development are tax deductible.

Lately I have become one of those people that give lectures, run seminars, and organize professional development programs. My conversations with the people who attend these events lead me to believe that success in business is directly linked to a continued effort to expand one's intellectual and technical horizons. A substantial supplemental benefit is camaraderie and mutual support. You will find that many who attend lectures and conventions are from out of state and not your direct competitors anyway.

Just taking a measure of the generosity and ingenuity that exists in the professional world is inspiring in itself. Here's a true story.

I shook hands with Victor Skrebnesky at the beginning of the very last seminar at the very end of the very last day of a large professional development conference. I turned up at room 206C in the Toronto Convention Center somewhat reluctantly, having already taken in fifteen of the nearly one hundred high-intensity seminars, workshops, and lectures offered during the massively attended five-day event. My mission was to gather research material for this book.

Short and unprepossessing, Victor did not at all personify the electrified rapid-fire image that has come to be associated with upscale East Coast photography. He stood at the meeting room door and graciously greeted each participant with a handshake and "How do you do, I am Victor Skrebnesky." Many smiled as they passed, some snickered. A moment later at the podium Victor offered an explanation: "I would rather not talk to a room full of strangers." There were chuckles as an assistant dimmed the lights and cranked up a 16mm movie projector.

Nevertheless, within minutes I was glad I was there. The flicker and clatter that accompanied the black and white film took me back to a less complicated but no less intriguing era. Victor modestly narrated what turned out to be an intimate thirty-minute documentary of his life's work: elegantly-sensual fashion and fine-art photography, produced over fifty years, almost all in black and white. How did he make these photographs, the majority of which were created on assignment for the most prestigious magazines and commercial clients in the world? "With two or three lights and a Hassleblad," replied Victor, in his self-

deprecating manner. Exactly who, or what, is Victor Skrebnesky? He is a gentleman and an artist who has earned a reputation on a par with Irving Penn and Richard Avedon. It was a treat to meet him. I shook his hand and thanked him for his presentation as I left the room.

Had I missed the conference I would never have met Victor. I came for high tech, and I got high art. I didn't mean for it to happen, but that is what one finds at a well-organized event. In a world where information is money, professional development training is a bargain.

FORMAL CONTINUING EDUCATION

Where I live, school teachers are paid according to a sliding scale on which experience and formal education are determining factors for salary increases. This means that many teachers, inspired by the promise of higher incomes, attend summer school or night school in order to finish undergraduate and postgraduate degrees. I know many of these people, and I can say that although they sometimes sign up for these courses kicking and screaming they benefit in more ways than the financial. It is possible to ignore the deadbeats and the internal politics and discover that universities and technical colleges are full of people dedicated to helping others achieve professional excellence. My teacher friends who make the effort to expand themselves, whatever the initial motivation, are clearly more interesting personally and more effective professionally.

Photographers may not have the same direct financial incentive to follow the path of postsecondary education, but for all practical purposes the incentives are the same. Education inevitably pays. It is not necessary to pursue only those courses specific to one's own business or profession in order to accrue some benefit. A course that explores the psychology of political propaganda could be as enlightening to a commercial advertising photographer as to an anthropologist or sociologist.

CLIENT EDUCATION

In Chapter 19 I talked about practical responses to clients of various temperaments and abilities. A successful community is built around the mutual respect of its members — this is just as true for a community of business people as it is for other types of communities. Client

education is an exercise that combines community service with self-preservation. Here are some strategies for raising the consciousness of the people for whom you work.

A colleague and I were asked to talk at a meeting of the Graphic Designers Association of Canada about problems arising between commercial photographers and graphic designer clients. We talked about layouts, the quoting process, how to establish a realistic budget, and how to deal with a less than perfectly executed assignment. Events like this are great for blowing away stereotypes and improving business relationships — a client education initiative skillfully tucked into a professional development agenda organized by a group of clients!

With what number of people would you like to maintain professional contact? Fifty? A hundred? A simple desktop published newsletter will cover a lot of territory — both literally and figuratively. Everyone is interested in everyone else's business. There is no harm in offering personal notes and observations about successfully completed projects. After all, there is no industry quite as public as the advertising industry. Tell your story in simple, interesting language. Be discrete about your clients' business affairs, but keep the tone entertaining.

The business lunch is a traditional tool for client education that is becoming something of a dinosaur. With couriers, fax, voice mail, and e-mail interposed between us, clients might not see a supplier in person for months at time. This is an age where everyone is in a hurry but actual social contact is still important. Your clients are human beings with personalities and insights and particular idiosyncrasies. Have lunch once in a while. It is really no fun any other way.

Since I started giving seminars on photographic topics I have enjoyed the luxury of being able to invite clients to the events. This is nice not only in terms of exposing them to my teaching persona but also by bringing diverse people together whose common interest is good photography. I invited people from a professional color lab, a sales manager from Nikon, and several accomplished students of photography and architecture to an event in Toronto where I instructed architects and interior designers. The room buzzed with excited conversation as these people discovered mutual interests. Cross-fertilization can happen anywhere. Why not invite one of your commercial clients and your favorite retouch artist out for lunch at the same time?

RECOMMENDED READING

It is a crime to waste all the insights stored on the printed page simply because we are distracted by more glamorous media.

I recommend subscriptions to a variety of up-to-date periodicals, among them titles that are not directly related to still photography. I like *American Cinematographer*, for example. *Communication Arts* is the international bible for art directors, graphic artists, and graphic designers — world-class photography is lavishly reproduced and presented in context with superior examples of the other types of advertising art.

Books, old and new, are a rich source of inspiration. Ansel Adams' series on the Zone System, particularly *The Negative*, *The Print*, and *Available Light Photography* demonstrate a marvelous juxtaposition of the profoundly practical with the profoundly passionate. Langford's *Professional Photography* and Andreas Feinager's books are favorites from the past that are still available from the library. Modern technical and critical books about photography are available from a number of sources. University bookstores are reliable suppliers, as are the photo bookclubs that advertise in photography magazines. Contact your local technical college or university to obtain their reading lists for students of photography.

For those who appreciate very compact and practical technical books I recommend the many excellent pamphlets and books published by Kodak. A list of what Kodak offers may be obtained at any large photo store or by contacting your local Kodak technical representative. Find Kodak in the white pages of your phone book or ask your suppliers for a number to call.

STRESS MANAGEMENT

Any occupation that demands high performance under pressure of time is stressful. With one eye on the clock and the other on the competition, photographers must control tricky technical variables, assuage the worries of demanding clients, and make a decent living. Such potentially soul-consuming preoccupations have forced many artistically gifted people out of the marketplace. Nevertheless, lots of others do succeed in minimizing the destructive aspects of stress and carry on profitable and fulfilling commercial careers. Like all life skills,

stress management can be learned. Those who enjoy the benefits of relaxed genes may acquire the necessary experience more easily than the rest of us, but we all benefit by consciously cultivating a few simple survival techniques.

Physical Health

The first and most obvious strategy is to pursue a state of physical well-being. Inside the studio or on location, the photographer's typical working day involves lifting and carrying equipment as well as stretching, bending, and constant bustling around. The ability to remain truly motionless in odd postures is a basic requirement; something that is impossible without a sturdy, supple body.

You don't need to look like a body-builder. You just need to maintain stamina, which you can do by doing some sort of aerobic exercise for twenty to thirty minutes every other day. This could be supplemented with some weight training for strength. A moderate diet, sufficient rest, and an avoidance of nicotine, caffeine, and other unwholesome substances makes life easier in the long run.

The lifestyle of a busy photographer offers many temptations and physical pitfalls, such as social drinking with clients, long workdays fueled by junk food, and all-night marathons to meet impossible deadlines. Relaxed self-discipline in relation to these matters will allow occasional excesses within an overall context of self-control.

Short-term and Long-term Pressures

Maintaining equilibrium within a frantic business milieu requires the ability to identify the two different types of stress inducing forces: short term and long term. Each requires a different response.

Maintaining physical health is a good strategy for dealing with the long-term physical stress that might otherwise result in heart disease, chronic fatigue, etc. The mental and emotional arena is a little more complicated, but it helps to first catalog the controllable aspects of life in the photo business and then make plans that reduce the need for minute-by-minute review. Responsible budgeting, planned capital expenditures, sensible marketing and advertising, regular consultation with the bank, and prudent use of credit all contribute to long-term

peace of mind and a state of creative inner harmony.

Having addressed some external long-term factors, the next step is to discipline the mind. Short-term stress is mostly a mental state, usually a consequence of negative self-talk aggravated by fatigue. During periods of low energy, when work seems tedious and repetitious, it is easy to blame others for your own negative feelings. If you allow yourself to do this, a chain of misunderstanding and hostility develops, and your dark worldview becomes a self-fulfilling prophecy. Try not to worry. There is a saying in the Zen Buddhist tradition: "When walking, walk; when eating, eat; when sleeping, sleep." This could be extended to "when taking a picture, take a picture." In other words, do only the task at hand at any given moment, but do it completely. Many tasks will arise, but do only one at a time, completely. Keep mental noise to a minimum.

Here is a simple but effective tip: Make a detailed list of what you have to do during the day. The list can be put together and prioritized at the end of the previous working day, or first thing each morning. New responsibilities can be added to the list as they arise. Every item should be a task that you can manage while not thinking about something else. Be hard-headed about what may be accomplished any given day. It is a discipline to take on only those things that can be properly handled with the time and resources available. What you are able to do will inevitably expand with experience, but that expansion is slowed or reversed if you insist on existing in a perpetually over-extended state.

At the Edge of Your Abilities

Your portfolio should demonstrate your photographic skills and accomplishments to potential clients. When you show your book you are saying: "Look here, I can do this for you…at a cost you can afford." It is true that much of the work that comes your way will involve a creative recycling of techniques already mastered using skills already learned. But it is also true that if you do well, the natural course of events will lead you to new challenges and the development of new abilities. It sounds great, even wholesome — the American Way of Business. The downside is having to decide whether to take on jobs you may not be capable of handling.

The dilemma is not a straightforward one, since the pressure to accept all work offered is tough to resist. Many clients, particularly in small markets, will look to you to solve all visual problems with skill and speed. It is very possible that a refusal will diminish your image in the client's eyes, as well as your own — and of course, you will always need the money.

What to do? First, take some time to think. I don't mean sweaty, shallow breathing, racing heartbeat thinking, but rather "I'll call you back tomorrow…this afternoon…in an hour" even-tempered contemplative-type thinking. If your best instincts say that the job is beyond you, try to figure out why. Was it a lack of financial depth, lack of equipment, lack of experience, or lack of confidence that elicited your negative response? If so, which of these conditions are under your control and which will yield to extraordinary effort? Will expert advice make the decision easier? Are you willing to experiment, to research, to take a risk? Will your bank support the effort? Can rented equipment be flown in from a big city supplier? Can you manage self-generated fears sufficiently well to allow the concentration required to complete the job? There are answers to all these questions. And honesty is the best policy.

Failure and Success

Unavoidably and repeatedly, you will face the decision of whether or not to extend yourself. A successful coping strategy must accommodate either success or failure should you accept the job, as well as the possibility of client rejection or personal self-doubt should you refuse the job. The key here is to develop a sense of attentive detachment. That is to say, any action is appropriate, as long as one is prepared to accept the consequences of that action with equanimity.

There is not a lot of open discussion about failure in most business relationships. In fact, the unspoken agenda for business is the bred-in-the-bone expectation of never-ending success. Goal setting and positive visualization is a growth-inducing process, but unsubstantiated expectation is not. Be realistic, pragmatic, and honest. Distinguish between those variables over which you have a degree of influence and those that are beyond your control. Keep track of the fruits of your labors and remember to be amazed at how well most sober-minded endeavors turn out.

Worry, Burnout, and Boredom

The negative mantra, "What if? What if? What if?" will diminish the enjoyment of even the most spectacular achievements. Similarly, any activity, no matter how exotic, will be reduced to something unpleasant by endless repetition. Worry itself is both a cause and a result of burnout and boredom.

The antidote to the erosion of joy is a decent life outside and beyond photography. This could mean family, professional education, hobbies, travel, or the simple ability to walk out of a frustrating situation for a period, however brief, of rest and relaxation. The key is to recognize the symptoms of distress and attribute them to the appropriate causes. In other words, learn not to blame the messenger, but instead act on the message.

Recognizing Honesty and Dishonesty in Business

There are two approaches to business. One approach defines success as the defeat of the other guy, while the second recognizes that true success allows all parties in an interaction to benefit. Those in the former category tend to be aggressive and manipulative, and in the extreme, dishonest. Unsavory practices in business are just slightly denatured dishonesty — inside the law but outside the unwritten ethical code of behavior.

I have come to believe that one reaps what one sows, that one attracts negativity if one projects negativity. It is impossible to predict exactly how events will evolve and how one will be personally affected during the constant ebb and flow of human affairs. However, it is possible to maintain a conscious intention to do good and to experience life positively. If the intention is wholesome, the results will be satisfactory most of the time.

Fifty Tips for Increasing Productivity

STUDIO

Remote Control

I love having music in the studio and the darkroom whenever I am working; however music that is inappropriate or too loud can spoil the atmosphere. In the darkroom I can reach the controls on the stereo easily, but changing anything from the studio was a hassle before I installed an extension remote control sensor. Now I can switch CDs and sound levels with the touch of a button anywhere in the building.

A Dim Reception

Install dimmers on studio room lights so that you will be able to lower ambient levels enough to view model lights effectively while your clients and models can still safely navigate the premises.

Let There Be Dark

A studio without windows can sometimes feel oppressive, but windows must be blacked out for those situations requiring total lighting control. The windows in my place are thirteen feet off the floor, so I made a remotely operated blind using some black denim ($16), a 1¼" wooden dowel ($8.75), and a low-rpm gearhead motor ($9.95) obtained from a surplus store. I weighted the bottom of the blinds with a length of ½" steel rod ($6) sewn along the trailing edge.

Power Switching

I am paranoid about fire, so when I remodeled and rewired my studio I installed the electrical panel right next to the front door. Now, whenever I leave the building, I automatically switch off all circuitbreakers except for those that control the furnace and the hot water heater: This way I don't have to worry about whether or not I have forgotten to turn off potentially dangerous equipment such as flash units and film dryers.

Studio Bumpout

Studio too small? The look of many commercial images can be enhanced with the compressed perspective offered by long lenses, but indoors this technique requires a fairly big room. My studio is only thirty-five feet along its longest dimension. To make a full-figure shot with a moderate telephoto while maintaining a reasonable working distance between the subject and the backdrop, I need 38 feet. Instead of moving to a bigger building, I added a *bumpout* — a small "room," 7' high by 4' wide by 3' deep, just big enough for me and my camera stand.

EQUIPMENT

Frugal Flashlight

A small flashlight makes shooting performing arts and other dimly lit events easier. The light will be less obtrusive (but still sufficiently bright to be useful) and the battery will last much, much longer if the standard lamp is exchanged for one with a higher voltage rating. (A flashlight with two AA batteries is usually supplied with a 2.2-volt bulb. Try replacing it with a bulb with a 3.3-volt rating).

Grease and Oil

Photographers generally respect their creative tools but often forget that they are just machines. Some of them, microprocessor-governed cameras and lenses, for example, are such sophisticated machines that they should only be repaired, adjusted, and maintained by factory-

trained technicians. However, many tools we use daily, such as tripods, lightstands, umbrellas, equipment cases, enlargers, even the darkroom easel, are relatively simple mechanical devices that have exposed moving parts: All will benefit greatly from periodic cleaning and judicious lubrication. A little maintenance will extend the life and improve the operations of mechanical apparatus which in turn will reduce distractions and increase efficiency on the job.

Mix and Match

Investing in a particular camera system does not necessarily mean that one is precluded from using lenses built by competing manufacturers for their own cameras. Mixing and matching is best done with nonautomatic lenses, however. Nikon makes two very useful perspective control lenses, which because of their built-in shift capability must rely on manually operated diaphragms: These lenses are good candidates for transplantation. I had a machine shop fit a Canon bayonet mount to a Nikkor 35mm PC. The procedure cost only sixty-five dollars, plus twenty-five dollars for the Canon mount.

Long Live Lithium

I use lithium cells in low-current applications such as light meters, remote flash triggers, and some cameras; my Mamiya Super 645 cameras require a small 6-volt PX28, for example. Batteries in these applications usually expire from old age rather than from electrical drain. Since lithium cells have a useful shelf life of five years, they seem to be a smarter investment.

Pack Attack

High-power portable flash units require expensive battery packs. When it came time to replace several 24-volt nicad packs for my 650ws units, I balked at the manufacturer's price of two hundred and fifty dollars each. Luckily I found a cheap source of fast-charge/high-discharge C cells at a local surplus dealer. These batteries were enclosed in brand new factory-wrapped 12-volt power packs from discontinued Zenith laptop computers. I carefully disassembled the Zenith units, and, using the connectors and cases from the old units, reassembled the individual cells to fit my purpose. Final cost: sixty dollars each. SAFETY NOTE: Improperly matched nicad batteries can cause electrical damage and

present a fire hazard — ask someone knowledgeable in electronics to check the compatibility of replacement packs before charging or installing in your equipment.

Hydride Hybrids
Nickel metal hydride batteries are somewhat heavier than ordinary nickel cadmium, but cell for cell they hold about 60% more energy and don't suffer from the memory effect. They aren't cheap, but for dedicated users of portable equipment they are available from specialized suppliers. Most computer magazines have ads for firms that will take old nicad packs, and rebuild them with the beefier NiMH substitutes.

Stop Battery Drain
After switching from fully mechanical cameras to fully automatic cameras I was alarmed at how many AA alkaline batteries I was going through: Auto-focus and powerwind are power-hungry functions. A little research revealed that industrial strength rechargeable nickel-cadmium penlights are relatively inexpensive and very long-lasting. I have settled on Panasonic P-70AAS's, at about $4.50 each. These cells have higher than usual capacity (700maH) and will tolerate quick charging. (Look under "Batteries, Industrial" in the yellow pages.) If the cells are used almost to the point of total exhaustion before recharging, they will last for hundreds of charge and discharge cycles.

Security in Odd Places
Have a welding shop securely attach a ⅜" coarse thread bolt to the upper jaw of a vise-grip style pliers. With this device you can mount a tripod head to a door, a handrail, a scaffold, a ladder, or just about anything with a lip or an edge. Use a folded magazine to prevent the jaws from scratching furniture or architectural fixtures.

Equipment Cases
The resilient roll-up sleeping mats available at camping and outdoor specialty stores are a ready source of thin yet strong closed-cell foam for equipment case dividers. The same stores sell lightweight Coleman-type food and beverage coolers in a variety of sizes that make sturdy yet unobtrusive shipping containers for your delicate gear.

Anti–Rock and Roll

Many fine telephoto prime and zoom lenses are much more useful with rotating tripod mounts. These devices are omitted by manufacturers for reasons of economy, but most machinists will make one for about one hundred dollars. If you do not feel competent to prepare the necessary measurements and drawings, find a machinist or engineering student who is willing to do it for you. The outer diameter of the movable ring should be large enough so that all parts of the camera, including a motor drive or auxiliary battery grip, can travel through at least 180° of rotation without obstruction.

Free Facts

Stay current with the latest trends in equipment design by regularly filling out the cards in photography magazines that offer technical information from advertisers. Sometimes there is a nominal charge, but quite often comprehensive catalogs, technical specifications, and application tips are available absolutely free and without obligation from both familiar and obscure manufactures and distributors.

Handy Instructions

Modern cameras and flash units are sophisticated devices with amazing capabilities and complex operating instructions. Since they are sold worldwide, most manufacturers supply manuals printed in several different languages, making for some pretty bulky booklets. I separate the English language portions with a razor knife — these instructions go into an unused pocket in my camera bag so that I can refresh my memory on the job, or simply learn a new trick or two during down-time.

SHOOTING

Security Strap

It is often difficult to establish a good, solid tripod position when shooting down from a balcony, a staircase, or an elevated walkway in a mall or atrium-style office building. I carry three ¾"x 3' nylon tie-down straps in my camera case: I use two of them to fasten the legs of my

tripod to the banister or protective railing. The third strap is looped through the tripod head or a suitable location on the camera itself, as added insurance.

A Slick Shade
Photo equipment manufactures offer a variety of lens shades and compendium hoods, some of which are quite expensive. Generally the threat of lens flare comes from just one bright light source, such as the sun or an exposed tungsten lamp, just outside the frame. I use a small accessory-shoe-mounted flex-arm attached to a lightweight black card to block non-image-forming light. This little gizmo is inexpensive and works well on all my various camera systems.

Furniture Fix
I do a lot of photography of architectural interiors which naturally involves the use of wide-angle lenses: This work often puts the camera very close to furniture and other wooden architectural details like door and window frames. Dents and scratches in the surfaces of these objects can be quite distracting in a photograph, so I carry children's crayons in various shades of brown to make on-site touchups.

Travel Time
I carry a small alarm clock equipped with a second hand on location — it helps me stay on schedule and doubles as a timer for long exposures at dusk, dawn, and when shooting architectural interiors by available light. The model I prefer is only about 2½" square, making it small enough to tuck into a pocket or camera bag, but large enough to be a lot easier to read than a wristwatch, especially under dim conditions.

Traveling Stands
Lightstands and umbrellas are difficult to pack for shipping because of their shape. Sleek padded and zippered nylon cases are very handy on arrival, but they are an open invitation to thieves during transit. I pack the nylon cases separately but I insert the stands, umbrellas, and collapsed softboxes into ordinary cardboard shipping tubes. These tubes are durable, lightweight, and too ordinary looking to attract the attention of camera-crazy criminals.

LIGHTING

Featherweight Flashheads

Because they usually come from the factory with a long cable attached, the flash heads that work with large power units are awkward to pack and heavy to carry on jobs outside the studio. A technician can shorten the cords into 6" or 8" *pigtails* terminated with a male connector. Now the heads can be conveniently tucked away in modest-sized protective cases, while the cables can be stowed separately with other less fragile hardware.

A Hot Conversion

The usefulness of a "pig-tailed" flash head and accessories like grids, barn doors, and snoots, can be extended by a custom connecting cable with a standard three-prong wall plug on one end and a female flash connector on the other. The cable should be wired to provide 120VAC power directly to the model light and cooling fan, which makes the head into a "hot light" that will work independently of its power pack when shooting with tungsten-balanced film.

Light Modifiers

A serviceable softbox can be made from white foam-core board, silver foil, and diffusion sheeting. Diffusion material is available from the same people that rent lighting hardware to the movie industry or from an industrial photography supply dealer. (A durable, cheap alternative is lightweight nylon sailcloth.) Determine dimensions by examining commercial softboxes. Adapter rings to fit your lights are available separately from Chimera, Plume, Larson, and Calumet.

Old Is New

I am particularly fond of 1950s vintage Photogenic flash heads. By adding new flash tubes, cables, connectors, model-light sockets, and cooling fans I have upgraded several of these units from 200ws to 3200ws. The heads are built like tanks: Refurbished and upgraded — at a cost of about three hundred dollars each — they serve me wonderfully in the studio.

Small Footprint

I make regular use of forty-year-old Photogenic lightstands. These rolling beauties are steel, three-sectioned, air-cushioned, and indestructible. I replaced the original castors and added a circular twenty-five pound weight from a body-building kit to each base for extra stability. My studio is small, and I don't have the height for a suspended grid system: As a functional alternative, I rely on the small footprint of the Photogenic stands and cables suspended on tracks around the outer walls to keep the studio floor uncluttered.

Fix that Flash

I carry two acetate filters — an 85B (5500°K–3200°K warming) and a 30G (green) — which I tape over the reflector of my on-camera flash units for color-balanced fill-flash under tungsten and fluorescent ambient lighting.

Handy Hosemaster

Some visual effects are impossible to make except without the precise light-painting capabilities of fiber-optic-based Hosemaster-style tools. An ordinary flashlight is a modestly priced substitute. Use a penlight for small, delicate work, while a large multi-D-cell krypton-lamp unit will work with larger objects indoors or even outdoors at night. Start experimenting with an open shutter and an aperture of f8, with ISO 100 film. (A flashlight is a tungsten source, so some filtration on the light or at the camera may be required.)

Model Portable

My portable electronic flash units became a lot more useful after I installed model lights. I used 50-watt quartz lamps that draw power through an on–off switch from the same battery pack that energizes the flash. The lamps are mounted in small sockets that I installed in the flashhead reflectors. The model lights cannot be used continuously since they are too power hungry, but even when turned on for two or three minutes at a time, they are indispensable for previewing lighting effects on location.

Reflectology

A very useful lighting accessory can be made from four 28" x 32" sheets of white-on-one-side and black-on-the-other-side ¼" foam-core board. The four sheets can be taped together so that they form a free-standing 56" x 64" reflector/flag that can fold up into a 28" x 32" x 1" package for easy travel. This inexpensive device is much faster to set up and take down than the fabric and plastic units offered by Lightform and others.

Traveling Light

Stripping the legs off a conventional aluminum alloy lightstand yielded a sturdy, lightweight, collapsible pole. I fitted a rubber foot on the bottom and added a plastic utility handle to make a device that turns an assistant into a "walking lightstand" for fast work during time-sensitive location shooting.

DARKROOM

Cheap Spouts

Buying photochemicals in bulk form is economical and convenient, but using the big twenty-five gallon size cube-tainers can be a headache. Kodak sells dispensers that consist of a foot or two of rubber tubing, a stainless clamp, and a twist-on collar that replaces the cube-tainer's cap, but these devices cost approximately fifteen dollars. Find a section called "Containers, Plastic" in the yellow pages and locate a supplier who stocks plastic utility spouts and taps in a variety of sizes. Prices are typically one or two dollars each. You may have to bring your containers to the supplier in order to find a dispenser with the proper thread.

Fast Proofs

Printing frames for making gang-proofs are available from Patterson and other manufacturers. They consist of a metal or rigid plastic base with a thin foam pad and a hinged glass cover that swings down to hold negatives and paper in close contact. Speed up proofing by removing whatever guides or retainers are provided by the manufacturer to secure individual negative strips to the glass. Instead of fiddling with

individual strips, use Printfile-type plastic sleeves and proof an entire roll at once. Make the process more efficient by using sleeves that have been punched for insertion into three-ring binders. Attach two short pieces of ¼" dowel (metal, plastic, or even machine-screws) to the upper edge of the printing frame: Position the dowels so that they properly locate the sleeves via the prepunched holes. (In the graphic arts business they call this method *pin-registration.*)

Cheaper Paper
Photographic paper is expensive. Make it cheaper by resisting packaging. Your dealer can order Kodak and Ilford materials in "bulk-packs" that dispense with the usual heavy-duty cardboard boxes in favor of black plastic bags. Products packaged like this are about 10% to 15% cheaper, but they must be handled a little more carefully.

Out Damned Spot
Kodak's Photoflo does a great job of shortening drying time while eliminating drip marks on film. It can do the same for both black and white (b&w) and color RC paper — add Photoflo to the final rinse before you squeegee. This technique also enhances the gloss on F-surface papers. Save money by buying highly concentrated Photoflo 600 in a one-gallon container, rather than Photoflo 200 in a sixteen-ounce container.

Heat It Up
Aquarium heaters are modestly priced, come in a variety of wattages, and have thermostats that are surprisingly accurate. Unfortunately, the highest temperature settings are too low for most color processes. Close examination reveals that the temperature setting on many aquarium heaters is limited only by a plastic bump or stop that constricts the movement of an adjuster knob. The judicious application of just a little force will skip the knob over the stop: Usually just one extra revolution will put the heater's thermostat into the 90°–100°F range. Calibrate with a thermometer. SAFETY NOTE: Carefully check your modified aquarium heater for cracks in the glass or damaged seals; test before using; inspect regularly for water leakage; and do not operate while unattended.

Let It Bleach

Fine b&w printing is making a commercial comeback. Master printer and photographer W. Eugene Smith used to use an overall wash of dilute ferricyanide bleach to eliminate what he called "the gray veil" that subtly dulls highlights in typically processed prints. He used bleach carefully applied with retouching brushes on specific highlight areas, as well. Anyone set up to make color prints can add a delicate brilliance to their b&w efforts using the bleach/fix from the Ektacolor RA process: Try a quick dip—just five or ten seconds, with constant agitation—followed by a brisk rinse in running water. Repeat if necessary. Local areas can be enhanced by applying bleach/fix to a wet print with a Q-tip. After bleaching, wash and dry as usual.

Safe Switches

All of us have lost valuable film and photographic paper through inadvertent exposure to light. It happened to me when I accidentally hit a light switch in the darkroom. This can't happen again because I fashioned protective switch guards out of ½" wide strips of stainless steel. Shaped like a broad, upside down "U," the guards are secured over the toggle with the two screws that fasten the switchplate. The guards stand away from the switch plate far enough to allow easy finger-access from the side, but they are wide enough to guard against any clumsy motion.

Flexible Fluid Filter

A cheap automotive in-line gas filter and a foot or two of ⁵⁄₁₆" vinyl tubing makes a handy source of particulate-free water for darkroom processes.

Back to Back

Making color prints in trays is fast and economical. Save even more money and time by making two prints at once. Dunk them in the chemistry back-to-back, emulsion side out. Agitate the pair just like a single print, but flip them over (180°) every twenty seconds or so. Avoid dragging the sensitive surfaces over the edge of the trays when transferring to the next solution.

Built-in Squeegee
I never use a squeegee when processing roll film—I use the inside edges of two fingers. Clean, water-softened skin won't hurt film so long as only light pressure is applied.

Proof Positive
Cover the glass on your proofing frame with a sheet of clean, wrinkle-free diffusion material in order to enhance the tonal range of contact sheets. If you use your enlarger as a light source for this procedure, try removing the lens first: This further softens the light and reduces contrast. Both these techniques suppress the appearance of dust marks, as well.

File Card
I file my negatives in ordinary manila folders, to which I tape the business card of the client. Having all pertinent data permanently attached to the negatives saves several valuable minutes each time prints are required.

Big Proofs
As film and lenses improve, the rationale for using large- or medium-format equipment gets less and less convincing. Although most of my work is done on medium format, very often I avoid 35mm only because art directors (AD) are too impatient to carefully examine tiny images on contact sheets made from small-format negatives. There are two solutions to this dilemma. One is to get 3" x 5" machine prints from a commercial lab, the other is to make enlarged proof sheets. I don't like the first approach because such prints are difficult to match up with the corresponding negatives, and because everyone — including ADs — has been conditioned to think of small machine prints as snapshots rather than photographs. My solution was to modify an old 5" x 7" Durst enlarger to make enlarged gang-proofs of several strips of 35mm negatives at once. I had a graphic designer make up a litho mask with my logo and address, which added practicality and a professional look to my presentation.

Negative Data
Whenever I print a negative I use a felt pen to mark exposure, contrast, and color balance information right on its protective sleeve. This information provides a starting point for the next time.

BUSINESS

Sensible Stationery
I have streamlined my stationery needs to just one item. Rather than pay a printer to make invoices, business cards, envelopes, or shipping labels, I paid a designer friend to create a stylish sticker 2 ½" x 2 ¾" in size, printed on stiff, semi-gloss stock with a peel-off backing. The design is clever and contemporary and has attracted some very favorable comments. I use them as business cards, for letterhead on quality bond writing paper, and as shipping labels. They also work well on invoices and envelopes as well as on prints and transparencies.

Return Defective Stuff
Model lamps for studio flashheads are expensive and fragile — an irritating combination for busy location shooters. Did you know that most manufacturers will replace bulbs that fail prematurely? Just mail them back in the original packaging. Polaroid Corporation will take back any of its products that don't perform perfectly — send them your instant rejects and they will exchange them for new stock.

Safe at Home
My clever insurance broker came up with a great idea when I complained that my equipment insurance rates were too high. He offered to make the following proposal to a number of insurance companies on my behalf: only a portion of my equipment is outside the studio for any given job. Instead of insuring all my equipment for expensive all-risk coverage all the time, why not insure everything at an economical base rate that would increase automatically whenever an item was taken on location? The deal we finally worked out involved identifying several location "kits"— 35mm, medium format, 4"x 5", and lighting — that would each be valued at approximately fifteen thousand dollars. By

agreement with the insurer, I pay an annual all-risk premium to cover one camera kit and one lighting kit for location use at any one time. When a job comes along that is equipment intensive I simply phone my broker and he arranges for temporary extra coverage with the insurer. This plan saves me more than one thousand dollars in premiums each year.

Taped Testimonials
We live in an age of answer machines and voice mail. My voice mail collects many "thank-you" messages from satisfied clients who have called to confirm delivery of jobs they feel have been well done.... I save these electronic testimonials on a cassette tape, which I use occasionally as an audio letter of reference when approaching new clients.

Get Organized
Some time I ago I replaced my paper-based day timer with an electronic version. It only took one experience of having to find and reenter lost data from a misplaced organizer for me to start backing-up regularly. Manufacturers can supply software and cables that will allow all but the least sophisticated units to be easily downloaded to a desktop or laptop computer.

Conclusion

This book began by quoting Stewart Brand, editor of *The Whole Earth Catalog*, who said, "When a technological revolution overtakes a craft, one has but two choices: Either you get up on the steamroller or you become part of the road." One of my goals throughout this book has been to deconstruct this rather dour remark as it applies to commercial photography. Please consider the following observations:

1. Photography is not simply a craft. *Webster* defines a craft as "an art, a skill, or an occupation requiring special skills." Photography has always been a resilient marriage between art and technology...and commercial photography is like a ménage à trois, where business is the third partner.

2. This is a big world, and there are many different roads to take, not all of which are being threatened by cataclysmic changes.

3. If you are feeling threatened by steamrollers, please keep in mind that they are not necessarily made of steel, as Bill Gates and his clones would have you believe. They are more like those giant fabric balloon sculptures that can be seen from time to time tethered to the roofs of buildings: big, but not life threatening. Anyone can see them coming a long way off.

Focal Press

Focal Press

Related Titles

Digital Imaging
Tips, Tools, and Techniques
Joe Farace

This book takes a look at digital photography through the eyes of a photographer – not a computer expert. In this book you will find information about using digital imaging hardware and software that could never be created by photo-chemical means. Digital Imaging is a tool that lets you create images that can only be envisioned in a photographer's mind. The tips, tools and techniques covered all show – through step-by-step examples and case studies – exactly how to produce a specific image or effect.

June 1998 • 224pp • pb w/ CD-ROM • 0-240-80297-7

Digital Graphic Design
Ken Pender

Written for PC and Mac platforms, *Digital Graphic Design* covers the latest software: Photoshop, Fractal Painter, Ray Dream Designer, Illustrator, Freehand, Corel Draw, Pagemaker, and Quark-Xpress. Written from the designer's point of view, not the software vendor's, it is a DIY guide to the creation of a wide range of graphic effects: from the scanning and manipulation of photographs to exciting 3D graphics and the creative use of typography.

1996 • 336pp • Paperback • 0-240-51477-7

 Focal Press

Related Titles

The Hasselblad Manual
Fourth Edition, Revised
Ernst Wildi

This book meticulously presents all the information you need to operate this camera system, including useful insights on systems ranging from the oldest Hasselblad camera, the 1600F, to the latest models with built in metering and dedicated flash systems. Presented in an easily accessible format, this book shows not only the working and manipulation of individual cameras, but also gives insight into ways in which these superb cameras, and the ancillary equipment, may be best applied in the many fields.

1996 • 416pp • hc • 0-240-80251-9

Advanced Photography
Sixth Edition
Michael Langford

Advanced Photography takes you beyond the basics to a much more detailed knowledge of photography. Written as a companion volume to the international bestseller *Basic Photography*, this book has enjoyed a long established reputation as a technical "bible" and has now been revised to include the latest technological advances, including electronic imaging.

June 1997 • 320pp • Paperback • 0-240-51486-6

http://www.bh.com/focalpress

Available from all better book stores or in case of difficulty call:
1-800-366-2665 in the U.S. or +44 1865 310366 in Europe.

FOCAL PRESS

Focal Press is a leading provider of quality information worldwide in all areas of media and communications, including: photography and imaging, broadcasting, video, film and multimedia production, media writing, communication technology, theatre and live performance technology. To find out more about media titles available from Focal Press, request your catalog today.

Free Catalog

For a free copy of the Focal Press Catalog, call 1-800-366-2665 in the U.S. (ask for Item Code #560); and in Europe call +44 1865 310366.

Mailing List

An e-mail mailing list giving information on latest releases, special promotions/offers and other news relating to Focal Press titles is available.

To subscribe, send an e-mail message to: majordomo@world.std.com Include in message body (not in subject line) subscribe focal-press.

Web Site

Visit the Focal Press Web Site at:
http://www.bh.com/focalpress